TOBACCO TINS
A Collector's Guide

Douglas Congdon-Martin

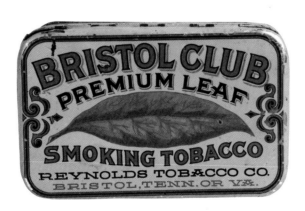

77 Lower Valley Road, Atglen, PA 19310

Dedicated to the memory of C.J. Simpson,
November 29, 1923—May 14, 1992

Published by Schiffer Publishing, Ltd.
77 Lower Valley Road
Atglen, PA 19310
Please write for a free catalog.
This book may be purchased from the publisher.
Please include $2.95 postage.
Try your bookstore first.

We are interested in hearing from authors
with book ideas on related subjects.

Printed in the United States of America.
ISBN: 0-88740-429-4

We are interested in hearing from authors with book ideas on
related topics.

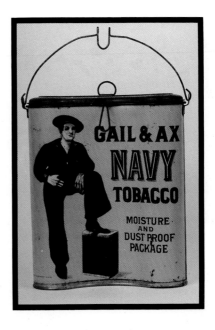

Acknowledgements

This book would have been impossible to compile without the assistance of others. Some of them are old friends, some new, and all were willing and excited to help in this project. John and Elsie Booker of Patterson's Mill Country Store in Chapel Hill, North Carolina were at the hub of the network of contributors. When I was hesitant to begin the project, they prodded me along, even after it became clear that John's first love, cigarette packs, would not be included in the book.

John and Elsie took me to see the collection of John's cousin, C.J. Simpson. It was wonderful. C.J. had been collecting since he was a child and his collection reflected his passion for those miniature works of art. He was generous enough to allow us to invade his home for the better part of a week and photograph nearly every piece. C.J. and his son helped move things along, and provided us with a wealth of information. Examples from the Simpson collection make up the bulk of this book.

It was with sadness that I learned of C.J.'s death in the spring of 1992. I am privileged to dedicate this book to his memory and hope that it is a work that would have pleased him.

The Bookers also introduced me to Tom Gray and Frank and Betty Lou Gay who opened their collections to me and offered me their hospitality and time when I went to their homes to do my work.

The Gays, in turn, introduced me to George Goehring and Dennis O'Brien who shared their beautiful collection of upright pocket tins with me and provided a wealth of information. The network expanded even more as they put me in contact with Dave and Betty Horvath, and C.J. introduced me to Ben Roberts.

Other old friends have shared their collections as well. They include Mary Lou Holt, Oliver's Auction Gallery, Joe and Sue Ferriola, Ron Koehler and Cindy Marsh, Harold and Elsie Edmondson, and Gary Metz.

I thank them all for their support.

That thanks extends to the team at Schiffer Publishing. Kate Dooner endured great hardship to assist me in taking the photos and gathering the data on the tins shown here. Ellen J. (Sue) Taylor again has used her talent at design to present the tins in a way that is beautiful and easy to use. Finally, Bonnie Hensley and Jean Cline spent long hours in the layout of captions and doing the other things necessary to finish this project.

As always, this is a collaborative effort and I am deeply indebted to the many who have shared of themselves.

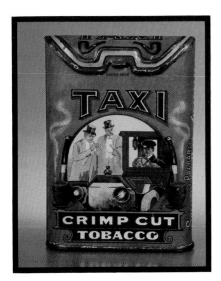

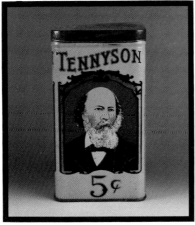

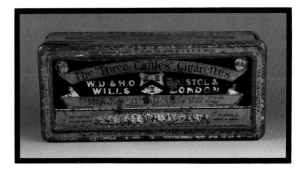

Introduction

It is easy to see why tobacco tins appeal to collectors. They are, at the same time, artifacts of history and objects of beauty. When you hold a tin you think about those who held it before you and begin to understand why they cherished it enough to preserve it through the years.

You also learn much about the development of an American industry and its pioneering role in the history of advertising. The tobacco industry traces its origins back to the founding of the colonies. It was one of early exports back to England and Europe and a vital ingredient in the colonial economy. Virginia, the Carolinas and Maryland were centers of the growing industry, but it also spread as far north as Connecticut and as far west as Missouri.

Until the middle of the nineteenth century, tobacco was a generic product. While different varieties were recognized, little effort was made to distinguish the product of one grower or manufacturer from another. Then, latching onto an advertising innovation that would have far-reaching consequences, some tobacco manufacturers began to give names to their products, in the hope of creating product identification and loyalty. They created catchy names and, with hot irons, "brand"-ed the names onto the wooden caddies and crates that they used for shipping, some of which you will see in the pages that follow.

The use of the brand name spread to a variety of products, but no industry used it more effectively than the tobacco manufacturers. Thousands of names were registered to tobacco products in the years preceding 1908. You will find many of them represented in this book.

The goal was to find the name that would strike the consumer's fancy, to "hook" them into trying a brand for the first time and keep them coming back. But there was more to this art than name alone. To promote their products advertisers turned increasingly to advertising to spread the word.

The story of John Ruffin Green offers a good example of this. During the Civil War, Yankee soldiers were introduced to his "bright tobacco." They were so enamored of it that following the war they wrote to him at his Durham Station, North Carolina factory asking if he would send them some. Green was quick to capitalize on its widening circle of admirers. The product, known as "Best Flavored Spanish Smoking Tobacco" before and during the war, was named "Genuine Durham Smoking Tobacco." The figure of a Durham bull was used to symbolize Durham, and the product became popularly known as "Bull Durham" tobacco. Green died in 1869 and W.T. Blackwell took over ownership of the firm. On January 3, 1871 the trademark of the Durham bull was registered as trademark number 122, one of the earliest uses of an animal as a trademark.

Blackwell believed in advertising. According to Goodrum and Dalrymple (*Advertising in America*, p. 192):

By the early 1880s he was spending $100,000 a year in country newspapers, $50,000 in metropolitan dailies, and giving out premiums (from coupons packed inside the little sacks) of as much as $60,000 a year for clocks alone. By the mid-1880s, the Bull Durham factory was the largest tobacco processor in the world, employing over a thousand people in a single building.

In 1881 two million pounds of Bull Durham were produced. Later the company was equipped to process 20,000 pounds of tobacco a day. American Tobacco acquired Blackwell's business in the 1890s.

The tobacco tins that concern us here are an extension of this advertising. From the first branded wooden caddies, the manufacturers realized the importance of "point of purchase" advertising. In addition to the brands, wooden caddies began to carry lithographed paper labels, some of them quite beautiful. Lithographed paper labels also adorned the cloth bags of tobacco and the early tobacco tins.

The breakthrough in the art of the decorated tin came with the introduction of commercially viable methods of lithography on tin, beginning in England in 1877. Earlier lithography used hard stones to transfer an image onto a surface. This worked well with absorbent paper, but was not successful with the hard shiny surface of tin, so tin makers were limited to paper labels, transfer printing, or crude lithography. Adjustments were made, and the closing years of the nineteenth century saw the development of some beautifully lithographed tins. By 1903 a rotary offset lithograph was developed which transferred the image from a rotating metal drum to a rotating rubber drum and then onto the tin.

With lithography it was possible to create a striking image directly onto the tin. With the many competing brands of tobacco it is difficult to underestimate the importance of this. The manufacturer needed a distinct identity in the consumer's mind. The tin needed to stand out from the crowd, to appeal to the eye. This would encourage the initial sale, but it also created a visual marker that would trigger future sales and establish brand loyalty. So we get the red bull's eye of Lucky Strike, the Bull of Durham, Old Joe Camel, or George Washington on Continental Cubes.

As Jane Webb Smith writes in *Smoke Signals: Cigarette Advertising and the American Way of Life*:

Color printing on tin had furthered the use of packaging as an advertising medium through tin tags on individual plugs and tobacco tins in all shapes and sizes. Distribution of these goods was on a local level, but in a city like Richmond, which in 1893 had over 90 tobacco factories

each with a large number of brands, product differentiation was critical. In a Chamber of Commerce publication, the Cameron and Cameron firm lists the brand names of its products: five brands of 'paper cigarettes,' six of cheroots, five 'all tobacco cigarettes,' and ten more of miscellaneous blends of tobaccos. Colorful labels and packaging, along with an attention-getting brand name, therefore, were early attempts at 'modern' advertising at the local level. *(page 20)*

As the years passed and advertising grew from an art to a science, manufacturers became more sophisticated in their approach. Typical of these is the R.J. Reynolds Tobacco Company. Richard Joshua Reynolds believed in advertising, and from the earliest years of the company invested a significant amount to get the name of his tobacco products before the public. The names of Our Advertiser, Prince Albert, B.F. Gravely & Sons, George Washington, and Stud found strong consumer acceptance and loyalty.

Despite his success, Reynolds was without a manufactured cigarette product. Each of the companies that resulted from the split of the American Tobacco Company in 1911, had their own cigarette operations, and it was clear that this was a growing trend in the industry. So, in 1913, Reynolds made the move into the field. To do so he tested four brands, Reyno, Red Kamel, Osman, and Camel. Each had a different blend of tobacco, but all had the advantage of a short, easy to remember name. Camel was the clear winner in the test, and in 1914 was introduced with a now famous series of teaser ads in December of that years. By 1919 Camel was the top selling brand of manufactured cigarettes, and had taken a 40 percent share of the market. From then, through the highly successful "I'd walk a mile for a Camel" advertisements, and to the controversial Joe Camel ads of the 1990s, R.J. Reynolds has been an innovator and leader in the area of tobacco advertising.

While a number of companies produced tobacco tins in the early years, a few were prominent. They include:
Ilsley, Brooklyn, New York, c. 1865-1901
Ginna, New York, New York, probably originated in the 1870s.
Norton Bros., Illinois, c. 1879-1901
Somers Bros., Brooklyn, New York, late 1870s (some say 1869)-1901.
Hasker & Marcuse, Richmond, Virginia, 1891-1901.
In 1901 over 100 tin manufacturers joined forces to form the American Can Co. This is a helpful fact when trying to date a tin. At the same time some new companies entered the field, including Tindeco, Heekins, and Continental Can.

While the principal focus of this book is tobacco tins, I have found other containers, advertising, and ephemera that contribute to an understanding of the tobacco industry in America, and enhance the enjoyment of collecting tobacco tins.

I hope this will be an entertaining, informative book for collectors new and old.

Condition: A Question of Value

One of the reasons lithographed tin is collectible is that it is perishable. Time, the environment, and the useful practicality of the tins have taken their toll. Most of the tins that were originally manufactured have found their way to trash heaps. Those that have survived usually bear the scars of their long years. But miraculously some tins have come to us relatively unscathed. Either some sensitive eye must have been captured by their inate beauty and taken steps preserve them, or they found their way into a hidden, safe corner of the pantry waiting to be rediscovered.

The importance of condition in assessing the value of a tin is a relative thing. The newer or more common a tin is, the higher is the Importance condition has in its value. For a tin that is older or rarer, the collector tends to have more tolerance of flaws. In any case, the finer the condition of the tin, the greater its value. The dedicated collector is always seeking to upgrade his collection, finding better tins to replace his or her less than perfect examples.

You will see that the tins in this volume are of varying grades from the most pristine mint pockets to a couple that look like they have "been through a war." Instead of omitting the examples that are less than great we have left them in to provide a visual reference. Like the collector we will attempt to upgrade the collection in future editions.

The traditional ratings of a tin's condition ranges from "Poor" to "Mint". They are, of necessity, somewhat subjective, and, indeed, it is a rare occasion when the opinions of two collectors match, especially when one is buying and the other selling. That said, the rating system at least sets the guideline for the debate, and familiarity with it can save the collector from some costly mistakes.

"Mint": To qualify for this rating a tin has to be in new condition and have no flaws. Although a few tins in this book have had the good fortune to qualify for this condition, it is an extreme rarity.

"Near Mint": This tin will show that it has been used, but only slightly. It may have some minor flaws, but if it has rusted or faded it is disqualified.

"Excellent/Fine": Most of the tins in most collections will fall into this category. Some collectors subdivide this rating into "Fine Plus," "Fine," and "Fine Minus" to achieve an even more accurate distinction. In general the Fine class of tin will have only minor blemishes. Bergevin allows no rust in this catagory, while other collectors permit some rust and minor fading at the lower end of this category.

"Good": There is not much good about "Good." These are tins that have minor scratching, fading, and rust...and yet are "good" enough to hold a place in your collection until you find something better.

"Fair/Poor": These are tins that you wouldn't think twice about, except that you been looking for the XYZ tin for seven years, and finally find one in this condition. You pay your $1-10, put it in your collection, and start searching for something better.

This traditional scale of condition has worked for a number of years, but numerical systems have been proposed. Bergevin's goes from 5 to 1 with 5 being "Mint" and 1 being "Fair." Others use a system based on a scale of 10 to 1, mint to poor.

Prices and Investing

The prices of tobacco tins fluctuate, as do those of all collectibles. The trend, however, has been generally in an upward direction, sometimes moving quickly and sometimes slowing to a dirge. Unless you are really good or really lucky, the chances are that you will not make a killing in the tobacco tin market. But you probably will not lose your shirt either.

If, however, you enjoy beautiful things, you have the perfect motivation for buying tins. For the beginner, especially, it is helpful to deal with a reputable and knowledgeable dealer. While you are less likely to find that undiscovered underpriced tin we all dream of, you are more likely to get a tin that is exactly what is purported to be and is fairly priced. The bonus is that the good dealers are more than pleased to share the information you need to be an enthusiastic and informed collector.

The value ranges given in this book are compiled from a variety of sources. They represent a range of values for tins in Fine to Near Mint condition. The tins illustrated usually fall into that range, but sometimes are below or above it.

Tins & Things

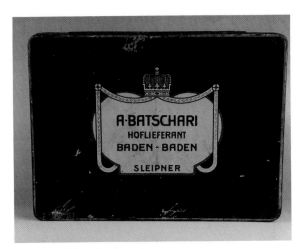

A. Batschari Cigarettes (500), Sleipner, Baden-Baden. Lithographed tin. 2" x 11" x 8". *Courtesy of C.J. Simpson.*

A. Batschari Cigarettes, Sleipner, Berne, Switzerland. Lithographed tin. .5" x 2.5" x 4.5". *Courtesy of C.J. Simpson.*

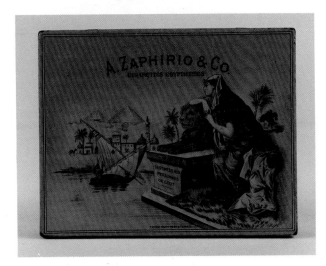

A. Zaphiro & Co. Cigarettes Egyptiennes. Lithographed tin. 0.75" x 5.5" x 4.25". *Courtesy of C.J. Simpson.*

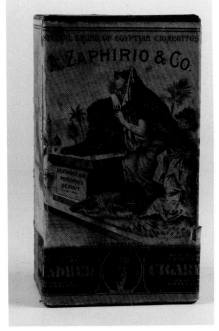

A. Zaphiro & Co. Egyptian Cigarettes (100). Tin with paper label. *Courtesy of C.J. Simpson.*

Abbey Cigars (Factory No. 268, 1st Pennsylvania). Glass jar with embossed tin lid. 5.5" x 4.25". *Courtesy of C.J. Simpson.*

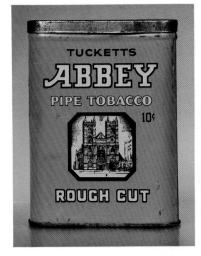

Abbey Pipe Tobacco. Tuckett Tobacco, Hamilton, Ontario. 4" x 3" x 1". *Courtesy of Dennis O'Brien and George Goehring.*

Abdulla & Co., Ltd., Turkish No. 5 Cigarettes, London. Tin with paper label. 3.25" x 2.75". *Courtesy of C.J. Simpson.*

Abdulla & Co., Magnum No. 37 Cigarettes, London. 3.25" x 3". *Courtesy of C.J. Simpson.*

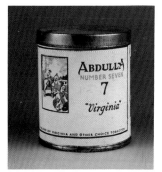

Abdulla Number Seven Cigarettes, Abdulla & Co., London. Tin with paper label. 3.25" x 2.75". *Courtesy of C.J. Simpson.*

Abdulla Virginia No. 70, Abdulla & Co., London. 3.25" x 2.75". *Courtesy of C.J. Simpson.*

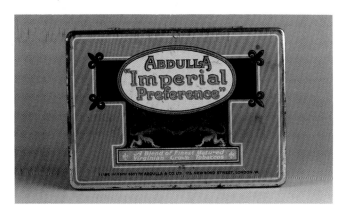

Abdulla Imperial Preference, Abdulla & Co., Ltd., London. Curved lithographed tin to fit in pocket as did flasks. 0.5" x 5.5" x 4". *Courtesy of C.J. Simpson.*

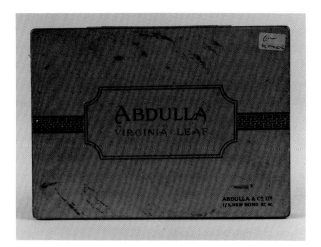

Abdulla Virginia Leaf, Abdulla & Co., London. Lithographed tin. .75" x 6" x 4.5". *Courtesy of C.J. Simpson.*

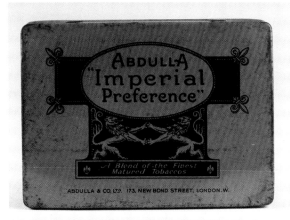

Abdulla Imperial Preference, Abdulla & Co., Ltd., London. Lithographed tin. .75" x 6" x 4.5". *Courtesy of C.J. Simpson.*

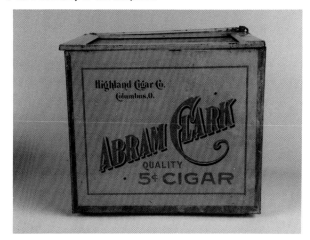

Abram Clark 5 cent Cigars, Highland Cigar Co., Columbus, Ohio. Glass topped tin box manufactured by the Brazil Stamping & Mfg. Co., Brazil, Indiana. 7.5" x 6 ". *Courtesy of C.J. Simpson.*

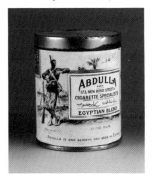

Abdulla No. 16 Egyptian Cigarettes, Abdulla & Co., London. 3.25" x 2.75". *Courtesy of C.J. Simpson.*

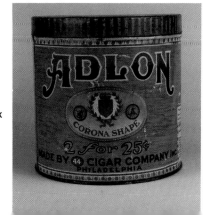

Adlon Cigars, 44 Cigar Company, Philadelphia (Factory 370, Pennsylvania). Lithographed tin. 5.5" x 5.5 ". *Courtesy of C.J. Simpson.*

7

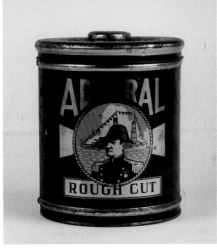
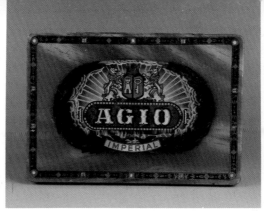
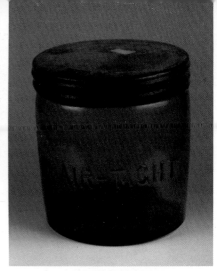

Admiral Rough Cut (Factory No. 3, 1st Missouri). Lithographed tin, American Can Co. 5.75" x 4.5". *Courtesy of C.J. Simpson.*

Agio Imperial Cigarettes, Firma A. Wintermans & Zonen Duizel, Holland. Lithographed tin. .75" x 7" x 4.5". *Courtesy of C.J. Simpson.*

Air Tight (Factory No. 1429, 1st. Pennsylvania). Glass container. 5.5" x 4.75". *Courtesy of C.J. Simpson.*

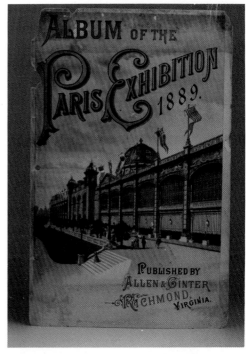

Alisa Highest Grade Havanna Cigars. Embossed cardboard. 4.5" x 3.5" x 0.5". *Courtesy of C.J. Simpson.*

Allen & Ginter cover of the *Album of the Paris Exhibition, 1889.* Courtesy of Betty Lou and Frank Gay.

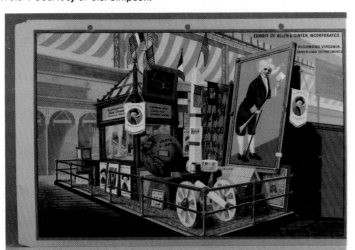

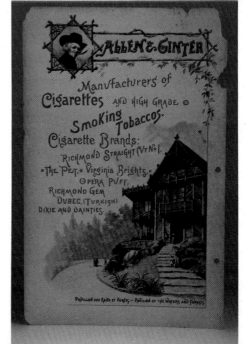

Allen & Ginter exhibit at the 1889 Paris exhibition. From the *Album of the Paris Exhibition, 1889.* 9.25" x 6". *Courtesy of Betty Lou and Frank Gay.*

Allen & Ginter exhibit at the 1889 Paris exhibition. From the *Album of the Paris Exhibition, 1889.* 9.25" x 6". *Courtesy of Betty Lou and Frank Gay.*

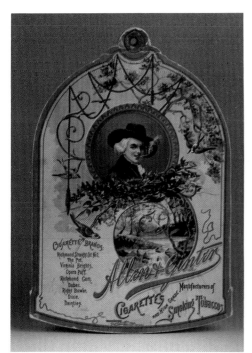

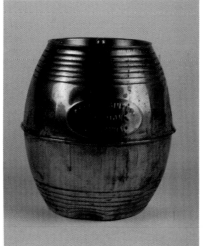

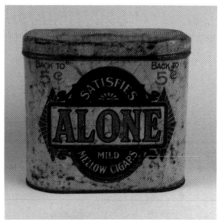

Allen & Ginter bird booklet featuring cigarette premiums. Geo. G. Harris Lithographer, Phila, New York. 9" x 6". *Courtesy of Betty Lou and Frank Gay.*

Allen & Ginter, Richmond, Virginia. Embossed tin barrel. 6" x 4.5". *Courtesy of C.J. Simpson.*

Alone Mild Mellow Cigars (Factory No. 98, Ohio). 5.25" x 6" x 4". *Courtesy of C.J. Simpson.*

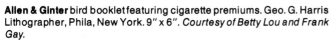

American Beauty Fine Mixture, B. Seiderson & Co. (Factory No. 8, 1st Wisconsin). Lithographed tin, Ginna. 1.5" x 4.5" x 2.50". *Courtesy of C.J. Simpson.*

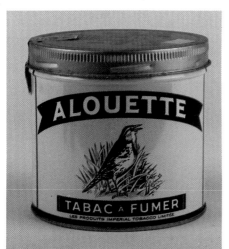

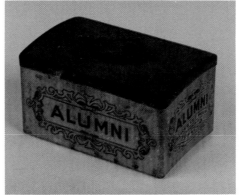

Alouette Tabac A Fumer, Imperial Tobacco Co., Montreal. Lithographed tin. 4.25" x 4.25". *Courtesy of C.J. Simpson.*

Alumni Sliced Cut Plug Tobacco, United States Tobacco Co. (Factory No. 15, 2nd Virginia). Lithographed tin with curved bottom. 2.50" x 5" x 3.50". *Courtesy of C.J. Simpson.*

Ambar Cigarettes, Ahmed Lohman, Cairo, Egypt. 2" x 5.25" x 2.75". *Courtesy of C.J. Simpson.*

American Mixture, Alfred Dunhill (Factory No. 15, Virginia), 1926 stamp. Cardboard with paper label. Left 4.5" x 5"; right 4.5" x 4". *Courtesy of C.J. Simpson.*

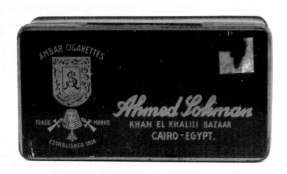

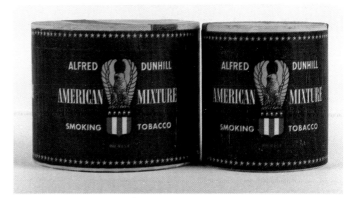

9

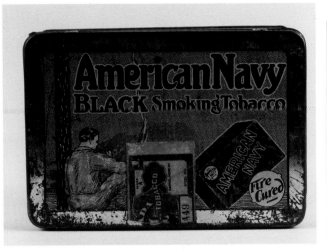

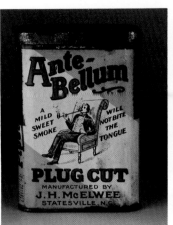

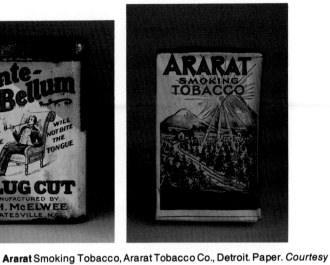

American Navy Black Smoking Tobacco, Canada. Lithographed tin. 3" x 6" x 4.25". *Courtesy of C.J. Simpson.*

Ante-Bellum Plug Cut, J.H. McElwee, Statesville, North Carolina. Lithographed tin. *Courtesy of Elsie and John Booker.*

Ararat Smoking Tobacco, Ararat Tobacco Co., Detroit. Paper. *Courtesy of Betty Lou and Frank Gay.*

Arcadia Mixture, Surbrug Company, New York (Factory No. 4, 2nd Virginia). Lithographed tin. Left: 1" x 4" x 2.5"; Right: 1.25" x 3.5" x 3.25". *Courtesy of C.J. Simpson.*

Apple Chewing Tobacco poster, dated 1921. Paper, lithography by Strobridge Litho Co., Cincinnati & New York. 11" x 21". Apple was introduced in 1905 to compete with R.A. Patterson's "Grape" brand. *Courtesy of Thomas Gray.*

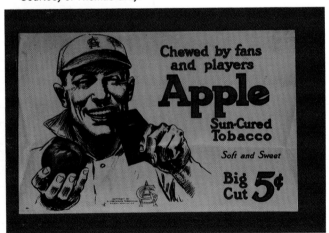

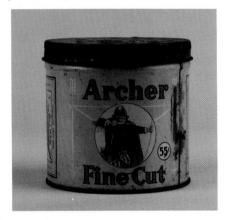

Archer Fine Cut, MacDonald Tobacco, Canada. Lithographed tin. 4.25" x 4". *Courtesy of C.J. Simpson.*

Apple Sun-Cured Tobacco poster, R.J. Reynolds, Winston-Salem, c. 1913. Paper. 8.5" x 13.5". *Courtesy of Thomas Gray.*

Arabian Latakia, John Middleton, Philadelphia. Lithographed tin. 3" x 3". *Courtesy of C.J. Simpson.*

Auto. Lithographed tin. .5" x 3.75" x 2". *Courtesy of C.J. Simpson.*

Ardath Cork-Tipped Virginia Cigarettes, Ardath Tobacco Co., Ltd., London. Lithographed tin. .75" x 6" x 5.5". *Courtesy of C.J. Simpson.*
Arm-Chair Club English Mixture, Royal Canadian Tobacco Co., Toronto. Lithographed tin. 3.5" x 4.25". *Courtesy of C.J. Simpson.*

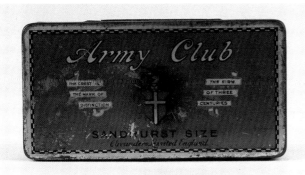

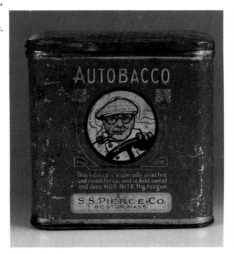

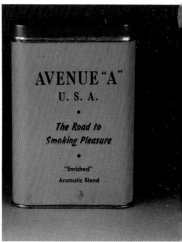

Army Club Sandhurst Size Cigarettes, Cavanders Limited, England. Lithographed tin. 1.5" x 5.5" x 2.75". *Courtesy of C.J. Simpson.*

Autobacco, S.S. Pierce, Boston. Lithographed tin. 4.25" x 4.25" x 2.50". *Courtesy of Betty Lou and Frank Gay.*
Avenue "A" U.S.A., Rainey-Young Tobacco (Factory No. 93, 1st Missouri). Tin with paper label. *Courtesy of Elsie and John Booker.*

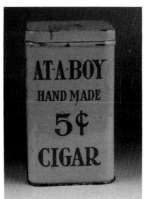

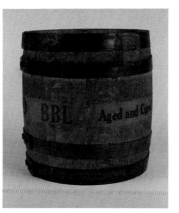

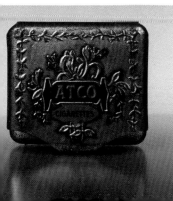

Arrow Snuff, A. Soderberg Co., South Bend, Indiana (Factory No. 43, Indiana). *Courtesy of C.J. Simpson.*
At-A-Boy Hand Made 5-cent Cigars, Hilson-Reis Cigar Corporation (Factory No. 12, 12th Pennsylvania). Lithographed tin, Ritter(?) Can Co. 6.25" x 3" x 3". *Courtesy of C.J. Simpson.*

ATCO Cigarettes, American Tobacco Company. Embossed, lithographed tin. 3" x 3.25" x .25". *Courtesy of Dennis O'Brien and George Goehring.*

BBL (Factory 1288, 1st Pennsylvania). Wood and metal. 7" x 6". *Courtesy of C.J. Simpson.*
Bagdad Short Cut Smoking. Lithographed tin, unusual in nice condition because of the thin finish. 3.75" x 3.25" x 1". *Courtesy of Dennis O'Brien and George Goehring.*

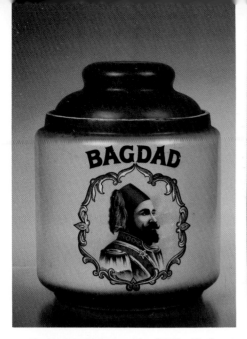
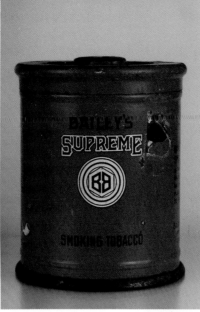
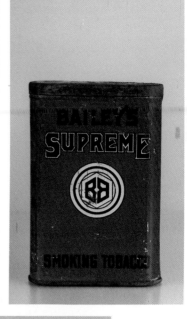

Bagdad, ceramic humidor. 6.25" x 5". *Courtesy of Dennis O'Brien and George Goehring.*
Bailey's Supreme, Bailey Brothers Inc., Winston-Salem, North Carolina. Lithographed tin, American Can Co. 6" x 5". *Courtesy of Thomas Gray.*
Bailey's Supreme, Bailey Brothers Inc., Winston-Salem, North Carolina. Lithographed tin. 4.5" x 3". *Courtesy of Thomas Gray.*

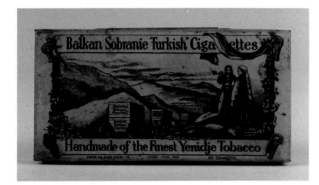

Balkan Sobranie Turkish Cigarettes (50), England. Lithographed tin. 1.5" x 6" x 3". *Courtesy of C.J. Simpson.*

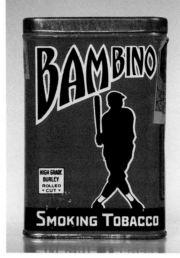
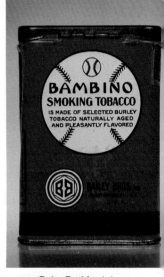

Bambino Smoking Tobacco pocket playing upon Babe Ruth's nickname and silhouette. Bailey Bros., Winston-Salem, North Carolina. 4.5" x 3" x 1". *Courtesy of Dennis O'Brien and George Goehring.*

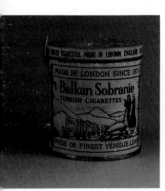
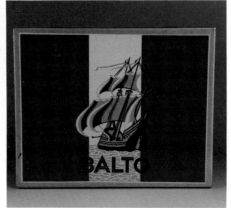
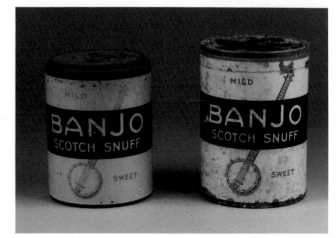

Balkan Sobranie Turkish Cigarettes, Sobranie Ltd., London. Lithographed tin. 3.25" x 3". *Courtesy of C.J. Simpson.*
Balto Cigarettes (50), Regi Francaise. Lithographed tin. 0.5" x 4.25" x 5.75". *Courtesy of C.J. Simpson.*

Banjo Scotch Snuff, United States Tobacco, Nashville, Tennessee (Factory No. 33, Tennessee). Snuff on right has 1945 stamp. L: 1.75" x 1.25"; R: 2.25" x 1.5". *Courtesy of C.J. Simpson.*

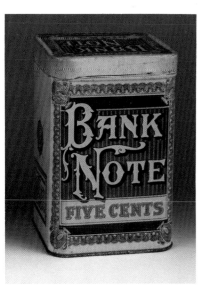
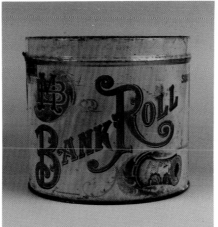
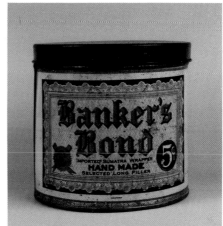

Bank Note Five Cent Cigars (Factory No. 750, 1st Pennsylvania). Lithographed tin, Federal Tin Co., Baltimore. 5.25″ x 3.25″ x 3.5″. *Courtesy of Betty Lou and Frank Gay.*

Bank Roll, Bressler Cigar Mfg. Co., Freeland, Pennsylvania (Factory No. 309, Pennsylvania). Lithographed tin, Liberty Can Co, Lancaster, Pennsylvania. 5.25″ x 5.75″. *Courtesy of C.J. Simpson.*

Banker's Bond Cigars (Factory No. 67, Pennsylvania). Lithographed tin. 5.25″ x 5″. *Courtesy of C.J. Simpson.*

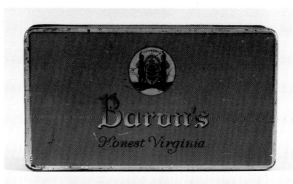

Baron's Honest Virginia, Carreras, Canada. Lithographed tin. 1″ x 5.5″ x 3″. *Courtesy of C.J. Simpson.*

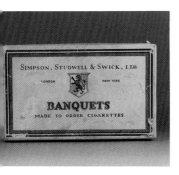
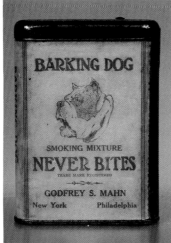

Beatall Rich Dark Flake, C.W.S. Lithographed tin. 0.25″ x 3.25″ x 2.25″. *Courtesy of C.J. Simpson.*

Banquets Made to Order Cigarettes, Simpson, Studwell & Swick, Ltd, London and New York, series 112 stamp. Cardboard case with paper label. Lithographed tin. 1.25″ x 3″ x 5″. *Courtesy of C.J. Simpson.*

Barking Dog, Godfrey S. Mahn, New York & Philadelphia, 1910 stamp. Tin pocket with paper label in extra fine condition. 4.50″ x 3″ x .75″. *Courtesy of Dennis O'Brien and George Goehring.*

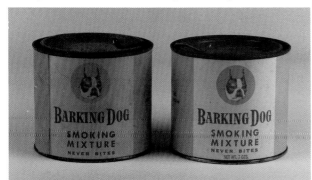
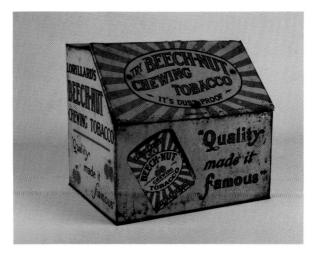

Barking Dog Smoking Mixture, "Never Bites," Philip Morris, New York and Richmond. Tin with paper labels. 4″ x 4.25″. *Courtesy of C.J. Simpson.*

Beech-Nut Chewing Tobacco, P. Lorillard Co., Jersey City. Lithographed tin store dispenser. 8.75″ x 10″ x 9″. *Courtesy of C.J. Simpson.*

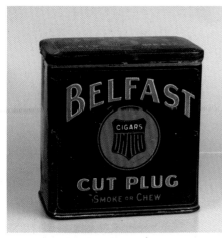

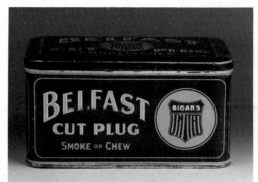

Belfast Cut Plug Smoke or Chew, United Cigar Stores, Chicago (Factory No. 8, 1st Illinois). Lithographed tin. 6" x 6" x 3.75". *Courtesy of Betty Lou and Frank Gay.*

Belfast Cut Plug Smoke or Chew, United Cigar Stores, Illinois (Factory No. 3, 1st Illinois). Lithographed tin. 3" x 5.75" x 3.75". *Courtesy of Betty Lou and Frank Gay.*

Belwood Smoking Mixture. Embossed tin. 1" x 4.25" x 3.25". *Courtesy of C.J. Simpson.*

Benson & Hedges London Cigarettes, Benson & Hedges, New York. Tin with paper label. 1" x 6" x 3". *Courtesy of C.J. Simpson.*

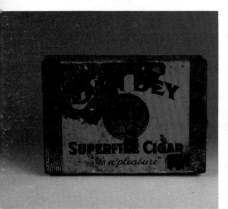

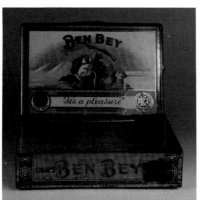

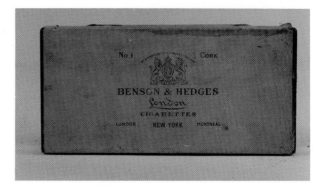

Ben Bey Superfine Cigars, "It's a Pleasure," Nathau Elson & Co. (Factory No. 44, Louisiana). Lithographed tin. 1.25" x 5.5" x 3.5". *Courtesy of C.J. Simpson.*

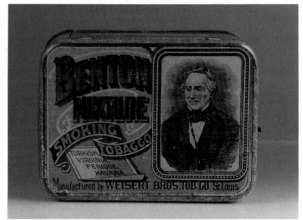

Benton Mixture Smoking tobacco, Weisert Brothers Tobacco Co., St. Louis (Factory No. 13, 1st Missouri). Lithographed tin. 2.25" x 4.5" x 3.25". *Courtesy of Betty Lou and Frank Gay.*

Berriman's Hand Made Havana Specials, for Sears, Roebuck & Co. (Factory 182, Florida). Lithographed tin. 5" x 4". *Courtesy of C.J. Simpson.*

Bestoval Crushed Plug, H.M. Schermerhorn, Inc., Chicago (Factory No. 15, Virginia). Tin with paper label. 4" x 3" x 1". *Courtesy of C.J. Simpson.*

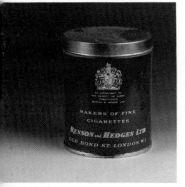

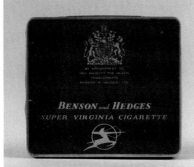

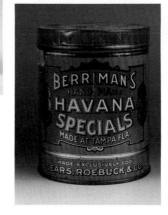

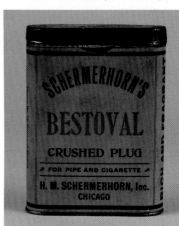

Benson & Hedges Super Virginia Cigarettes, Benson & Hedges, Ltd., London. Tin with paper label, embossed tin lid. 3.25" x 2.75". *Courtesy of C.J. Simpson.*

Benson and Hedges Super Virginia Cigarettes. Lithographed aluminum. 0.5" x 3.25" x 3". *Courtesy of C.J. Simpson.*

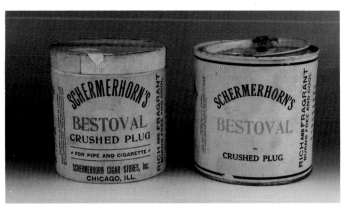

Bestoval Crushed Plug, Schermerhorn Cigar Stores, Chicago, Illinois (Factory No. T-15, Virginia). Left 1926, cardboard with paper label, 4.5" x 4"; Right tin with paper label. 4.25" x 4". *Courtesy of C.J. Simpson.*

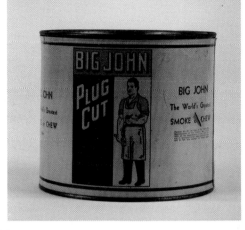

Big John, John Weisert Tobacco Co., St. Louis (Factory No. 93, 1st Missouri). Tin with paper label. 5" x 5". *Courtesy of C.J. Simpson.*

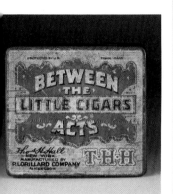

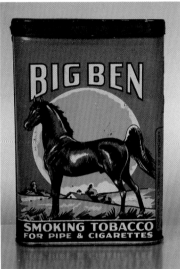

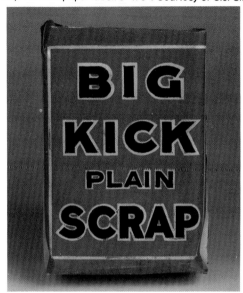

Between the Acts Little Cigars, Thomas H. Hall, P. Lorillard Company, successor. Lithographed tin. *Courtesy of Elsie and John Booker.*
Big Ben Smoking Tobacco, Brown & Williamson Tobacco Corp., Louisville, Kentucky (Factory No. 21, Kentucky). Common, but pretty, lithographed pocket. 4.5" x 3" x 1". *Courtesy of Dennis O'Brien and George Goehring.*

Big Kick Plain Scrap, Scotten, Dillon Co., Detroit. Paper. *Courtesy of Betty Lou and Frank Gay.*

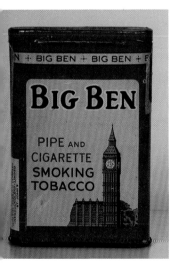

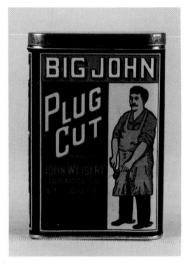

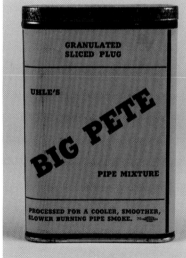

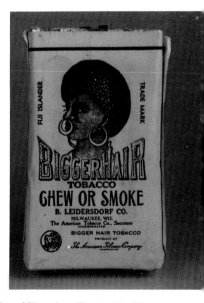

Big Ben Smoking Tobacco. A rare Canadian pocket. Imperial Tobacco Co., St. John's, Newfoundland, 1942. 4.5" x 3" x 1". *Courtesy of Dennis O'Brien and George Goehring.*
Big John Plug Cut, John Weisert Tobacco Co., St. Louis (Factory No. 93, 1st Missouri). Tin with paper label. 4.5" x 3". *Courtesy of C.J. Simpson.*

Big Pete Pipe Mixture, Uhle's Smoke Shop, Milwaukee (Factory No. 93, 1st Missouri). Tin with paper label. 4.5" x 3". *Courtesy of C.J. Simpson.*
Bigger Hair Chew or Smoke, B. Leidersdorf Co., Milwaukee, American Tobacco Company, Successor. Paper. *Courtesy of Betty Lou and Frank Gay.*

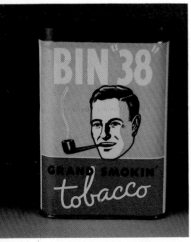
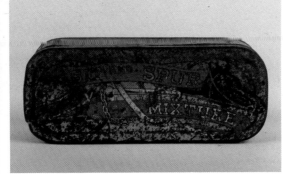
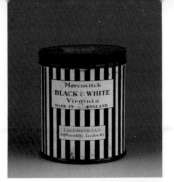

Bin "38" Grand Smokin' Tobacco, blended for Coxhill Smoke Shop. Tin with paper label. *Courtesy of Elsie and John Booker.*

Bit and Spur Mixture, Miller & Sons, New York (Factory No. 57, 2nd New York). Lithographed tin. 1.75" x 7" x 2.75". *Courtesy of C.J. Simpson.*

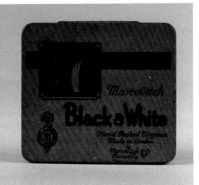
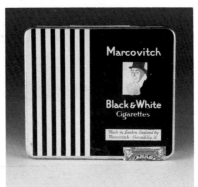
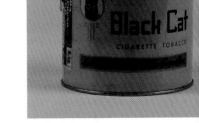

Black & White, Cigarettes (50), Marcovitch & Co., London. Tin with paper label. 3" x 2.5". *Courtesy of C.J. Simpson.*

Black Cat Cigarette Tobacco, Carreras, Canada. Lithographed tin. 4.25" x 4.25". *Courtesy of C.J. Simpson.*

Black & White Cigarettes, Marcovitch & Co., London. Lithographed tin. 0.5" x 3.5" x 3". *Courtesy of C.J. Simpson.*

Black & White Cigarettes, Marcovitch, London. Tin with paper label. *Courtesy of Elsie and John Booker.*

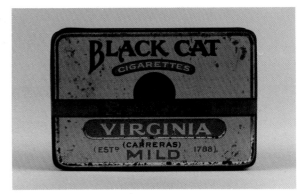

Black Cat Cigarettes, Carreras, Canada. Lithographed tin. 1.5" x 4" x 3". *Courtesy of C.J. Simpson.*

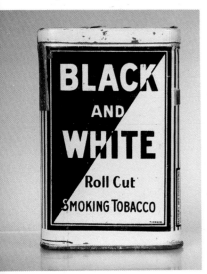

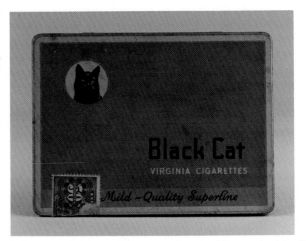

Black & White pocket. Tin manufactured by Tindeco, Baltimore, Maryland. 4.5" x 3" x 1". *Courtesy of Dennis O'Brien and George Goehring.*

Black and White Cigars (Factory No. 5, Indiana). Lithographed tin, American Can Co. 5.25" x 5.25". *Courtesy of C.J. Simpson.*

Black Cat Virginia Cigarettes, Carreras, Canada. Lithographed tin. .75" x 6" x 4.5". *Courtesy of C.J. Simpson.*

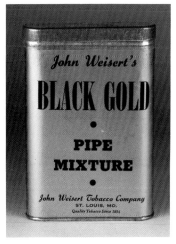 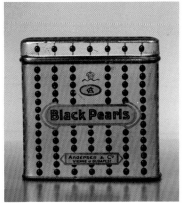

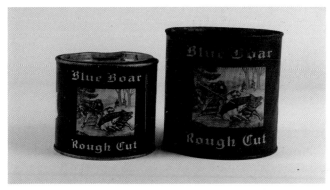

Blue Boar Rough Cut, American Tobacco Company (Factory No. 2, Maryland). Tin with paper label. Left: 3" x 2.5"; right: 3.75" x 2.75". *Courtesy of C.J. Simpson.*

Black Gold, John Weisert Tobacco Co., St. Louis, Missouri (Factory No. 93, Missouri). Tin with paper label. 4.5" x 3". *Courtesy of Elsie and John Booker.*

Black Pearls Cigarettes pocket. Anderson & Co., Vienne & Budapest. 3" x 3" x .75". *Courtesy of Dennis O'Brien and George Goehring.*

Blue Boar Rough Cut, American Tobacco Company (Factory No. 2, Maryland). Glass with paper label. 5" x 5.5". *Courtesy of C.J. Simpson.*

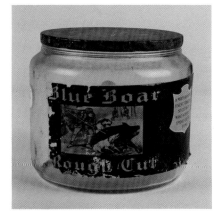

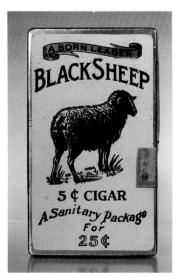 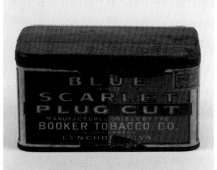

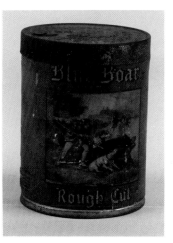 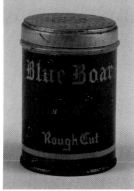

Black Sheep Cigar Tin. W.K. Gresh & Sons. 5.5" x 3.25" x .75". *Courtesy of Dennis O'Brien and George Goehring.*

Blue and Scarlet Plug Cut, Booker Tobacco Co., Lynchburg, Virginia (Factory No. 54, 6th Virginia). Tin with paper label. *Courtesy of C.J. Simpson.*

Blue Boar. *Courtesy of C.J. Simpson.*

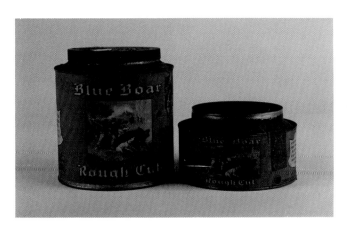 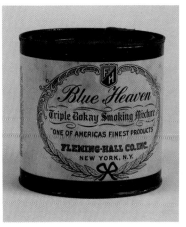

Blue Boar Rough Cut, American Tobacco Company (Factory No. 2, Maryland). Tin with paper label. Left: 5.5" x 4.75"; right: 3" x 4.75". *Courtesy of C.J. Simpson.*

Blue Heaven Triple Bokay Smoking Mixture, Fleming-Hall Co., Inc., New York (Factory No. 100, 1st New York). Tin with paper label. 4" x 4". *Courtesy of C.J. Simpson.*

17

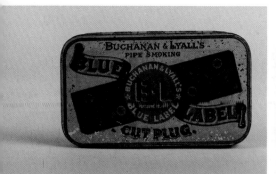

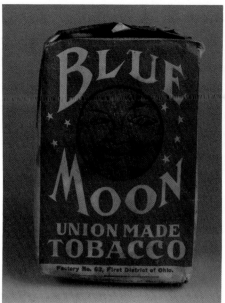

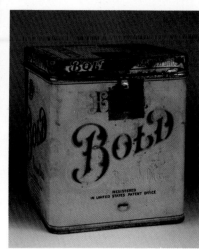

Blue Label Cut Plug, Buchanan & Lyall, New York (Factory No. 2, 1st New York). Lithographed tin. 1″ x 4.5″ x 2.5″. *Courtesy of C.J. Simpson.*

Bob White Cigars, J.N. Williams Co., Reading, Pennsylvania (Factory No. 798, 1st Pennsylvania). Wood box with paper labels. 1.50″ x 5″ x 3.5″. *Courtesy of C.J. Simpson.*

Blue Moon Union Made Tobacco (Factory No. 63, 1st Ohio). Paper. *Courtesy of Betty Lou and Frank Gay.*
Bold, Boscrow Bros., Philadelphia (Factory 324, 1st Pennsylvania), 1917 stamp. Lithographed tin. 5.5″ x 5″. *Courtesy of C.J. Simpson.*

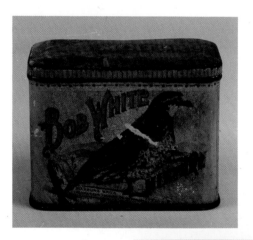

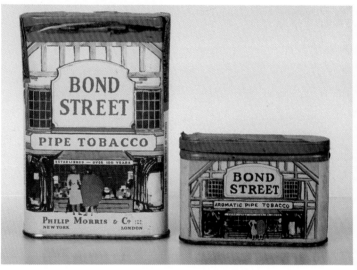

Bond Street Pipe Tobacco pocket and sample. Philip Morris & Co., New York and London (Factory No. 15, Virginia). 4.5″ x 3″, 2″ x 3″. *Courtesy of Dennis O'Brien and George Goehring.*

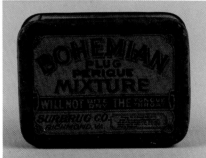

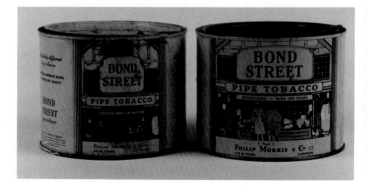

Bob White Mixture, Marburg Bros., American Tobacco Co., Successor, Baltimore (Factory No. 2, Maryland). Lithographed tin, Ginna. 3″ x 4″ x 2.50″. *Courtesy of C.J. Simpson.*
Bohemian Plug Perique Mixture, Surbrug Co., Richmond (Factory No. 4, 2nd Virginia). Lithographed tin. 1.25″ x 4.5″ x 3″. *Courtesy of C.J. Simpson.*

Bond Street Pipe Tobacco, Philip Morris, New York, London (Factory No. 15, Virginia). Lithographed tin. 4″. *Courtesy of C.J. Simpson.*

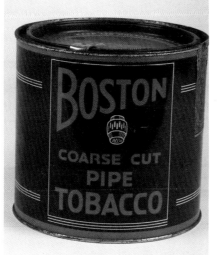

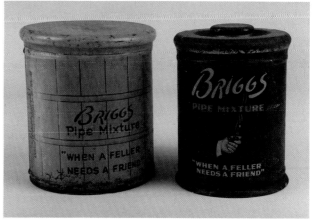

Boot Jack Plug, American Tobacco Co. Embossed tin. 0.25" x 3.25" x 1.5". *Courtesy of C.J. Simpson.*

Boston Coarse Cut Pipe Tobacco, P. Lorillard (Factory No. 6, 1st Ohio). Lithographed tin. 5" x 5". *Courtesy of C.J. Simpson.*

Briggs Pipe Mixture, P. Lorillard Co. (Factory No. 6, 1st Ohio). Lithographed tin. Left 5.5" x 4.5"; right 5.5" x 4". *Courtesy of C.J. Simpson.*

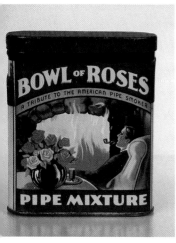

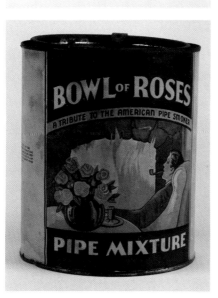

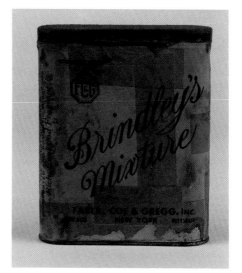

Bright Virginia Granulated, H.F. Cadwell & Co., Watertown, New York. Tin with paper label, Chicago Exposition featured on the bottom. 1.75" x 4" x 2.75". *Courtesy of C.J. Simpson.*

Bowl of Roses pocket, "a tribute to the American pipe smoker." Cambridge Tobacco Co., New York. Series 109 stamp. 3.5" x 3" x 1". *Courtesy of Dennis O'Brien and George Goehring.*

Bowl of Roses Pipe Mixture, Fleming-Hall, New York (Factory No. 100, 1st New York). Lithographed tin, 6" x 5". *Courtesy of C.J. Simpson.*

Briar Pipe Smoking Tobacco, Spaulding & Merrick, Chicago. Cloth bag. *Courtesy of Betty Lou and Frank Gay.*

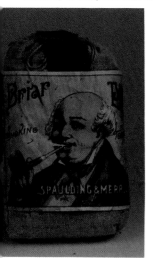

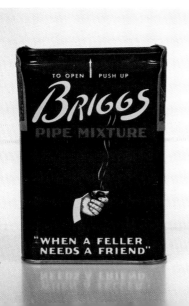

Brindley's Mixture, Faber, Coe & Gregg, Inc., New York (Factory No. 15, Virginia). Tin with paper label. 4.5" x 3.25". *Courtesy of C.J. Simpson.*

Briggs Pipe Mixture, P. Lorillard Company, series 118 stamp. While common, this is unusual in that is unopened and full. Lithographed tin. 4.25" x 3" x 1". *Courtesy of Dennis O'Brien and George Goehring.*

19

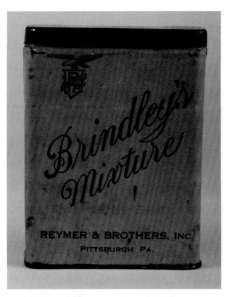

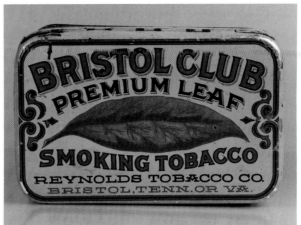

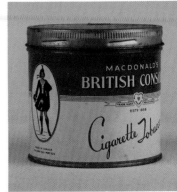

Brindley's Mixture, Reymer & Brothers, Inc., Pittsburgh, Pennsylvania (Factory 15, Virginia). Tin with paper label. 4.5" x 3.5". *Courtesy of C.J. Simpson.*

Bristol Club Premium Leaf Smoking Tobacco, Reynolds Tobacco Co., Bristol, Tennessee or Virginia. Lithographed tin. 3" x 5.75" x 4". *Courtesy of Betty Lou and Frank Gay.*

British Consols Cigarette Tobacco, MacDonalds, Canada (Factory No. 1, Port 10-d). Lithographed tin. 4.25" x 4". *Courtesy of C.J. Simpson.*

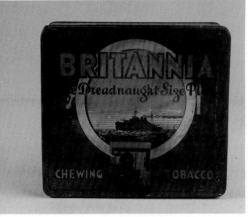

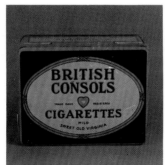

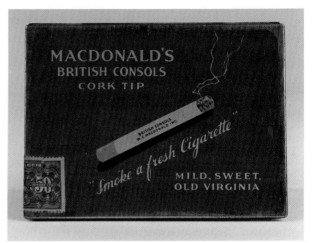

Britannia "The Dreadnought Size Plug" Chewing Tobacco. Lithographed tin. 2.5" x 7" x 6.25". *Courtesy of C.J. Simpson.*

British Consols Cigarettes (50), "The Tobacco with a Heart," W.C. MacDonald, Montreal. 1.5" x 4.25" x 3 *Courtesy of C.J. Simpson.*

British Consols Cork Tip, W.C. MacDonald Inc., Canada. Lithographed tin. .75" x 6" x 4.5". *Courtesy of C.J. Simpson.*

British Consols Cigarettes (50), W.C. MacDonald, Montreal. Lithographed tin. 1" x 3" x 5.5". *Courtesy of C.J. Simpson.*

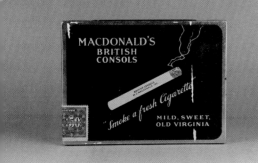

British Consols Cigarettes (50), W.C. MacDonald Inc., Montreal. Lithographed tin. .75" x 6" x 4.5". *Courtesy of C.J. Simpson.*

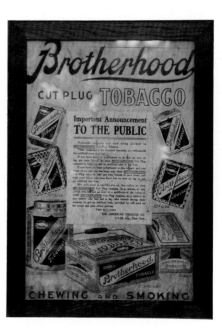

Brotherhood Tobacco, poster. In this only known poster for the brand, Brotherhood lives up to its name. The text is an announcement of an offer of artificial arms and legs to those "unfortunate as to lose their's." As a starter they offer 500 free coupons to anyone who has lost an arm and 1000 coupons to anyone who has lost a leg. Paper. 24.25" x 16". *Courtesy of Elsie and John Booker.*

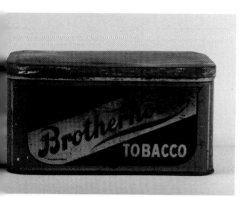

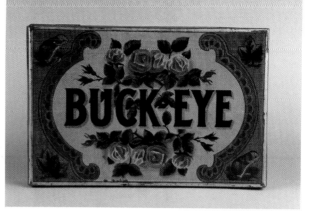

Brotherhood Tobacco, United Bros. (Factory No. 10, 5th New Jersey). Lithographed tin. 3″ x 6″ x 3.5″. *Courtesy of C.J. Simpson.*

Brown Clunte, Charles Rattray. Tin with paper label, 4.25″ x 2.75″. *Courtesy of C.J. Simpson.*

Buck-Eye, H.E. Ledoux Co., Ltd., Winnipeg & Montreal. Lithographed tin. 1″ x 8″ x 5.25″. *Courtesy of C.J. Simpson.*

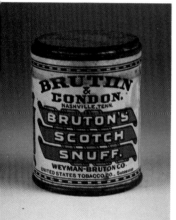
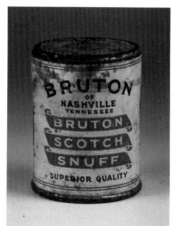

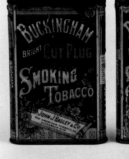
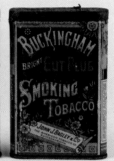

Buckingham Bright Cut Plug Smoking Tobacco, John J. Bagley, American Tobacco Co. (Factory No. 1, Virginia). Lithographed tin with slight variations in color and style. Left: 4.75″ x 3″; right: 4.5″ x 3″. *Courtesy of C.J. Simpson.*

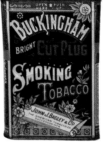
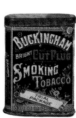

Bruton's Scotch Snuff, Bruton & Condon, Nashville, Weyman-Bruton Co., United States Tobacco, Successor. 1.75″ x 1.25″. *Courtesy of C.J. Simpson.*

Bruton Scotch Snuff, Bruton, Nashville, Tennessee, United States Tobacco Co. 1.75″ x 1.25″. *Courtesy of C.J. Simpson.*

Buckingham Bright Cut Plug Smoking Tobacco pocket and sample. John J. Bagley & Co., The American Tobacco Co., Successor. 4″ x 3″, 3″ x 2.5″. *Courtesy of Dennis O'Brien and George Goehring.*

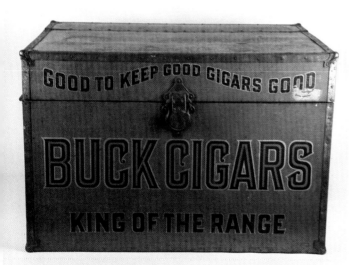

Buck Cigars, "King of the Range." Lithographed tin chest with locking clasp. 18″ x 27″ x 18″. *Courtesy of Koehler Bros. Inc.—The General Store, Lafayette, Indiana.*

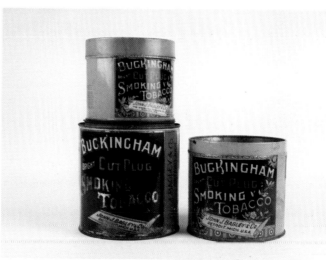

Buckingham Bright Cut Plug Smoking Tobacco, John J. Bagley & Co., Detroit (Factory No. 6, First Michigan), 1910 stamps. Lithographed tin. Top left: American Tobacco Co., Successor, 4″ x 4.5″; bottom left: American Can Company, 5.5″ x 5.5″; bottom right: 5″ x 5″. *Courtesy of C.J. Simpson.*

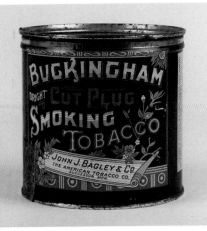 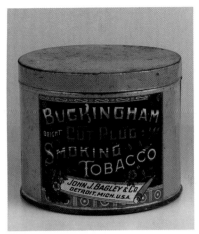 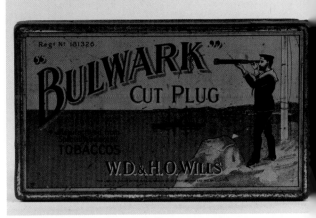

Buckingham Bright Cut Plug Smoking Tobacco, John J. Bagley & Co., American Tobacco Co. Successor. Lithographed tin, CANCO. 5.25" x 5". *Courtesy of C.J. Simpson.*

Buckingham Cut Plug Smoking Tobacco, John J. Bagley & Co., Detroit, Michigan. Lithographed tin. 3.75" x 4.5". *Courtesy of Betty Lou and Frank Gay.*

Bulwark Cut Plug, W.D. & H.O. Wills, London. Lithographed tin. 1.5" x 6.5" x 3.75". *Courtesy of C.J. Simpson.*

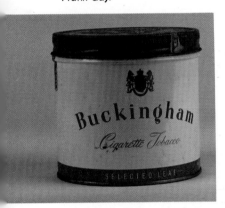 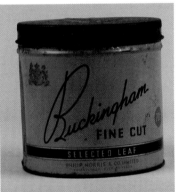

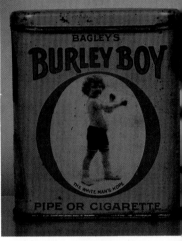

Bulwark Cut Plug, W.D. and H.O. Wills, London. Lithographed tin. 1" x 2" x 3.5". *Courtesy of C.J. Simpson.*

Buckingham Cigarette Tobacco, Philip Morris & Co. Ltd., Canada. Lithographed tin with embossed top. 4.25" x 4.25". *Courtesy of C.J. Simpson.*
Buckingham Fine Cut, Philip Morris & Co., Ltd., Canada. Lithographed tin. 4.25" x 4.25". *Courtesy of C.J. Simpson.*

Burley Boy, Jno. J. Bagley, Detroit, Michigan. Lithographed tin pocket with a photograph of "The White Man's Hope." This is in reference to Jack Johnson, a black man, who held the heavy weight title for many years. 4" x 3.5" x 1". *Courtesy of Dennis O'Brien and George Goehring.*

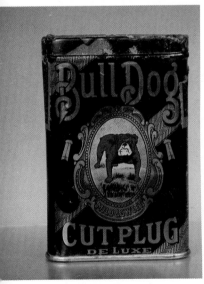 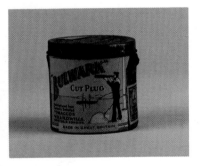 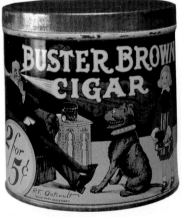 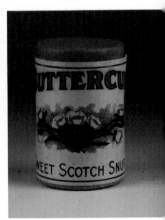

Bull Dog Cut Plug, Lovell-Buffington Tobacco Co., Covington, Kentucky, 1910 stamp.. 4.5" x 3" x .75". *Courtesy of Dennis O'Brien and George Goehring.*
Bulwark Cut Plug, W.D. & H.O. Wills, Bristol & London. Tin with paper label. 2.5" x 2.5". *Courtesy of C.J. Simpson.*

Buster Brown Cigars. Lithographed tin. R.F. Outcault, artist. *Courtesy of Oliver's Auction Gallery.*
Buttercup Sweet Scotch Snuff, George W. Helme Co. (Factory No. 4, 5th New Jersey). Cardboard Box. 2" x 1.25". *Courtesy of C.J. Simpson.*

Calabash Pipe/Smoking Mixture, Imperial Tobacco Co. Left: embossed lithographed tin (bottom: 1.25″ x 4.75″ x 3″); right lithographed tin, 2″ x 3.25″. *Courtesy of C.J. Simpson.*

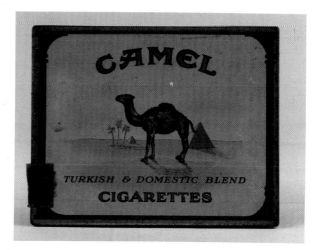

Camel Cigarettes, R.J. Reynolds. Lithographed tin. 0.75″ x 5.5″ x 4.25″. *Courtesy of C.J. Simpson.*

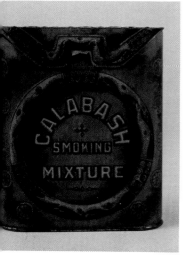

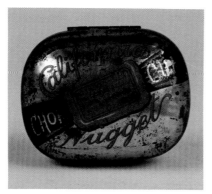

California Nugget Chop Cut, American Tobacco Co. (Factory No. 2, Maryland). 2″ x 2.5″ x 2″. *Courtesy of C.J. Simpson.*

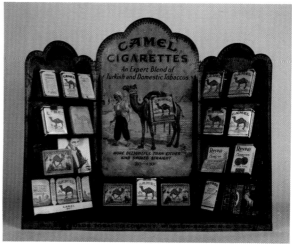

Calabash Smoking Mixture, Imperial Tobacco Co., Canada. Embossed lithographed tin. 4″ x 3.5″. *Courtesy of C.J. Simpson.*

California Nugget Chop Cut Pipe Tobacco, American Tobacco Co. (Factory No. 2, Maryland). Lithographed tin. 0.75″ x 4.75″ x 2.5″. *Courtesy of C.J. Simpson.*

Camel Cigarettes, R.J. Reynolds, Winston-Salem (Factory No. 4, North Carolina). Lithographed tin. 3.25″ x 3.5″. *Courtesy of C.J. Simpson.*

Camel Cigarette, R.J. Reynolds, 1915. Lithographed tin display, 1916. 21″ high. *Courtesy of Thomas Gray.*

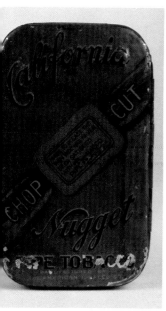

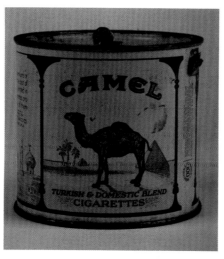

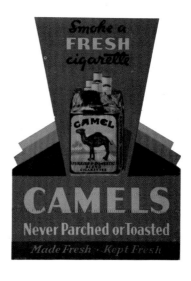

Camel Cigarettes display. Cardboard. *Courtesy of Thomas Gray.*

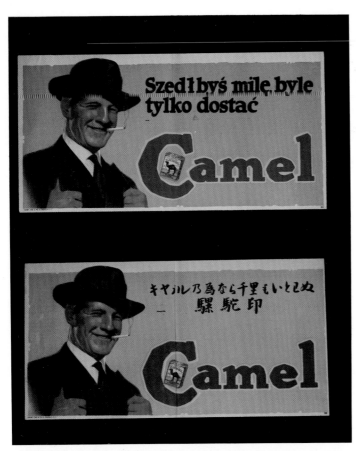

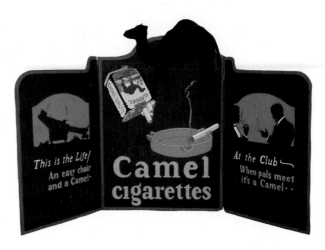

Camel Cigarettes. Cardboard Advertisement. W.C. Kaufman. 15". *Courtesy of Thomas Gray.*

Camel Cigarettes, foreign language signs for streetcars or store windows, c. 1921. "I'd walk a mile for a camel" (Polish). Paper, Latham Litho., Brooklyn. 11" x 21.5". *Courtesy of Thomas Gray.*

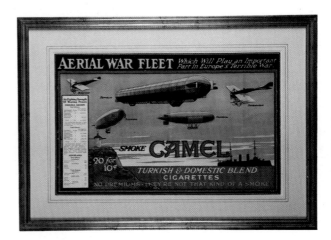

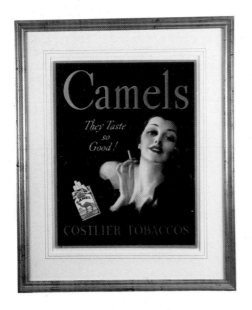

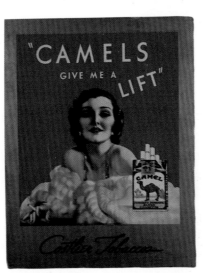

Camel Cigarettes, World War I poster, 1917. Paper. 9.5" x 15.75". *Courtesy of Thomas Gray.*

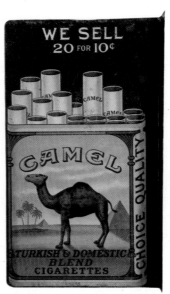

Camel Cigarettes sign, c. 1932. Cardboard poster. 11" x 13.5". While women were featured in Camel advertising before this time, they were usually shown admiring the men who smoked but never smoking themselves. In 1926 Chesterfield produced an ad featuring a woman saying to a man, "Blow some my way." It created an uproar, but the campaign continued and women who smoked came "out of the closet." *Courtesy of Thomas Gray.*
Camel Cigarettes sign. Cardboard. *Courtesy of Thomas Gray.*

Camel Cigarettes, R.J. Reynolds. Tin and enameled two-sided sign. 17.5" x 10.25". *Courtesy of Thomas Gray.*

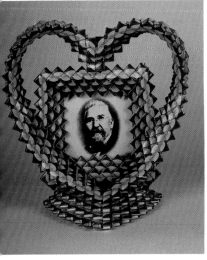

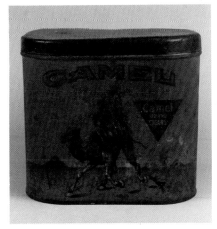

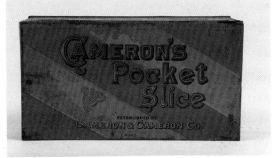

Camel tramp art picture frame with photo of Reynolds, c. 1930-1940. 8.5". *Courtesy of Thomas Gray.*
Camel Cigars (Factory No. 127, Ohio). 5.25" x 6" x 4". *Courtesy of C.J. Simpson.*

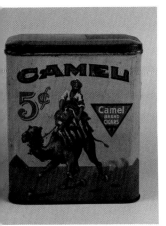

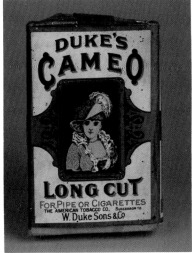

Cameron's Pocket Slice, Cameron & Cameron, American Tobacco Co. (Factory No. 2, Maryland), 1910 stamp. Lithographed tin. 2" x 6.25" x 3.25". *Courtesy of C.J. Simpson.*
Cameron's Private, Cameron & Cameron (Factory No. 4, 2nd Virginia). Lithographed tin. 1.5" x 6.25" x 3.25". *Courtesy of C.J. Simpson.*

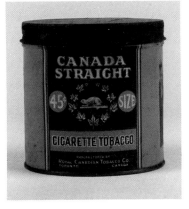

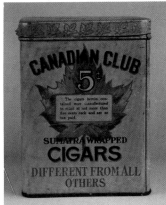

Camel Cigars. Lithographed tin. 5.25" x 4.75" x 2.5". *Courtesy of C.J. Simpson.*
Cameo Long Cut Tobacco, W. Duke Sons & Co., American Tobacco Co., Successor. Paper. *Courtesy of Betty Lou and Frank Gay.*

Canada Straight Cigarette Tobacco, Royal Canadian Tobacco Co., Toronto. Lithographed tin. 4.25" x 4.25". *Courtesy of C.J. Simpson.*
Canadian Club Cigars (Factory No. 890, 1st Pennsylvania). Lithographed tin. 6" x 4.25" x 4.25". *Courtesy of C.J. Simpson.*

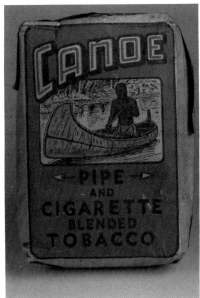

Cameron's Fine Smoking, Cameron & Cameron, Richmond (Factory No. 4, 2nd Virginia). Lithographed tin in a variety of color combinations. Some have paper labels in the square. 2" x 4.5" x 3.25". *Courtesy of C.J. Simpson.*

Canoe Pipe and Cigarette Tobacco, Ohio. Paper. *Courtesy of Betty Lou and Frank Gay.*

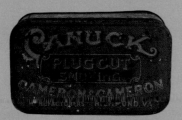

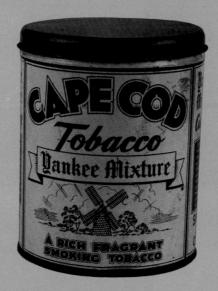

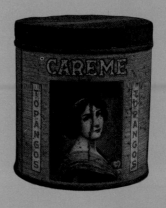

Careme Cigars (Factory No. 1000, 3rd New York). 4.5" x 4.25". *Courtesy of C.J. Simpson.*

Canuck Plug Cut Smoking, Cameron & Cameron, Richmond (Factory No. 4, 2nd Virginia). Lithographed tin, 1.75" x 4.25" x 1.5". *Courtesy of C.J. Simpson.*

Cape Cod Tobacco, "Yankee Mixture" (Factory No. 29, Massachusetts). Lithographed tin. 6.25" x 5". *Courtesy of C.J. Simpson.*

Capstan Navy Cut, W.D. & H.O. Wills, Bristol & London. Lithographed tin, English. 2.25" x 1.5". *Courtesy of C.J. Simpson.*

Careme Kings Cigars (Factory No. 9000, 2nd New York). Lithographed tin. 5" x 5.5". *Courtesy of C.J. Simpson.*

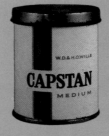

Capstan Medium Cigarettes, W.D. & H.O. Wills, Bristol and London. 3.25" x 2.75". *Courtesy of C.J. Simpson.*

Carhart's Choice "CC" Snuff, sample, United States Tobacco Co., Nashville (Factory No. 33, Tennessee). 2.75" x 1.75". *Courtesy of C.J. Simpson.*

Capstan Navy Cut Cigarettes, W.D. & H.O. Wills, Bristol and London. Lithographed tin. 0.5" x 5.75" x 4.5". *Courtesy of C.J. Simpson.*

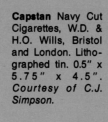

Capstan Navy Cut Cigarettes, W.D. and H.O. Wills, Bristol and London, American Tobacco Company, U.S. distributors. 3.25" x 2.75". *Courtesy of C.J. Simpson.*

Cardinal Cut Plug, Myers Cox & Co., Dubuque, Iowa, 1910 stamp intact. Only known example of an unopened Cardinal pocket tin. Lithographed tin. 4.5" x 3" x 1". *Courtesy of Dennis O'Brien and George Goehring.*

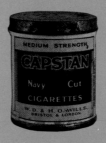

Carlton Club Mixture pocket, found in the Tindeco sample room. America Tobacco Company (Factory No. 1, Virginia). 4.5" x 3" x 1". *Courtesy of Dennis O'Brien and George Goehring.*

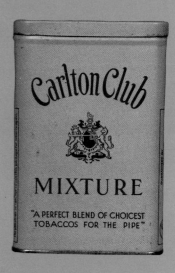

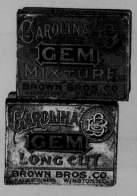

Carolina Gem Mixture, Brown Brothers Co., Winston, North Carolina (Factory No. 1, 5th North Carolina), c. 1885. In 1913 Winston became Winston-Salem. Lithographed tins: Top right: 2 oz.; bottom right: 12/3 oz. square corner tins. 2" x 4". *Courtesy of Thomas Gray.*

Catac Mixture, Cameron & Cameron, Richmond (Factory No. 4, 2nd Virginia). Lithographed tin. 2.25" x 4.5" x 3.25". *Courtesy of C.J. Simpson.*

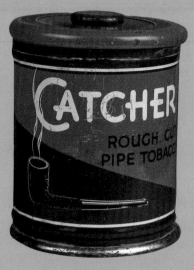

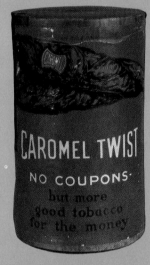

Carolina Gem Mixture, Brown Bros. Co., Winston, North Carolina. Tin with paper label. 4" x 3" x 2". *Courtesy of Betty Lou and Frank Gay.*

Caromel Twist, R.J. Reynolds, 1926 stamp. Cardboard canister, unopened. 7" x 4.5". *Courtesy of Thomas Gray.*

Catcher Rough Cut Pipe Tobacco, Brown & Williamson Tobacco Co., Louisville, Kentucky. Lithographed tin. 6" x 5". *Courtesy of Betty Lou and Frank Gay.*

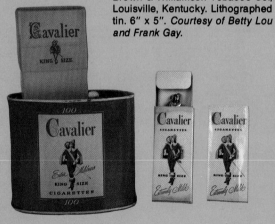

Carte Blanche Cut Cavendish, Marburg Bros., American Tobacco Co., Baltimore (Factory No. 2, Maryland). Lithographed tin, Ginna & Co. 1.5" x 5" x 2.75". *Courtesy of C.J. Simpson.*

Cavalier, R.J. Reynolds, Winston-Salem, North Carolina. Bottom left: oval 100 tin, c. 1955, 4" x 4.75"; top right plastic carrying case, c. 1955; right: premium pin from sample box, c. 1948. *Courtesy of Thomas Gray.*

Central Union Cut Plug, United States Tobacco Co., Richmond (Factory No. 15, 2nd Virginia). Lithographed tin. Left lunch box, 5.25" x 7.25" x 4.5"; center: lunch box, 4.25" x 6.75" x 4.5"; right: 3.25" x 6" x 3.5". *Courtesy of C.J. Simpson.*

Casino Mixture, Wade Cook Cigar Stores (Factory No. 2, Maryland). Tin with paper label, 1.25" x 3" x 4.5". *Courtesy of C.J. Simpson.*

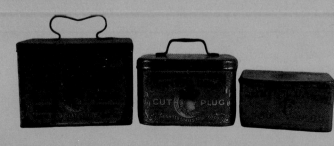

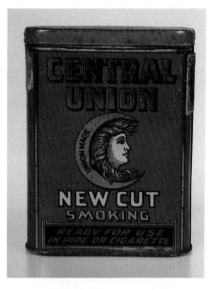 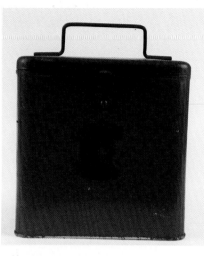

Chamber Commerce, Rohae(?) & Co., Cincinnati (Factory No. 17, 1st Ohio). Lithographed tin. 1.5" x 5" x 3.25". *Courtesy of C.J. Simpson.*

Central Union New Cut Smoking Tobacco pocket, with 1910 stamp. United States Tobacco Co., Richmond, Virginia. 4.5" x 3.5" x 1". *Courtesy of Dennis O'Brien and George Goehring.*
Central Union Cut Plug, United States Tobacco Company, Richmond. Lithographed tin. 6" x 5.75". *Courtesy of C.J. Simpson.*

Champagne Sparklets, Falk Tobacco Co., Richmond (Factory No. 1, Virginia), 1926 stamp. Tin with paper label. 4.25" x 4". *Courtesy of C.J. Simpson.*

Champagne Sparklets, Falk Tobacco Co., Richmond (Factory No. 1, Virginia), 1926 stamp. Tin with paper label. 4.25" x 4". *Courtesy of C.J. Simpson.*

Century, P. Lorillard Co. Embossed tin with three combination locks that work. 0.75" x 3.5" x 2". *Courtesy of C.J. Simpson.*

Chaliapine Russian Cigarettes, made for Sobranie, London. 3" x 3". *Courtesy of C.J. Simpson.*
Chalmers Quality Cigars (Factory No. 563, 1st Pennsylvania). Lithographed tin. 5.5" x 3.25" x 3.25". *Courtesy of C.J. Simpson.*

Charles I Favorite, Charles 1st Cigar Factory, H.J. Van Abbe, Zindhoven, Holland. Lithographed tin. 1" x 4.75" x 3.25". *Courtesy of C.J. Simpson.*
Charles Denby Cigars, H. Fendrich, Evansville, Indiana (Factory No. 202, Indiana). 5.25" x 3.25". *Courtesy of C.J. Simpson.*

 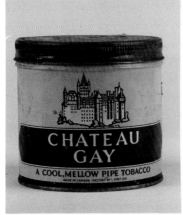

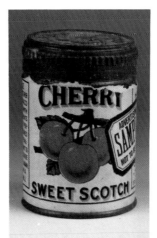 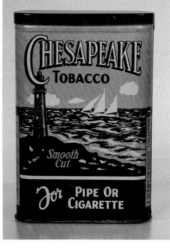

Charles Gordon Cigars, C.A. Kildow, Bethesda, Ohio (Factory No. 700, 18th Ohio). Lithographed tin. 5″ x 5″. *Courtesy of C.J. Simpson.*

Chateau Gay (Factory No. 1, Port 230). Lithographed tin. 4.25″ x 4.25″. *Courtesy of C.J. Simpson.*

Cherry Sweet Scotch, sample, George W. Helme Co., New York, New Jersey, and Delaware (Factory No. 4, 5th New Jersey), 1934 tax stamp. 2.5″ x 1.5″. *Courtesy of C.J. Simpson.*

Chesapeake Tobacco pocket. Maker unknown, but presumed to be from the Maryland area. Lithographed tin. 4.5″ x 3″ x .75″. *Courtesy of Dennis O'Brien and George Goehring.*

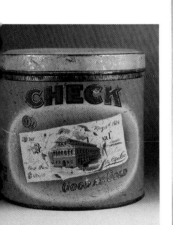 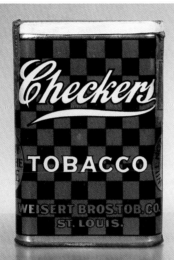

Check Cigars, "Good as Gold," Rock City Cigar Co., Ltd., Levis, Quebec. Lithographed tin, Thomas Davidson Mfg. Co., Montreal. 5″ x 5″. *Courtesy of C.J. Simpson.*

Checkers Tobacco, Weisert Bros. Tobacco Co., St. Louis, 1926, series 107 stamp. Lithographed tin. 4.5″ x 3″ x 1″. *Courtesy of Dennis O'Brien and George Goehring.*

Cherry Diamond Club Special, Missouri Athletic Club, St. Louis (Factory No. 93, 1st Missouri). Tin with paper label. 4.5″ x 3″. *Courtesy of C.J. Simpson.*

Cherry Maccoboy Snuff (Factory No. 4, 5th New Jersey), 1902 stamp. Glass with paper label. 7.5″ x 3″. *Courtesy of C.J. Simpson.*

Chesterfield Cigarettes, Liggett & Myers Tobacco Company. Lithographed tin. 0.75″ x 5.5″ x 4.25″. *Courtesy of C.J. Simpson.*

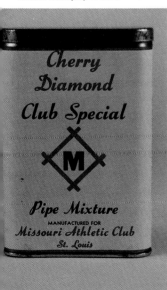 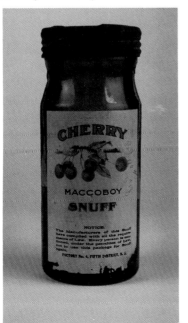

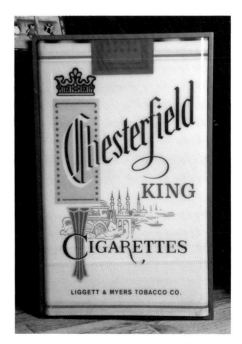

Chesterfield Cigarettes lighted sign. *Courtesy of Elsie and John Booker.*

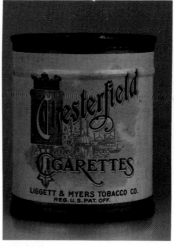

Choice, Ogburn, Hill & Co., R.J. Reynolds. Successor. Lithographed tin. 1.5" x 12" x 3". *Courtesy of Thomas Gray.*

Chesterfield Cigarettes, Liggett & Myers Tobacco Company. Lithographed footed tin. 1" x 5.5" x 4.25". *Courtesy of C.J. Simpson.*
Chesterfield Cigarettes (50), Liggett & Myers Tobacco Co., (Factory No. 25, Virginia). Unopened vacuum packed lithographed tin. 3.25" x 2.5". *Courtesy of Betty Lou and Frank Gay.*

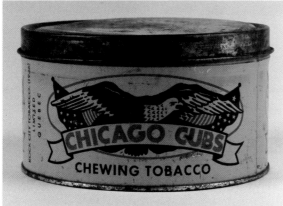
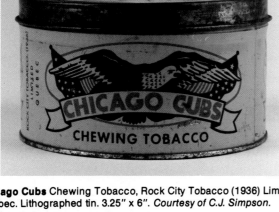

Chicago Cubs Chewing Tobacco, Rock City Tobacco (1936) Limited, Quebec. Lithographed tin. 3.25" x 6". *Courtesy of C.J. Simpson.*

Churchman's Special No. 1 Cigarettes, W.A. & A.C. Churchman, England. 3.25" x 3". *Courtesy of C.J. Simpson.*
Cigarettes Moulai Youseef (100), Gabriel Effendi & Co., Alexandria-Cairo, Egypt. Tin with paper label. 1.5" x 3.5" x 5.5". *Courtesy of C.J. Simpson.*

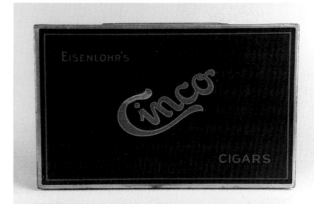

Cinco Cigar, Eisenlohr Tobacco (Factory No. 202, 1st Pennsylvania). Lithographed tin, Acme. 1.25" x 8.25" x 1.75". *Courtesy of C.J. Simpson.*

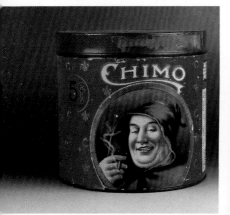

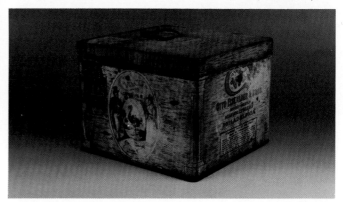

Chimo Cigars (Factory No. 1190, 1st Pennsylvania). Tin with paper label. 5.25" x 5.5". *Courtesy of C.J. Simpson.*
Choice, A.S. Aude(?), Troy, New York. Cloth bag. *Courtesy of Betty Lou and Frank Gay.*

Cinco Handy Humidor, Otto Eisenlohr & Bros., Philadelphia (Factory No. 5, 1st Pennsylvania). 2.75" x 4.75" x 4.75". *Courtesy of C.J. Simpson.*

 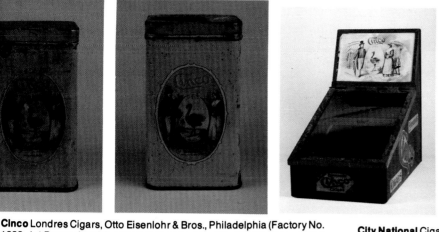 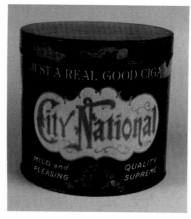

Cinco Londres Cigars, Otto Eisenlohr & Bros., Philadelphia (Factory No. 1632, 1st Pennsylvania). Lithographed tin. 5" x 3" x 3". *Courtesy of C.J. Simpson.*

Cinco Cigars, Otto Eisenlohr & Bros., Philadelphia (Factory No. 202, 1st Pennsylvania). Lithographed tin, Acme. 5" x 3" x 3". *Courtesy of C.J. Simpson.*

Cinco Cigars, Otto Eisenlohr & Bros. Tin and glass counter case. 14" x 9" x 15". *Courtesy of Koehler Bros. Inc. —The General Store, Lafayette, Indiana.*

City National Cigars, C.K.(?) Co. (Factory No. 301, 1st Pennsylvania). 5" x 5.5". *Courtesy of C.J. Simpson.*

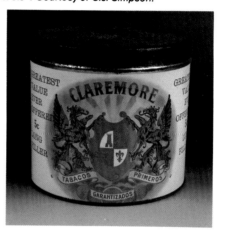

Claremore Cigars (Factory No. 890, 1st Pennsylvania). Tin with embossed paper label. 5.25" x 6". *Courtesy of C.J. Simpson.*

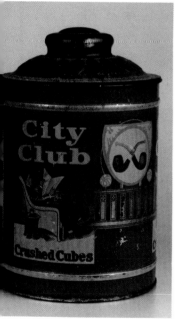 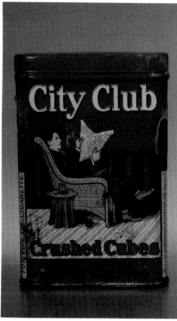

City Club Crushed Cubes, Burley Tobacco Co., Louisville, Kentucky. Lithographed tin. (see also *Strater Bros.*) 7.5" x 5". *Courtesy of Betty Lou and Frank Gay.*

City Club Crushed Cubes, Strater Bros. Tobacco Co., branch of Burley Tobacco Co., Louisville, Kentucky. Lithographed tin. 4.5" x 3" x 1". *Courtesy of Dennis O'Brien and George Goehring.*

Clarence Cigarettes, Carreras Ltd., London. Lithographed tin. 0.25" x 3.25" x 3". *Courtesy of C.J. Simpson.*

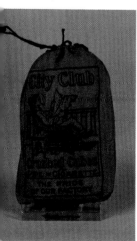

City Club Crushed Cubes, lithographed cloth bag, 3" x 2". *Courtesy of Thomas Gray.*

Class Honeycomb Cigars (Factory No. 95, 5th New Jersey). Embossed lithographed tin. 5.25" x 7" x 3.5". *Courtesy of C.J. Simpson.*

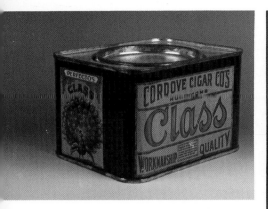
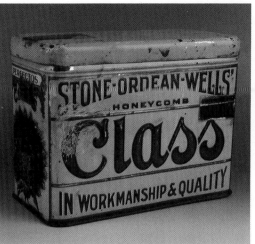

Class Honeycomb Cigars, Cordove Cigar Co. 4.25″ x 5.75″ x 3.5″. *Courtesy of C.J. Simpson.*

Class, Honeycomb Cigars, Stone-Ordean-Wells (Factory No. 5, Louisiana). Embossed lithographed tin. 5.25″ x 7″ x 3.25″. *Courtesy of C.J. Simpson.*

J.T. & H. Clay Tobacco, B.F. Gravely, Leatherwood, Virginia. The name was registered in 1887. Wood caddy. 13.5″ x 13.5″. *Courtesy of Thomas Gray.*

Climax Plug, P. Lorillard (Factory No. 6, 1st Ohio). Lithographed tin. 0.25″ x 3″ x 1.25″. *Courtesy of C.J. Simpson.*

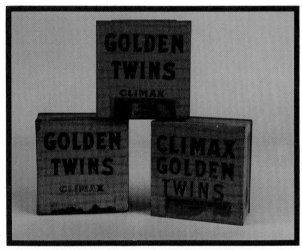

Climax Golden Twins, P. Lorillard, Jersey City (Factory No. 10, 5th New Jersey). Lithographed tin. 2″ x 4″ x 4″. *Courtesy of C.J. Simpson.*

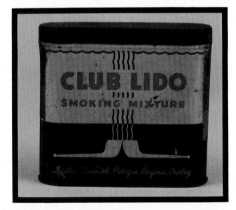

Club Lido Smoking Mixture, Crimson Coach, Toledo (Factory No. 6, 10th Ohio). Lithographed tin. 3″ x 3.5″. *Courtesy of C.J. Simpson.*

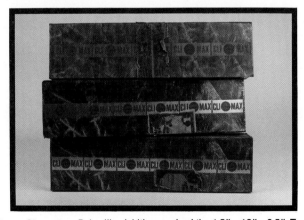

Climax Cigarettes, P. Lorillard. Lithographed tin. 1.5″ x 12″ x 3.5″. Top: New Jersey, 1909 stamp; middle and bottom: Factory No. 6, 1st Ohio. *Courtesy of C.J. Simpson.*

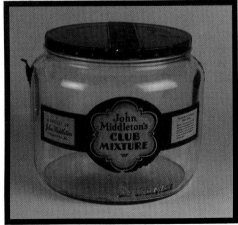

Club Mixture, John Middleton, Inc., Philadelphia, 1926 stamp. Glass jar with lithographed tin top. 5″ x 5.5″. *Courtesy of C.J. Simpson.*

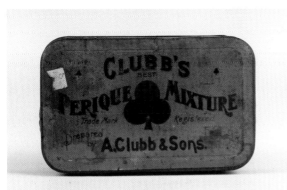

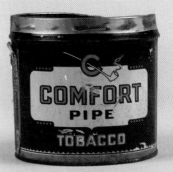

Clubb's Perique Mixture, A. Clubb & Sons, Toronto. Lithographed tin. 2.25" x 6.5" x 4". *Courtesy of C.J. Simpson.*

Columbia Mixture, American Tobacco Co. (Factory No. 2, Maryland). Lithographed tin, 2" x 4" x 2.50". *Courtesy of C.J. Simpson.*
Comfort Pipe Tobacco, B. Houde. Lithographed tin. 4.25" x 4.25". *Courtesy of C.J. Simpson.*

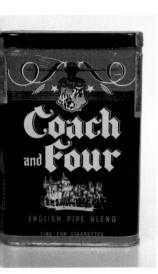

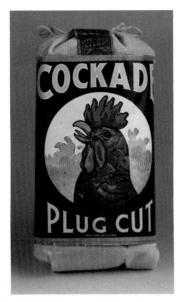

Coach and Four, Crimson Coach Inc., Toledo, Ohio (Factory No. 6, 10th Ohio), copyright 1937. Lithographed tin. 4.5" x 3" x .75". *Courtesy of Dennis O'Brien and George Goehring.*
Cockade Plug Cut, Liggett & Myers. Cloth. *Courtesy of Betty Lou and Frank Gay.*

Compass Cut Plug, Jno. J. Bagley & Co., American Tobacco Co., Successor. Tin with paper label. 4.75" x 5.5". *Courtesy of C.J. Simpson.*
Compass Cut Plug. Jno. J. Bagley & Co., American Tobacco Co., Successor (Factory No. 1, Virginia). Tin with paper label. 5" x 5"

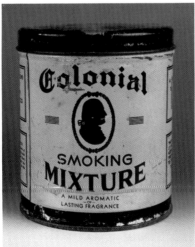

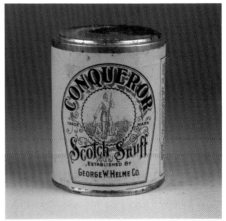

Cocktail Sobranie, Virginia. 3.25" x 2.75". *Courtesy of C.J. Simpson.*

Colonial Smoking Mixture (Factory No. 20, Kentucky). Lithographed tin, Heekin Can Co. 6.75" x 5.25". *Courtesy of C.J. Simpson.*

Conqueror Scotch Snuff, George W. Helme Co. (Factory No. 4, Delaware). 2.25" x 1.75". *Courtesy of C.J. Simpson.*

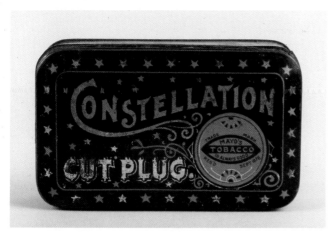

Constellation Cut Plug, Mayo (Factory No. 42, 2nd Virginia). Lithographed tin. 1.75″ x 4″ x 2.75″. *Courtesy of C.J. Simpson.*

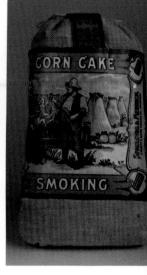

Copenhagen Snuff, Pittsburgh, Pennsylvania. Pottery crock. 4.75″ x 6″. *Courtesy of C.J. Simpson.*
Corn Cake Smoking Tobacco, Spaulding & Merrick, Liggett & Myers, Successors, Chicago. Cloth. *Courtesy of Betty Lou and Frank Gay.*

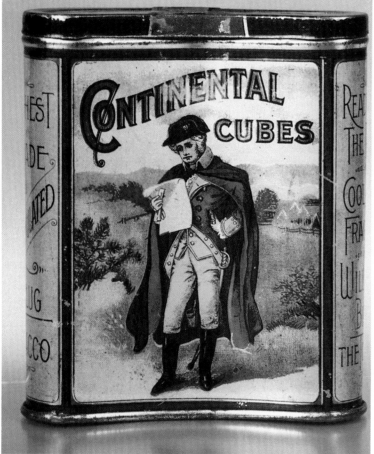

Continental Cubes, American Tobacco Company. (Factory No. 2, Maryland). Lithographed tin concave pocket. 3.75″ x 3.25″ x 1″. *Courtesy of Dennis O'Brien and George Goehring.*

Cornell Mixture, Marburg Bros., American Tobacco Co., Baltimore (Factory No. 2, Maryland). Lithographed tin. Left 3.75″ x 3.75″ x 2″; right 4.5″ x 3.75″ x 2″. *Courtesy of C.J. Simpson.*

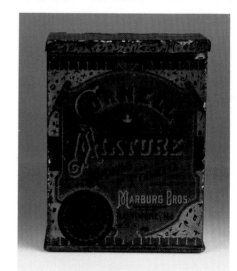

Cornell Mixture Smoking Tobacco. Marburg Bros., American Tobacco Co., Successors, Baltimore. Lithographed tin. 4.5″ x 3.5″ x 2″. *Courtesy of Betty Lou and Frank Gay.*

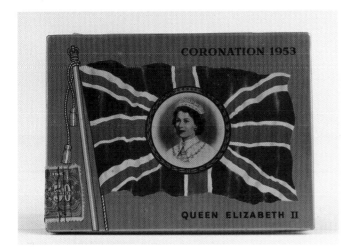

Coronation 1953, Elizabeth II, MacDonalds Tobacco. Lithographed tin. 0.5" x 5.75" x 4.5". *Courtesy of C.J. Simpson.*

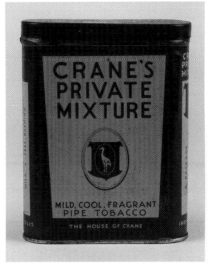

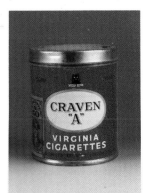

Crane's Private Mixture, Crane, Indianapolis. Lithographed tin, Tindeco. 4.25" x 3.25". *Courtesy of C.J. Simpson.*

Craven "A" Virginia Cigarettes (50), Carreras Ltd., London, series 125 stamp. Tin with paper label with embossed top. 3.25" x 2.5". *Courtesy of C.J. Simpson.*

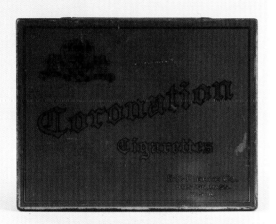

Coronation Cigarettes, S.S. Pierce Co., Boston, Massachusetts. Lithographed tin. 0.75" x 5.5" x 4.25". *Courtesy of C.J. Simpson.*

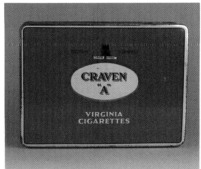

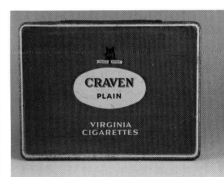

Craven "A" Virginia Cigarettes, Carreras Limited, Arcadia Works, London, England. Lithographed tin. 1.5" x 6" x 4". *Courtesy of C.J. Simpson.*

Craven Plain, Carreras (Factory No. 6, Canada). Lithographed tin. .75" x 6" x 4". *Courtesy of C.J. Simpson.*

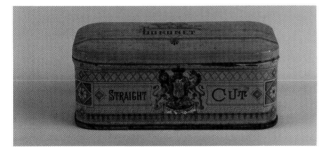

Coronet Straight Cut. Lithographed tin, Somers Bros., Brooklyn, New York, Patent applied for April 29, 1878. 2" x 4.5" x 2.5". *Courtesy of C.J. Simpson.*

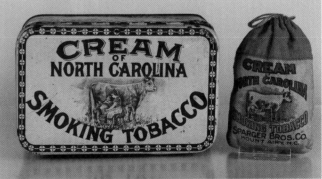

Cream of North Carolina. Tin: Rucker & Whitman, c. 1895-1900, 2.75" x 6". Cloth bag: Sparger Bros. Co., Mount Airy, North Carolina, c. 1895, lithographed paper label, 4" x 3". *Courtesy of Thomas Gray.*

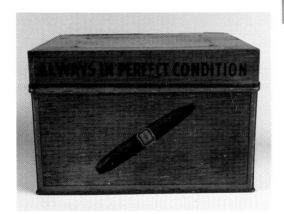

Cremo Cigars. Lithographed tin humidor, 5.75" x 9" x 7.25". *Courtesy of C.J. Simpson.*

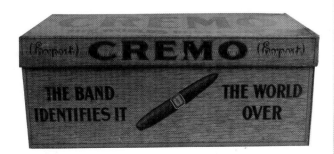

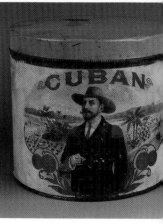

Cremo Cigars. Lithographed tin humidor, 6″ x 14″ x 14″. *Courtesy of C.J. Simpson.*

Crown Chewing Tobacco, W.C. MacDonald. 4.25″ x 4.75″. *Courtesy of C.J. Simpson.*

Cuban Cigars (Factory No. 417, 1st Pennsylvania). Tin with paper label. 5.25″ x 6″. *Courtesy of C.J. Simpson.*

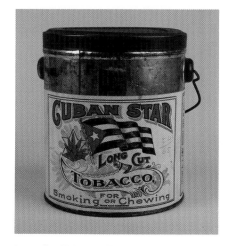

Crest High Grade Smoking, Lovell-Buffington Tobacco Co., Inc., Covington, Kentucky (Factory No. 5, Kentucky), copyright 1921. Tin with paper label. 4.75″ x 4″. *Courtesy of C.J. Simpson.*

Cross Roads Mixture (Factory No. 20, Kentucky), Series 112, 1926 stamp. Wartime container, cardboard with paper label. 4.75″ x 4.25″. *Courtesy of C.J. Simpson.*

Cuban Star Long Cut Tobacco (Factory No. 3, 1st Illinois), 1910 stamp. Tin lunch pail with paper half-label. 7″ x 5.25″. *Courtesy of C.J. Simpson.*

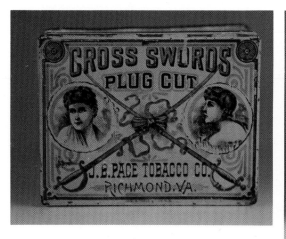

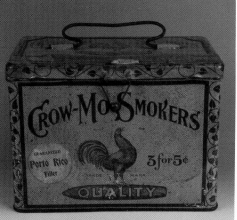

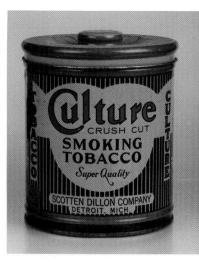

Cross Swords Plug Cut, J.B. Pace Tobacco Co., Richmond. Lithographed tin, Ilsley. Note the variation in the faces of the women from the other example. 1.25″ x 4.5″ x 3.25″. *Courtesy of Betty Lou and Frank Gay.*

Crow-Mo Smokers, Gordon Cigar & Cheroot Co., Patterson Bros. Tob. Co., Successors, Richmond (Factory No. 1, Virginia). Lithographed tin with slight embossing on lid. 5.25″ x 7.5″ x 5.5″. *Courtesy of C.J. Simpson.*

Culture Smoking Tobacco, Scotten Dillon Company, Detroit, Michigan (Factory No. 1, Michigan). Lithographed tin. 6″ x 4.75″. *Courtesy of Betty Lou and Frank Gay.*

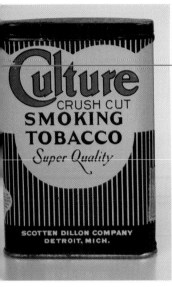

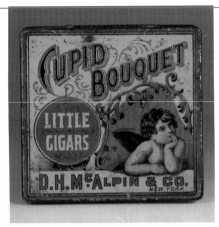

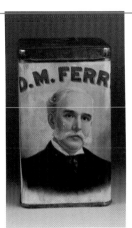

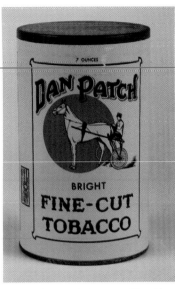

Culture Smoking Tobacco pocket, c. 1929. Scotten Dillon Company, Detroit, Michigan. 4.25″ x 3.25″ x 1″. *Courtesy of Dennis O'Brien and George Goehring.*

Cupid Bouquet Little Cigars, D.H. McAlpin & Co., New York. 10 cigars. Lithographed tin. 3.25″ x 3.5″ x 0.25″. *Courtesy of Betty Lou and Frank Gay.*

D.M. Ferry Cigars (Factory No. 241, 11th Ohio), 1916 stamp. Tin with paper label. 5.5″ x 3.25″ x 3.25″. *Courtesy of C.J. Simpson.*

Dan Patch Fine-Cut Tobacco, Scotten, Dillon Company, Detroit. Tin with paper label. 5.5″ x 3″. *Courtesy of C.J. Simpson.*

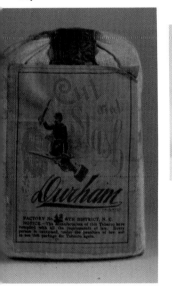

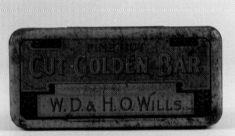

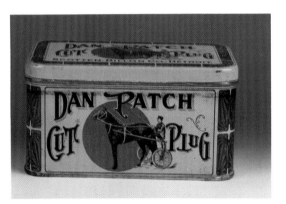

Cut Golden Bar, W.D. & H.O. Wills, London. Lithographed tin. 1.5″ x 7.5″ x 3.5″. *Courtesy of C.J. Simpson.*

Cut and Slash, Durham (Factory No. 42, 4th North Carolina). Cloth bag. *Courtesy of Betty Lou and Frank Gay.*

Dan Patch Cut Plug, Scotten, Dillon Co., Detroit (Factory No. 1, Michigan). Lithographed tin. 3″ x 6″ x 3.75″. *Courtesy of Betty Lou and Frank Gay.*

Cutty-Pipe Tobacco, Weyman's. Lithographed store tin. 13.75″ x 9.5″ x 9.5″. *Courtesy of Dave and Betty Horvath.*

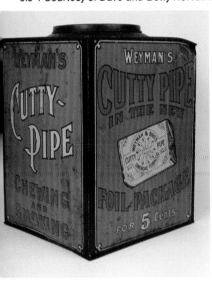

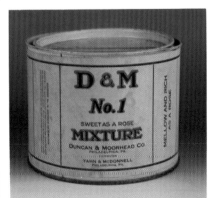

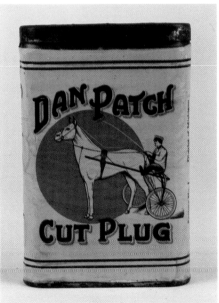

D & M No. 1 Mixture, "Sweet as a Rose," Duncan & Moorhead, Philadelphia, Pennsylvania (Factory No. 15, Virginia). Tin with paper label. 4.5″ x 5.5″ x 5.5″. *Courtesy of C.J. Simpson.*

Dan Patch Cut Plug, Scotten, Dillon, Detroit (Factory No. 1, Michigan). Tin with paper label. 4.5″ x 3″. *Courtesy of C.J. Simpson.*

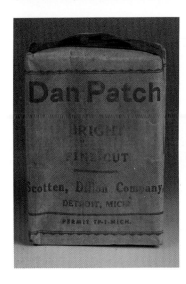

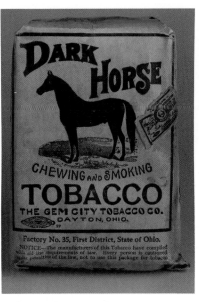

"De Reszke" Minors, "The Aristocrat of Cigarettes," J. Millhoff & Co., Ltd. Manufactured for the proprietors of the Godfrey Phillips Ltd. London. 3" x 2.75". *Courtesy of C.J. Simpson.*

"De Reszke", The Aristocrat of Cigarettes (100), J. Millhoff & Co., London. Lithographed tin. 1.5" x 6" x 4". *Courtesy of C.J. Simpson.*

Dan Patch, Scotten, Dillon Company, Detroit. Cloth bag. *Courtesy of Betty Lou and Frank Gay.*

Dark Horse Chewing and Smoking Tobacco, Gem City Tobacco Co., Dayton, Ohio (Factory No. 35, 1st Ohio). Paper. *Courtesy of Betty Lou and Frank Gay.*

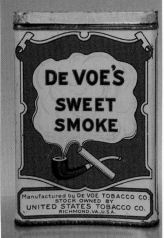

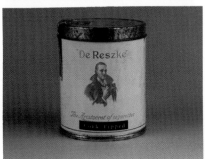

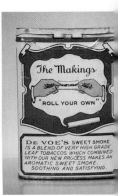

De Reszke Minors Cigarettes (60), J. Millhoff & Co. Ltd., London. Lithographed tin. *Courtesy of C.J. Simpson.*

Day and Night Chewing & Smoking Tobacco, Pinkerton Tobacco, Toledo, Liggett & Myers, successors (Factory No. 1, 10th Ohio). Paper. *Courtesy of Betty Lou and Frank Gay.*

De Luxe Pall Mall, Rothmans Ltd., London. Lithographed tin. .75" x 5.75" x 4". *Courtesy of C.J. Simpson.*

"De Reszke" Cigarettes J. Millhoff & Co., Ltd, London. 3.25" x 2.75". *Courtesy of C.J. Simpson.*

"De Reszke" Cigarettes J. Millhoff & Co., Ltd, London. 3.25" x 2.75". *Courtesy of C.J. Simpson.*

"De Reszke" Minors Cigarettes, J. Millhoff & Co., Ltd., London. Lithographed tin oval pocket. J. Millhoff & Co., London. 3" x 3" x 1.25". *Courtesy of C.J. Simpson.*

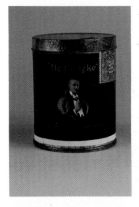

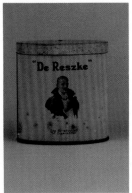

De Voe's Sweet Smoke, De Voe Tobacco Co., stock owned by United States Tobacco Co., Richmond. Nice concave lithographed tin pocket. The back is also interesting. 4.25" x 3" x 1". *Courtesy of Dennis O'Brien and George Goehring.*

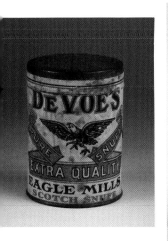
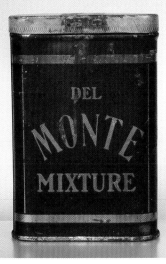

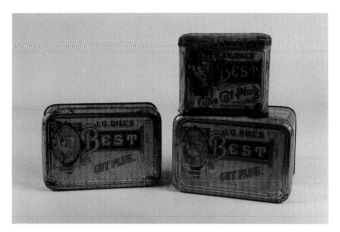

J.G. Dill's Best Cut Plug, J.G. Dill, Richmond (Factory No. 25, 2nd Virginia). Lithographed tin. Left 2" x 6" x 4"; top right 4" x 3.5" x 2.75"; bottom right 3" x 6" x 4". *Courtesy of C.J. Simpson.*

De Voe's Eagle Mills Scotch Snuff, De Voe Tobacco Co. (Factory No. 33, Tennessee). Tin with paper label. 2" x 1.5". *Courtesy of C.J. Simpson.*

Del Monte Mixture rare pocket, c. 1917. While the manufacturer is unknown, it may have some relation to the fruit packagers. 4.5" x 3" x 1". *Courtesy of Dave and Betty Horvath.*

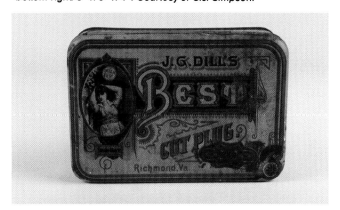

J.G. Dill's Best Cut Plug, J.G. Dill, Richmond (Factory No. 25, 2nd Virginia). Lithographed tin. 2" x 6" x 4". *Courtesy of C.J. Simpson.*

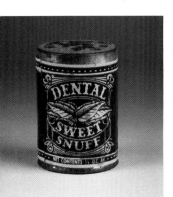
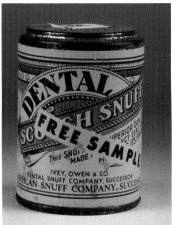

Dental Sweet Snuff, American Snuff Company, Memphis, Tennessee. 1.75 x 1.25". *Courtesy of C.J. Simpson.*

Dental Scotch Snuff Sample, Ivey, Owen & Co., Dental Snuff Company, Successor, American Snuff Company, Successor. (Factory No. 23, Tennessee). *Courtesy of C.J. Simpson.*

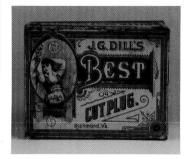
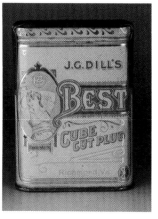

J.G. Dill's Best Cut Plug, J.G. Dill, Richmond, Virginia. Lithographed tin, Hasker and Marcuse. 1.25" x 4.75" x 3.25". *Courtesy of C.J. Simpson.*
J.G. Dill's Best J.G. Dill Tobacco, Richmond (series 1910 stamp). Lithographed tin. *Courtesy of Elsie and John Booker.*

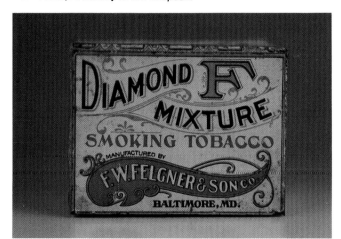

Diamond F Mixture, F.W. Felgner & Son, Baltimore, Maryland. Lithographed tin. 3" x 4" x 2". *Courtesy of Betty Lou and Frank Gay.*

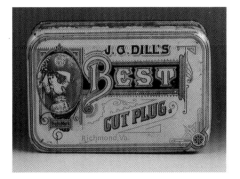

J.G. Dill's Best Cut Plug. J.G. Dill Co., Richmond, Virginia. Lithographed tin. 2" x 6" x 4". *Courtesy of Betty Lou and Frank Gay.*

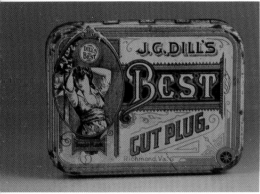

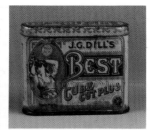

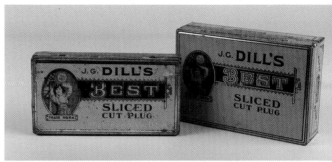

J.G. Dill's Best Cube Cut Plug, J.G. Dill Company, Richmond. Lithographed tin. 2.75" x 3.75" x 1". Courtesy of C.J. Simpson/

J.G. Dill's Best, J.G. Dill, Richmond. Lithographed tin. .75" x 3.75" x 2.75". *Courtesy of Betty Lou and Frank Gay.*

J.G. Dill's Best Cut Plug, J.G. Dill, Richmond (Factory No. 25, 2nd Virginia). Lithographed tin. Left: 1910 stamp, 1" x 6" x 3.25"; right 1.75" x 6.25" x 4.25". *Courtesy of C.J. Simpson.*

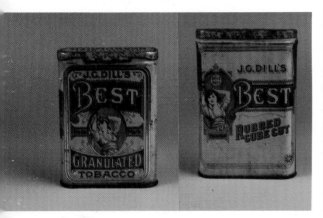

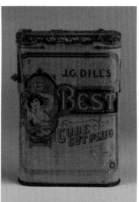

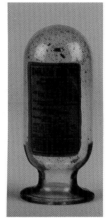

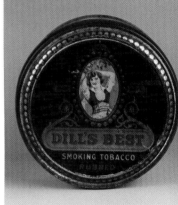

J.G. Dill's Best Granulated Tobacco, J.G. Dill Company, Richmond, Virginia. Lithographed tin, American Can Co. 4" x 3" x .75". *Courtesy of C.J. Simpson.*

J.G. Dill's Best Rubbed Cube Cut, J.G. Dill Company, Richmond. Lithographed tin. 4.25" x 3" x .75". *Courtesy of C.J. Simpson.*

J.G. Dill's Best Cube Cut Plug, J.G. Dill Company, Richmond, Virginia. Lithographed tin. 4.25" x 3" x .75". *Courtesy of C.J. Simpson.*

Dill's Best, J.G. Dill Co., Richmond (Factory No. 26, Virginia), sample (?), 1909. Glass with paper label. 4.5" x 2". *Courtesy of C.J. Simpson.*

Dill's Best Smoking Tobacco, J.G. Dill Co., Richmond, Virginia. Lithographed tin, American Can Co. 3" x 4.25". *Courtesy of C.J. Simpson.*

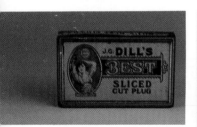

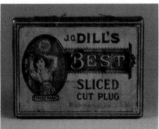

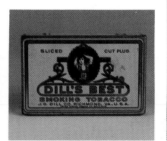

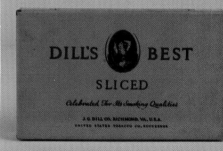

J.G. Dill's Best Sliced Cut Plug tin, Richmond, Virginia (Factory No. 25, 2nd Virginia). Lithographed tin, American Can Co. 1" x 4" x 2.75". *Courtesy of C.J. Simpson.*

J.G. Dill's Best Sliced Cut Plug, J.G. Dill, Richmond, Virginia. Lithographed tin. .75" x 4.5" x 3". *Courtesy of C.J. Simpson.*

Dill's Best Smoking Tobacco, J.G. Dill Co., Richmond, Virginia, United States Tobacco Co., Successor. Lithographed tin. .75" x 4" x 2.25". *Courtesy of C.J. Simpson.*

Dill's Best Sliced, J.G. Dill, Richmond, United States Tobacco Co., Successor (Factory No. 25, 2nd Virginia). Lithographed tin. 1.5" x 7.25" x 4.5". *Courtesy of C.J. Simpson.*

Dill's Best Smoking Tobacco, J.G. Dill, Richmond, United States Tobacco Co., Successor (Factory No. 25, 2nd Virginia). Lithographed tin. Left 2" x 6.25" x 4.25"; right 1.5" x 6.25" x 3.25". *Courtesy of C.J. Simpson.*

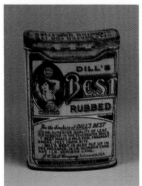

Dill's Best Rubbed, J.G. Dill Company, Richard, Virginia. Concave lithographed tin. 4.5" x 3" x 1". *Courtesy of C.J. Simpson.*

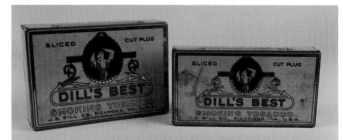

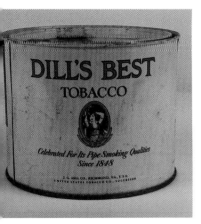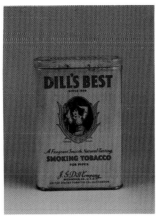

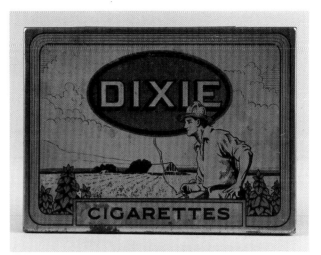

Dill's Best Tobacco, J.G. Dill, Richmond, United States Tobacco Co., Successor (Factory No. 25, 2nd Virginia), series 115, 1925 stamp. Lithographed tin. 4.5" x 5.5". *Courtesy of C.J. Simpson.*
Dill's Best Smoking Tobacco for Pipes, J.G. Dill Company, Richmond, United States Tobacco Co., Successor. Lithographed tin. 4.5" x 3" x .75". *Courtesy of C.J. Simpson.*

Dixie Cigarettes. Lithographed tin. 1.5" x 6" x 4.25". *Courtesy of C.J. Simpson.*

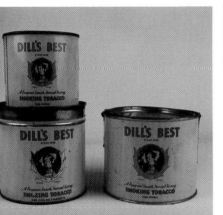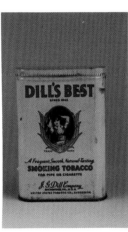

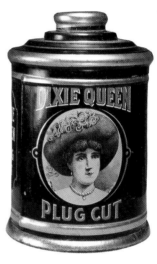

Dill's Best Smoking Tobacco, J.G. Dill, Richmond, United States Tobacco Co., Successor (Factory No. 25, 2nd Virginia). Lithographed tin. Top left: 4" x 4.25"; bottom left: 4.5" x 5.5"; right: 5" x 5". *Courtesy of C.J. Simpson.*
Dill's Best Smoking Tobacco for Pipe or Cigarette, J.G. Dill Co., Richmond, United States Tobacco Co., Successor. Lithographed tin. 4.5" x 3" x .75". *Courtesy of C.J. Simpson.*

Dixie Queen Plug Cut Tobacco. Lithographed tin in rare, small knob version. *Courtesy of Oliver's Auction Gallery.*

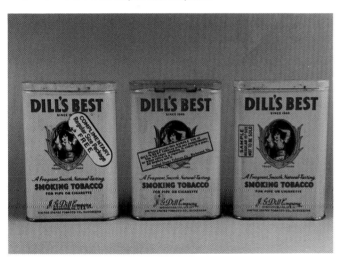

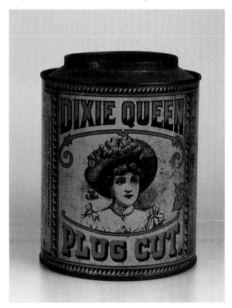

Dill's Best Smoking Tobacco for Pipe and Cigarette, samples. J.G. Dill Company, Richmond, United States Tobacco Co., Successor. Lithographed tin. 4.5" x 3" x .75". *Courtesy of C.J. Simpson.*

Dixie Queen Plug Cut, A. T. Motley, American Tobacco Co., Successor. Lithographed tin. 6" x 4.75". *Courtesy of Betty Lou and Frank Gay.*

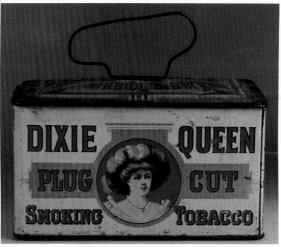
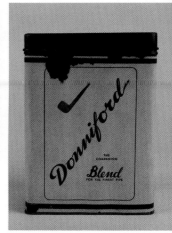

Dixie Queen (Factory No. 127, Kentucky). Lithographed tin lunch box, Tindeco. 4" x 7" x 4.25". *Courtesy of C.J. Simpson.*

Dixie Queen Plug Cut Smoking Tobacco, Maryland. Lithographed tin lunch box. 4" x 7.5" x 5.25". *Courtesy of Betty Lou and Frank Gay.*

Donniford Blend, Christian Peper, St. Louis (Factory No. 3, Missouri), Series 118, 1926 stamp. Tin with paper label. 4" x 3.25" x 1.25". *Courtesy of C.J. Simpson.*

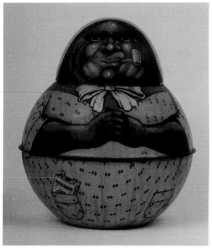

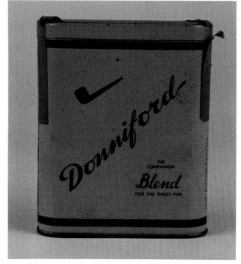

Dixie Queen Brownie "Mammy" roly poly tin. (for other examples of roly poly tins see Mayo) *Courtesy of Dennis O'Brien and George Goehring.*

Doctor's Blend Cut Plug Smoking Tobacco, B. Houde, Quebec, for United Cigar Stores. Lithographed tin. 3.75" x 5" x 3". *Courtesy of C.J. Simpson.*

Donniford, Christian Peper Tobacco Co., St. Louis (Factory No. 3, 1st Missouri). Lithographed tin. 4" x 3.25" x 1". *Courtesy of C.J. Simpson.*

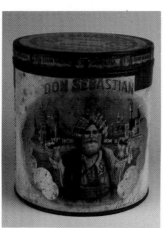
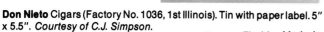

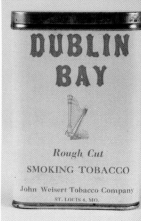

Dromedary Dixie Mix, Embossed tin, CANCO. 3" x 6" x 3.25". *Courtesy of C.J. Simpson.*

Don Nieto Cigars (Factory No. 1036, 1st Illinois). Tin with paper label. 5" x 5.5". *Courtesy of C.J. Simpson.*

Don Sebastian Cigars, Arango y Arango, Tampa, Florida. Made in Cuba, 1933 import stamp. Tin with paper label. 5.75" x 5.5". *Courtesy of C.J. Simpson.*

Dublin Bay Smoking Tobacco, John Weisert Tobacco Company, St. Louis (Factory No. 93, 1st Missouri). Tin with paper label. 4.5" x 3". *Courtesy of C.J. Simpson.*

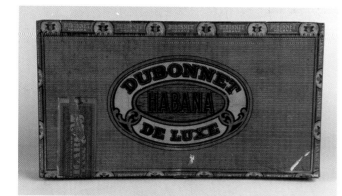

Dubonnet Habana De Luxe Cigars (Factory No. 1487, 1st Pennsylvania), 1917 stamp. Lithographed tin. 1.5″ x 9″ x 4.5″. *Courtesy of C.J. Simpson.*

Durham Plug Cut, W.T. Blackwell Durham Tobacco Company, Durham (Factory No. 39, 4th North Carolina). Lithographed tin, Somers Bros. 2.5″ x 6″ x 4″. *Courtesy of C.J. Simpson.*

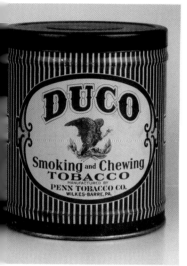

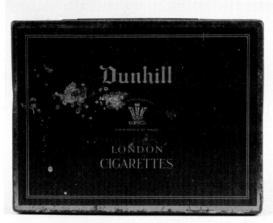

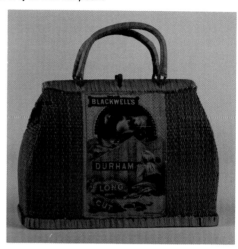

Duco Smoking and Chewing Tobacco, Penn Tobacco Co., Wilkes-Barre, Pennsylvania. Lithographed tin. 6.25″ x 5.25″. *Courtesy of Betty Lou and Frank Gay.*

Dunhill Cigarettes, London. Lithographed tin. .75″ x 6″ x 4.5″. *Courtesy of C.J. Simpson.*

Durham Long Cut, W.T. Blackwell Durham Tobacco Company, Durham. Straw handbag. 5″ x 7″ x 3″. *Courtesy of C.J. Simpson.*

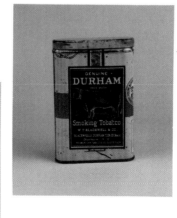

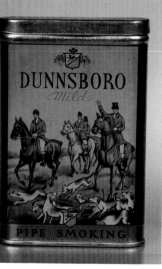

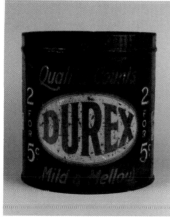

Dunnsboro Pipe Smoking Tobacco, Chas. C. Auld Tobacco Co., New York (Factory No. 1, Virginia). This mint and uncirculated tin is from the Tindeco factory. Because they used no primer, it is rare to find one in this condition. 4.5″ x 3″ x 1″. *Courtesy of Dennis O'Brien and George Goehring.*

Durex Cigars, L.R. Gregg Manufacturers, Belmont, Ohio (Factory No. 130). Lithographed tin. 5″ x 5″ x 5″. *Courtesy of C.J. Simpson.*

Durham Smoking Tobacco, W.T. Blackwell & Co., American Tobacco Co., Successors. Lithographed tin, Tindeco, Baltimore. 4.25″ x 3″ x .75. *Courtesy of Ben Roberts.*

Durham Smoking Tobacco, W.T. Blackwell & Co., American Tobacco Co., Successor. Cloth bag. *Courtesy of Betty Lou and Frank Gay.*

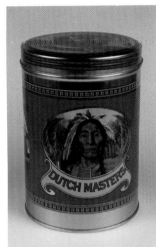

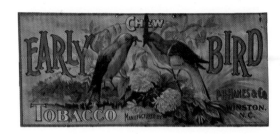

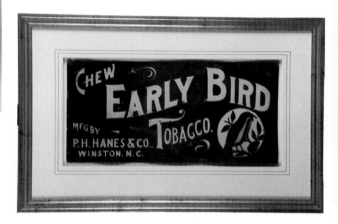

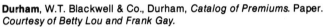

Durham, W.T. Blackwell & Co., Durham, *Catalog of Premiums*. Paper. *Courtesy of Betty Lou and Frank Gay.*

Dutch Masters Panatellas (25). Lithographed tin. 6″ x 4″. *Courtesy of C.J. Simpson.*

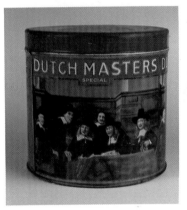

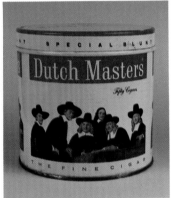

Early Bird Tobacco, P.H. Hanes & Co. Winston, North Carolina. Two-sided hanging embossed tin sign, Kaufman and Strauss, New York. 13″ x 6″. *Courtesy of Thomas Gray.*

Early Bird Tobacco, P.H. Hanes, Winston, North Carolina, sign. Lithographed tin, -?-& -?-Co., Barnesville, Ohio-maker of sign. 6″ x 14″. *Courtesy of Thomas Gray.*

Dutch Masters Special Cigars (Factory No. 2, 1st Pennsylvania). Lithographed tin. 5.25″ x 5.5″. *Courtesy of C.J. Simpson.*

Dutch Masters Special Blunt Cigars, Consolidated Cigar Corp., New York. 5.25″ x 5.5″. *Courtesy of C.J. Simpson.*

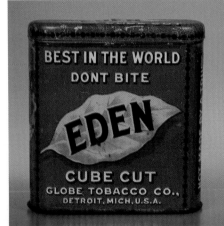

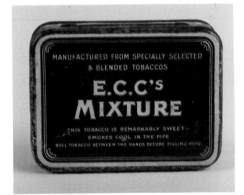

E-R Navy Cut Cigarettes, "To Commemorate the Coronation of Queen Elizabeth II, 1953." 2″ x 6″ x 4″. *Courtesy of C.J. Simpson.*

Eden Cube Cut, Globe Tobacco Co., Detroit, Michigan. Lithographed tin. 3.75″ x 3.5″ x 1.5″. *Courtesy of Dennis O'Brien and George Goehring.*

E.C.C.'s Mixture, American Tobacco Co. (Factory No. 2, Maryland). Tin with paper label. 1.25″ x 4.5″ x 3″. *Courtesy of C.J. Simpson.*

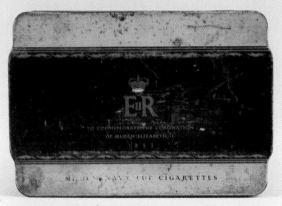

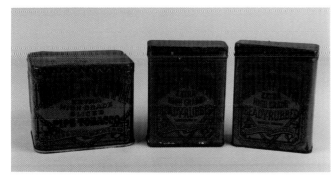

Edgeworth, Larus & Bros., Richmond (Factory No. 45, Virginia). Lithographed tin. Left 4″ x 4″ x 3″; middle and right 4.25″ x 4″ x 1.5″. *Courtesy of C.J. Simpson.*

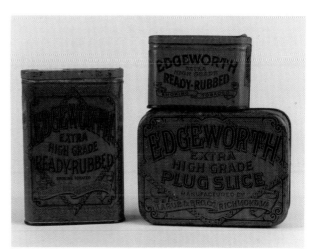

Edgeworth Plug Slice, Larus & Bro. Co., Richmond (Factory No. 45, 2nd Virginia). Lithographed tin. Left 4.5″ x 3″; top right 2″ x 3″; bottom right 1.5″ x 4″ x 3″. *Courtesy of C.J. Simpson.*

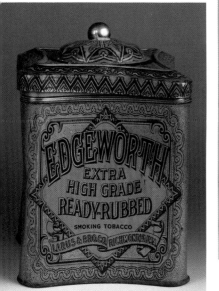

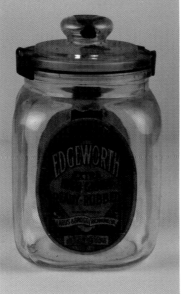

Edgeworth, Larus & Bros., Richmond. Lithographed tin concave canister. 6.5″ x 4.25″ x 4.5″. *Courtesy of Betty Lou and Frank Gay.*

Edgeworth, Larus & Bro. Co., Richmond (Factory No. 45, Virginia). Glass with paper label. 8″ x 5″ x 4″. *Courtesy of C.J. Simpson.*

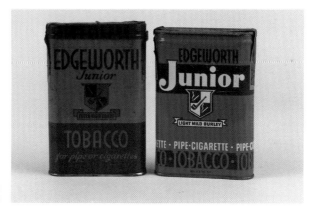

Edgeworth Junior, Larus & Bro. Co., Richmond (Factory No. 45, 2nd Virginia). Lithographed tin. 4.5″ x 3″. *Courtesy of C.J. Simpson.*

Edgeworth, Larus & Bros., Richmond (Factory No. 45, Virginia). Lithographed tin. "Extra High Grade...": (left) "Plug Slice Manufactured by..."; (middle) "Plug Slice Smoking Tobacco"; (top right) "Sliced Pipe Tobacco". These three are all 1″ x 3″ x 2″. The larger tin is 1.25″ x 4″ x 3″. *Courtesy of C.J. Simpson.*

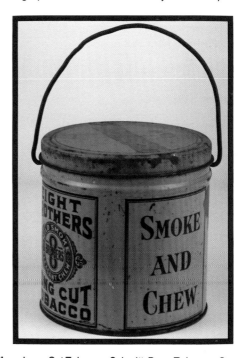

Eight Brothers Long Cut Tobacco, Schmitt, Penn Tobacco, Successors. Lithographed tin pail. 6″ x 5.25″. *Courtesy of C.J. Simpson.*

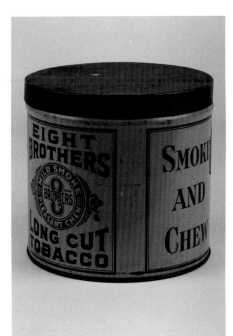
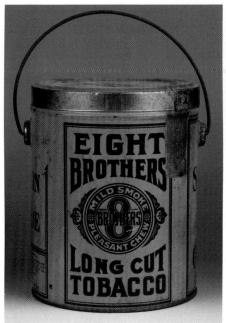
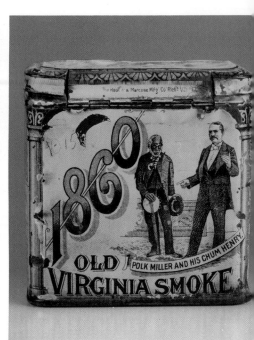

Eight Brothers Long Cut Tobacco, Schmitt, Penn Tobacco, Successors (Factory No. 36, 12th Pennsylvania). Lithographed tin. 5.75" x 5.25".
Eight Brothers Long Cut Tobacco, Penn Tobacco Co., Wilkes-Barre, Pennsylvania, Successors to Schmitt Bros. Tobacco Works. Lithographed tin. 6.25" x 5.25". *Courtesy of Betty Lou and Frank Gay.*

1860 Old Virginia Smoke, W.T. Hancock. This tin features "Polk Miller and his chum Henry." Miller was a pharmacist who toured the country giving talks about the South. W.T. Hancock. Lithographed tin, Hasker & Marcuse. 4" x 3.75" x 2.25". *Courtesy of Betty Lou and Frank Gay.*

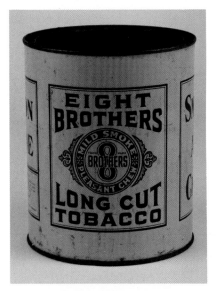
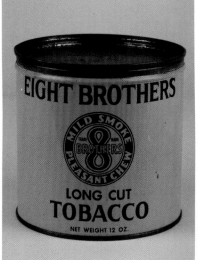
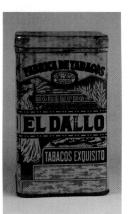

El Dallo Cigars, Fabrica de Tabacos (Factory No. 192, Maryland). Lithographed tin. 5.25" x 3" x 3". *Courtesy of C.J. Simpson.*
El Producto Blunt Cigars (Factory No. 2, 1st Pennsylvania), series 107 stamp. Lithographed tin. 6" x 5" x 5". *Courtesy of C.J. Simpson.*

Eight Brothers Long Cut Tobacco, Penn Tobacco Co., Bloch, Successors. Lithographed tin. 6" x 5". *Courtesy of C.J. Simpson.*
Eight Brothers Long Cut Tobacco, Bloch. 5" x 5". *Courtesy of C.J. Simpson.*

8-Hour Union Scrap, Eight Hour Tobacco Co., Cincinnati, Ohio (Factory No. 10, 1st Ohio). Paper. *Courtesy of Betty Lou and Frank Gay.*

Elcho Cigars, Elcho Cigar Co., Boston (Factory No. 435, Massachusetts). 2.5" x 5" x 3.25". *Courtesy of C.J. Simpson.*
"Embassy" Mild Virginia Cigarettes. W.D. & H.O. Wills, Bristol and London. 3.25" x 2.75". *Courtesy of C.J. Simpson.*

Emilia Garcia Mild Havana Cigars. Lithographed tin. 6" x 5". *Courtesy of C.J. Simpson.*

Emilia Garcia Primeros Cigars (Factory No. 620, New York). Lithographed tin. 4.75" x 5.5 ". *Courtesy of C.J. Simpson.*

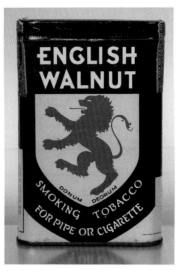

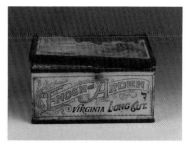

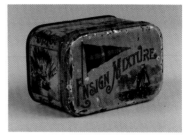

English Walnut Smoking Tobacco, Christian Peper Tobacco Co., St. Louis, Missouri, series 103 stamp. 4.5" x 3" x 1". *Courtesy of Dennis O'Brien and George Goehring.*

Enoch Arden Virginia, Long Cut, Scotten, Dillon, Detroit (Factory No. 1, 1st Michigan). Tin with paper label, 2" x 4" x 2.5". *Courtesy of C.J. Simpson.*

Ensign Mixture, Marburg Bros., American Tobacco Co. (Factory No 2, Maryland). Lithographed tin. 2" x 3.75" x 2". *Courtesy of C.J. Simpson.*

English Flake Cut, W.T. Blackwell Durham Tobacco Company, Durham (Factory No. 39, 4th North Carolina). Lithographed tin. 3.5" x 6" x 4". *Courtesy of C.J. Simpson.*

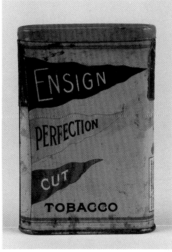 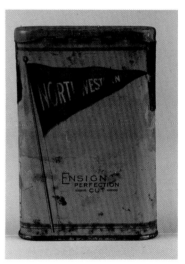

Ensign Perfection Cut Tobacco with Northwestern on back (Factory No. 2, Maryland), 1910 stamp. At least fourteen other schools are included in this series. Lithographed tin. 4.5" x 3". *Courtesy of C.J. Simpson.*

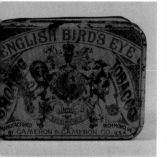 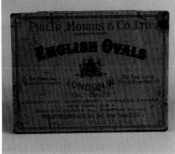

English Bird's Eye Smoking Tobacco, Cameron & Cameron, Richmond (Factory No. 4, 2nd Virginia). Lithographed tin, Hasker & Marcuse. 2.25" x 4.5" x 3". *Courtesy of C.J. Simpson.*

English Ovals Cigarettes (50), Philip Morris & Co., London & New York. Lithographed tin. 0.5" x 5.5" x 4". *Courtesy of C.J. Simpson.*

English Slice Cavendish, Marburg Bros., American Tobacco Co., Baltimore (Factory No. 2, Maryland). Lithographed tin. 0.5" x 4.75" x 2.75". *Courtesy of C.J. Simpson.*

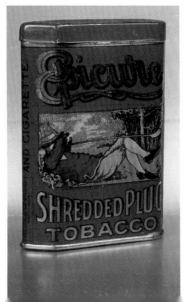

Epicure Shredded Plug pocket with beveled side, designed for ease of pouring. The United States Tobacco Co., Richmond, Virginia (Factory No. 15, 2nd Virginia). Lithographed tin. 4" x 3" x 1". *Courtesy of Dennis O'Brien and George Goehring.*

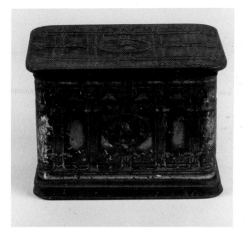

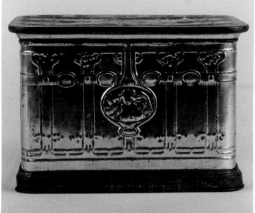

Epicure, United States Tobacco Co., Richmond. Embossed lithographed tin casket by F.S. Towle Co. 4.75" x 6.5" x 5". *Courtesy of C.J. Simpson.*

Epicure. Embossed tin. 4.5" x 6.5" x 4.75". *Courtesy of C.J. Simpson.*

Epicure (Factory No. 15, 2nd Virginia). Lithographed embossed tin. 5" x 4.5" x 4.5". *Courtesy of C.J. Simpson.*29-00 $16-25

Epicure (Factory No. 15, 2nd Virginia). Lithographed embossed tin. 4" x 4" x 4". *Courtesy of C.J. Simpson.*

Epicure (Factory No. 15, 2nd Virginia). Lithographed embossed tin. 4" x 4" x 4". *Courtesy of C.J. Simpson.*

Epicure (Factory No. 15, 2nd Virginia). Lithographed embossed tin. 5" x 4.5" x 4.5". *Courtesy of C.J. Simpson.*13/6

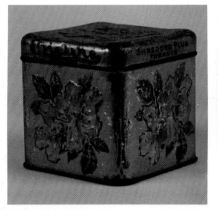

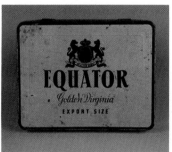

Epicure (Factory No. 15, 2nd Virginia). Lithographed embossed tin. 4" x 4" x 4". *Courtesy of C.J. Simpson.*

Epicure (Factory No. 15, 2nd Virginia). Lithographed embossed tin. 4" x 4" x 4". *Courtesy of C.J. Simpson.*

Equator Golden Virginia, Sonntag Cigaretten Fabrik, GMBH., Bonn, Germany. Lithographed tin. .75" x 4" x 3". *Courtesy of C.J. Simpson.*

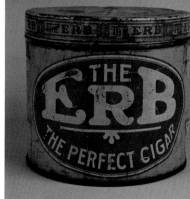

The Erb, "The Perfect Cigar, **D.S. Erb Co., Boyertown, Pennsylvania (Factory No. 33, 1st Pennsylvania). 5.25" x 6".** *Courtesy of C.J. Simpson.*

Eringold Cut Plug, Lane Limited, New York (Factory No. 24, 3rd New York). Lithographed tin. 2" x 2.25". Courtesy of C.J. Simpson.

Escort, Rainey-Young (Factory No. 93, 1st Missouri). Tin with paper label. 4.5" x 3". Courtesy of C.J. Simpson.

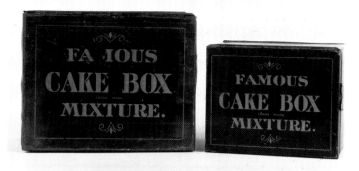

Famous Cake Box Mixture, Leavitt & Peirce, Cambridge (Factory No. 1, Virginia). Lithographed tin, American Can Co. Left 3.75" x 6.5" x 5"; 3.25" x 5.25" x 3.75". Courtesy of C.J. Simpson.

Famous Cake Box Mixture, Leavitt & Peirce, Cambridge (Factory No. 3 (?), 3rd Massachusetts). Lithographed tin. 2" x 4.5" x 3.25". Courtesy of C.J. Simpson.

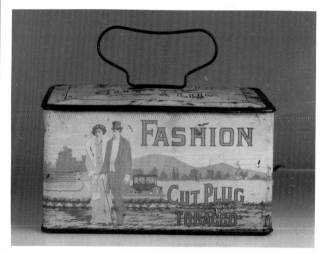

Eve Cube Cut, Globe Tobacco Co., Detroit (Factory No. 32, 1st Michigan). They also made Eden tobacco, but, to date, no one has found an Adam tin. Lithographed tin. 3.75" x 3.5" x 1.25". Courtesy of Dennis O'Brien and George Goehring.

Fairmount Tobacco, Weisert Bros. Tob. Co., St. Louis. Lithographed tin pocket in uncirculated condition. Marked O.I.C. Co., it was found in the Tindeco sample room in Baltimore. 4.5" x 3" x 1". Courtesy of Dennis O'Brien and George Goehring.

Famosa Mixture, Cameron & Cameron, Richmond, VA. Lithographed tin, Hasker & Marcuse Mfg. Co., Richmond. 3.25" x 4.5" x 2.25". Courtesy of Betty Lou and Frank Gay.

Fashion Cut Plug. Lithographed tin lunch box. 4" x 7.50" x 5.25". Courtesy of Betty Lou and Frank Gay.

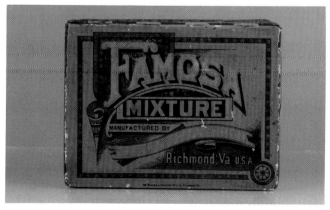

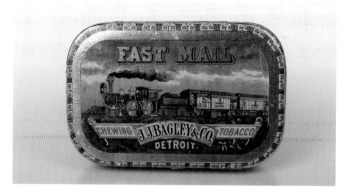

Fast Mail flat pocket, c. 1880. J.J. Bagley & Co., Detroit. The detail is amazing, down to a small sign on the train that reads "Gov. Hays." 3.75" x 2.25" x .5". Courtesy of Dennis O'Brien and George Goehring.

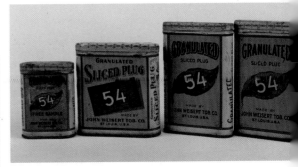

54 Granulated Sliced Plug, John Weisert Tobacco Co., St. Louis (Factory No. 93, 1st Missouri). Lithographed tin. Left to right: sample, 2.75" x 2"; 3.5" x 3.25"; 4.25" x 3"; 4.5" x 3". *Courtesy of C.J. Simpson.*

Fatima Cigarettes. Lithographed tin. 0.75" x 5.5" x 5.25". *Courtesy of C.J. Simpson.*

Fatima Turkish Blend Cigarettes, Cameron & Cameron Co., Richmond, Liggett & Myers Tobacco Co., Successors. Tin with paper label, embossed top. 3.25" x 2.75". *Courtesy of C.J. Simpson.*

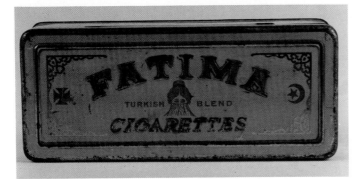

Fatima Cigarettes. Lithographed embossed tin. 2" x 7" x 3". *Courtesy of C.J. Simpson.*

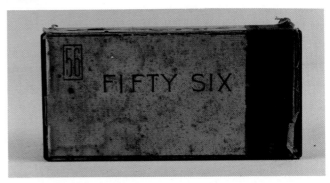

Fifty Six Cigarettes. Tin with paper label. 2" x 6" x 3". *Courtesy of C.J. Simpson.*

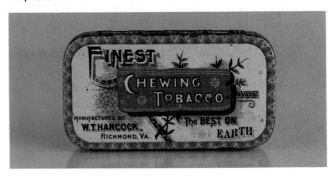

Finest Chewing Tobacco, W.T. Hancock, Richmond Virginia. Rare lithographed tin, Ginna & Co., N.Y. 3.75" x 1.75". *Courtesy of Thomas Gray.*

Finest Grade of Smoking Tobacco, Cameron & Cameron, Richmond. Lithographed tin, American Can Co., 5" x 7" x 4.5". *Courtesy of Betty Lou and Frank Gay.*

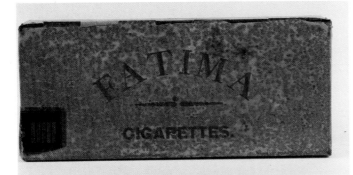

Fatima Cigarettes (100). Tin with paper label. 2" x 7" x 3". *Courtesy of C.J. Simpson.*

Fifty-Fifty Cigars (Factory No. 1100, 1st Pennsylvania). 5" x 3.25" x 3.25". *Courtesy of C.J. Simpson.*

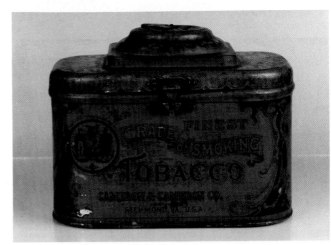

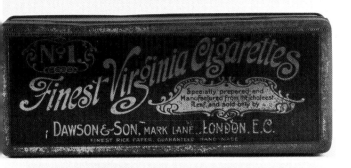

Finest Virginia Cigarettes, Dawson & Son, London. Lithographed tin. 2" x 8" x 3.25". *Courtesy of C.J. Simpson.*

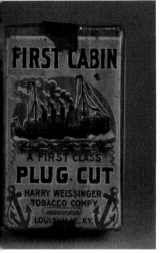

First Cabin Plug Cut, Harry Weissinger Tobacco Co., Louisville, Kentucky. Paper. *Courtesy of Betty Lou and Frank Gay.*

Flynt's Sun Cured and **Black Jack** tobacco watch fobs, J.G. Flynt Tobacco Co., Winston-Salem, North Carolina. *Courtesy of Thomas Gray.*

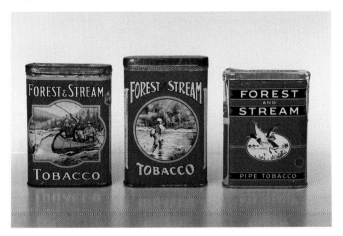

Forest and Stream Tobacco. A complete set of Forest and Stream pockets. The tin on the left is known as the "Double Fisherman" and is the oldest and most desirable. The "Single Fisherman" in the middle is next oldest. "The Duck" on the right is the most recent. Height: 4"-4.5", Width: 3"; Depth: 1". Imperial Tobacco Co., Montreal. *Courtesy of Dennis O'Brien and George Goehring.*

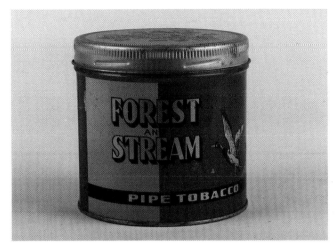

Forest and Stream Pipe Tobacco, Canada. Lithographed tin. 4.25" x 4.25". *Courtesy of C.J. Simpson.*

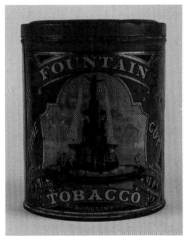

Fountain Tobacco, Lovell-Buffington, Covington, Kentucky (Factory No. 5, Kentucky). Lithographed tin, Heekin. 6.25" x 5". *Courtesy of C.J. Simpson.*

44 Invincible Cigars, "That Good Cigar," Consolidated Cigar Corporation, New York (Factory No. 372, 1st Pennsylvania). Lithographed tin. 5.5" x 3.25". *Courtesy of C.J. Simpson.*

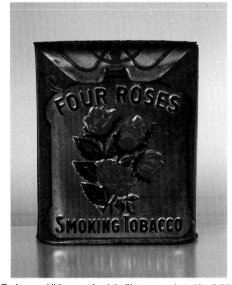

Four Roses Embossed lithographed tin flip top pocket. 4" x 3.5" x 1.25". *Courtesy of Dennis O'Brien and George Goehring.*

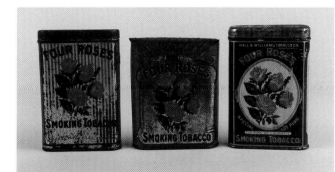

Four Roses Smoking Tobacco. Left: Liggett & Myers Tobacco Co. (Factory No. 3, 1st Illinois), lithographed tin, 4.5″ x 3″; middle: Embossed lithographed tin, 4″ x 3.25″; right: Nall & Williams Tobacco Co. (Factory No. 15, 5th Kentucky), lithographed tin, 4.5″ x 3″. *Courtesy of C.J. Simpson.*

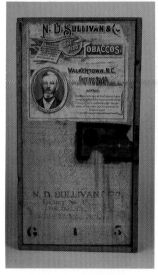
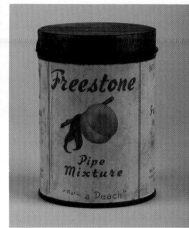

Free and Easy Tobacco N.D. Sullivan, Manufacturers of Fine Plug Tobaccos, Walkertown, North Carolina (Factory No. 45, 5th North Carolina). Wood caddy. 12″ x 6.5″. *Courtesy of Thomas Gray.*
Freestone Pipe Mixture, Christian Peper (Factory No. 3, 1st Maryland), series 110, 1926 stamp. Tin with paper label. 4.25″ x 2.75″. *Courtesy of C.J. Simpson.*

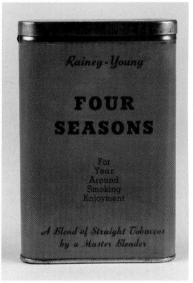
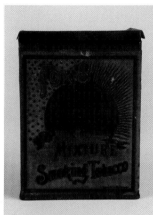

Four Seasons, Rainey-Young (Factory No. 93, 1st Missouri). Tin with paper label. 4.5″ x 3″. *Courtesy of C.J. Simpson.*
Fox's Mixture Smoking Tobacco (Factory No. 2, Maryland). Lithographed tin, A. Hoen & Co., Baltimore. 4.5″ x 3.75″ x 2″. *Courtesy of C.J. Simpson.*

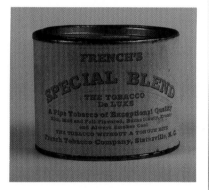

French's Special Blend, French Tobacco Company, Statesville, North Carolina (Factory No. 32, 5th North Carolina). Tin with paper label. 3″ x 3″. *Courtesy of C.J. Simpson.*

Frishmuth's Special, Frishmuth Bro. & Co., Philadelphia (Factory No. 1, 1st Pennsylvania). Lithographed tin pail. 6″ x 5″. *Courtesy of C.J. Simpson.*

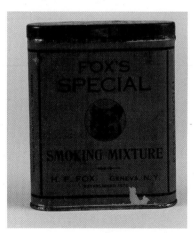
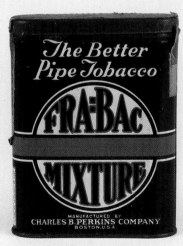

Fox's Special Smoking Mixture. H.F. Fox, Geneva, New York (Factory No. 15, Virginia). Tin with paper label. 4.25″ x 3.25″. *Courtesy of C.J. Simpson.*
Fra-Bac Mixture, Charles B. Perkins Company, Boston (Factory No. 26, Massachusetts) series 106, 1926 stamp. Lithographed tin, 4.25″ x 3.75″. *Courtesy of C.J. Simpson.*

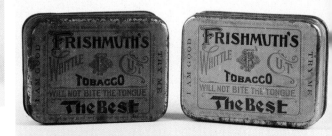

Frishmuth's Whittle Cut Tobacco, Frishmuth Bro., & Co., Philadelphia (Factory No. 1, 1st Pennsylvania). Left: lithographed tin, 1902 stamp; right: tin with paper label. 1.25″ x 4.5″ x 3″. *Courtesy of C.J. Simpson.*

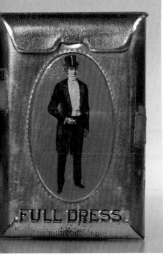
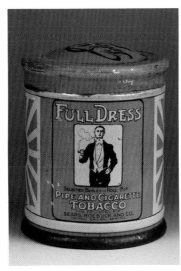

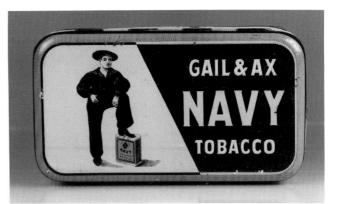

Gail & Ax Navy Tobacco, Gail & Ax, American Tobacco Company, Successor, Baltimore. Lithographed tin. 3" x 5.5" x 1.5". *Courtesy of Betty Lou and Frank Gay.*

Full Dress Tobacco, R.A. Patterson Tobacco Co., Richmond, Virginia (Factory No. 60, 2nd Virginia). Embossed lithographed tin. 4.25" x 3" x .75". *Courtesy of Dennis O'Brien and George Goehring.*
Full Dress Pipe and Cigarette Tobacco, Sears and Roebuck, Chicago (Factory No. 42, 2nd Virginia). Lithographed tin canister. 5" x 4". *Courtesy of Betty Lou and Frank Gay.*

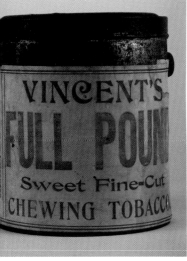

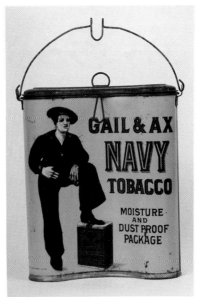

Gail & Ax Navy Tobacco. Lithographed kidney shaped pail. 8.5" x 7" x 2.5". *Courtesy of Dennis O'Brien and George Goehring.*
G.W. Gail & Ax Navy Smoking Tobacco, Gail & Ax, Baltimore, American Tobacco Company, Successor. Paper. *Courtesy of Betty Lou and Frank Gay.*

Full Pound Sweet Fine Cut Chewing Tobacco, Vincent Bros., Rochester, New York (Factory No. 1, 1st Michigan). Tin pail with paper label. 6.25" x 5.5". *Courtesy of C.J. Simpson.*
C.W. Gaele Cigar (Factory No. 706, 9th Pennsylvania). Glass. 5.5" x 3.5". *Courtesy of C.J. Simpson.*

Gallaher's Medium Deluxe Cigarettes, Gallaher Ltd., Virginia House, London & Belfast. 3.25" x 2.75". *Courtesy of C.J. Simpson.*

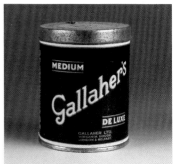

Game Fine Cut Tobacco, Jno. J. Bagley & Co., Detroit, Michigan. Lithographed store tin. 7.5" x 11.5" x 6.5". *Courtesy of Gary Metz.*

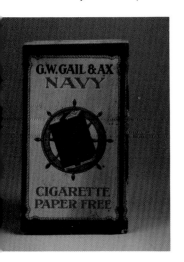

G.W. Gail & Ax Navy Cigarette Paper free, *Courtesy of Betty Lou and Frank Gay.*

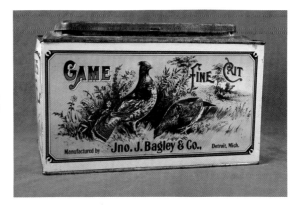

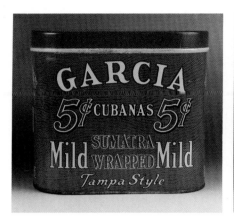 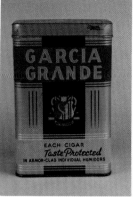

Garcia Cubanas Cigars, (Factory No. 447, 1st Pennsylvania). 4.25″ x 6.25″ x 4.25″. *Courtesy of C.J. Simpson.*

Garcia Grande Cigars (Factory No. 29, 5th New Jersey). 5.5″ x 2.5″ x 3.75″. Lithographed tin. *Courtesy of C.J. Simpson.*

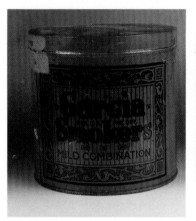 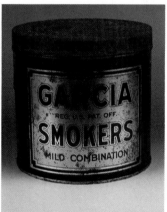

Garcia Smokers, C.A. Kildow, Bethesda, Ohio (Factory No. 700, 18th Ohio), 1926 stamp. Lithographed tin. 5″ x 5.25″. *Courtesy of C.J. Simpson.*

Garcia Smokers, C.A. Kildow, Maker, Bethseda, Ohio (Factory No. 700, 18th Ohio). Lithographed tin. 5.25″ x 5.5″. *Courtesy of C.J. Simpson.*

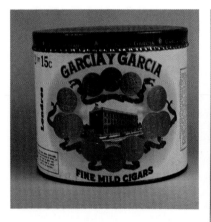 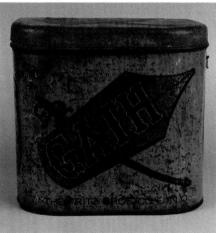

Garcia Y Garcia Fine Mild Cigars, Consolidated Tobacco Co., Inc., Tampa, Florida. Tin with paper label. 4.75″ x 5″. *Courtesy of C.J. Simpson.*

Gath Cigars, "The Pen is Mightier than the Sword," Fritz Bros. Co., Cincinnati, Ohio (Factory No. 113, 1st Ohio). 5.25″ x 6.25″ x 4″. *Courtesy of C.J. Simpson.*

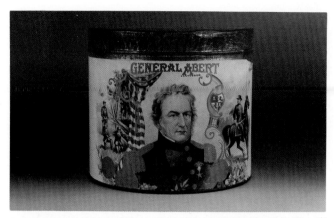

General Abert Cigars (Factory No. 413, 1st Pennsylvania). Tin with embossed paper label. 5.25″ x 6″. *Courtesy of C.J. Simpson.*

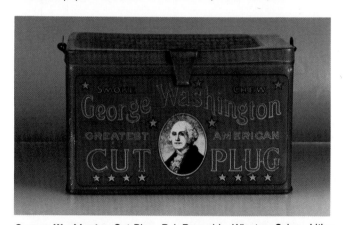

George Washington Cut Plug, R.J. Reynolds, Winston-Salem. Lithographed tin lunch box in a lighter color. The George Washington brand name was first used for a Reynolds twist tobacco in the 1880s. In 1909 it was given to a new cut plug tobacco. 5″ x 7.5″. *Courtesy of Thomas Gray.*

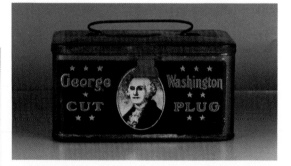

George Washington Cut Plug, R.J. Reynolds, Winston-Salem. Lithographed tin lunch box, smaller size, darker color. *Courtesy of Thomas Gray.*

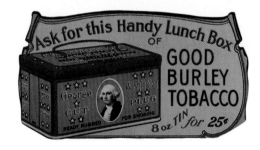

George Washington display. Cardboard. 11.5″ x 10″. *Courtesy of Thomas Gray.*

54

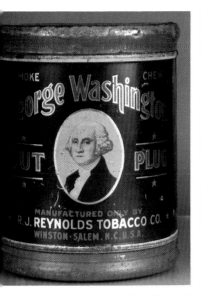
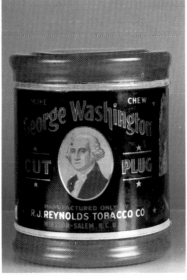
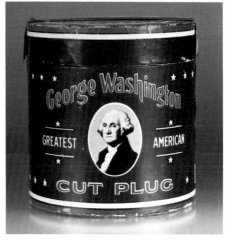

George Washington Cut Plug, R.J. Reynolds, Winston-Salem. Cardboard, 4.5" x 4.75". *Courtesy of Thomas Gray.*

George Washington Cut Plug, R.J. Reynolds, Winston-Salem. Lithographed tin. *Courtesy of Thomas Gray.*
George Washington Cut Plug, R.J. Reynolds, Winston-Salem, North Carolina. Lithographed tin. 5" x 4". *Courtesy of Thomas Gray.*

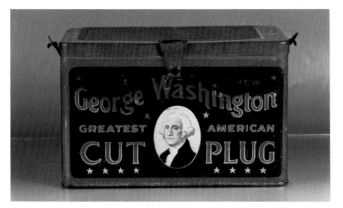

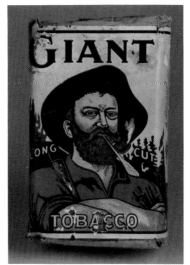

George Washington Cut Plug, R.J. Reynolds, Winston-Salem. Lithographed tin lunch box, darker color. 5" x 7.5". *Courtesy of Thomas Gray.*

Giant Tobacco, American Tobacco Co. Paper. *Courtesy of Betty Lou and Frank Gay.*

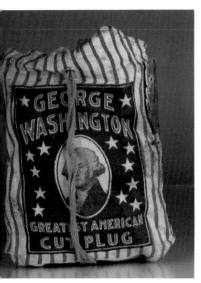
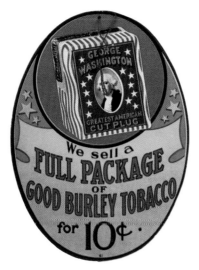

George Washington Cut Plug, R.J. Reynolds, Winston-Salem. Cloth Bag. 5.25" x 3.5". *Courtesy of Thomas Gray.*
George Washington oval hanger. Cardboard. 11" x 8". *Courtesy of Thomas Gray.*

Gildemann Cigarettes. Lithographed tin. 2.5" x 8" x 4.75". *Courtesy of C.J. Simpson.*

Ginks Stogies, West Virginia. Lithographed tin. 6" x 4.25" x 4.25". *Courtesy of Betty Lou and Frank Gay.*

55

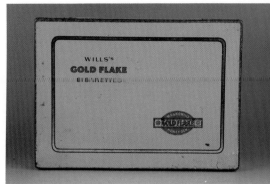

Globe Tobacco Co. Glass. 7" x 4". *Courtesy of C.J. Simpson.*

Globe Fine Cut, Globe Tobacco Co., Detroit, Michigan and Windsor, Ontario (Factory No. 32, Michigan). Lithographed tin. 0.5" x 3.5" x 2.25". *Courtesy of C.J. Simpson.*

Gold Flake Cigarettes (100), W.D. & H.O. Wills., London & Bristol. Lithographed tin. 1.5" x 6" x 4". *Courtesy of C.J. Simpson.*

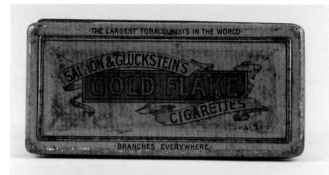

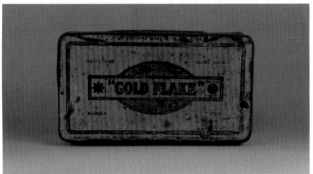

Gloriana Mixture, Surbrug Co., New York (Factory No. 16, 2nd New York). Lithographed tin. 1.75" x 6.5" x 2.75". *Courtesy of C.J. Simpson.*

Gold Flake Cigarettes, Salmon & Gluckstein. Lithographed tin. 2" x 6.5" x 3". *Courtesy of C.J. Simpson.*

Gold Flake Honey Dew Cigarettes (50), W.D. & H.O. Wills, Bristol & London. Lithographed tin. 1" x 5.75" x 3". *Courtesy of C.J. Simpson.*

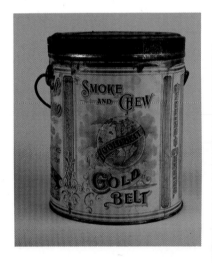

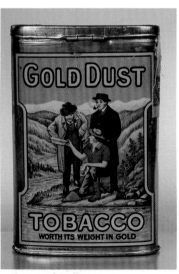

Gold Belt, Myers-Cox Co., Kentucky, American Tobacco Co. (Factory No. 27, Kentucky). Tin with paper label. 6.25" x 5". *Courtesy of C.J. Simpson.*

Gold Dust Tobacco, B. Houde Company, Limited, Quebec. Lithographed tin pocket with wonderful graphics. 4.5" x 3" x .75". *Courtesy of Dennis O'Brien and George Goehring.*

Gold Flake Honey Dew, W.D. & H.O. Wills, Bristol & London. Lithographed tin. .75" x 6" x 4.5". *Courtesy of C.J. Simpson.*

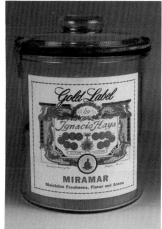

Gold Flake Honey Dew Cigarettes, W.D. & H.O. Wills Bristol & London. Lithographed tin. *Courtesy of C.J. Simpson.*

Gold Label Miramar, Ignacio Haya, Gradiaz, Amnis y Ca, Tampa, Florida. Glass with paper label. 7.5″ x 6″. *Courtesy of C.J. Simpson.*

Golden Chain Mixture, Gravely & Miller, Danville, Virginia (Factory No. 9, 6th Virginia). Lithographed tin, Ginna. 2.25″ x 4.5″ x 3.25″

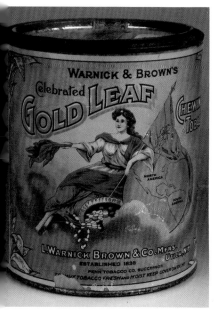

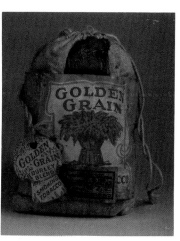

Golden Crown, R.J. Reynolds, Winston, North Carolina (Factory No. 256, 5th North Carolina). Wood caddy with paper label featuring a portrait of R.J. Reynolds. 4″ x 12.5″. *Courtesy of Thomas Gray.*

Golden Grain Smoking Tobacco. Cloth bag. *Courtesy of Betty Lou and Frank Gay.*

Golden Rod Curly Cut, John Middleton, Philadelphia. Tin with paper label. *Courtesy of C.J. Simpson.*

Gold Leaf Chewing Tobacco, L. Warnick Brown & Co., Utica, New York, Penn Tobacco Co., Successor. Tin with paper label. 6.5″ x 5.5″. *Courtesy of Betty Lou and Frank Gay.*

Golden Rod Little Cigars. Embossed lithographed tin. 3″ x 3.5″ x .25″. *Courtesy of Dennis O'Brien and George Goehring.*

Gold Medal, Cameron & Cameron, Richmond. The embossed bottom notes the accomplishments of Cameron & Cameron at the Columbian Exposition in Chicago, 1892. Lithographed tin, Hasker & Marcuse. 3.25″ x 4.5″ x 1.25″. *Courtesy of Betty Lou and Frank Gay.*

Golden Sceptre, Surbrug, New York. Lithographed tin, Hasker & Marcuse. 2.75" x 3.5" x 1.5". *Courtesy of Betty Lou and Frank Gay.*

Golden Sceptre, Surbrug, New York. Lithographed tin. 2.75" x 3.25" x 3.50". *Courtesy of Betty Lou and Frank Gay.*

Golden Square Cut Mixture, Cameron & Cameron, Richmond. Lithographed tin. 3" x 4.25" x 1.5". *Courtesy of Betty Lou and Frank Gay.*

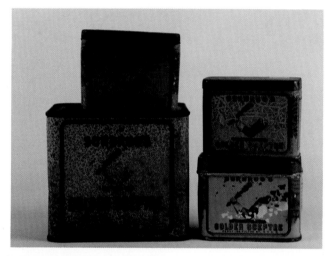 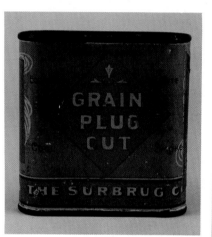

Golden Sceptre, Surbrug Co., New York (Factory 16, 2nd New York). Lithographed tin. Top left, top right 2.75" x 3.5" x 1.5"; bottom left 4.5" x 5" x 5"; bottom right 1891, 2.75" x 3.75" x 2.25". *Courtesy of C.J. Simpson.*

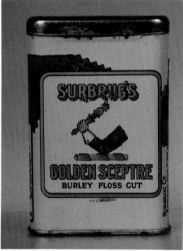

Grain Plug Cut, Surbrug Co., Richmond & New York (Factory No. 4, 2nd Virginia). Lithographed tin. 4.5" x 3". *Courtesy of C.J. Simpson.*

Grain Plug Cut, The Surbrug Co., Richmond & New York. Tin with paper label. 3.5" x 3.25". *Courtesy of C.J. Simpson.*

Golden Seal, Christian Peper, St. Louis. Embossed tin. 0.5" x 3.5" x 2". *Courtesy of C.J. Simpson.*

Golden Sceptre, Surburg Co., Richmond, c. 1911. Lithographed tin , American Can Co. (30A). 4.5" x 3" x 1". *Courtesy of Dennis O'Brien and George Goehring.*

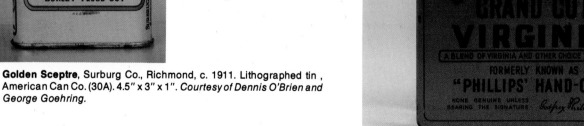

Grand Cut Virginia, Godfrey Phillips & Sons. Lithographed tin. 2.25" x 5.25" x 4". *Courtesy of C.J. Simpson.*

Grand Duchess, Oliver & Robinson, Richmond. The cardboard box is by A. Hoen Co., Baltimore, Maryland. 6.25″ x 4.25″ x 2″. *Courtesy of Betty Lou and Frank Gay.*

Granger Rough Cut Pipe Tobacco, Liggett & Myers Tobacco Co. (Factory No. 74, 1st Missouri), 1932. Lithographed tin. 4″ x 4″. *Courtesy of C.J. Simpson.*

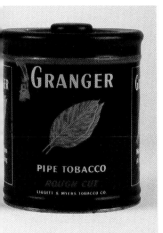

Granger Rough Cut Pipe Tobacco, Liggett & Myers Tobacco Co. Lithographed tin. 6″ x 5″. *Courtesy of C.J. Simpson.*

Granger Pipe Tobacco, Rough Cut, Liggett & Myers Tobacco Co. Lithographed tin. 6″ x 4.5″. *Courtesy of C.J. Simpson.*

Granger Rough Cut Pipe Tobacco, Liggett & Myers Tobacco Company, c. 1920s. The Granger canister is common, but the pocket is scarce. Lithographed tin. 4.5″ x 3″ x .75″. *Courtesy of Dennis O'Brien and George Goehring.*

B.F. Gravely's Plug Cut, B.F. Gravely, Henry County, Leatherwood, Virginia (Factory No. 45, Virginia). Lithographed tin, Ginna. 1.75″ x 4.5″ x 3″. *Courtesy of Thomas Gray.*

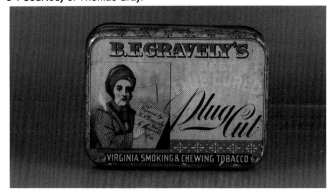

B.F. Gravely's Plug Cut, B.F. Gravely, Leatherwood, Virginia (Factory No. 31, Virginia). Lithographed tin, this is the only one known in this size. 1″ x 4.5″. *Courtesy of Thomas Gray.*

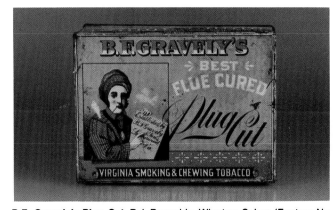

B.F. Gravely's Plug Cut, R.J. Reynolds, Winston-Salem (Factory No. 256, North Carolina). 1.5″ x 4.5″ x 3.25″. *Courtesy of Thomas Gray.*

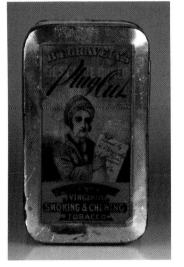

B.F. Gravely's Plug Cut, B.F. Gravely, Henry County, Leatherwood, Virginia (Factory No. 45, Virginia). Lithographed tin, Ginna. 1.75″ x 4.5″ x 3″. *Courtesy of Thomas Gray.*

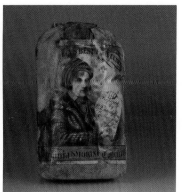

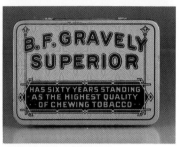

B.F. Gravely's Best Flue Cured Virginia Smoking Tobacco, R.J. Reynolds (Factory No. 256, North Carolina). Dovetailed wooden caddy with paper label, A. Hoen & Co., Baltimore. 7.25″ x 5″ x 4″. *Courtesy of Betty Lou and Frank Gay.*

B.F. Gravely's Best Flue Cured Virginia Smoking Tobacco. Cloth bag, paper label. 3.5″ x 2″. *Courtesy of Thomas Gray.*

B.F. Gravely Superior, R.J. Reynolds, Winston-Salem (Factory No. 8, North Carolina). 3.75″ x 2.75″. *Courtesy of Thomas Gray.*

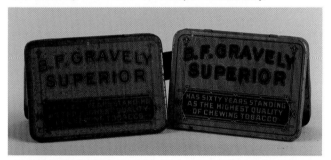

B.F. Gravely Superior, R.J. Reynolds (Factory No. 8, 5th North Carolina), series 115 stamp on tin on right. Lithographed tin. 0.25″ x 3″ x 2″. *Courtesy of C.J. Simpson.*

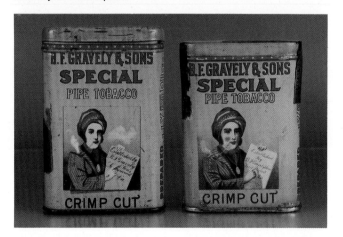

B.F. Gravely & Sons Special Pipe Tobacco, R.J. Reynolds, Winston-Salem (Factory No. 256, North Carolina). Lithographed tin. Left 4.5″ x 3″, rarer size; right 4″ x 3″, 1910 stamp. *Courtesy of Thomas Gray.*

B.F. Gravely & Sons Special Pipe Tobacco, R.J. Reynolds, Winston-Salem (Factory No. 256, North Carolina), 1910 stamp. Glass canister, Compton & Lewis Co., St. Louis, lithographer. *Courtesy of Thomas Gray.*

Gravely & Miller's Best Plug Cut, Gravely & Miller, Danville, Virginia (Factory No. 9, 6th Virginia). Tin with paper label, litho by Asten (?) & Co., Richmond, Virginia. 2″ x 5″ x 3″. *Courtesy of C.J. Simpson.*

Grayhurst of Tampa Cigars (Factory No. 61, Florida). Tin with paper label. 5.25″ x 4.25″. *Courtesy of C.J. Simpson.*

Greek Slave Tobacco, P.H. Hanes & Co. Wood caddy. 13″ x 4″. *Courtesy of Thomas Gray.*

60

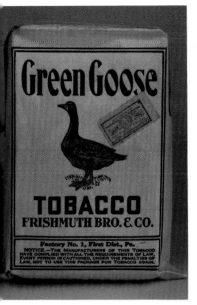

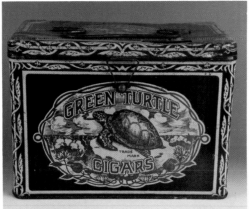

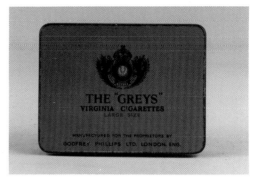

The **"Greys"** Virginia Cigarettes, Godfrey Phillips Ltd., London. Aluminum. 1" x 4" x 3.25". *Courtesy of C.J. Simpson.*

Green Goose Tobacco, Frishmuth Bro. & Co., Pennsylvania (Factory No. 1, 1st Pennsylvania). Paper. *Courtesy of Betty Lou and Frank Gay.*
Green Turtle Cigars, Gordon Cigar & Cheroot Co., Inc., Patterson Bros. Tobacco Co., Successor, Richmond (Factory No. 1, Virginia). Lithographed tin lunch box with slight embossing on lid. 5" x 7.5" x 5.5". *Courtesy of C.J. Simpson.*

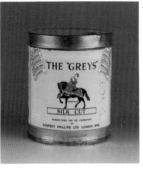

"Greys" Silk Cut Virginia Cigarettes (50), Godfrey Phillips Ltd., London. Tin with paper label. 3" x 2.5". *Courtesy of C.J. Simpson.*

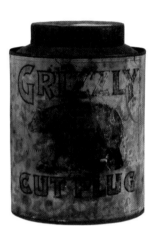

Grizzly Cut Plug, P. Lorillard Co. (Factory No. 10, 5th New Jersey). Tin with paper label. 6.5" x 4.5". *Courtesy of C.J. Simpson.*

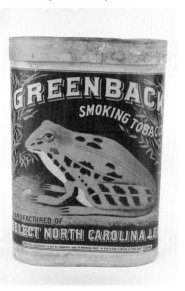

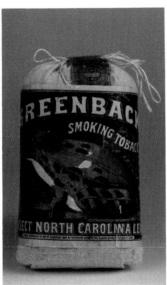

Greenback Smoking Tobacco cardboard container. Marburg Bros. *Courtesy of Holt's Country Store, Grandview, Missouri.*
Greenback Smoking Tobacco, Marburg Brothers Tobacco Co. Cloth bag. *Courtesy of Betty Lou and Frank Gay.*

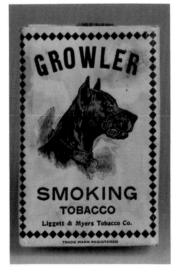

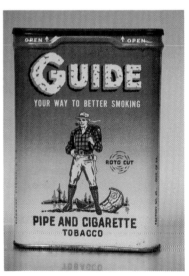

"Greys" Silk Cut Virginia Cigarettes, Major Drapkin & Co., London, branch of United Kingdom Tobacco Co. Ltd. Lithographed tin. 2" x 5.75" x 3". *Courtesy of C.J. Simpson.*

Growler Smoking Tobacco, Liggett & Myers Tobacco, Co. Paper. *Courtesy of Betty Lou and Frank Gay.*

Guide Pipe and Cigarette Tobacco (Factory No. 45, Virginia), c. 1950s. Larus & Bros., Richmond, Virginia. 4.25" x 3" x 1". *Courtesy of Dennis O'Brien and George Goehring.*

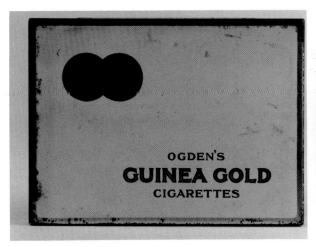

Guinea Gold Cigarettes, Ogden, Liverpool. Lithographed tin. 0.5" x 5.75" x 4.5". *Courtesy of C.J. Simpson.*

Ogden's Guinea Gold Cigarettes (50), Imperial Tobacco Co. of Canada, pat'd. 1934-35. Lithographed tin. .75" x 6" x 4". *Courtesy of C.J. Simpson.*

Half and Half Tobacco pocket and sample. 4.5" x 3", 3" x 2.25". *Courtesy of Dennis O'Brien and George Goehring.*

H-O Tobacco, R.A. Patterson Tobacco Co., Richmond (Factory No. 60, 2nd Virginia). Lithographed tin lunch box. 4.5" x 7" x 5". *Courtesy of C.J. Simpson.*

H-O Cut Plug, R.A. Patterson Tobacco Co., Richmond (Factory No. 60, 2nd Virginia). Lithographed tin. 3" x 6" x 3.75". *Courtesy of C.J. Simpson.*

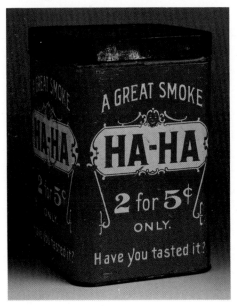

Ha-Ha Cigars, Pennsylvania. Lithographed tin. 6" x 4" x 4". *Courtesy of Betty Lou and Frank Gay.*

Half and Half, Lucky Strike and Buckingham, American Tobacco Co., Richmond (Factory No. 1, Virginia). Lithographed tin. 6" x 4.5". *Courtesy of C.J. Simpson.*

Hambone Smoking Tobacco. Cloth bag. *Courtesy of Betty Lou and Frank Gay.*

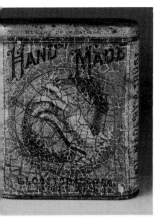 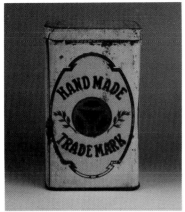 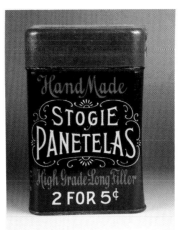 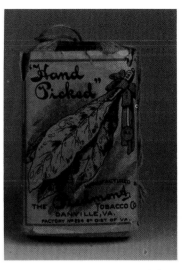

Hand Made, Globe Tobacco Co., Detroit. Lithographed tin. *Courtesy of Elsie and John Booker.*

Hand Made Trademark Cigars (Factory No. 361, Ohio). Lithographed tin. 5.25" x 3.5" x 3.5". *Courtesy of C.J. Simpson.*

Hand Made Stogie Panatellas (Factory No. 6, 23rd Pennsylvania), 1909 stamp. 6" x 4" x 4". *Courtesy of C.J. Simpson.*

"Hand Picked", Piedmont Tobacco Company, Danville, Virginia (Factory No. 254, 6th Virginia). Cloth bag. *Courtesy of Betty Lou and Frank Gay.*

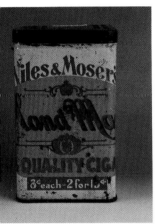 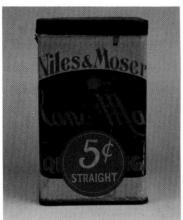

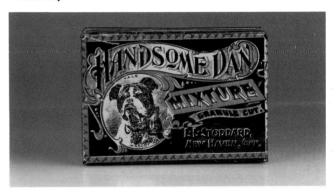

Hand Made Cigars, "A Quality Cigar," Niles & Moser (Factory No. 38, Ohio). Lithographed tin, Cadillac Can Co. 5.75" x 3.5" x 3.5". *Courtesy of C.J. Simpson.*

Hand Made, Niles & Moser (Factory No. 69, Michigan). Lithographed tin, Cadillac Can Co. 5.75" x 3.5". *Courtesy of C.J. Simpson.*

Handsome Dan Mixture, L.L. Stoddard, New Haven. Connecticut. Lithographed tin. 2.75" x 4" x 1.25". *Courtesy of Betty Lou and Frank Gay.*

 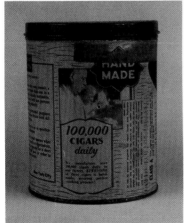

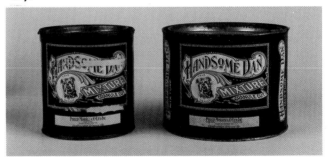

Hand Made Cigars (Factory No. 1068, Pennsylvania). Tin with paper label. 5" x 3.5" x 3.5". *Courtesy of C.J. Simpson.*

Hand Made Cigars, Edwin Cigar Co., New York. Tin with paper label and lithographed lid. 5.5" x 4.25". *Courtesy of C.J. Simpson.*

Handsome Dan Mixture, Philip Morris & Co., New York, successors to Continental Tobacco Co. (Factory No. 15, Virginia). Tin with paper label. Left 4.25" x 4"; right 4.25" x 5.25". *Courtesy of C.J. Simpson.*

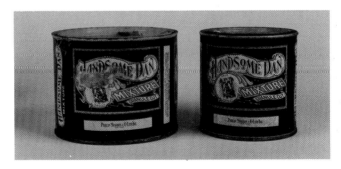

Handsome Dan Mixture, Philip Morris & Co., New York, Series 124, 1926 stamp. Tin with paper label. Left 4.25" x 5.25"; right 4.25" x 4.25". *Courtesy of C.J. Simpson.*

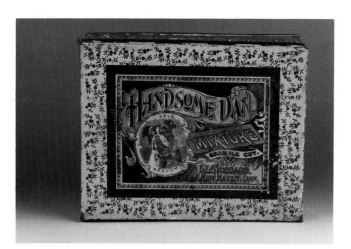

Handsome Dan Mixture, with Yale Mascot. L.L. Stoddard, New Haven, Connecticut, packed in Virginia. Lithographed tin. 2.5" x 6.5" x 5". *Courtesy of Betty Lou and Frank Gay.*

Handsome Dan Mixture, L.L. Stoddard, New Haven, Connecticut. Lithographed tin. L-R:1.5" x 4.5" x 3"; 2.5" x 6.75" x 5"; 1.25" x 4" x 2.5". *Courtesy of C.J. Simpson.*

B.F. Hanes' Best, c. 1890. Wood caddy with paper border. 13" x 4". *Courtesy of Thomas Gray.*

P.H. Hanes match safe advertising Missing Link, Speckled Beauty, and Extra Heavy tobacco brands, Winston, North Carolina. Pleasant Henderson Hanes was selling over one million pounds of plug tobacco each year before he sold the business to R.J. Reynolds. Hanes went into men's underwear, and the company is still active. *Courtesy of Thomas Gray.*

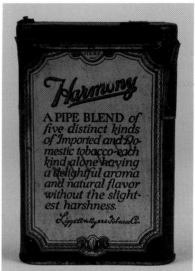
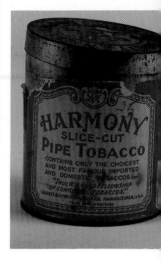

Harmony, Liggett & Myers Tobacco Company (Factory No. 15, 2nd New York). Tin with paper label. 4.5" x 3". *Courtesy of C.J. Simpson.*

Harmony Slice-Cut Pipe Tobacco, Liggett & Myers Tobacco Co. (Factory No. 74, 1st Missouri). Tin with paper label. 3" x 2.5". *Courtesy of C.J. Simpson.*

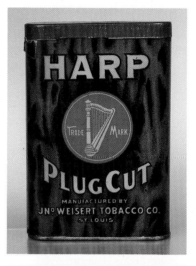

Harp Plug Cut Tobacco, Jno. Weisert Tobacco Co., St. Louis. This one-of-a-kind tin pocket has a paper label. 4.5" x 3" x 1". *Courtesy of Dennis O'Brien and George Goehring.*

Harvard Club of New York City. Tin with paper label. 2" x 6" x 2.75". *Courtesy of C.J. Simpson.*

Hash-Brown Tri Cut Blend round corner tobacco tin. Falk Tobacco Co., Richmond, Virginia. 3.25" x 4.5" x 1". *Courtesy of Dennis O'Brien and George Goehring.*

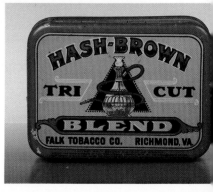

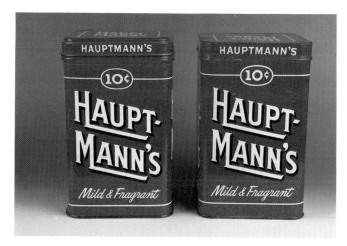

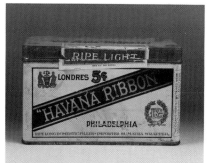

Haupt-Mann's Cigars. Both are lithographed tin, but the left one has a paper label strip with the new 10 cent price. 5.75" x 3.25" x 3.25". *Courtesy of C.J. Simpson.*

Havana Ribbon Cigars, Bayuk Bros, Philadelphia (Factory No. 630, 1st Pennsylvania). Embossed lithographed tin. 5.25" x 3". *Courtesy of C.J. Simpson.*

Havana Ribbon Cigars, Bayuk, Philadelphia (Factory No. 1600, Pennsylvania). Lithographed tin. 3" x 5" x 3". *Courtesy of C.J. Simpson.*

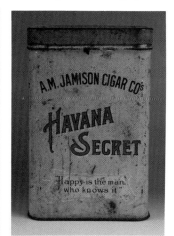

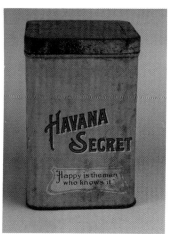

Havana Secret, A.M. Jamison Cigar Co. (Factory No. 835, Maryland). Lithographed tin. *Courtesy of C.J. Simpson.*

Havana Secret, (no "A.M. Jamison") (Factory No. 835, Dist. Maryland). Lithographed tin. 6" x 4" x 4". *Courtesy of C.J. Simpson.*

Havana Blend Cigars (50) (Factory No. 771, 9th Pennsylvania). Lithographed tin. 6" x 4". *Courtesy of C.J. Simpson.*

Havana Blossom Plain Chewing Tobacco, Kentucky. Paper. *Courtesy of Betty Lou and Frank Gay.*

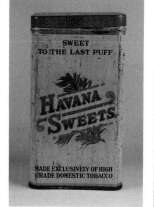

Havana Cadet (Factory No. 660, 1st Pennsylvania). Tin with paper label. 4.75" x 5.25" x 5.25". *Courtesy of C.J. Simpson.*

Havana Cadet Cigars, Pennsylvania. Tin with ashtray top and paper label. 4.75" x 5.5". *Courtesy of Betty Lou and Frank Gay.*

Havana Sweets Cigars (Factory No. 890, 1st Pennsylvania). Lithographed tin, Liberty Can Co. 5.75" x 3.5" x 3.5". *Courtesy of C.J. Simpson.*

Hayward Mixture, Moss & Lowenhaupt, St. Louis (Factory No. 10, Virginia), Series 113, 1926 stamp. Cardboard with paper label, 4.25" x 4". *Courtesy of C.J. Simpson.*

Headline (Factory No. 17, Virginia). 7″ tall. *Courtesy of Elsie and John Booker.*

Helme's Railroad Snuff. Embossed glass. 4.5″ x 3″. *Courtesy of C.J. Simpson.*

Herbert Tareyton Cigarettes, Herbert Tareyton. Lithographed 100s tin. 1″ x 5.5″ x 4.25″. *Courtesy of C.J. Simpson.*

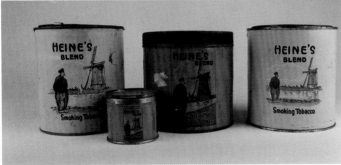

Heine's Blend Smoking Tobacco. L-R: Sutliff Tobacco Co., Richmond (Factory T-60, Virginia), tin with paper label, 5.5″ x 5″; Sutliff, San Francisco (Factory No. 32, 1st California), lithographed tin, 2.25″ x 2.5″; Heine's Tobacco Company, Massillon, Ohio (Factory No. 234, 18th Ohio), the oldest of the group, lithographed tin, 5.25″ x 5″; Sutliff, Richmond, lithographed tin, 5.5″ x 5″. *Courtesy of C.J. Simpson.*

Herbert Tareyton Cigarettes, Herbert Tareyton. Lithographed tin. 0.5″ x 5.75″ x 4.5″. *Courtesy of C.J. Simpson.*

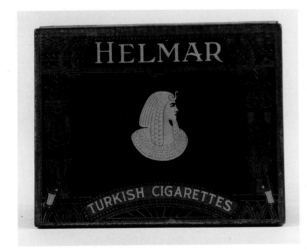

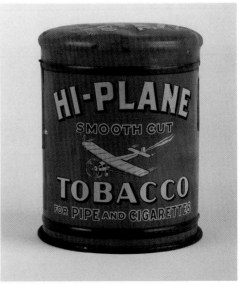

Helmar Turkish Cigarettes. Lithographed tin. 0.75″ x 5.5″ x 4.25″. *Courtesy of C.J. Simpson.*
Helme's Railroad snuff. Glass. 7.5″ x 3″. *Courtesy of C.J. Simpson.*

Hi-Plane Tobacco, Larus Bros., Richmond (Factory No. 45, Virginia). Lithographed tin canister. 6″ x 5″. *Courtesy of C.J. Simpson.*

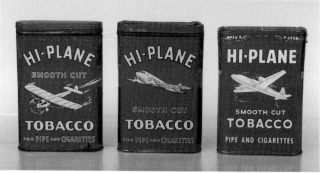

Hi-Plane Tobacco. A complete set of Hi-Plane pockets. The "Single Engine" on the left is oldest and the "two engine" is next oldest. The "four engine" is newest, but it is the most valuable because of its rarity. Larus & Bros., Richmond. 4.5″ x 3″ x 1″. *Courtesy of Dennis O'Brien and George Goehring.*

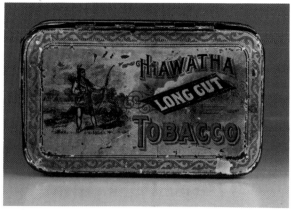

Hiawatha Long Cut Tobacco, Daniel Scotten & Co, Detroit. Lithographed tin. 3″ x 5″ x 2″. *Courtesy of Betty Lou and Frank Gay.*

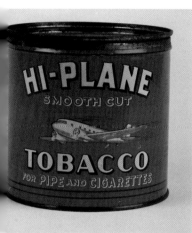

Hiawatha Fine Cut, patented 1899. Embossed tin. 0.75″ x 3.5″ x 1.75″. *Courtesy of C.J. Simpson.*

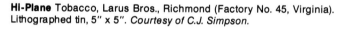

Hi-Plane Tobacco, Larus Bros., Richmond (Factory No. 45, Virginia). Lithographed tin, 5″ x 5″. *Courtesy of C.J. Simpson.*

Hickey & Nicholson, Hickey and Nicholson, Charlottetown, Prince Edward Island. Lithographed tin. 2″ x 5″ x 3.5″. Left Perique Mixture; right Tobacco. *Courtesy of C.J. Simpson.*

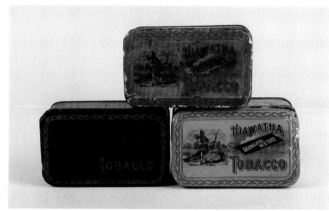

Hiawatha, Daniel Scotten & Co., Detroit (Factory No. 1, 1st Michigan). Lithographed tin. 2″ x 5″ x 3″. Green: Straight Cut, Hasker & Marcuse; yellow, Ginna: granulated mixture; white, Ginna: flake. *Courtesy of C.J. Simpson.*

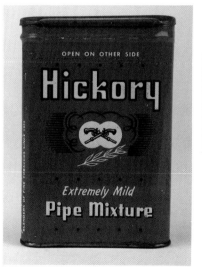

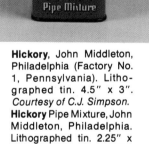

Hickory, John Middleton, Philadelphia (Factory No. 1, Pennsylvania). Lithographed tin. 4.5″ x 3″. *Courtesy of C.J. Simpson.*
Hickory Pipe Mixture, John Middleton, Philadelphia. Lithographed tin. 2.25″ x 2″ x 2″. *Courtesy of C.J. Simpson.*

"High Card" Pure Virginia Flake, Cope Bros. & Co. Ltd., Liverpool & London. Lithographed tin. 2″ x 7.25″ x 2.5″. *Courtesy of C.J. Simpson.*

Hiawatha Dark Fine Cut, Spaulding & Merrick, Liggett & Myers, Chicago (Factory No. 3, 1st Illinois). Lithographed tin. 2″ x 8″. *Courtesy of C.J. Simpson.*

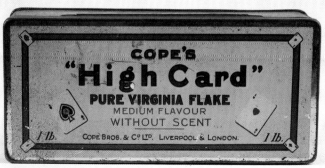

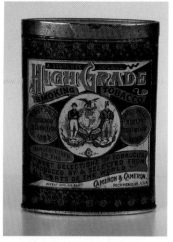
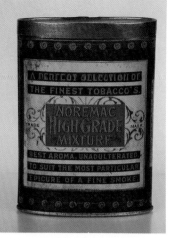

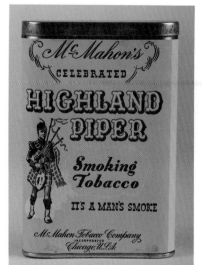

Highland Piper Smoking Tobacco, McMahon Tobacco Company, Chicago (Factory No. 93, 1st Missouri). Tin with paper label. 4.25" x 3". *Courtesy of C.J. Simpson.*

High Grade, "A Student's Solace," Cameron & Cameron, Richmond, Virginia. Lithographed tin oval pocket by S. A. Ilsley, Brooklyn, New York. A very early, pre-1900 pocket. 4" x 3" x 1.25". *Courtesy of Dennis O'Brien and George Goehring.*

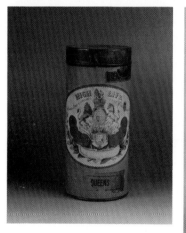
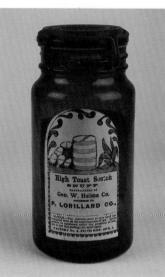

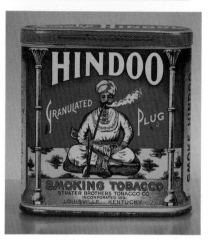
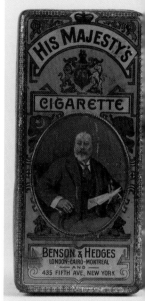

Hindoo Granulated Plug Smoking Tobacco, Strater Brothers Tobacco Co., Louisville, Kentucky, Incorporated 1891. Lithographed tin by American Stopper Company, Brooklyn, New York. 3.75" x 3.5" x 1.25". *Courtesy of Dennis O'Brien and George Goehring.*

His Majesty's Cigarette, Benson & Hedges, London, Montreal & New York. Lithographed tin. 2.5" x 6.5" x 3". *Courtesy of C.J. Simpson.*

High Life Cigars, Gene Vale (?) Cigar Co. (Factory No. 26, 2nd New York). Tin with paper label and applied embossed paper oval. 5.5" x 2.5". *Courtesy of C.J. Simpson.*

High Toast Scotch Snuff, Geo. W. Helme, successor to P. Lorillard Co. (Factory No. 4, 5th New Jersey). Glass with paper label. 7" x 3". *Courtesy of C.J. Simpson.*

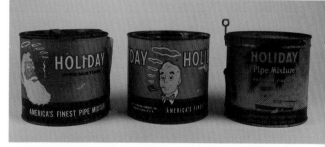

Holiday Pipe Mixture, Larus & Bros., Co., Richmond (Factory 45, 2nd Virginia). L-R: Santa, February 26, 1926 stamp, tin with paper label, 5" x 5"; Man with pipe, tin with paper label, 5" x 5"; cruise ship, lithographed tin, 5" x 5". *Courtesy of C.J. Simpson.*

Honest Labor Cut Plug, R.A. Patterson, Richmond, Lithographed tin, Hasker & Marcuse. 1.5" x 4.5" x 2.5". *Courtesy of Betty Lou and Frank Gay.*

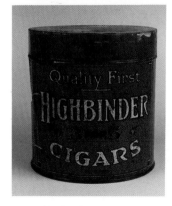
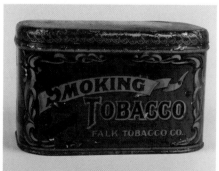

Highbinder Cigars, (Factory No. 955, 9th Pennsylvania). Lithographed tin. 5" x 5". *Courtesy of C.J. Simpson.*

Highest Grade Smoking Tobacco, Falk Tobacco Co., New York and Richmond (Factory No. 1, 2nd Virginia). Lithographed tin. 4.25" x 7" x 4.5". *Courtesy of C.J. Simpson.*

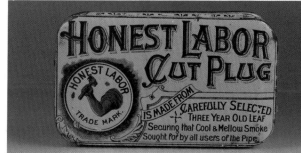

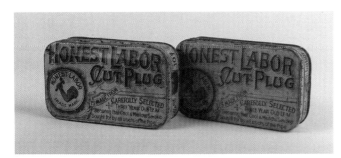

Honest Labor Cut Plug. R.A. Patterson Co., Richmond (Factory No. 60, 2nd Virginia). Lithographed tin. Left: 1.25" x 4.5" x 2.5", Hasker & Marcuse; right 1" x 4.5" x 2.5", American Can Co. *Courtesy of C.J. Simpson.*

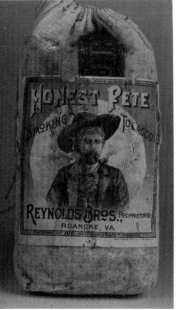

Hot Spur Mixture (Factory No. 26, 2nd Virginia). Lithographed tin, Ginna. 2.25" x 4.5" x 3". *Courtesy of C.J. Simpson.*

Honest Pete Smoking Tobacco, Reynolds Bros., Roanoke, Virginia (Factory No. 100, 6th Virginia). Cloth bag, with paper label lithographed by Guggenheimer, Weil & Co. Litho, Baltimore. *Courtesy of Betty Lou and Frank Gay.*

Honest Scrap, Ohio. Paper. *Courtesy of Betty Lou and Frank Gay.*

Hugh Campbell's Shag pocket with beveled pouring edge. United States Tobacco Co., Richmond, Virginia, c. 1910. 4.5" x 3" x 1". *Courtesy of Dennis O'Brien and George Goehring.*

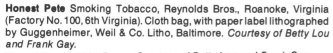

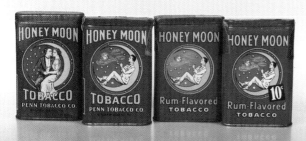

Honey Moon Tobacco. A complete set of Honey Moon Tobacco pockets. The tin on the left, known as "Two-On-The-Moon," is the earliest and most desirable. Next to it is the "One-On-The-Moon." Penn Tobacco Co., Wilkes-Barre, Pennsylvania. 4.5" x 3" x 1". *Courtesy of Dennis O'Brien and George Goehring.*

Honey Moon Tobacco, Penn Tobacco Co., Wilkes-Barre, Pennsylvania. Paper. *Courtesy of Betty Lou and Frank Gay.*

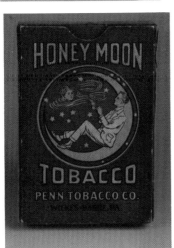

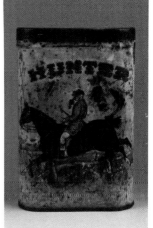

Humbug Tobacco, W.T. Hancock, R.J. Reynolds, Winston-Salem. Wood caddy. 7" x 7". *Courtesy of Thomas Gray.*

Hunter Cigar (Factory No. 57, 11th Ohio). Lithographed tin pocket. 5.25" x 3.75" x 1.25". *Courtesy of C.J. Simpson.*

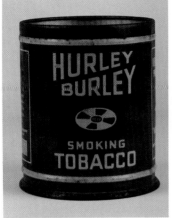

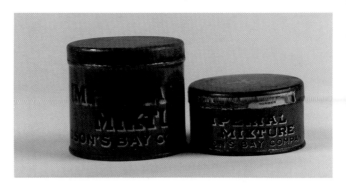

Imperial Mixture, Hudson Bay Co. Lithographed tin. Left 3.25" x 3.25"; right 2.75" x 3". *Courtesy of C.J. Simpson.*

Hurley Burley Smoking Tobacco, P. Lorillard Co. (Factory No. 6, 1st Ohio). Lithographed tin. 5.75" x 5". *Courtesy of C.J. Simpson.*

Idle Hour Cut Plug, United States Tobacco Co., Richmond. This tin was also made with the words "Not made by a trust" under the wing. Lithographed tin. .75" x 2.5" x 4.75" *Courtesy of C.J. Simpson.*

Imperial Smoking Mixture, Allen & Ginter (Factory No. 14, 2nd Virginia). Lithographed tin, Ginna. 2.5" x 4.75" x 3". *Courtesy of C.J. Simpson.*

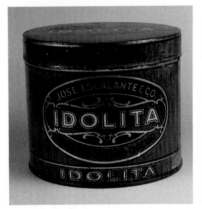

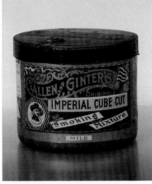

Idolita Cigars, Jose Escalante & Co., Tampa, New Orleans, Chicago (Factory No. 406, Florida). 4.5" x 5.25". *Courtesy of C.J. Simpson.*

Imperial Cube Smoking Mixture, Allen and Ginter, c. 1910. Lithographed paper on tin. 2.25" x 2.5". *Courtesy of Dennis O'Brien and George Goehring.*

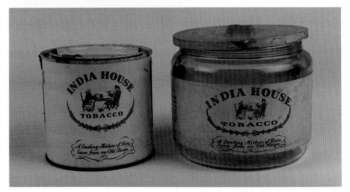

India House Tobacco, P. Lorillard Co. Left Permit T-7, Kentucky, lithographed tin, 4" x 4"; right Factory No. 6, 1st Ohio, glass with paper label and tin lid, 4.5" x 5". *Courtesy of C.J. Simpson.*

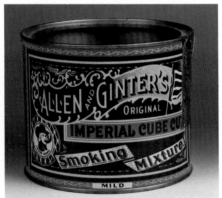

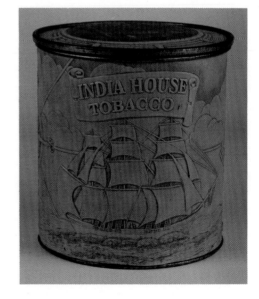

Imperial Cube Cut, Allen & Ginter (Factory No. 2, Maryland). Tin with paper label. 2.25" x 2.25". *Courtesy of C.J. Simpson.*

Imperial Cut Cube, Allen & Ginter, American Tobacco Co., Successor. Richmond, Virginia. Lithographed tin. 4" x 5". *Courtesy of Betty Lou and Frank Gay.*

Imperial Cube Cut, Allen & Ginter (Factory No. 2, Maryland). Lithographed tin. 2.25" x 3". *Courtesy of C.J. Simpson.*

India House Tobacco, P. Lorillard Co. (Factory No. 6, 1st Ohio). Embossed lithographed tin. 6" x 5". *Courtesy of C.J. Simpson.*

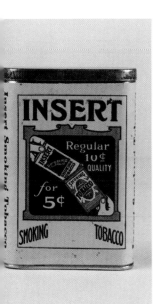

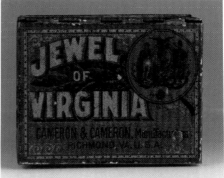

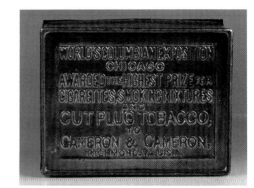

Insert Smoking Tobacco. John Weisert, St. Louis (Factory No. 93, 1st Missouri). Tin with paper label. 4.5″ x 3″. *Courtesy of C.J. Simpson.*

Iroquois Special Egyptian Cigarettes (100), plain, Buffalo, New York, 1910 stamp. Tin with paper label. 2.5″ x 5.75″ x 2.75″. *Courtesy of C.J. Simpson.*

Ivy Leaf Flake Cut Smoking Tobacco (Factory No. 1, 1st Michigan). Tin with paper label, Ginna. 1.75″ x 4.5″ x 3.25″. *Courtesy of C.J. Simpson.*

Jewel of Virginia, Cameron & Cameron, Richmond (Factory No. 4, 2nd Virginia). Lithographed tin, embossed on the bottom to recognize awards won at the Chicago World's Fair. 2″ x 4″ x 2.75″. *Courtesy of Betty Lou and Frank Gay.*

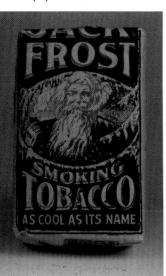

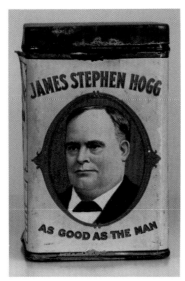

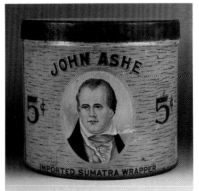

John Ashe Cigars (Factory No. 342, 1st Pennsylvania). Lithographed tin, Liberty Can Co. 5.25″ x 6″. *Courtesy of C.J. Simpson.*

John Cotton's No. 1 Cigarettes, John Cotton Tobacco and Cigarette Manufacturers, Edinburgh, Scotland. 3″ x 3.25″. *Courtesy of C.J. Simpson.*

Jack Frost Smoking Tobacco, 1926 stamp. Paper. *Courtesy of Betty Lou and Frank Gay.*

James Stephen Hogg, "As Good as the Man" Cigars, Pennsylvania. Tin with paper label. 5.25″ x 3.5″ x 3.5″. *Courtesy of Betty Lou and Frank Gay.*

Jewel of Virginia Mixture, Cameron & Cameron, Richmond. Lithographed tin, Hasker & Marcuse. 2.75″ x 4.5″ x 1.5″. *Courtesy of Betty Lou and Frank Gay.*

Jolly Granulated Tobacco (Factory No. 45, Virginia). Tin with paper label. 4.5″ x 4″. *Courtesy of C.J. Simpson.*

71

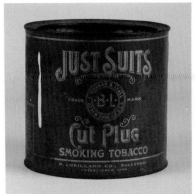

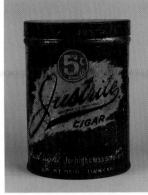

Just Suits Cut Plug, P. Lorillard Co., Successor (Factory No. 6, 1st Ohio). Lithographed tin. 5″ x 5″. *Courtesy of C.J. Simpson.*

Justrite Cigars, Kunles & Spock Cigar Co., St. Paul, Minneapolis, Minnesota. Lithographed tin. 5″ x 3.5″. *Courtesy of C.J. Simpson.*

Jonny Cigarettes (50), Austria Tabakwerke A.G. Tin with paper label. 3″ x 2.5″. *Courtesy of C.J. Simpson.*

Joysmoke, Excelsior Tobacco Co., St. Louis (Factory No. 25, 1st Missouri). Cardboard with paper label. 5.5″ x 2.75″. *Courtesy of C.J. Simpson.*

Jule Carps Choice Cut Plug, Blackwell's Durham Tobacco Co., Durham (Factory No. 39, 4th North Carolina). Lithographed tin, Ginna. 1.5″ x 4.75″ x 3.25″. *Courtesy of C.J. Simpson.*

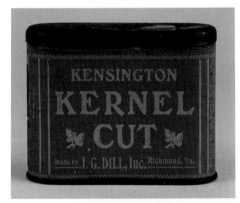

Kensington Kernel Cut, J.G. Dill, Richmond (Factory No. 25, 2nd Virginia). Lithographed tin. 2″ x 3.25″. *Courtesy of C.J. Simpson.*

Kensitas Cigarettes. Lithographed tin. 0.5″ x 5.75″ x 4.5″. *Courtesy of C.J. Simpson.*

Just Suits Cut Plug, Buchanan & Lyall, New York, P. Lorillard Co. (Factory No. 10, 5th New Jersey). Lithographed tin lunch box. 4″ x 8″ x 5″. *Courtesy of C.J. Simpson.*

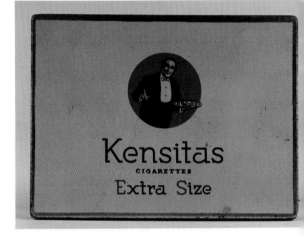

Kensitas Cigarettes (100). Lithographed tin. 0.5″ x 5.75″ x 4.5″. *Courtesy of C.J. Simpson.*

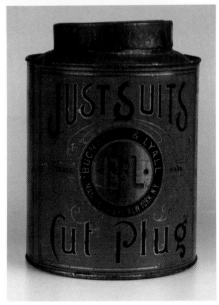

Just Suits Cut Plug, Buchanan & Lyall, New York, P. Lorillard Co. (Factory No. 10, 5th New Jersey). Lithographed tin, 6″ x 4.5″. *Courtesy of Betty Lou and Frank Gay.*

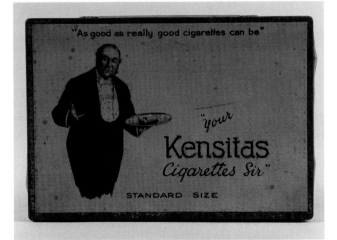

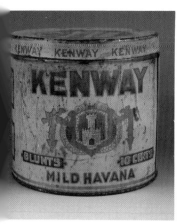 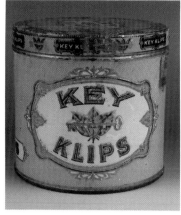

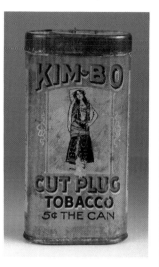 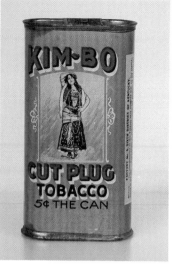

Kenway Blunts, Hilson-Reis Cigar Corporation (Factory No. 12, 12th Pennsylvania). Lithographed tin. 5" x 5.25". *Courtesy of C.J. Simpson.*
Key Klips Cigars (Factory No. 20, Georgia). Embossed lithographed tin. 5" x 5.25" x 5.25". *Courtesy of C.J. Simpson.*

Kim-Bo Cut Plug, Lovell and Buffington, Covington, Kentucky. Cardboard container with tin slide top by Kemiweld, Detroit. 4.25" x 2.25" x 1". *Courtesy of Betty Lou and Frank Gay.*
Kim-Bo Cut Plug Tobacco, Lovell & Buffington, Covington, Kentucky (Factory No. 5, 6th Kentucky), 1910 stamp. Cardboard pocket. 4.25" x 2.25" x 1". *Courtesy of Dennis O'Brien and George Goehring.*

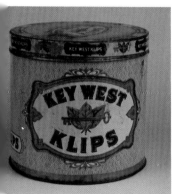

Key West Klips Cigars (Factory No. 20, Georgia). Embossed lithographed tin. 5" x 5.5". *Courtesy of C.J. Simpson.*

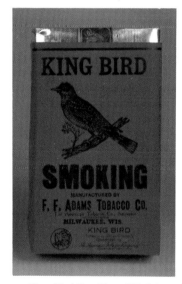 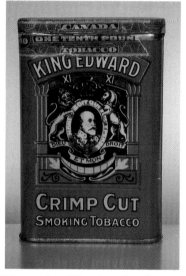

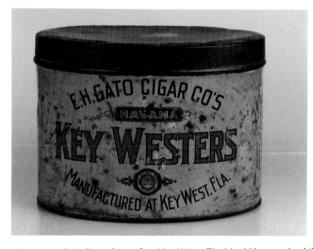

King Bird Smoking. F.F. Adams Tobacco Co., Milwaukee, American Tobacco Company, Successor. Paper. *Courtesy of Betty Lou and Frank Gay.*
King Edward Crimp Cut, Dominion Tobacco Co., Montreal. Lithographed tin pocket, scarce in this condition. 4.5" x 1" x 3". *Courtesy of Dennis O'Brien and George Goehring.*

Key Westers, E.H. Gato Cigar Co., Key West, Florida. Lithographed tin. 4.75" x 6.25". *Courtesy of Betty Lou and Frank Gay.*

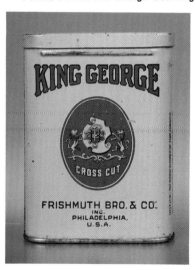

Khedive, Austria & Munich. Lithographed tin. .75" x 4.5" x 3". *Courtesy of C.J. Simpson.*

King George Cross Cut, Frismuth Bro. & Co, Inc., Philadelphia. Lithographed tin, Tindeco, Baltimore, Maryland. Mint and uncirculated. 4.25" x 3.25" x 1". *Courtesy of Dennis O'Brien and George Goehring.*

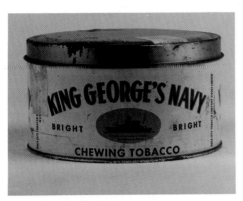
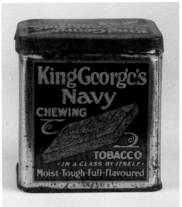
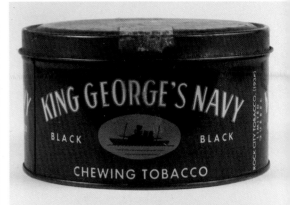

King George's Navy Chewing Tobacco, Rock City Tobacco Co., Ltd., Quebec. Lithographed tin. 3.25″ x 6″. *Courtesy of C.J. Simpson.*
King George's Navy Chewing Tobacco, Rock City Tobacco Co. Ltd., Quebec (Factory No. 6, Port 13D). Lithographed tin. 4.75″ x 4.75″ x 3″. *Courtesy of C.J. Simpson.*
King George's Navy Chewing Tobacco, Rock City Tobacco (1936) Limited, Quebec. 3.25″ x 6″. *Courtesy of C.J. Simpson.*

Kyriazi Frères, Cairo, Egypt. Lithographed tin. 2″ x 6″ x 4.5″. *Courtesy of C.J. Simpson.*

Kingsway Cigarette Tobacco, B. Houde Company, Quebec. Lithographed tin. 2.5″ x 4.25″. *Courtesy of C.J. Simpson.*
Kolb Roughs Cigars, John N. Kolb Tobacco Co. (Factory No. 1524, ?). Lithographed tin, Liberty Can Co., Lancaster, PA. This tin was covered with a paper label for another brand, pieces of which remain. 5″ x 3.75″ x 3.75″. *Courtesy of C.J. Simpson.*

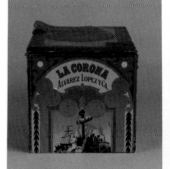

La Corona Cuban Cigars, Alvarez Lopez y Ca. (Factory No. 1, Customs District 11), 1930 tariff stamp. Grown in Cuba, blended in Havana, rolled and packed in the USA (Trenton, New Jersey). 3″ x 5.25″ x 3″. *Courtesy of C.J. Simpson.*

Kool Cigarettes (50). 4.5″ x 5.5″ x .5″. *Courtesy of Dennis O'Brien and George Goehring.*

Kuba Export Cigars (10), Czechoslovakia Tobacco Co. Lithographed tin. 0.5″ x 4.5″ x 6.25″. *Courtesy of C.J. Simpson.*

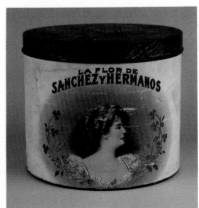

La Flor de Sanchez y Hermanos Cigars, Villazon & -?-, Tampa (Factory No. 102, Florida). Cardboard with tin top. 4.75″ x 5.5″. *Courtesy of C.J. Simpson.*

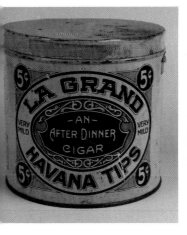
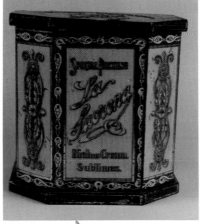

La Grand Havana Tips, "An After Dinner Cigar," J.F. Bolon, Bethseda, Ohio (Factory No. 114, 18th Ohio). Lithographed tin. 5" x 5.25". *Courtesy of C.J. Simpson.*

La Lucrena Cigars (Factory No. 1101, Pennsylvania). Embossed and lithographed octagon tin, American Can Co. 5.25" x 5.25" x 5.25". *Courtesy of C.J. Simpson.*

La Palina Cigar, Congress Cigar Co. (Factory No. 23). Lithographed tin. 1.5" x 5" x 3". *Courtesy of C.J. Simpson.*

La Resta Cigars, Rothenberg & Schloss Cigar Company (Factory No. 202, 1st Pennsylvania). Lithographed tin. 5.25" x 3" x 3". *Courtesy of C.J. Simpson.*

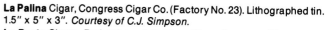
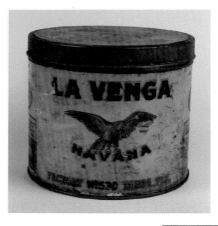

La Venga Havana Cigars (Factory No. 530, Tampa, Florida). Tin with paper label. 4.5" x 5.5". *Courtesy of C.J. Simpson.*

La Muna Cigars, Gans Brothers, New York (Factory No. 1389, 5th New Jersey). 2.5" x 8.75" x 4.75". *Courtesy of C.J. Simpson.*

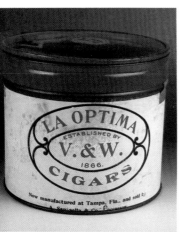

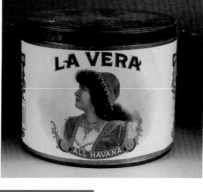

La Vera Cigars La Vera Cigar Co., Chicago (Factory No. 312, 1st Illinois). Tin with paper label. 5" x 6". *Courtesy of C.J. Simpson.*

Lady Churchill (Factory No. 119, South Carolina). Lithographed tin. *Courtesy of Elsie and John Booker.*

La Optima Cigars, A. Santaella & Co., Tampa (Factory No. 4, Florida). Tin with paper label and glass top. Lithography by Consolidated Lithographic Corp, Brooklyn New York. 5" x 5.5". *Courtesy of C.J. Simpson.*

La Palina Senators Cigars. Brass humidor with cedar liner. 6" x 4.5". *Courtesy of C.J. Simpson.*

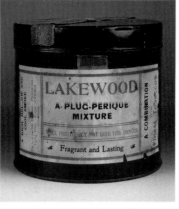

Lafayette Mixture, Marburg Bros., Baltimore, American Tobacco Co., Successor (Factory No. 2, Maryland). Lithographed tin, 2.25" x 4.75" x 3".
Lakewood, Falk Tobacco Co., Richmond, Virginia (Factory No. 1, 2nd Virginia), 1910 stamp. Tin with paper label, 4.75" x 5". *Courtesy of C.J. Simpson.*

Lewis Medium Navy Cut Cigarettes (100). A. Lewis & Co., London. Lithographed tin. *Courtesy of C.J. Simpson.*

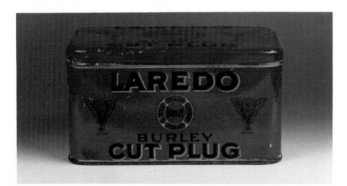

Laredo Burley Cut Plug, Scotten Dillon, Detroit, 1910 Stamp. Lithographed tin. 3.25" x 6" x 3.75". *Courtesy of Betty Lou and Frank Gay.*

Lewis Medium Navy Cut, A. Lewis & Co. Ltd., London. Lithographed tin. 1.75" x 6" x 4". *Courtesy of C.J. Simpson.*

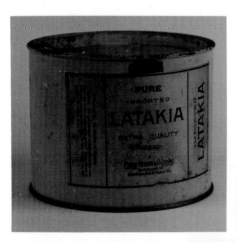

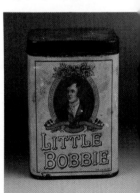

Latakia, Philip Morris, New York, London (Factory 15, Virginia). Tin with paper label. 4.5" x 5.5". *Courtesy of C.J. Simpson.*
Lester Square Aromatic Pipe Mixture (Factory No. 3, 1st Missouri), 1926 stamp. Tin with paper label. 4" x 3". *Courtesy of C.J. Simpson.*
Lester Square, Windsor Tobacco Co., New York (Factory No. 3, 1st Missouri), 1926 stamp. Tin with paper label. 4" x 4". *Courtesy of C.J. Simpson.*

Life Pipe Tobacco pocket. Ryan-Hampton Tobacco Co., Louisville, Kentucky. 4.5" x 3" x 1". *Courtesy of Dennis O'Brien and George Goehring.*
Little Bobbie Cigars, smaller version of Robert Burns Cigar (Factory No. 252, 12th Pennsylvania). Tin with paper label. *Courtesy of C.J. Simpson.*

Little Cuestas Cigars, Cuesta-Ray, Tampa (Factory No. 55, Florida), series 125 stamp. Tin with paper label. 4.75" x 5.5". *Courtesy of C.J. Simpson.*

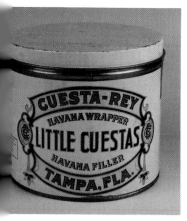
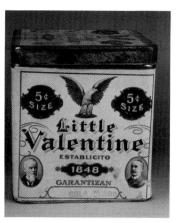

Little Cuestas Cigars Cuesta-Rey & Co., Tampa, Florida (Factory No. 55, Florida). Tin with paper label. 4.75" x 5.5". *Courtesy of C.J. Simpson.*
Little Valentine Cigars, A.S. Valentine & Son (Factory No. 1272, 1st Pennsylvania). Tin with paper labels. 4.75" x 4.25" x 4.25". *Courtesy of C.J. Simpson.*

Long Horn Tobacco, R.J. Reynolds, Winston, North Carolina, c. 1890. Wood caddy with paper label featuring a portrait of R.J. Reynolds. 13.5" x 13.5". *Courtesy of Thomas Gray.*

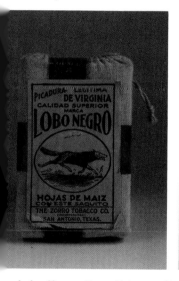
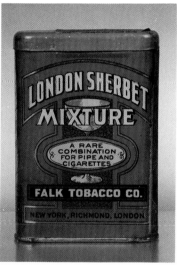
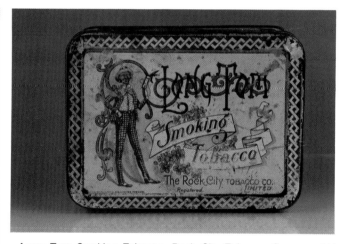

Long Tom Smoking Tobacco, Rock City Tobacco Company Ltd., Canada. Lithographed tin, Toronto. 3.75" x 5" x 2". *Courtesy of Betty Lou and Frank Gay.*

Lobo Negro, Zorro Tobacco Co., San Antonio, Texas. Cloth bag. *Courtesy of Betty Lou and Frank Gay.*
London Sherbet Mixture, Falk Tobacco Co., New York, 1910 stamp. Lithographed tin, rare in this condition because of thin paint. 4.25" x 3" x 1". *Courtesy of Dennis O'Brien and George Goehring.*

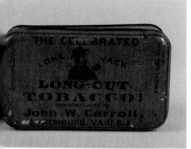

Lone Jack Long-cut Tobacco, John W. Carroll, Lynchburg, Virginia (Factory No. 1, 6th Virginia). Lithographed tin, Ilsley. 1.25" x 5" x 2.5". *Courtesy of C.J. Simpson.*

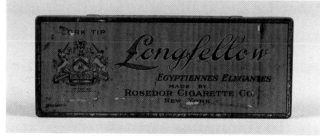

Longfellow Egyptiennes Elegantes, Rosedor Cigarette Co., New York. Lithographed tin. 0.25" x 6" x 2.25". *Courtesy of C.J. Simpson.*

Long Horn advertisement. Paper. 10" x 10". *Courtesy of Thomas Gray.*

Longfellow Egyptiennes Elegantes, Rosedor Cigarette Co., New York. 0.75" x 5.75" x 2". *Courtesy of C.J. Simpson.*

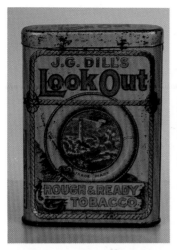

Lord Clive (Factory No. 3, Missouri), 1926 stamp, c. 1939. 2" x 4"

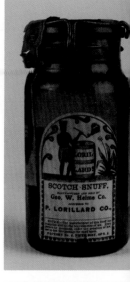

Lorillard's Scotch Snuff, Geo. W. Helme co., successor to P. Lorillard Co. (Factory No. 4, 5th New Jersey), 1910 stamp. Glass. 7" x 3". Courtesy of C.J. Simpson.

Look Out Rough and Ready Tobacco, an early and scarce pocket, c. 1900. J.G. Dill, Richmond, Virginia. 4" x 3" x 1". Courtesy of Dennis O'Brien and George Goehring.

Lookout/Réunion Cigarettes (100). Lithographed tin. 1.75" x 5.5" 5". Courtesy x 2.7of C.J. Simpson.

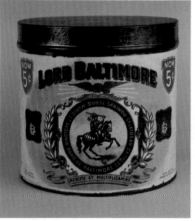

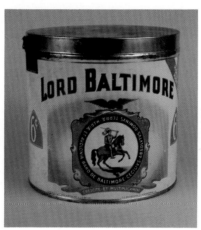

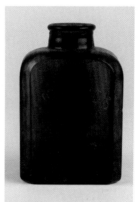

Lorillard's Snuff. Embossed glass. 4.5" x 3". Courtesy of C.J. Simpson.

Lorillard snuff. Glass. 6.5" x 4" x 3". Courtesy of C.J. Simpson.

Lord Baltimore, (Factory No. 728, 1st Pennsylvania). Tin with paper label. 5.25" x 5.5". Courtesy of C.J. Simpson.

Lord Baltimore Cigars, F.X. Smith's Sons Co., McSherrystown, Pennsylvania (Factory No. 331, 1st Pennsylvania). Tin with paper label. 5.25" x 5.5". Courtesy of C.J. Simpson.

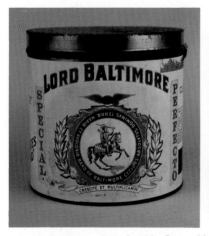

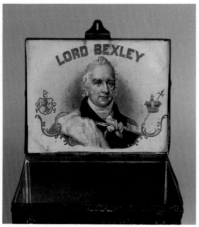

Louis K Cigars, (Factory No. 690, 1st Pennsylvania) Lithographed tin, Liberty Can Co., Lancaster, Pennsylvania. 5" x 5.5". Courtesy of C.J. Simpson.

Lord Baltimore, F.X. Smith's Sons, McSherrystown, Pennsylvania (Factory No. 331, 1st, Pennsylvania). Tin with embossed paper label. 5.25" x 5.5". Courtesy of C.J. Simpson.

Lord Bexley Cigar, Deutsch Bros., New York (Factory No. 92, 3rd New York). Lithographed tin caddy. 2.75" x 6.75" x 5". Courtesy of C.J. Simpson.

Closed Lord Bexley tin.

Louisiana Perique, Allen & Ginter, Richmond (Factory No. 24, 2nd Virginia). Lithographed tin. 1.25″ x 4″ x 2.5″. *Courtesy of C.J. Simpson.*

Louisiana Perique, Falk Tobacco. Cardboard pocket. *Courtesy of C.J. Simpson.*

Lovell's Extra Pressed Twist, Lovell-Buffington, Covington, Kentucky (Factory No. 5, 16th Kentucky. Lithographed tin. 3″ x 6.5″ x 4″. *Courtesy of C.J. Simpson.*

Lovera Cigars, Jose Lovera Co. (Factory 690, 1st Pennsylvania), 1926 stamp. Lithographed tin. 5.5″ x 5″. *Courtesy of C.J. Simpson.*

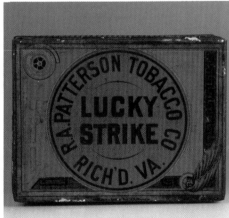

Loving Cup Tobacco, John D. Moore Tobacco Company, Lexington, Kentucky (Factory No. 1, 7th Kentucky), c. 1900-1905. Lithographed tin, Heekin Can Co. 4.5″ x 3″ x 1″. *Courtesy of Dennis O'Brien and George Goehring.*

Lucky Strike, R.A. Patterson Tobacco Co., Richmond. Lithographed tin. 1.25″ x 4.5″ x 3.25″. *Courtesy of Betty Lou and Frank Gay.*

Lucky Strike, R.A. Patterson Tobacco Co. Lithographed tin, American Can Co. 2″ x 4.5″ x 3″. *Courtesy of C.J. Simpson.*

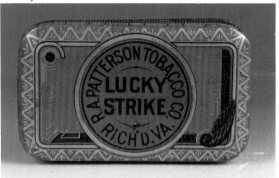

Lucky Strike, R.A. Patterson Tobacco Co., Richmond. Lithographed tin, American Can Co. .75″ x 4.50″ x 2.75″. *Courtesy of Betty Lou and Frank Gay.*

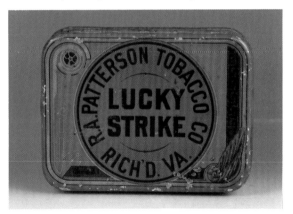

Lucky Strike, R.A. Patterson Tobacco Co., Richmond. Lithographed tin. 1.25″ x 4.25″ x 3.25″. *Courtesy of Betty Lou and Frank Gay.*

Lucky Strike, R.A. Patterson Tobacco Co., Richmond, American Tobacco Co., Successor, Richmond (Factory No. 42. 2nd Virginia). Lithographed tin, American Can Company. 3.75″ x 4.25″ x 3.25″. *Courtesy of Betty Lou and Frank Gay.*

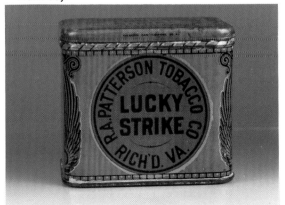

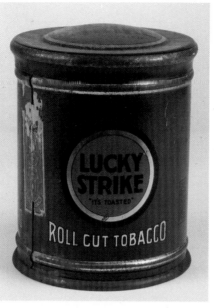
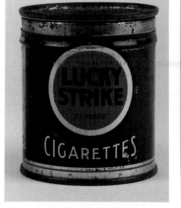
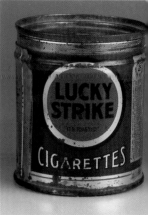

Lucky Strike Cigarettes (Factory 30, North Carolina). Lithographed tin. 3.25" x 2.5". *Courtesy of C.J. Simpson.*
Lucky Strike Cigarettes (50), American Tobacco Company, Richmond. Lithographed tin. 3.25" x 2.75". *Courtesy of Betty Lou and Frank Gay.*

Lucky Strike, R.A. Patterson Tobacco Co., American Tobacco Co., Richmond. Lithographed tin canister. 5.5" x 4.25". *Courtesy of C.J. Simpson.*
Lucky Strike, American Tobacco Co. (Factory No. 127, Kentucky). Lithographed tin. 6" x 5". *Courtesy of C.J. Simpson.*

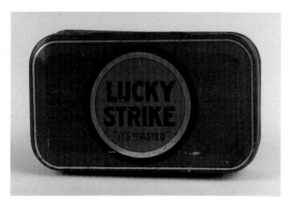

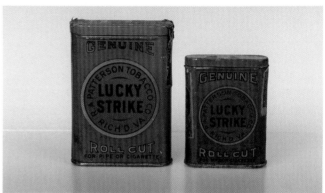

Lucky Strike Roll Cut pocket and sample, R.A. Patterson Tobacco Co., American Tobacco Co., Richmond (Factory No. 42, 2nd Virginia). Lithographed tin. 4.25" x 3", 3.25" x 2.5". *Courtesy of Dennis O'Brien and George Goehring.*

Lucky Strike, American Tobacco Co., Richmond. Lithographed tin. 1" x 4.5" x 2.5". *Courtesy of C.J. Simpson.*

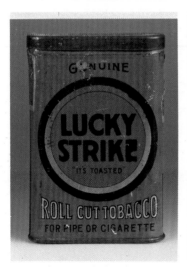
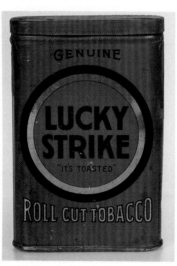

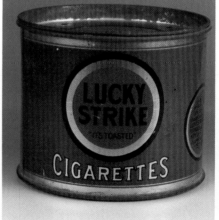

Lucky Strike. Lithographed tin. 4.25" x 2.75" x .75". *Courtesy of Betty Lou and Frank Gay.*
Lucky Strike pocket. American Tobacco Company, 1920s. 4.5" x 3" x 1". *Courtesy of Dennis O'Brien and George Goehring.*

Lucky Strike Cigarettes (100), American Tobacco Company. The bottom spells out a "tax free" promotion. Lithographed tin. 3.25" x 4.0". *Courtesy of Betty Lou and Frank Gay.*

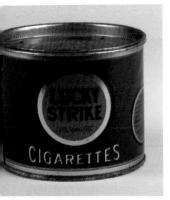 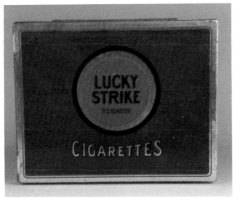

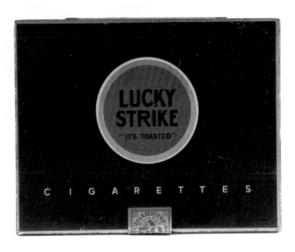

Lucky Strike, American Tobacco Co. (Factory No. 30, North Carolina). Lithographed tin. 3.25″ x 3.5″. *Courtesy of C.J. Simpson.*
Lucky Strike Cigarettes (50). 0.5″ x 4.25″ x 5.5″. *Courtesy of C.J. Simpson.*

Lucky Strike Cigarettes, American Tobacco Co. Lithographed tin. 0.75″ x 5.5″ x 4.25″. *Courtesy of C.J. Simpson.*

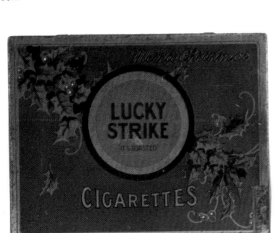

Lucky Strike Cigarettes, American Tobacco Co. Lithographed Christmas tin. 0.75″ x 5.5″ x 4.25″. *Courtesy of C.J. Simpson.*

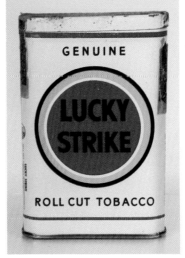 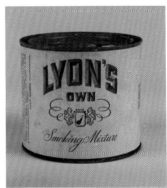

Lucky Strike pocket, the rare white variety produced for only a few months in the early 1940s. American Tobacco Company. 4.5″ x 3″ x 1″. *Courtesy of Dennis O'Brien and George Goehring.*
Lyon's Own Smoking Mixture, Philip Morris. Tin with paper label. 3.75″ x 4″. *Courtesy of C.J. Simpson.*

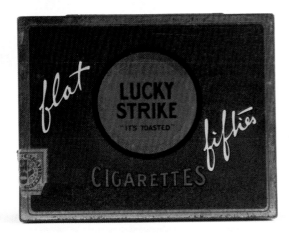

Lucky Strike Cigarettes "Flat Fifties", American Tobacco Company. Lithographed tin. 0.75″ x 5.5″ x 4.25″. *Courtesy of C.J. Simpson.*

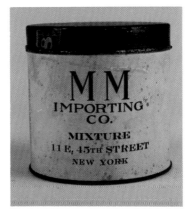 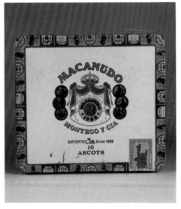

M M Importing Co. Mixture, New York (Factory No. 1, 2nd Virginia). Tin with paper label. 4.25″ x 4″. *Courtesy of C.J. Simpson.*
Macanudo Ascot Cigars (10), Montego Y Cia, imported from the Domican Republic. Lithographed tin. 0.5″ x 5.25″ x 4.25″. *Courtesy of C.J. Simpson.*

81

MacDonald's **Blends** Cigarettes, Canada. Lithographed tin. 1.25″ x 5.5″ x 3.25″. *Courtesy of C.J. Simpson.*

MacDonald's **'Export' Cigarette Tobacco**, W.C. MacDonald Inc., Montreal. Lithographed tin. 4.25″ x 4.25″. *Courtesy of C.J. Simpson.*
MacDonald's **Fine Cut** Smoking Tobacco, W.C. MacDonald Inc., Montreal. Lithographed tin. 4″ x 4″. *Courtesy of C.J. Simpson.*

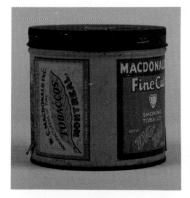 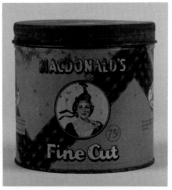

MacDonald's **Fine Cut** Smoking Tobacco with Zig Zag cigarette papers, W.C. MacDonald Inc., Montreal. Lithographed tin. 4.25″ x 4.25″. *Courtesy of C.J. Simpson.*
MacDonald's **Fine Cut**, W.C. MacDonald Inc., Montreal. Lithographed tin. 4.25″ x 4″. *Courtesy of C.J. Simpson.*

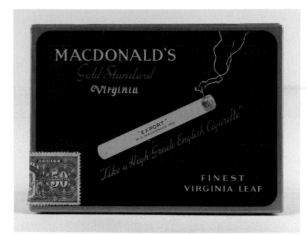

MacDonald's **Gold Standard** Cigarettes, W.C. MacDonald Inc. Lithographed tin. .75″ x 6″ x 4.5″. *Courtesy of C.J. Simpson.*

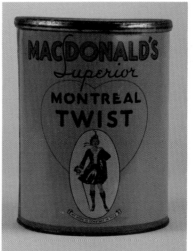

MacDonald's **Montreal Twist**, W.C. MacDonald. Lithographed tin. 6.5″ x 4.75″. *Courtesy of C.J. Simpson.*
MacDonald's **Navy Cut** with Zig Zag cigarette papers, W.C. MacDonald Inc., Montreal. Lithographed tin. 3.25″ x 4.25″ *Courtesy of C.J. Simpson.*

Madeira Sliced Plug, W.J. Yarbrough & Sons, Richmond (Factory No. 31, 2nd Virginia). Lithographed tin, Hasker & Marcuse. 1″ x 4.5″ x 2.5″. *Courtesy of C.J. Simpson.*

Mahnola Egyptian Cigarettes, Godfrey S. Mahn, Philadelphia & New York, 1910 stamp. Tin with paper label. 1.5″ x 5.5″ x 2.75″. *Courtesy of C.J. Simpson.*

Mail Pouch, Bloch Brothers, West Virginia. Lithographed tin store bin. 13″ x 16″ x 11.5″. *Courtesy of C.J. Simpson.*

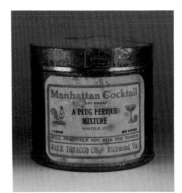
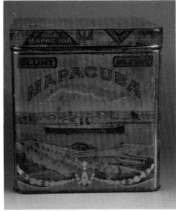

Manhattan Cocktail Plug Perique Mixture, Falk Tobacco Co., Richmond, Virginia, 1902 stamp. Tin with paper label. 4″ x 4.5″. *Courtesy of C.J. Simpson.*

Mapacuba Cigars (50) (Blunt), Mapacuba Cigar Co. (Factory No. 630, 1st Pennsylvania). Embossed lithographed tin, 5″ x 5″ x 5″. *Courtesy of C.J. Simpson.*

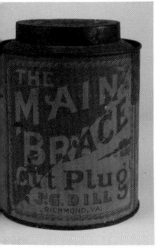
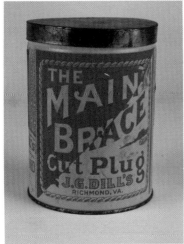

Main Brace, J.G. Dill, Richmond (Factory No. 25, 2nd Virginia). Lithographed tin. 5.75″ x 4.25″. *Courtesy of C.J. Simpson.*

Main Brace, J.G. Dill, Richmond (Factory No. 25, 2nd Virginia). Lithographed tin. 6.5″ x 4.75″. *Courtesy of C.J. Simpson.*

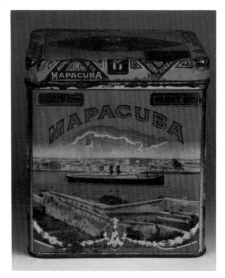

Mapacuba Cigars (Blunt Ten-cent), Bayuk Bros., Mfgrs., New Jersey. Lithographed tin. 5″ x 5″ x 5″. *Courtesy of Betty Lou and Frank Gay.*

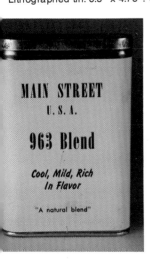
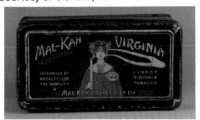

Mal-Kah Virginia Cigarettes (100), Mal-Kah Cigarette Co., Ltd., London. Lithographed tin. 2″ x 5.75″ x 3″. *Courtesy of C.J. Simpson.*

Main Street U.S.A. 963 Blend, Rainey-Young, Galesburg, Illinois. Tin with paper label. *Courtesy of Elsie and John Booker.*

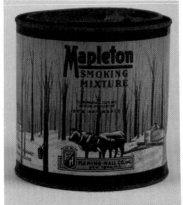
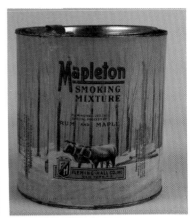

Mapleton Smoking Mixture, Fleming-Hall Co., Inc., New York (Factory No. 25, Virginia), 1926 stamp. Tin with paper label. 4.5″ x 4″. *Courtesy of C.J. Simpson.*

Mapleton Smoking Mixture, Fleming-Hall Co., New York (Factory No. 49, Kentucky), 1926 stamp. Tin with paper label. 5.5″ x 5″. *Courtesy of C.J. Simpson.*

Manco Sliced Plug. Lithographed tin. 2.75″ x 3.25″ x .75″. *Courtesy of Betty Lou and Frank Gay.*

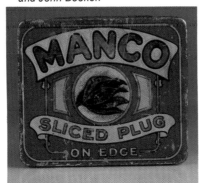

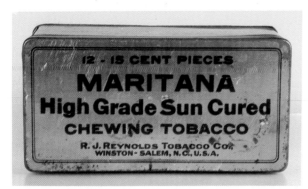

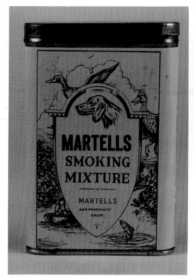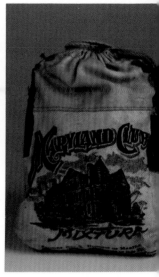

Maritana High Grade Sun Cured, R.J. Reynolds. The Maritana name originated with the W.T. Hancock Tobacco Company of Richmond, which was purchased by Reynolds in 1902. Earlier lithographed tin. .75" x 3.5". *Courtesy of Thomas Gray.*

Martells Smoking Mixture, Martells, San Francisco (Factory No 93, 1st Missouri). Tin with paper label. 4.5" x 3". *Courtesy of C.J. Simpson.*
Maryland Club Mixture (Factory No. 2, Maryland). Cloth bag. *Courtesy of Betty Lou and Frank Gay.*

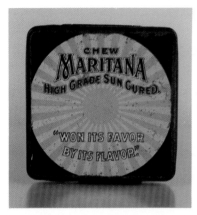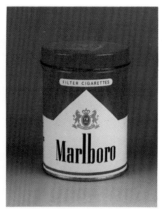

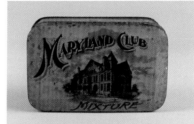

Maritana High Grade Sun Cured Chewing Tobacco, R.J. Reynolds, Winston-Salem, North Carolina, common. Lithographed tin. 2.5" x 6.75". *Courtesy of Thomas Gray.*
Marlboro Cigarettes (50), Philip Morris Co., Richmond. Lithographed tin. 3.75" x 3". *Courtesy of C.J. Simpson.*

Maryland Club Mixture, American Tobacco Co. (Factory No. 2, Maryland). Lithographed tin. 2" x 4.25" x 2.25". *Courtesy of C.J. Simpson.*

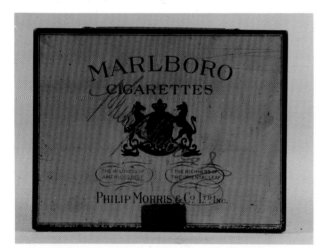

Maryland Club Original Mixture, American Tobacco Co., (Factory No. 2, Maryland). Lithographed tin, Ginna. 2" x 4" x 2". *Courtesy of C.J. Simpson.*

Marlboro Cigarettes, Philip Morris & Co., Ltd. Lithographed tin. 1.25" x 5.75" x 4.5" *Courtesy of C.J. Simpson.*

Maryland Club Mixture, Marburg Brothers. Left: An earlier flip top pocket, 4" x 3.5" x 1.5"; right: a flat top pocket, 4.25" x 3.25" x 1". Lithographed tin. The Maryland Club still stands in Baltimore. *Courtesy of Dennis O'Brien and George Goehring.*

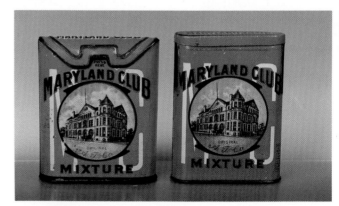

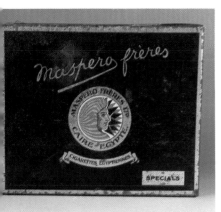

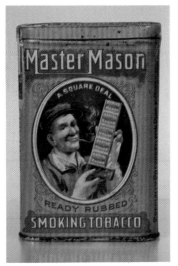

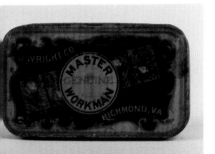

Maspera Frères Egyptian Cigarettes (100), Maspero Frères Ltd, **Cairo, Egypt.** Lithographed tin. **1.5″ x 6″ x 4.5″.** *Courtesy of C.J. Simpson.*

Master Mason, Rock City Tobacco Co., Granby, Canada. Lithographed tin pocket, unopened and full. Marked A.C.C. (American Can Company) 31A (Joppa, Maryland). 4.5″ x 3″ x 1″. *Courtesy of Dennis O'Brien and George Goehring.*

Master Workman, J. Wright Co., Richmond (Factory No. 31, 2nd Virginia). Lithographed tin, Hasker & Marcuse. 1″ x 4.5″ x 2.5″. *Courtesy of C.J. Simpson.*

Mayfield, Crox & Kittle, Rock City. Lithographed tin. 2.75″ x 5″. *Courtesy of C.J. Simpson.*

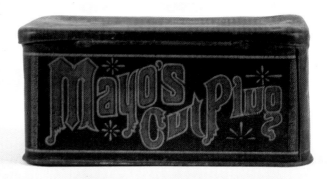

Mayo's Cut Plug, P.H. Mayo & Bro., Richmond (Factory No. 42, 2nd Virginia). Lithographed tin. 2″ x 6″ x 4″. *Courtesy of C.J. Simpson.*

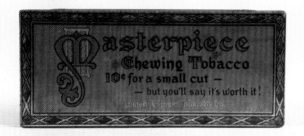

Masterpiece Chewing Tobacco, Liggett & Myers Tobacco Co. (Factory No. 74, 1st Missouri). Lithographed tin, American Can Co. 1″ x 7.5″ x 3″. *Courtesy of C.J. Simpson.*

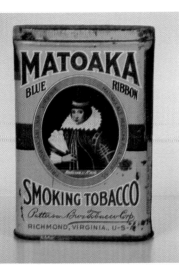

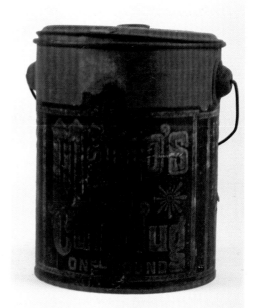

Matador Granulated Mixture, August Beck & Co., Chicago. Lithographed tin, Illinois Can Company, Chicago. 1.75″ x 4.5″ x 2.75″. *Courtesy of C.J. Simpson.*

Mayo's Cut Plug (Factory No. 42, 2nd Virginia). Tin with paper half label. 6″ x 5″. *Courtesy of C.J. Simpson.*

Matoaka Blue Ribbon Smoking Tobacco, Patterson Bros. Tobacco Corp., Richmond, Virginia, 1910 stamp. Lithographed tin. 4.5″ x 3″ x 1″. *Courtesy of Dennis O'Brien and George Goehring.*

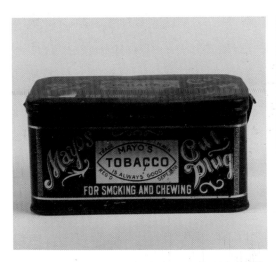
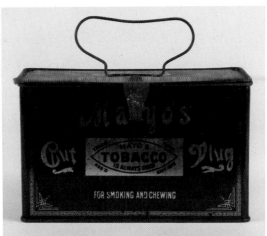
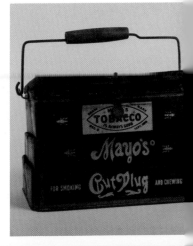

Mayo's Cut Plug, P.H. Mayo & Bro., Richmond (Factory No. 1, Virginia). Lithographed tin. 2" x 6" x 4". *Courtesy of C.J. Simpson.*
Mayo's Cut Plug, P.H. Mayo & Bro., Richmond (Factory No. 1, Virginia). Lithographed tin lunch box, Tindeco. 4.75" x 8" x 4". *Courtesy of C.J. Simpson.*
Mayo's Cut Plug. Lithographed tin expanding lunch box. 5" x 8" (open) x 5". *Courtesy of C.J. Simpson.*

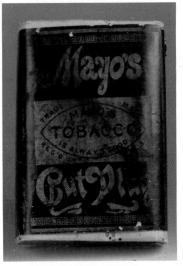
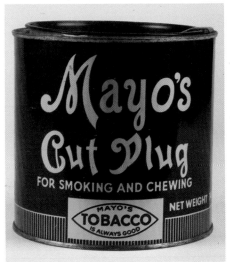
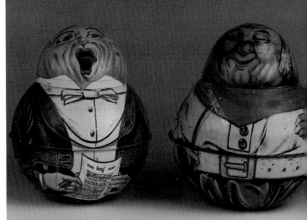

Roly Polys. On the left is a reproduction of Mayo's Singing Water Roly Poly, manufactured in 1979. On the right is an original Dutchman. In comparing them side by side you will find that the reproduction is generally smaller than the original. If you are looking at an individual piece take a measuring tape. The old neck measures 3.875" in diameter, while the new neck measures 3.5". At the belly the old is larger than 6.25", while the new is less than 6". *Courtesy of Betty Lou and Frank Gay.*

Mayo's Cut Plug. Paper. *Courtesy of Betty Lou and Frank Gay.*
Mayo's Cut Plug canister. Lithographed tin. *Courtesy of C.J. Simpson.*

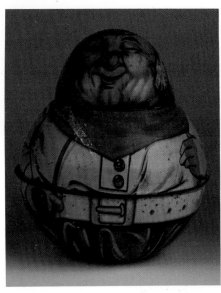
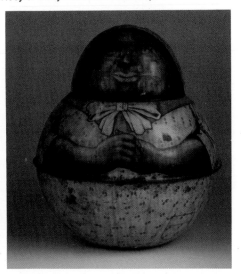

Mayo's Sliced Plug, Mayo (Factory 42, 2nd Virginia). Lithographed tin, Ginna. 1" x 4.5" x 2.5". *Courtesy of C.J. Simpson.*

Mayo's Dutchman Roly Poly tobacco container, American Tobacco Co., 1912-1915. Lithographed tin, Tindeco. *Courtesy of Betty Lou and Frank Gay.*

Mayo's Mammy Roly Poly tobacco container, American Tobacco Co., 1912-1915. Lithographed tin, Tindeco. (for another example see Dixie Queen) *Courtesy of Betty Lou and Frank Gay.*

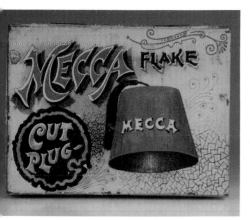

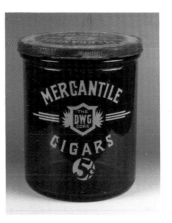

Mercantile Cigars, 5 cents, The SWG Corp. (Factory No. 77, 10th Ohio). Glass jar with lithographed tin lid. 5.5" x 5.25". *Courtesy of C.J. Simpson.*

Mecca Flake Cut Plug, Daniel Scotten & Son, Detroit. Lithographed tin. 3.25" x 4.5" x 1.5". *Courtesy of Betty Lou and Frank Gay.*
Mechanic's Delight, P. Lorillard, tobacco plug with tin tag. Plug: 3" x 3". *Courtesy of Betty Lou and Frank Gay.*

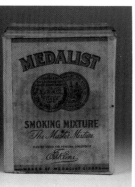
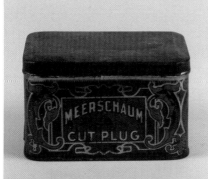

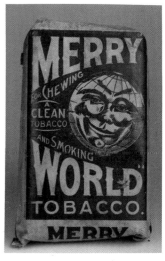

Mercedes Rein Orient (50), Batschari. Lithographed tin. .75" x 5.75" x 4.25". *Courtesy of C.J. Simpson.*

"Merry World" Tobacco, Bloch Bros. Tobacco Co., Wheeling, W. Virginia. Paper. *Courtesy of Betty Lou and Frank Gay.*

Medalist Smoking Mixture, F.A. Kline & Co. (Factory No. 1, Virginia), Series 114, 1926 stamp. Cardboard with paper label. 4.25" x 3.25" x 3.25". *Courtesy of C.J. Simpson.*
Meerschaum, Imperial Tobacco Co., Montreal. Lithographed tin. 3" x 5" x 3.5". *Courtesy of C.J. Simpson.*

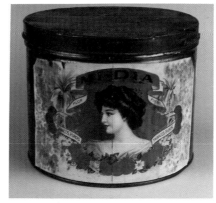

MI-Dia Cigars (100) (Factory No. C40, 2nd New York). Tin with lithographed, embossed half-label on tin. *Courtesy of C.J. Simpson.*

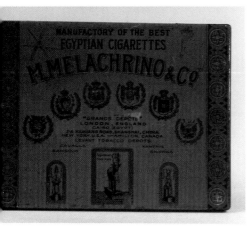

M. Melachrino & Co. Egyptian Cigarettes, London. Lithographed tin. 0.75" x 5.5" x 4.25". *Courtesy of C.J. Simpson.*

Melachrino Cigarettes (100), M. Melachrino & Co., New York. Two assortment packages, lithographed tin. 1" x 9.75" x 2.75". *Courtesy of C.J. Simpson.*

Mi-Dia Cigars (100), James B. Hall, Edwin Cigar Company, New York (Factory No. 327, 2nd New York). Tin with full lithographed embossed paper label on tin and lid. 5.75" x 7.5". *Courtesy of C.J. Simpson.*

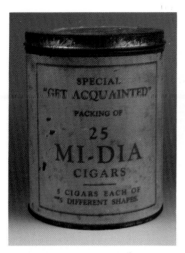

Middleton Mixing Humidor, John Middleton, Inc., Philadelphia. Lithographed tin. 2.5" x 4.25" x 4.25". *Courtesy of C.J. Simpson.*

Middleton 5, John Middleton, Philadelphia. Lithographed tin. 2.25" x 2" x 2". *Courtesy of C.J. Simpson.*

Mi-Dia Special "Get Acquainted" Packing of 25 cigars, James B. Hall (Factory No. 327, 2nd New York). Tin with paper label and colorful paper litho on lid. 5.5" x 4.25". *Courtesy of C.J. Simpson.*

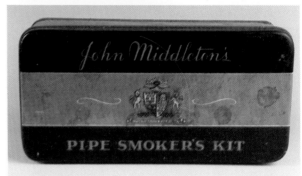

Middleton's Pipe Smoker's Kit, John Middleton, Philadelphia. Lithographed tin. 2.5" x 8.25" x 4". *Courtesy of C.J. Simpson.*

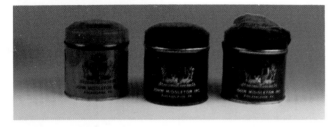

Middleton's tobacco in small containers, John Middleton, Inc., Philadelphia. Lithographed tin. 2.25" x 2.5". *Courtesy of C.J. Simpson.*

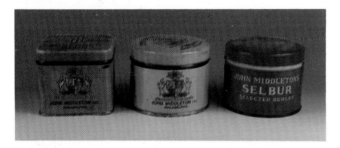

Middleton's tobacco in small containers, John Middleton, Inc., Philadelphia. Lithographed tin. 2" x 3". *Courtesy of C.J. Simpson.*

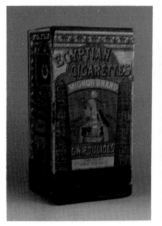

Mignon Brand Egyptian Cigarettes, C.N. Poulides (Factory No. 355, New York), March 2, 1901 stamp. Tin with paper label. 5.5" x 3" x 2". *Courtesy of C.J. Simpson.*
Mild Blunts, Three for Twenty (Factory No. 134, 1st Pennsylvania). Tin with paper label. 5.5" x 5". *Courtesy of C.J. Simpson.*

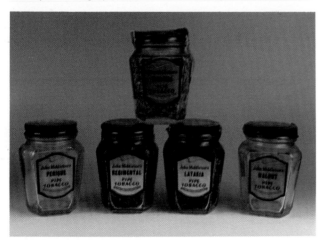

Middleton Tobacco in jars, John Middleton, Philadelphia, 1926 stamp. Glass with paper labels. 3.5" x 2.75" x 1.75". *Courtesy of C.J. Simpson.*

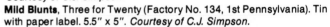

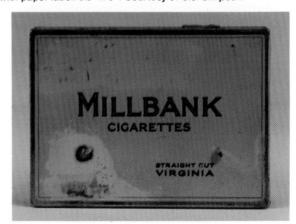

Millbank Cigarettes. Lithographed tin. .75" x 6" x 4.5". *Courtesy of C.J. Simpson.*

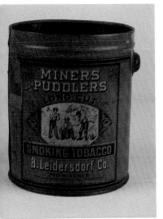

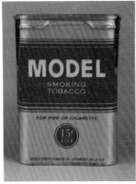

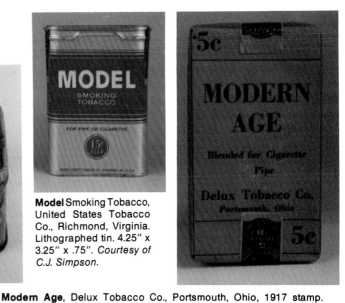

Model Smoking Tobacco, United States Tobacco Co., Richmond, Virginia. Lithographed tin. 4.25″ x 3.25″ x .75″. *Courtesy of C.J. Simpson.*

Miners and Puddlers Long Cut Smoking Tobacco, B. Leidersdorf Co., Milwaukee, American Tobacco Company, Successor. Factory No. 27, Kentucky). Lithographed tin pail. 6.5″ x 5.5″. *Courtesy of C.J. Simpson.*

Mixit Smoking Tobacco, Falk Tobacco Co., New York & Richmond (Factory No. 1, 2nd Virginia). Lithographed tin with paper label on front, contained three types of tobacco that the smoker could mix to taste. 2″ x 4.5″ x 3″. *Courtesy of C.J. Simpson.*

Modern Age, Delux Tobacco Co., Portsmouth, Ohio, 1917 stamp. Paper. *Courtesy of Betty Lou and Frank Gay.*

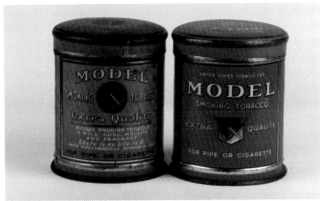

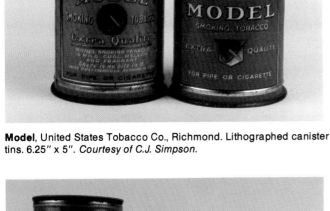

Model, United States Tobacco Co., Richmond. Lithographed canister tins. 6.25″ x 5″. *Courtesy of C.J. Simpson.*

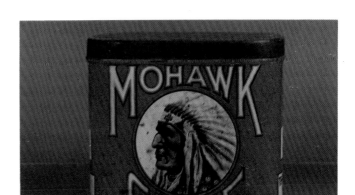

Mohawk Chief Cigar, The Charles Co., York, Pennsylvania. Lithographed tin. 5.5″ x 6″ x 4.25″. *Courtesy of Betty Lou and Frank Gay.*

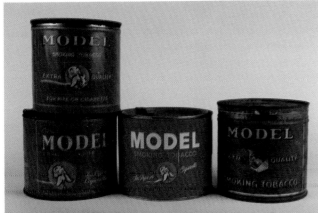

Model Smoking Tobacco, United States Tobacco Co., Richmond (Factory No. 25, 2nd Virginia). Lithographed tin. Top: 5.25″ x 5″; bottom, l-r: "Extra Quality", 4.5″ x 5″; no "Extra Quality," 4.5″ x 5.5″; shield, 5″ x 5″. *Courtesy of C.J. Simpson.*

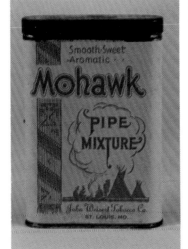

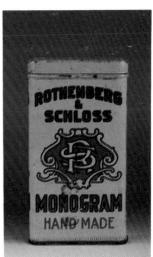

Mohawk Pipe Mixture, John Weisert, St. Louis (Factory No. 93, 1st Missouri). Tin with paper label. 4.5″ x 3″. *Courtesy of C.J. Simpson.*

Monogram Cigars, Rothenberg & Schloss (Factory 1542, 9th Pennsylvania). Lithographed tin. *Courtesy of C.J. Simpson.*

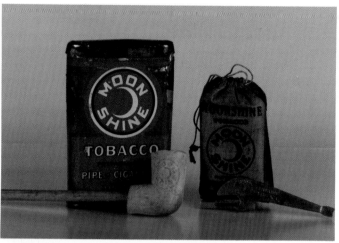

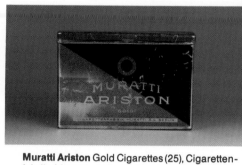

Muratti Ariston Gold Cigarettes (25), Cigarettenfabrik Muratti, A.G., Berlin. Lithographed tin. 2.75" x 0.5" x 4.25". *Courtesy of C.J. Simpson.*

Monte Cristo Filmy Cut Superior Quality Tobacco, Wm. Kimball, Rochester, New York. Lithographed tin, Somers Brothers, Brooklyn, New York. 8.75" x 2" x 1.25". *Courtesy of Betty Lou and Frank Gay.*
Moonshine products, Bailey Brothers. Upright pocket, lithographed tin, 4.5" x 3". Clay pipe, bottle opener, cloth bag. *Courtesy of Thomas Gray.*

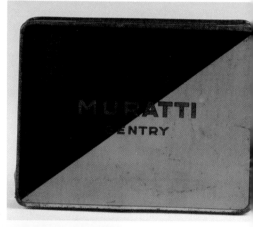

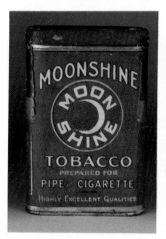

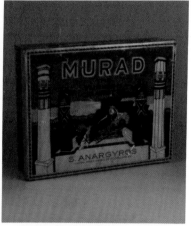

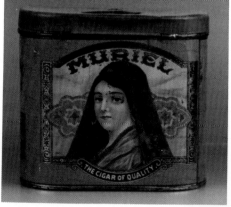

Muratti Gentry. Lithographed tin. .75" x 6" x 4.5". *Courtesy of C.J. Simpson.*

Moonshine Tobacco, Bailey Bros., Inc., Winston-Salem, North Carolina (Factory No. 100, 5th North Carolina). Lithographed tin. *Courtesy of Elsie and John Booker.*
Murad Turkish Cigarettes, S. Anargyros, P. Lorillard, capital stock owner. Lithographed tin. 1.5" x 5.75" x 4". *Courtesy of C.J. Simpson.*

Muriel Cigars, Delaware. Lithographed tin. 5.25" x 5.75" x 4". *Courtesy of Betty Lou and Frank Gay.*

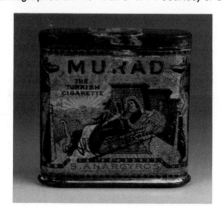

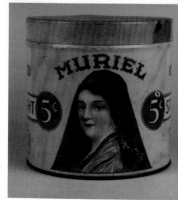

Muriel Senators, 5 cent Cigars. Lithographed tin. 5" x 5". *Courtesy of C.J. Simpson.*

Murad, S. Anargyros, owned by P. Lorillard. Lithographed tin. 3" x 2.75" x .75". *Courtesy of Betty Lou and Frank Gay.*

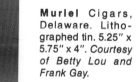

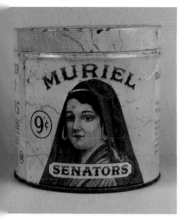
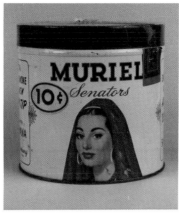
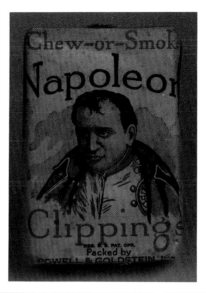

Napoleon Clipping, Powell & Goldstein, Inc., Oneida, New York. Paper. *Courtesy of Betty Lou and Frank Gay.*

Muriel Senators, 9 cent Cigars, P. Lorillard, Jersey City, New Jersey. Lithographed tin. 5″ x 5″. *Courtesy of C.J. Simpson.*
Muriel Senators, 10 cent Cigars, P. Lorillard, Jersey City, New Jersey. Lithographed tin. 5″ x 5″. *Courtesy of C.J. Simpson.*

Murray's Special No. 1 Cigarettes, Murray Sons & Co. Ltd. Whitehall Tobacco Works, Belfast. 3″ x 3″. *Courtesy of C.J. Simpson.*
My Mixture, a customized blend by Alfred Dunhill, New York (Factory No. T-17, 3rd New York). Tin with paper label. *Courtesy of C.J. Simpson.*

Nat. Wills Mixture. Tin with paper label. 1.25″ x 4.25″ x 3″. *Courtesy of C.J. Simpson.*
Native Granulated Mixture, S.P. Hess & Co., Rochester (Factory No. 3, 28th New York). Lithographed tin. 2″ x 4″ x 2.5″. *Courtesy of C.J. Simpson.*

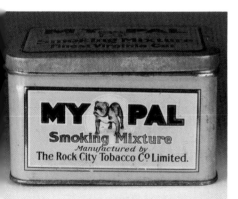

My Pal Smoking Mixture, Rock City Tobacco Co., Ltd., Canada. Lithographed tin. *Courtesy of Elsie and John Booker.*

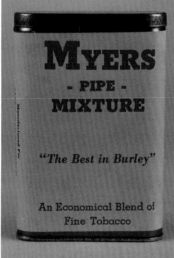
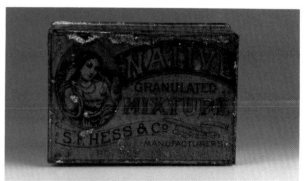

Native Granulated Mixture, S.F. Hess & Co., Rochester, New York. Lithographed tin, later version. 2.75″ x 4″ x 1.75″. *Courtesy of Betty Lou and Frank Gay.*

Myers Pipe Mixture, Myers Tobacco Shop (Factory No. 93, 1st Missouri). Tin with paper label. 4.5″ x 3″. *Courtesy of C.J. Simpson.*
N.C.C., Finks, Norma Cigar and Pipe Co., Boston. Tin with paper label. 1″ x 4.5″ x 3.25″. *Courtesy of C.J. Simpson.*

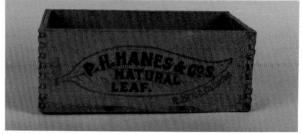

Natural Leaf, P.H. Hanes & Co., R.J. Reynolds, Successor, Winston-Salem. Wood caddy. 4.5″ x 10.75″. *Courtesy of Thomas Gray.*

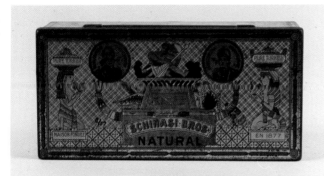

Natural Egyptian Cigarettes, Schinasi Brothers (Factory 2109, 3rd New York). Lithographed tin. 2" x 6" x 2.75". *Courtesy of C.J. Simpson.*

New Bachelor Cigars, Pennsylvania. Lithographed tin. 5" x 4.5" x 2.75". *Courtesy of Betty Lou and Frank Gay.*
New King Snuff, Weyman-Bruton Co., Nashville (Factory No. 33, Tennessee), 1928 stamp. Tin with paper label. 2.5" x 1.5". *Courtesy of C.J. Simpson.*

Natural Egyptian Cigarettes, Schinasi Bros., American Tobacco Co., Successor (Factory No. 30, North Carolina). 1.5" x 5.75" x 4". *Courtesy of C.J. Simpson.*
Navy Sweet Scotch Snuff, George. W. Helme Co. (Factory No. 4, 5th New Jersey). Tin with paper label. 2.5" x 1.5". *Courtesy of C.J. Simpson.*

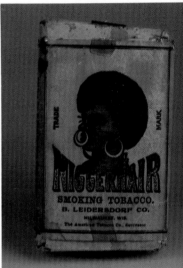

New York Club House cigars (25) (Factory No. 1292, 1st Pennsylvania). Lithographed tin. 5.5" x 4.5". *Courtesy of C.J. Simpson.*

Niggerhair Smoking Tobacco. B. Leidersdorf Co., Milwaukee, American Tobacco Company, Successor. Paper. *Courtesy of Betty Lou and Frank Gay.*

Niggerhair and Biggerhair tobacco containers. The name was changed in 1927 with changing sensibilities. Manufactured by B. Leidersdorf Co., Milwaukee, Wisconsin, American Tobacco Co., Successor. *Courtesy of Betty Lou and Frank Gay.*

Negrohead, Fribourg and Treyer, London. Lithographed tin. 1" x 4.5" x 3.25". *Courtesy of C.J. Simpson.*

Nestor Gianaclis Cigarettes, Grand Depot de Tabac Turcs, Nestor Gianaclis, Boston, Massachusetts. Tin with paper label. 5.5" x 2.25" x 3". *Courtesy of Betty Lou and Frank Gay.*

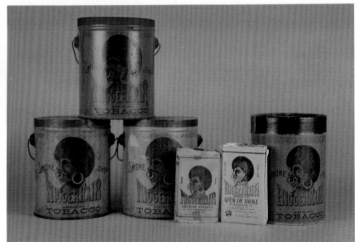

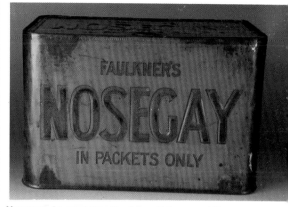

Nocico Plug Perique Mixture, Fink Cigar Co., Inc., Boston (Factory No. 4, 2nd Virginia). Tin with paper label. 1.25" x 4.5" x 3". *Courtesy of C.J. Simpson.*

North Carolina Bright Curly Cut, J.G. Dill, Richmond (Factory No. 25, 2nd Virginia). Lithographed tin. 2.25" x 4.5" x 3". *Courtesy of C.J. Simpson.*

Nosegay in packets, Faulkner Tobacco. Lithographed tin. *Courtesy of C.J. Simpson.*

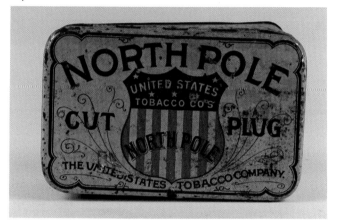
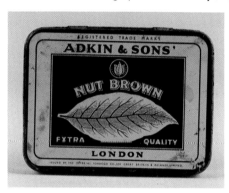

North Pole Cut Plug, United States Tobacco Company, Richmond (Factory No. 15, 2nd Virginia). Lithographed tin. 3.25" x 6" x 3.5". *Courtesy of C.J. Simpson.*

Nut Brown, Adkin & Sons, Imperial Tobacco Co. London. Lithographed tin. 1" x 4.5" x 3.25". *Courtesy of C.J. Simpson.*

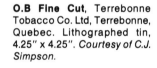

O.B Fine Cut, Terrebonne Tobacco Co. Ltd, Terrebonne, Quebec. Lithographed tin, 4.25" x 4.25". *Courtesy of C.J. Simpson.*

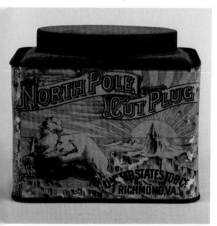
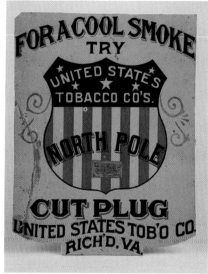

O.K. Smoking Tobacco, L. Larue. Lithographed tin. 1.75" x 3.5" x 5". Left American Tobacco Company of Canada, Ltd., Successors; right B. Houde Co., Limited. Successor.

North Pole Cut Plug, United States Tobacco Co., Richmond. Lithographed tin, Hasker & Marcuse. 5" x 6" x 4". *Courtesy of C.J. Simpson.*
North Pole sign with union sticker. Cardboard, 12.5" x 9.5". *Courtesy of Betty Lou and Frank Gay.*

O-U Cut Plug Smoking Tobacco, 1910 stamp. Glass with paper label. 7″ x 4.25″. *Courtesy of C.J. Simpson.*

O-NIC-O Smoking Tobacco, Denicotinized, Lincoln & Ulmer Inc., New York (Factory No. 12, 5th New Jersey). Lithographed tin. 3.25″ x 4″. *Courtesy of C.J. Simpson.*

Ogden's Cut Plug, Canada. Lithographed tin. 4.25″ x 4.25″. *Courtesy of C.J. Simpson.*

Ojibwa Bright Fine Cut Tobacco, Scotten, Dillon Company, Detroit (Factory No. 1, Michigan). Tin with paper label, 5.5″ x 3″. *Courtesy of C.J. Simpson.*

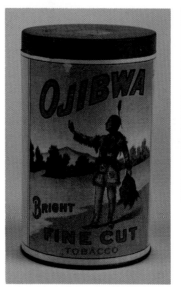

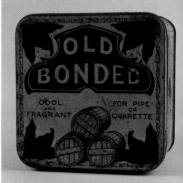

Oceanic Cut Plug, Scotten, Dillon Co., Detroit, Michigan. Lithographed tin. 3″ x 6″ x 4″. *Courtesy of Betty Lou and Frank Gay.*

Old Bonded. Lithographed tin. 4.25″ x 5″ x 5″. *Courtesy of C.J. Simpson.*

Ojibwa, Scotten, Dillon Company, Detroit, Michigan (Factory No. 1, Michigan). Paper. *Courtesy of Betty Lou and Frank Gay.*

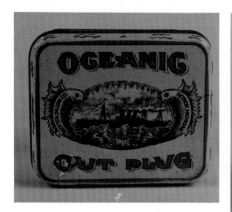

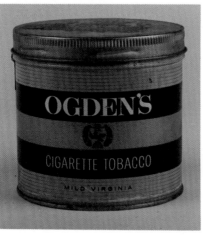

Oceanic Cut Plug, Scotten , Dillon Co., Detroit (Factory No. 1, 1st Michigan). Lithographed tin. 4.5″ x 6″ x 4.5″. *Courtesy of C.J. Simpson.*
Ogden's Cigarette Tobacco, Canada. Lithographed tin. 4.25″ x 4.25″. *Courtesy of C.J. Simpson.*

Old Chum Smoking Tobacco, D. Ritchie & Co., Imperial Tobacco Co., Montreal, Canada. Lithographed tin. 4.5″ x 4.25″ x 2.25″. *Courtesy of C.J. Simpson.*

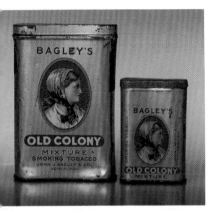

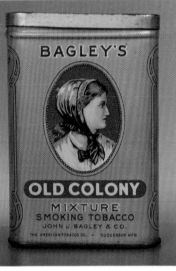

Old Colony Mixture Smoking Tobacco double concave pocket and sample. John J. Bagley & Co., Detroit, Michigan. 4.5″ x 3″ x 1″, 3″ x 2″ x .75″. *Courtesy of Dennis O'Brien and George Goehring.*

Old Colony Mixture, John J. Bagley & Co., American Tobacco Co., Successor. Uncirculated tin from the Tindeco sample room. Lithographed tin. 4.5″ x 3″ x 1″. *Courtesy of Dennis O'Brien and George Goehring.*

Old Gold Flake Cut, American Tobacco Co. successor to "W.S. Kimball". Cloth bag. *Courtesy of Betty Lou and Frank Gay.*

Old Gold Flake Cut Smoking Tobacco, American Tobacco Co., successor to Wm. S. Kimball & Co. (Factory No. 10, 5th New Jersey). Lithographed tin, 1″ x 4.75″ x 2.5″. *Courtesy of C.J. Simpson.*

Old Crock Tobacco, Peterson's Tobacco Corp., New York (Factory No. 13, 3rd Massachusetts), 1926 stamp. Tin with paper label. 4.5″ x 4″. *Courtesy of C.J. Simpson.*

Old Gold, Wm. S. Kimball, Rochester. Glass with paper label. 5.75″ x 3.5″. *Courtesy of C.J. Simpson.*

Old English Curve Cut Pipe Tobacco, American Tobacco Co. (Factory No. 1, Virginia). Top left: lithographed tin, 2.5″ x 3.5″ x 3″; bottom left: cardboard, 3″ x 5″ x 3.5″; right: lithographed tin, 3″ x 5″ x 3.5″. *Courtesy of C.J. Simpson.*

Old Gold Cigarettes, P. Lorillard. Lithographed tin. 0.75″ x 5.5″ x 4.25″. *Courtesy of C.J. Simpson.*

95

Old Gold Cigarettes (50), P. Lorillard Co., series 109 stamp. Cardboard. 1″ x 5.75″ x 4.25″. *Courtesy of C.J. Simpson.*
Old Gold Cigarettes. Lithographed tin. 0.75″ x 5.5″ x 4.25″. *Courtesy of C.J. Simpson.*

Old Mill Scotch Snuff, United States Tobacco, Nashville, 1945 tax stamp. Cardboard box. 3.25″ x 2.25″ x 1.25″. *Courtesy of C.J. Simpson.*

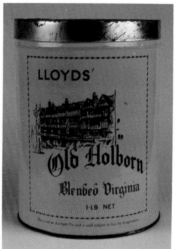

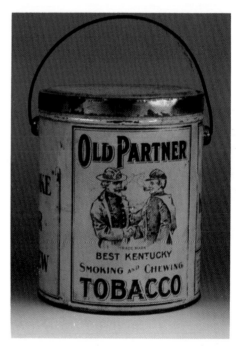

Old Hampshire Sliced Plug (Factory No. 2, Maryland). Lithographed tin. 1.25″ x 4.5″ 3″. *Courtesy of C.J. Simpson.*

Old Holborn Blended Virginia, Richard Lloyd & Sons, London. Lithographed tin. 6.5″ x 5″. *Courtesy of C.J. Simpson.*

Old Partner, Schmitt Bros., Milwaukee. Lithographed tin. 6.25″ x 5.25″. *Courtesy of Betty Lou and Frank Gay.*

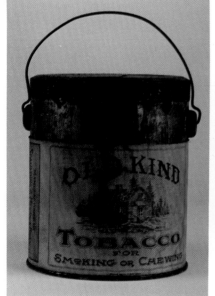

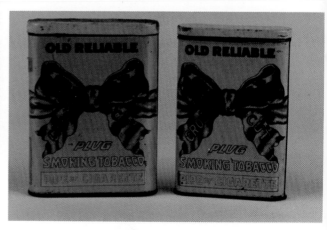

Old Kind Tobacco for Smoking or Chewing (Factory No. 3, 1st Illinois), 1936. Tin with paper half label. 6″ x 5″. *Courtesy of C.J. Simpson.*
Old Mariner Tobacco, John Middleton, Inc. Philadelphia. Lithographed tin. 5.5″ x 4.5″ x 4.5″. *Courtesy of C.J. Simpson.*

Old Reliable Gold Bond Cross Cut Plug, Larus & Bro. Co., Richmond (Factory No. 45, 2nd Virginia) Lithographed tin. Left 4.25″ x 3″; right 4.25″ x 2.75″. *Courtesy of C.J. Simpson.*

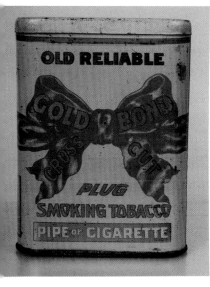 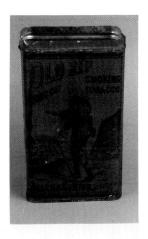 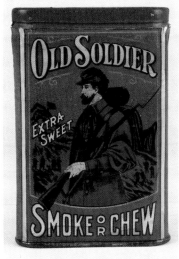 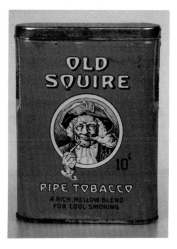

Old Reliable Gold Bond Cross Cut Plug pocket. Larus & Bro. Co., Richmond, Virginia. 4.5" x 3.5" x 1". *Courtesy of Dennis O'Brien and George Goehring.*
Old Rip Long Cut Smoking Tobacco, Allen & Ginter, Richmond, Virginia (Factory No. 14, 2nd Virginia), 1890 stamp. Lithographed tin, Ginna & Co., New York. 7.25" x 4.5" x 3". *Courtesy of C.J. Simpson.*

Old Soldier Smoke or Chew, A.S. Goodrich Co. (Factory No. 1, Michigan). Tin with paper label. 4.75" x 3". *Courtesy of C.J. Simpson.*
Old Squire Pipe Tobacco pocket. Tuckett Tobacco Company, Hamilton, Ontario. 4" x 3" x .75". *Courtesy of Dennis O'Brien and George Goehring.*

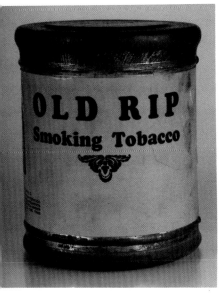 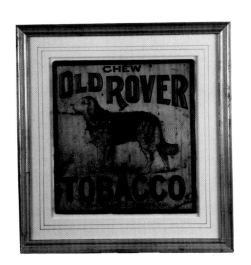 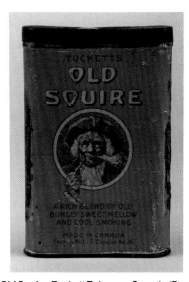

Old Squire, Tuckett Tobacco, Canada (Factory No. 1, I.R. Division No. 26). Lithographed tin. 4.5" x 3". *Courtesy of C.J. Simpson.*

Old Rip Smoking Tobacco R.J. Reynolds Tobacco, rare. Tin with paper label. 4" x 5". Old Rip originally made by W.C. Hancock, Richmond, Virginia, which was purchased by Reynolds. *Courtesy of Thomas Gray.*
Old Rover, Winston, North Carolina, sign. Embossed tin. 9" x 10". *Courtesy of Thomas Gray.*

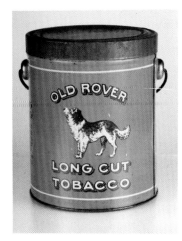

Old Rover, R.J. Reynolds, Winston-Salem, North Carolina. Lithographed tin lunch pail. 6.5" x 5.5". *Courtesy of Thomas Gray.*

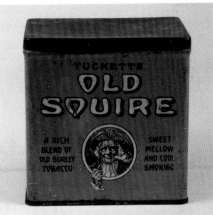

Old Squire, Tuckett Tobacco Co., Limited, Hamilton, Ontario. Lithographed tin. 4" x 4.25" x 3". *Courtesy of C.J. Simpson.*

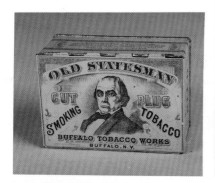
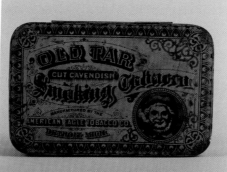

Old Statesman Cut Plug Tobacco, Buffalo Tobacco Works. Lithographed tin, Somers Bros. 2″ x 4.5″. *Courtesy of Oliver's Auction Gallery.*

Old Tar Smoking Tobacco, American Eagle Tobacco Co., Detroit (Factory No. 8, 1st Michigan). Lithographed tin, Ginna. 2.25″ x 6.25″ x 4″. *Courtesy of C.J. Simpson.*

Old Virginia, D. Ritchie & Co., Montreal. Lithographed tin. 4.25″ x 4.25″. *Courtesy of C.J. Simpson.*

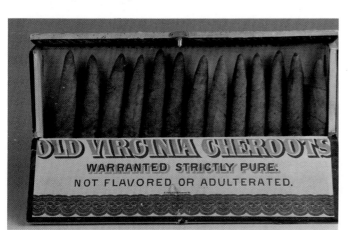
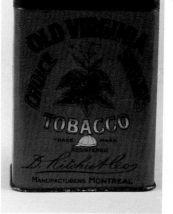

Old Virginia Choice Smoking Tobacco, D. Ritchie & Co., Montreal. 5″ x 4″ x 2.25″. *Courtesy of C.J. Simpson.*

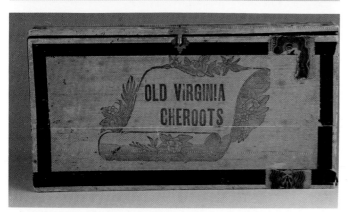
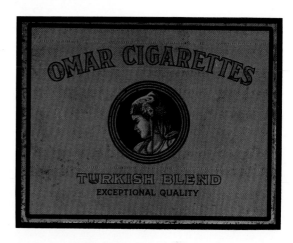

Old Virginia Cheroots. Wood and paper, litho by A. Hoen, Richmond. *Courtesy of Betty Lou and Frank Gay.*

Omar Cigarettes. Lithographed tin. 0.75″ x 5.5″ x 4.25″. *Courtesy of C.J. Simpson.*

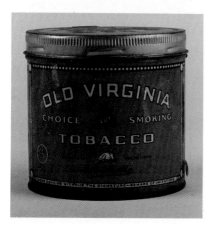
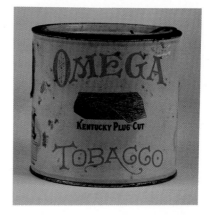

Old Virginia, D. Ritchie & Co., Montreal. Lithographed tin. 4.25″ x 4.25″. *Courtesy of C.J. Simpson.*

Omega Kentucky Plug Cut Tobacco, P. Lorillard Co. (Factory No. 6, 1st Ohio). Lithographed tin. 5″ x 5″. *Courtesy of C.J. Simpson.*

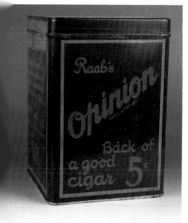
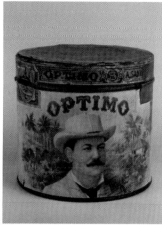
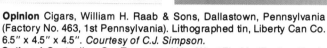
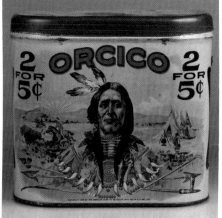

Opinion Cigars, William H. Raab & Sons, Dallastown, Pennsylvania (Factory No. 463, 1st Pennsylvania). Lithographed tin, Liberty Can Co. 6.5″ x 4.5″ x 4.5″. *Courtesy of C.J. Simpson.*
Optimo A Santaella y Ca., Tampa and Key West Florida (Factory No. 4, Florida). Tin with paper labels. 4.5″ x 4.25″. *Courtesy of C.J. Simpson.*

Orcico Cigars, Orrison Cigar Co., Bethesda, Ohio, copyright 1919. Lithographed tin. 5.5″ x 6″ x 4″. *Courtesy of Betty Lou and Frank Gay.*
Oriental, Lemesurier Tobacco Co., Quebec. Lithographed tin, 1″ x 3.5″ x 2.75″. *Courtesy of C.J. Simpson.*

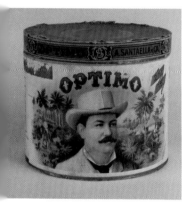
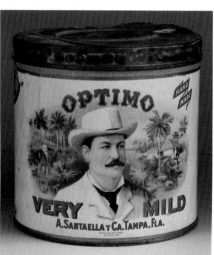
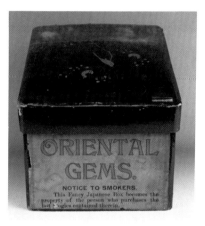

Oriental Gems. Japanned wooden cigar box with paper label. 4.5″ x 5.75″ x 7.25″. *Courtesy of C.J. Simpson.*

Optimo Dolls Cigars, A. Santaella y Ca., Tampa, Florida (Factory No. 221, Florida). Cardboard container with paper label. 4.5″ x 5″. *Courtesy of C.J. Simpson.*
Optimo Very Mild Cigars, A. Santaella y Ca., Tampa, Florida. Tin with paper label. 5.25″ x 5.5″. *Courtesy of Betty Lou and Frank Gay.*

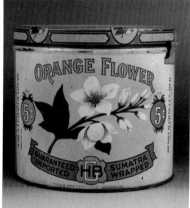

Oriental Mixture, American Tobacco Co., successor to American Eagle Tobacco Co. (Factory No. 1, 28th New York). Lithographed tin. 1.75″ x 6.75″ x 2.75″. *Courtesy of C.J. Simpson.*
Original Plug Perique Slice, Falk Tobacco Co., Richmond, Virginia. Lithographed tin. 3.25″ x 4.5″ x 1″. *Courtesy of Betty Lou and Frank Gay.*

Optimo Cigars, A Santaella y Ca, La Primadora Cigar Corp, Successor, Florida. Lithographed tin. 5.5″ x 5.5″. *Courtesy of C.J. Simpson.*
Orange Flower Cigars, Henry B. Grauley, Mfr., Quakertown, Pennsylvania (Factory No. 659, 1st Pennsylvania). Lithographed tin. 5.25″ x 6″. *Courtesy of C.J. Simpson.*

 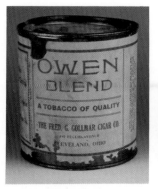

Orinoco Cut Coarse, Tuckett Tobacco Co., Hamilton, Ontario. Lithographed tin. 1.5″ x 3.5″ x 2.5″. *Courtesy of C.J. Simpson.*
Ottoman Fine Cut Tobacco, Rock City Tobacco Co. Ltd., Quebec. Lithographed tin. 3.25″ x 5″. *Courtesy of C.J. Simpson.*

Owen Blend, Fred G. Colmar Cigar Co., Cleveland, Ohio (Factory No. 15 Virginia). Tin with paper label, 4.25″ x 4″.
Oxford Turkish Cigaret, Khedivial Company, New York. Lithographed tin. 2.5″ x 5.5″ x 3″. *Courtesy of C.J. Simpson.*

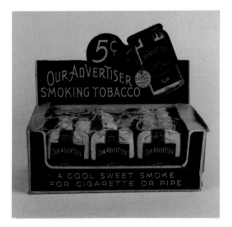 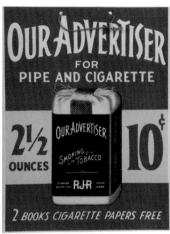 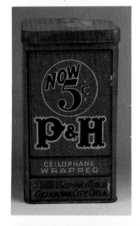

Oxford Turkish Cigaret, The Knedivial Co., New York, 1901 stamp. Lithographed tin. 0.5″ x 2.5″ x 2″. *Courtesy of C.J. Simpson.*

Our Advertiser counter box. Cardboard. Introduced in the 1890s, Our Advertiser is still made by Reynolds. *Courtesy of Betty Lou and Frank Gay.*
Our Advertiser hanger, c. 1910. Cardboard. 8″ x 10″. *Courtesy of Thomas Gray.*

P & H Cellophane Wrapped Cigars, Patterson & Hoffman, Oklahoma City, Oklahoma (Factory No. 319, 25th Michigan). Lithographed tin. 6″ x 3.25″ x 3.25″. *Courtesy of C.J. Simpson.*

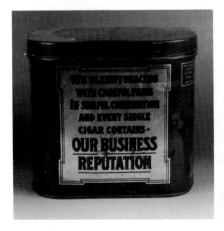 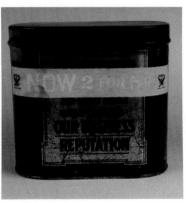 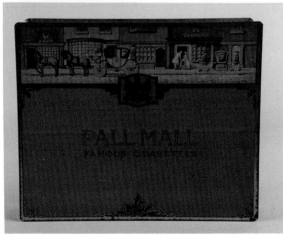

Our Business Reputation Cigars (Factory No. 463, 1st Pennsylvania). Lithographed tin. 5.5″ x 6″ x 4″. *Courtesy of C.J. Simpson.*
Our Business Reputation Cigars with NRA paper label (Factory No. 463, 1st Pennsylvania). 5.25″ x 6.25″ x 4″. *Courtesy of C.J. Simpson.*

Pall Mall Famous Cigarettes. Lithographed Christmas tin. 2″ x 8″ x 7″. *Courtesy of C.J. Simpson.*

Pall Mall Famous Cigarettes. Lithographed Christmas tin. 2″ x 8″ x 7″. *Courtesy of C.J. Simpson.*

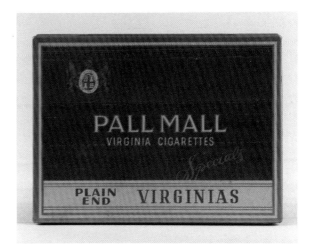

Pall Mall Virginia Cigarettes, Imperial Tobacco Co. Lithographed tin. .75″ x 6″ x 4.5″. *Courtesy of C.J. Simpson.*

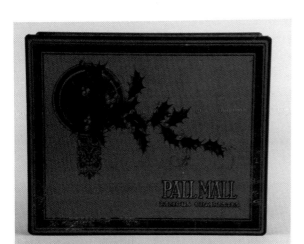

Pall Mall Famous Cigarettes. Lithographed Christmas tin. 2″ x 8″ x 7″. *Courtesy of C.J. Simpson.*

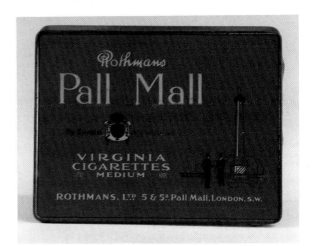

Pall Mall, Virginia Cigarettes, Rothmans, Ltd., London. Lithographed tin. .75″ x 6″ x 4.5″. *Courtesy of C.J. Simpson.*

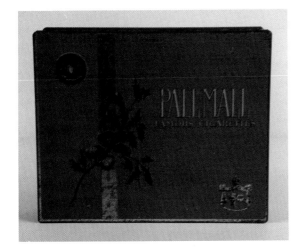

Pall Mall Famous Cigarettes. Lithographed Christmas tin. 2″ x 8″ x 7″. *Courtesy of C.J. Simpson.*

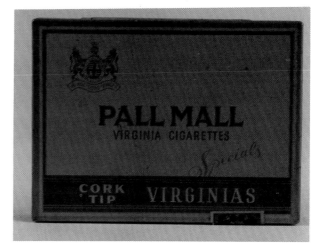

Pall Mall Virginia Cigarettes. Lithographed tin. .75″ x 6″ x 4.5″. *Courtesy of C.J. Simpson.*

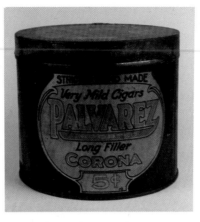
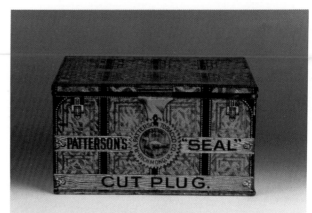

Palmy Days Tobacco, rare pocket. Originally came with a paper label, causing many tins to have water damage. L. Warnick Brown & Co., Utica, New York. 4.5″ x 3″ x 1″. *Courtesy of Dennis O'Brien and George Goehring.*

Palvarez Corona Cigars (Factory No. 1594, 1st Pennsylvania). Lithographed tin. 4.75″ x 5.5″. *Courtesy of C.J. Simpson.*

Patterson's Seal Cut Plug, R.A. Patterson Co., Richmond, Virginia. Lithographed tin. 3.5″ x 6.5″ x 5″. *Courtesy of Betty Lou and Frank Gay.*

Patterson's Seal. Lithographed tin lunch boxes. Top left R.A. Patterson (Factory No. 60, 2nd Virginia). 3.75″ x 6.75″ x 5″; top right Patterson (Factory No. 60, 2nd Virginia). 4.75″ x 6.75″ x 5″; bottom left Patterson, American Tobacco Co. (Factory No. 1, Virginia). 4.5″ x 6.75″ x 5″; bottom center: Patterson (Factory No. 60, 2nd Virginia). 4.74″ x 6.75″ x 5″; bottom right Patterson, American Tobacco Co. (Factory No. 42, 2nd Virginia). 4.5″ x 6.75″ x 5″. *Courtesy of C.J. Simpson.*

Parliament Cigarettes, Benson & Hedges, New York. Lithographed tin. 0.75″ x 5.5″ x 4.25″. *Courtesy of C.J. Simpson.*

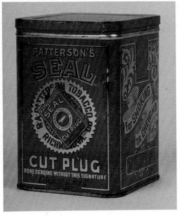

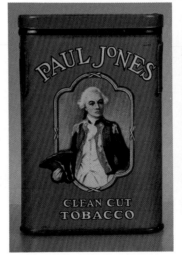
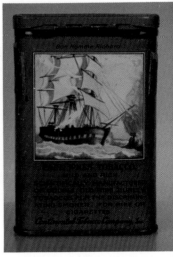

Pat Hand Cube Cut Granules, Globe Tobacco Co., Detroit, Michigan. Lithographed tin. 2.75″ x 2.5″ x 1.25″. *Courtesy of Betty Lou and Frank Gay.*

Patterson's Seal Cut Plug. R.A. Patterson Tobacco Co., Richmond, Virginia (Factory No. 60, 2nd Virginia). 5″ x 3.5″ x 3.5″. *Courtesy of Dennis O'Brien and George Goehring.*

Paul Jones Clean Cut Tobacco, Continental Tobacco Company, Richmond, Virginia, 1910 stamp. Lithographed tin pocket with beautiful graphics on the front and the back. 4.5″ x 3″ x 1″. *Courtesy of Dennis O'Brien and George Goehring.*

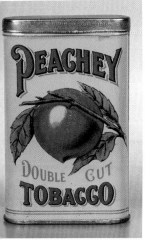
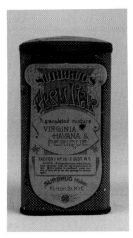

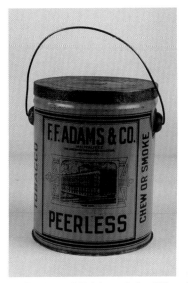
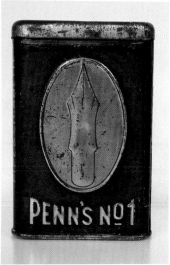

Peachey Double Cut Tobacco, Scotten, Dillon Company, Detroit (Factory No. 1, Michigan). 4″ x 2.5″ x 1″. *Courtesy of Dennis O'Brien and George Goehring.*

Peculiar, Surbrug, New York (Factory No. 16, 2nd New York). Lithographed triangular tin. 5″ x 2.5″. *Courtesy of C.J. Simpson.*

Peerless, F.F. Adams & Co., Milwaukee, American Tobacco Company, Successor (Factory No. 27, Kentucky). Lithographed tin pail. *Courtesy of C.J. Simpson.*

Penn's No. 1. An extremely rare and early pocket, with embossed oval and nib. Penn Tobacco Company, Wilkes-Barre, Pennsylvania, c. 1900. 4.5″ x 3″ x 1″. *Courtesy of Dennis O'Brien and George Goehring.*

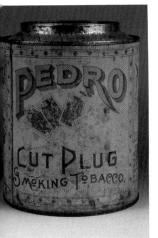
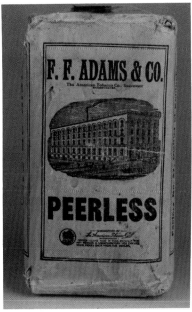

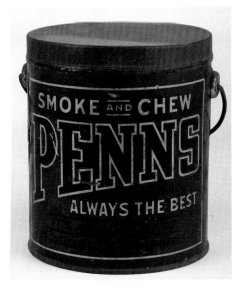

Pedro Cut Plug (Factory No. 2, Maryland). Lithographed tin. 5.75″ x 4.5″ x 4.5″. *Courtesy of C.J. Simpson.*

Penns Smoke and Chew, Penn Tobacco Co., Wilkes-Barre, Pennsylvania (Factory No. 36, 12th Pennsylvania). Lithographed tin pail. 6″ x 5.5″. *Courtesy of C.J. Simpson.*

Peerless, F.F. Adams Tobacco Co., Milwaukee, American Tobacco Company, Successor. Paper. *Courtesy of Betty Lou and Frank Gay.*

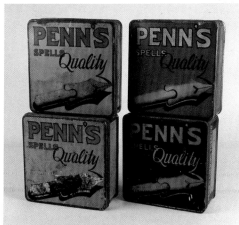

Peerless, F.F. Adams & Co., American Tobacco Co., Successor. Large 8″ paper package. *Courtesy of Betty Lou and Frank Gay.*

Penn's "Spells Quality," American Tobacco Company (Factory No. 33, North Carolina). Lithographed tin. Top left: 1.75″ x 6.5″ x 6.5″; top right: 1916 stamp, 2.5″ x 6.5″ x 6.5″; bottom left: 3″ x 6.5″; bottom right: 1910 stamp, 3″ x 6.5″ x 6.5″. *Courtesy of C.J. Simpson.*

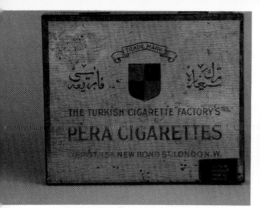 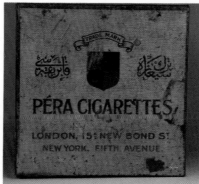 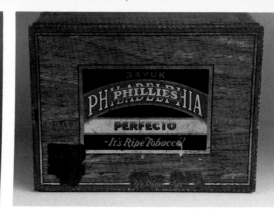

Péra Cigarettes, The Turkish Cigarette Factory, London. Lithographed tin. 1" x 4.5" x 4". *Courtesy of C.J. Simpson.*
Péra Cigarettes (100), Péra Cigarette Co., (formerly "Turkish Cigarette Factory"), London & New York. Lithographed tin. 1" x 5.5" x 5.75". *Courtesy of C.J. Simpson.*

Philadelphia Phillies Cigars, Bayuk Cigars, Inc. (Factory No. 550, Pennsylvania). Lithographed tin. 3" x 7.5" x 5.25". *Courtesy of C.J. Simpson.*

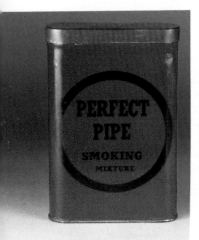 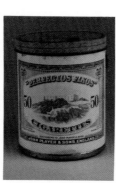 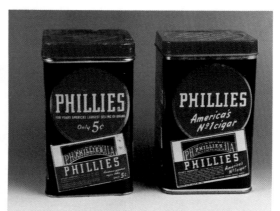

Perfect Pipe Smoking Mixture. *Courtesy of Elsie and John Booker.*
"Perfectos Finos" Cigarettes, John Player & Sons, England. Paper labeled tin with lithographed lid. 3.25" x 2.5". *Courtesy of C.J. Simpson.*

Philadelphia Phillies Cigars, Bayuk Cigar Co. (Factory No. 550, 1st Pennsylvania). Left (5 cent): copyright 1920; Right (America's No. 1): copyright, 1925. Lithographed tin. 5.5" x 3" x 3". *Courtesy of C.J. Simpson.*
Philip Morris & Co. Ltd. Cigarettes, Philip Morris, New York (Factory No. 7, Virginia). Lithographed tin. 3.25" x 2.5". *Courtesy of C.J. Simpson.*

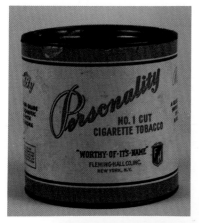

Personality No. 1 Cut Cigarette Tobacco, Fleming-Hall Co., Inc., New York (Factory No. 100, 1st New York). Tin with paper label. 4.25" x 4". *Courtesy of C.J. Simpson.*

Philadelphia Leader, Mild Cigars, 10 cent and 11 cent containers, F.J. Florio, Pennsylvania, Copyright 1933, series 116 stamp. Tin with paper label. 5.25" x 5.5" x 5.5". *Courtesy of C.J. Simpson.*

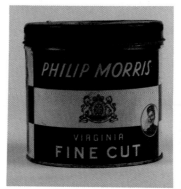

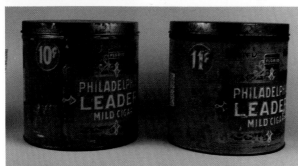

Philip Morris Virginia Fine Cut, Tackett Tobacco Co., Hamilton, Ontario. Lithographed tin. 4.25" x 4.25". *Courtesy of C.J. Simpson.*
Picadura Import, Newburger & Bro., Makers (Factory No. 18, 1st Ohio). Lithographed tin. 5.25" x 3.25" x 3.25". *Courtesy of C.J. Simpson.*

 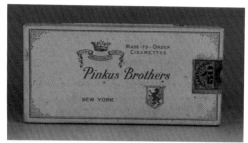

Piccadilly Juniors, Carreras, London. Lithographed tin. 3″ x 3″. *Courtesy of C.J. Simpson.*

Piccadilly Number One Cigarettes, Carreras, London. Lithographed aluminum. 0.5″ x 4.25″ x 3″. *Courtesy of C.J. Simpson.*

Pinkus Brothers Made-to-Order Cigarettes (50). Two variations of their lithographed tin. Each: 1″ x 6″ x 2.75″. *Courtesy of C.J. Simpson.*

Piccadilly Smoking Mixture, Wm. S. Kimball & Co. American Tobacco Co., Successor, Rochester, New York. Lithographed tin, Ginna. 2.25″ x 4.75″ x 3″. *Courtesy of C.J. Simpson.*

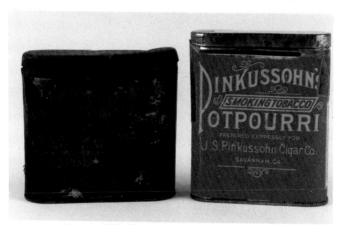

 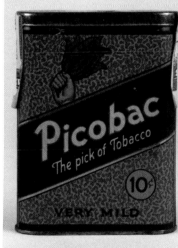

Pinkussohn's Potpourri, J.S. Pinkussohn Cigar Co., Savannah, Georgia (Factory No. 1, Virginia). Left: 3.25″ x 3.25″; right: 4.25″ x 3.25″. *Courtesy of C.J. Simpson.*

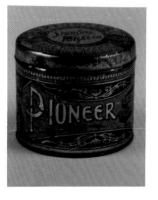

Picobac, Imperial Tobacco Co. of Canada. Lithographed tin. 4″ x 3″. *Courtesy of C.J. Simpson.*

Picobac, Imperial Tobacco Co. of Canada Ltd., Montreal. Lithographed tin with embossed lid. 4.25″ x 4.25″. *Courtesy of C.J. Simpson.*

Pioneer, Eagle Tobacco Co., Quebec. Lithographed tin. 3″ x 3.25″. *Courtesy of C.J. Simpson.*

"Pilot" Flake, Hignett. Lithographed tin. *Courtesy of C.J. Simpson.*

Pioneer Brand. Lithographed tin. 1.25″ x 4.5″ x 3″. *Courtesy of C.J. Simpson.*

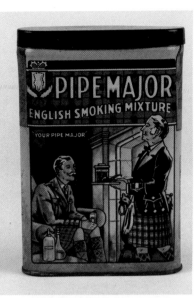

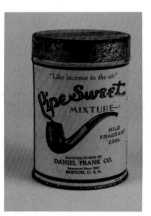

Pipe Sweet Mixture, Daniel Frank Co., Boston. Lithographed tin. 4.25" x 2.75". *Courtesy of C.J. Simpson.*

Pipe Major English Smoking Mixture, Brown & Williamson, Louisville, Kentucky (Factory No. 21, Kentucky). Lithographed tin. 4.5" x 3". *Courtesy of C.J. Simpson.*

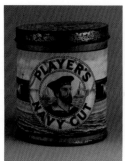
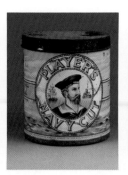
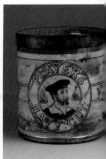

Player's Navy Cut, Castle Tobacco Factory, Newcastle. Tin with paper label and embossed top. 3.25" x 2.5". *Courtesy of C.J. Simpson.*

Player's Navy Cut, John Player and Sons, England. 3" x 2.75". *Courtesy of C.J. Simpson.*

Player's Navy Cut, John Player and Sons, England. Tin with paper label and embossed lid. 3" x 2.75". *Courtesy of C.J. Simpson.*

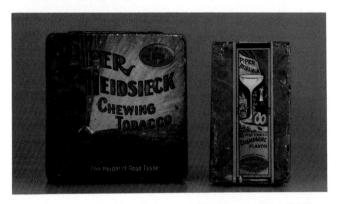

Piper Heidsieck Chewing Tobacco "Champagne Flavor", Piper Heidsieck, Louisville, Kentucky. Flat lithographed tin with cellophane wrapped contents. 3" x 3" x .5". *Courtesy of Betty Lou and Frank Gay.*

Player's Navy Cut Cigarettes. Lithographed tin. *Courtesy of C.J. Simpson.*

Player's Cigarettes (50). Tin with paper label, lithographed tin lid. 3.25" x 2.75". *Courtesy of C.J. Simpson.*

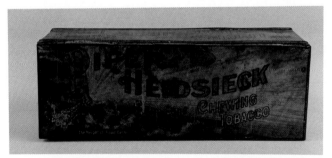

Piper Heidsieck Chewing Tobacco, American Tobacco Company (Factory No. 27, 5th Kentucky), series 1910 stamp. Lithographed tin. 3" x 8.5" x 3". *Courtesy of C.J. Simpson.*

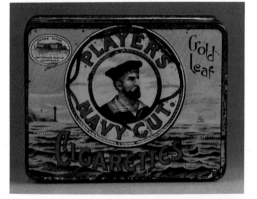

Player's Navy Cut Cigarettes, Gold Leaf. Lithographed tin. 1.5" x 4" x 3". *Courtesy of Betty Lou and Frank Gay.*

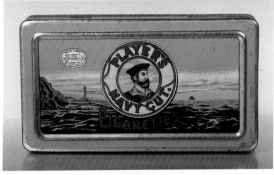

"Pirate" Cigarettes, W.D. & H.O. Wills, Bristol & London. Paper. *Courtesy of Betty Lou and Frank Gay.*

Players Navy Cut Cigarettes (50). 1" x 5.5" x 3". *Courtesy of Dennis O'Brien and George Goehring.*

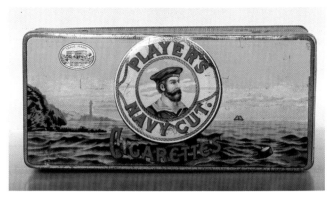

Player's Navy Cut Cigarettes (100), Imperial Tobacco Co., of Canada Ltd., Montreal, successor to John Player & Sons, England. Lithographed tin. 3" x 6.75" x 3" x 1.75". *Courtesy of Dennis O'Brien and George Goehring.*

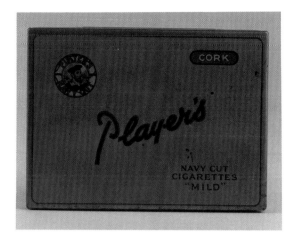

Player's Navy Cut Cork Cigarettes. Lithographed tin. .75" x 6" x 4.5". *Courtesy of C.J. Simpson.*

Player's Gold Leaf Navy Cut, London. Lithographed tin. 0.5" x 3.25" x 2.25". *Courtesy of C.J. Simpson.*

Player's "Navy" Mixture Imperial Tobacco Co. of Great Britain and Ireland. Lithographed tin. 5.5" x 4". *Courtesy of Betty Lou and Frank Gay.*

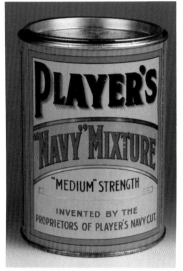

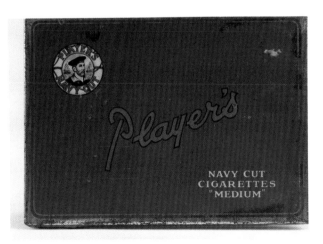

Player's Navy Cut Cigarettes. Lithographed tin. .75" x 6" x 4.5". *Courtesy of C.J. Simpson.*

Players Navy Cut Cigarettes (100), John Player, England. Lithographed tin. 1.25" x 6" x 4". *Courtesy of C.J. Simpson.*

Player's Navy Cut Cigarettes. Lithographed tin. *Courtesy of C.J. Simpson.*

Player's "Gold Leaf" Cigarettes (100) Lithographed tin with a vaulted top. 1.5" x 6" x 4.25". *Courtesy of C.J. Simpson.*

Player's Navy Cut, John Player, London. Lithographed tin. 1.25" x 5.5" x 3". *Courtesy of C.J. Simpson.*

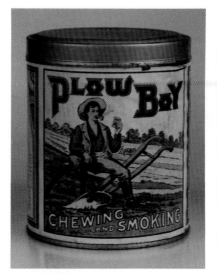

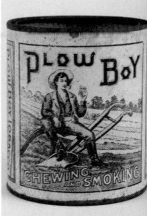

Player's Cigarettes (50), John Player, London. Lithographed tin. .75" x 6" x 4.25". *Courtesy of C.J. Simpson.*

Plow Boy Chewing and Smoking Tobacco, Spaulding & Merrick, Chicago, Liggett and Myers, Successor (Factory No. 74, 1st Missouri). Tin with paper label. 6" x 5.25". *Courtesy of Betty Lou and Frank Gay.*
Plow Boy Chewing and Smoking, Spaulding and Merrick, Liggett & Myers. Cardboard and paper. 6" x 5". *Courtesy of C.J. Simpson.*

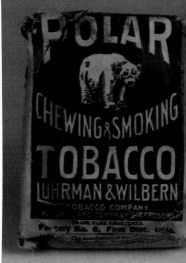

Player's No. 3 Extra Quality Cigarettes. Lithographed tin. 0.5" x 5.75" x 4.5". *Courtesy of C.J. Simpson.*

Plug Crumb Cut, David P. Ehrlich & Co., Boston (Factory No. 16, West Virginia). Tin with paper label. 5" x 3.5" x 3.5". *Courtesy of C.J. Simpson.*
Polar Chewing & Smoking Tobacco. Luhrman & Wilbern, P. Lorillard, Successor (Factory No. 6, 1st Ohio). Paper. *Courtesy of Betty Lou and Frank Gay.*

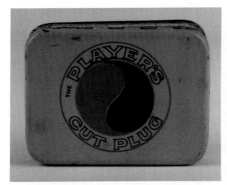

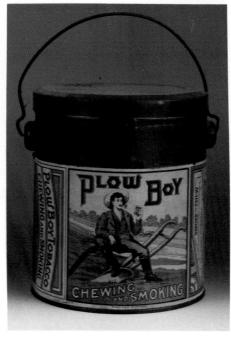

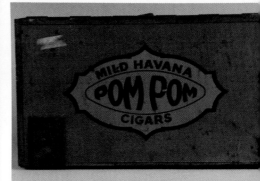

The Player's Cut Plug, Surbrug Tobacco (Factory No. 4, 2nd Virginia). Lithographed tin. 1.25" x 4.5" x 3.5". *Courtesy of C.J. Simpson.*

Plow Boy Chewing and Smoking Tobacco, Spaulding & Merrick, Liggett & Myers, Successors. Tin pail with paper half-label. 6" x 5.5". *Courtesy of Betty Lou and Frank Gay.*

Pom Pom Mild Blend Cigars (Factory No. 57, Ohio). 2.5" x 9" x 5". *Courtesy of C.J. Simpson.*

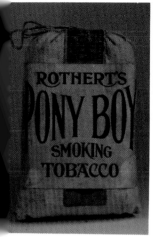
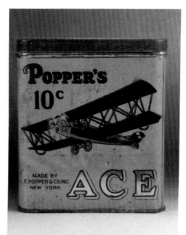
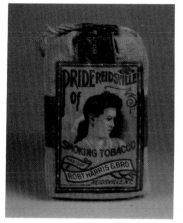
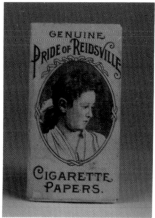

Pride of Reidsville Smoking Tobacco, Robert Harris & Bro., Reidsville, North Carolina. Cloth bag. *Courtesy of Betty Lou and Frank Gay.*
Pride of Reidsville Cigarette Papers. *Courtesy of Betty Lou and Frank Gay.*

Pony Boy Smoking Tobacco, Rothert's Sons Tobacco Company, Cincinnati, 1910 stamp. Cloth bag. *Courtesy of Betty Lou and Frank Gay.*
Popper's Ace, E. Popper & Co., New York (Factory No. 1488, 1st Pennsylvania). Lithographed tin. 5.75" x 5" x 5". *Courtesy of C.J. Simpson.*

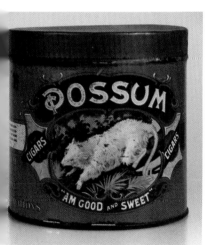
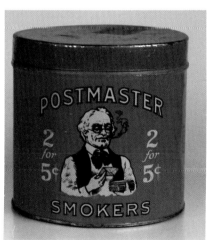

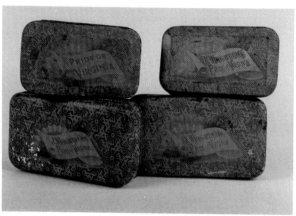

Pride of Virginia, J. Wright Co. (Factory No. 51, 2nd Virginia). Lithographed tin. Top left: 1" x 4.75" x 2.5"; top right: Hasker & Marcuse. 1" x 4.75" x 2.5"; bottom left: Somers, 1.25" x 5.75" x 3"; bottom right: Hasker & Marcuse. 1.25" x 5.75" x 3". *Courtesy of C.J. Simpson.*

Possum Cigars, "Am good and sweet," Virginia. 5.25" x 5.25". *Courtesy of Betty Lou and Frank Gay.*
Postmaster Smokers (Factory No. 17, Virginia). Lithographed tin. 5" x 5.25". *Courtesy of Betty Lou and Frank Gay.*

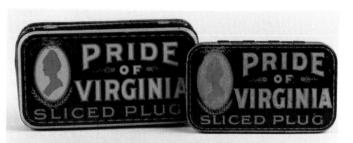

Pride of Virginia (Factory No. 42, 2nd Virginia). Lithographed tin. Left 1.25" x 5.5" x 3"; right 0.75" x 4.5" x 3". *Courtesy of C.J. Simpson.*

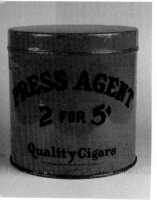
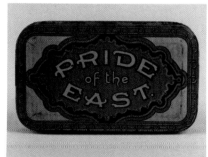

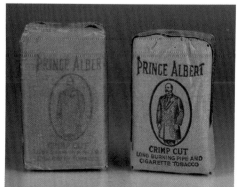

Prince Albert Crimp Cut, R.J. Reynolds, Winston-Salem, 1926 stamp. Cloth bags, the one on the left has its original wax paper wrapping. 3.5" x 2". *Courtesy of Thomas Gray.*

Press Agent Quality Cigars, J.S., Cleveland, Ohio (Factory No. 1532, 1st Pennsylvania). *Courtesy of C.J. Simpson.*
Pride of the East, United States Tobacco Co., Richmond (Factory No. 15, 2nd Virginia). Lithographed tin, Hasker & Marcuse. 1" x 4.5" x 2.5". *Courtesy of C.J. Simpson.*

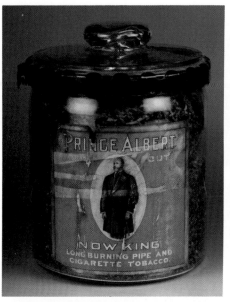

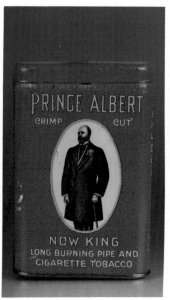

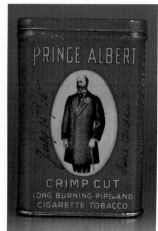

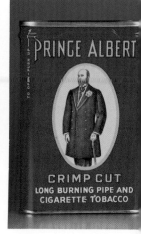

Prince Albert Crimp Cut, R.J. Reynolds, Winston-Salem, c. 1915. Lithographed tin (Reynolds had a tin shop and made their tins). 4.75" x 3". *Courtesy of Thomas Gray.*

Prince Albert Crimp Cut, R.J. Reynolds, Winston-Salem. Lithographed tin with "improved top". 4.75" x 3". *Courtesy of Thomas Gray.*

Prince Albert Now King Crimp Cut, R.J. Reynolds, Winston-Salem. Rare glass canister, paper label. 6" x 5". *Courtesy of Thomas Gray.*

Prince Albert Now King Crimp Cut, R.J. Reynolds, Winston-Salem, North Carolina. Introduced in 1907, the first Prince Albert pocket tin, was made in 1909. The copy on the tin was specified by R.J. Reynolds himself: "Prince Albert Crimp Cut, Now King, Long Burning Pipe and Cigarette Tobacco." After Prince Albert (King Edward VII) died in 1910, the tin was changed to simply read "Crimp Cut". Lithographed tin. The color was changed from orange to red when Albert died. 4.5" x 3". *Courtesy of Thomas Gray.*

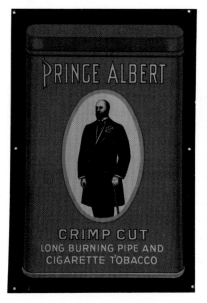

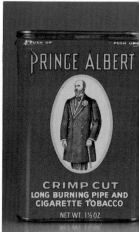

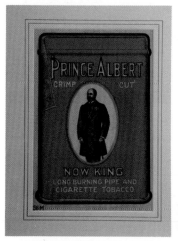

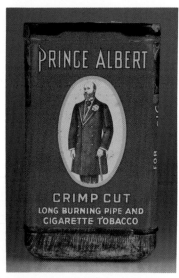

Prince Albert tin sign. 7" x 10.5". *Courtesy of Thomas Gray.*

Prince Albert Crimp Cut, R.J. Reynolds, Winston-Salem. Lithographed tin. 4.75" x 3". *Courtesy of Thomas Gray.*

Prince Albert Now King Crimp Cut, 1909. Extremely rare wax-coated cardboard sign to be used outside. 6.5" x 9.5". *Courtesy of Thomas Gray.*

Prince Albert Crimp Cut, R.J. Reynolds, Winston-Salem. Lithographed tin with match container on bottom. 5" x 3". *Courtesy of Thomas Gray.*

Prince Albert Crimp Cut, R.J. Reynolds, Winston-Salem. Glass with paper labels. Left: 6"; middle: 5" right: glass humidor, 7.5". *Courtesy of Thomas Gray.*

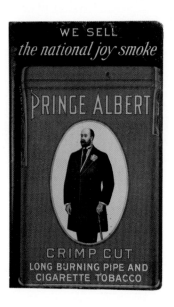

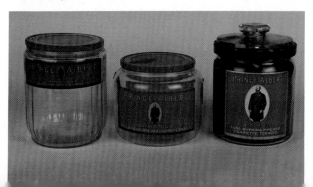

Prince Albert, R.J. Reynolds. Tin and enameled two-sided sign. 17.5" x 10.25". *Courtesy of Thomas Gray.*

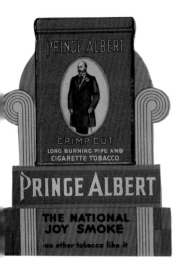

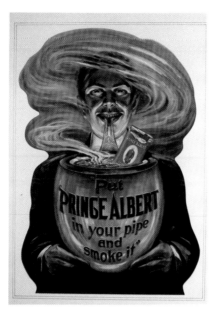

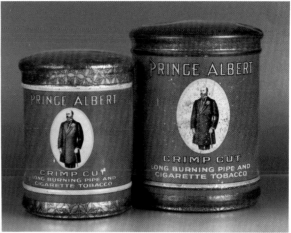

Prince Albert Crimp Cut, R.J. Reynolds, Winston-Salem. Lithographed tin. Left: 1909 stamp, 5.5" x 4"; right: 6.5" x 5.75". *Courtesy of Thomas Gray.*

Prince Albert counter display, c. 1928. Cardboard. *Courtesy of Thomas Gray.*

Prince Albert advertising poster. "Put Prince Albert in your pipe and smoke it." Paper, 1910. 23" x 16". *Courtesy of Thomas Gray.*

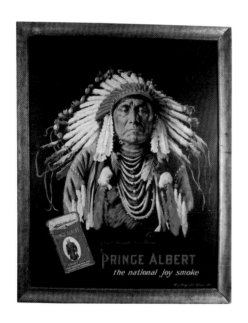

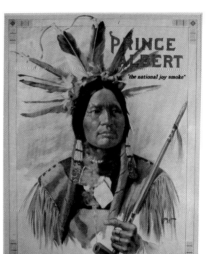

Prince Albert Indian series, c. 1914. This lithographed print with its original hand lettering was a prototype for 1914 signs. 20" x 25". *Courtesy of Thomas Gray.*

Prince Albert Indian series, c. 1914. Another hand lettered prototype sign. 20" x 25". *Courtesy of Thomas Gray.*

Prince Albert Crimp Cut sign, featuring Chief Joseph (1840-1904), Nez Percé, **c. 1916. Lithographed tin with wood frame, American Art Works, Coshocton, Ohio. Reynolds used the Indian theme successfully from 1913-1916. 19.5" x 24".** *Courtesy of Thomas Gray.*

Prince Albert hanger, c. 1912. Cardboard. 7" x 10". *Courtesy of Thomas Gray.*

Prince Albert Crimp Cut, R.J. Reynolds, Winston-Salem (Factory No. 256, North Carolina). Lithographed tin. 3.5" x 3.5". *Courtesy of Thomas Gray.*

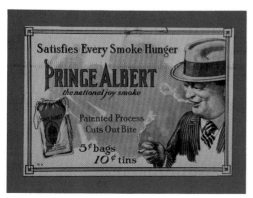

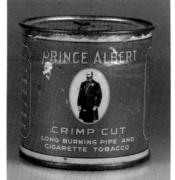

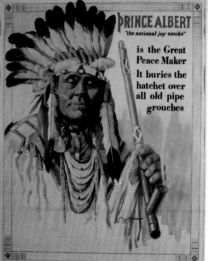

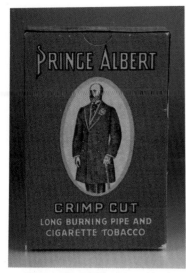

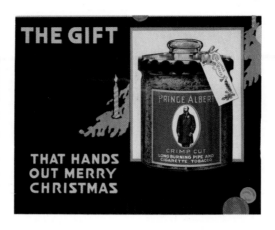

Prince Albert Crimp Cut, R.J. Reynolds, Winston-Salem, 1926 stamp. Cardboard. 4.5″ x 3″. *Courtesy of Thomas Gray.*

Prince Albert Christmas promotion featuring glass humidor, dated 1915. Paper. 11″ x 14″. *Courtesy of Thomas Gray.*

Prince Herald Cigars (Factory No. 53, Pennsylvania). Lithographed tin. 5″ x 5.25″ x 5.25″. *Courtesy of C.J. Simpson.*

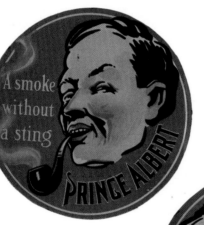

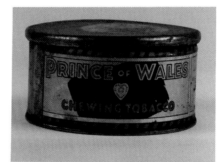

Prince of Wales Chewing Tobacco, MacDonald, Canada. Lithographed tin. 2.75″ x 5″. *Courtesy of C.J. Simpson.*
Prince of Wales, W.C. MacDonald. Lithographed tin. 4″ x 4.75″. *Courtesy of C.J. Simpson.*

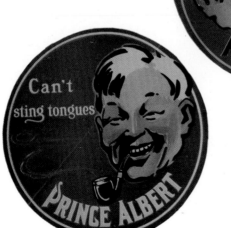

Private Estate Mixture (Factory No. 3, Missouri), Series 121 stamp. Tin with paper label. 4.75″ x 3.5″ x 3.5″. *Courtesy of C.J. Simpson.*

Private Stock Mixture, Straus Bros. & Co., Cincinnati (Factory No. 1, Virginia). Tin with paper label. Left 4.5″ x 3.5″; right: 4.75″ x 3.75″. *Courtesy of C.J. Simpson.*

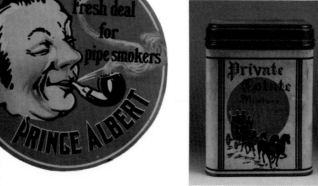

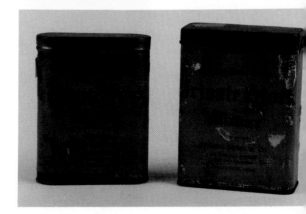

Prince Albert signs. c. 1912. Paper. 12.5″. *Courtesy of Thomas Gray.*

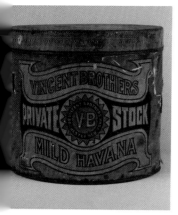
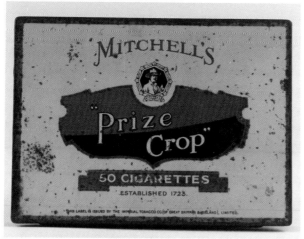
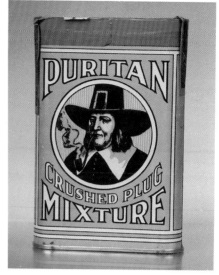

Private Stock Mild Havana Cigars, Vincent Bros. (Factory No. 666, Pennsylvania). Tin with paper label. 4.75" x 5.5" x 5.5". *Courtesy of C.J. Simpson.*

"Prize Crop" Cigarettes (50), Mitchell's, (Imperial Tobacco Co. (of Great Britain and Ireland) Limited. Lithographed tin. 0.5" x 5.75" x 4.5". *Courtesy of C.J. Simpson.*

Puritan Crushed Plug Mixture pocket with series 118 stamp (Factory No. 15, Virginia). Philip Morris. Lithographed tin. 4.5" x 3" x 1". *Courtesy of Dennis O'Brien and George Goehring.*

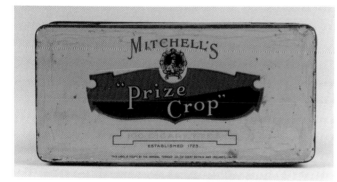

"Prize Crop" Cigarettes (100), Mitchell's, Imperial Tobacco Company (of Great Britain and Ireland). Lithographed tin. 2" x 6.5" x 3". *Courtesy of C.J. Simpson.*

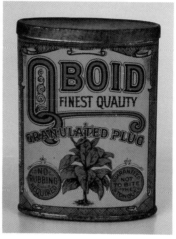

Q Bold Granulated Plug, Larus & Bro. Co., Richmond, Virginia, c. 1905. Lithographed tin oval pocket. 4" x 3" x 1.25". *Courtesy of Dennis O'Brien and George Goehring.*

Q Bold Granulated Plug, Larus & Bros., Richmond (Factory No. 45, 2nd Virginia). Lithographed tin. 4" x 3". *Courtesy of C.J. Simpson.*

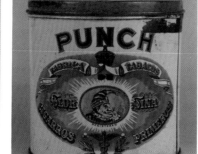

Prize Winners Cigars, C. Wells, Binghamton, New York (Factory No. 714, 21st New York). Lithographed tin by T. M Tose (?) & Bros. Brooklyn, New York. 1.75" x 3" x 5". *Courtesy of C.J. Simpson.*

Punch Cigaros Primeros, Punch Cigar Co. 5.25" x 5.25". *Courtesy of C.J. Simpson.*

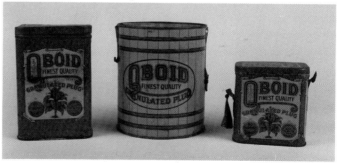

Q Bold Granulated Plug, Larus & Bro. Co, Richmond (Factory 45, 2nd Virginia), February 26, 1926 stamp. Lithographed tin. L-R: 5.5" x 3.75" x 2.5"; 5.75" x 5"; 4" x 3.5" x 2.25". *Courtesy of C.J. Simpson.*

Pure Perique, Surbrug Company. New York (Factory No. 16, 2nd New York). Lithographed tin. 1.5" x 3.5" x 2.5". *Courtesy of C.J. Simpson.*

Queed, Christian Peper, St. Louis, Missouri, Series 108, 1926 stamp. Tin with paper label. 5.75" x 4.5". *Courtesy of C.J. Simpson.*

Queen of Virginia Perique Mixture. Lithographed tin. 3.25" x 4.5" x 2.25". *Courtesy of Betty Lou and Frank Gay.*

Rainbow Cut Plug, Frishmuth Bro. & Co., Philadelphia (Factory No. 1, 1st Pennsylvania). Lithographed tin lunch box. 4" x 8" x 5". *Courtesy of C.J. Simpson.*

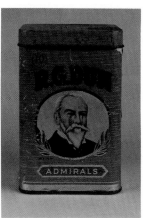
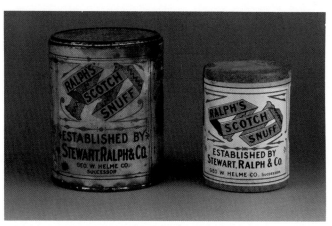

R F Gold Plug Cut. Lithographed tin with embossed lid. 1.25" x 3.75" x 2.75". *Courtesy of C.J. Simpson.*

R.G. Dun Admirals (Factory No. 35, 10th Ohio). Cardboard container with lithographed tin lid. 5" x 3.5" x 3.5". *Courtesy of C.J. Simpson.*

Ralph's Scotch Snuff, Stewart, Ralph & Co., George W. Helme Co., Successor (Factory No. 4, Delaware). Left tin with paper label, 3" x 2.25"; right cardboard box, 2.25" x 1.5". *Courtesy of C.J. Simpson.*

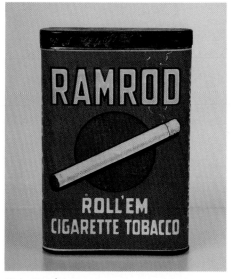

Ramrod Roll'em Cigarette Tobacco. Scotten, Dillon, Detroit, Michigan. Tin with paper label. 4.5" x 3" x 1". *Courtesy of Dennis O'Brien and George Goehring.*

Railroad Mills Sweet Scotch Snuff, George W. Helme Co., Helmetta, New Jersey. 2" x 1.25". *Courtesy of C.J. Simpson.*
Railroad Mills Sweet Scotch Snuff, George W. Helme Co., Helmetta, New Jersey. Cardboard box. 3" x 2" x .75". *Courtesy of C.J. Simpson.*

114

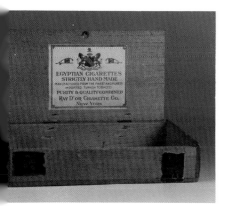 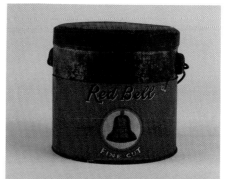

Ray D'Or Cigarettes (50), Ray D'Or Cigarette Co., New York. The slogan reads, "The ideal cigarette advertises itself." Wood with paper label. 6" x 3" x 1.25". *Courtesy of C.J. Simpson.*

Red Bell, Spaulding & Merrick, Chicago, Liggett & Myers, Successor (Factory No. 3, Illinois). Tin pail with paper half label. 5" x 5.5". *Courtesy of C.J. Simpson.*

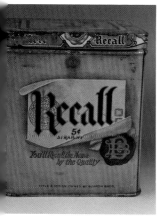 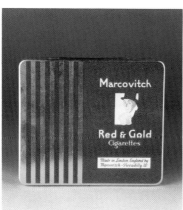

Recall Cigars, Bobrow Bros. (Factory No. 1626, 1st Pennsylvania). Lithographed tin, Liberty Can Co. 5.25" x 5" x 5". *Courtesy of C.J. Simpson.*

Red & Gold Cigarettes, Marcovitch, London. Lithographed tin. *Courtesy of Elsie and John Booker.*

Red Bell. Tin container with string cutter on the lid for future use. 7" x 4" x 4". *Courtesy of Koehler Bros. Inc.—The General Store, Lafayette, Indiana.*

Red Belt short pocket, Bagley (?). 3" x 3" x 1". *Courtesy of Dennis O'Brien and George Goehring.*

 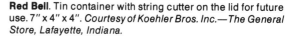

Red & White Brand Cigars, Serv-Us Grocery Products Corp., Flickinger-Elmira Co., Elmira, New York (Factory No. 192, Maryland). Tin with paper label. 6" x 3.25" x 3.25". *Courtesy of C.J. Simpson.*
Red Band Scrap. John J. Bagley, Detroit. Lithographed tin store bin. 12" x 18" x 13.75". *Courtesy of C.J. Simpson.*

Red Kamel store display. 11" x 14". *Courtesy of Thomas Gray.*

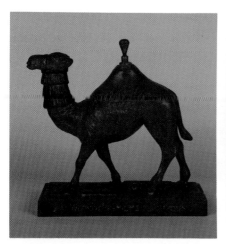
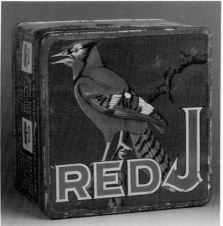
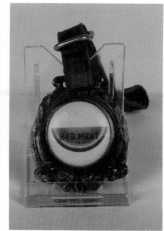

Red Kamel Turkish Cigarettes, R.J. Reynolds, cast iron lighter, c. 1914-15. Red Kamel was on the market until 1935. 8.5" x 8". *Courtesy of Thomas Gray.*

Red J Chewing Tobacco, American Tobacco Company. c. 1925. Lithographed tin. 4.5" x 6.5" x 6.5". *Courtesy of Betty Lou and Frank Gay.*

Red Meat watch fob, c. 1880-1890. Liipfert-Scales, Winston-Salem, North Carolina, later bought by Reynolds. *Courtesy of Thomas Gray.*

Red Rabbit Tobacco, B.F. Hanes & Co. Celluloid pin with metal stud back. *Courtesy of Thomas Gray.*

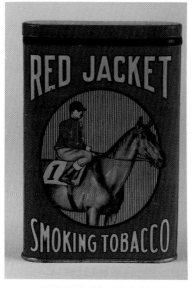
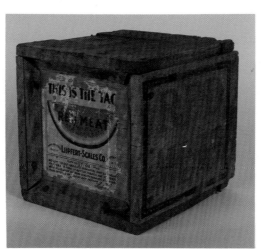
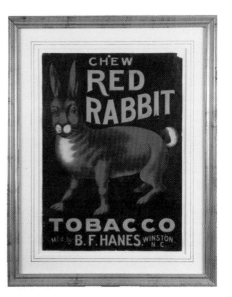

Red Jacket Smoking Tobacco, B. Payn's (?) Sons Tobacco Co., Albany, New York. Lithographed tin. 4.5" x 3". *Courtesy of C.J. Simpson.*

Red Meat Tobacco, Liipfert-Scales, Winston-Salem, North Carolina, dated 1902. Square wood caddy. Liipfert-Scales was sold to R.J. Reynolds in 1903, including the Red Meat brand. 7.5" x 8". *Courtesy of Thomas Gray.*

Red Rabbit Tobacco, B.F. Hanes, Winston, North Carolina, sign. Lithographed tin. 9.5" x 13". *Courtesy of Thomas Gray.*

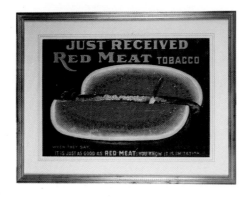

Red Meat Tobacco sign, c. 1910. Paper. *Courtesy of Thomas Gray.*

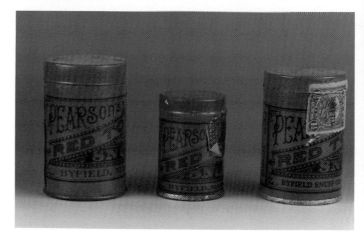

Red Top Snuff tins. Left: Pearson Mills, Byfield Mass., cardboard with paper label and litho tin top, 2.75" x 1.75"; middle: Byfield Snuff Mfg., lithographed tin, 2" x 1.5"; right: Byfield Snuff Co., series 122 stamp, cardboard with tin top, 2.75" x 1.75". *Courtesy of C.J. Simpson.*

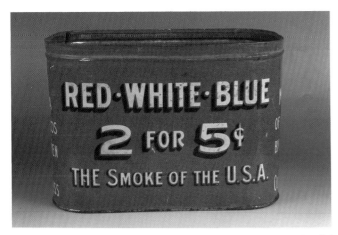

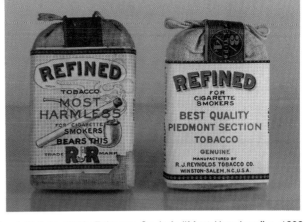

Red-White-Blue Cigars (Factory No. 1053, 1st Pennsylvania). Lithographed tin. 5.25″ x 8″ x 5″. *Courtesy of C.J. Simpson.*

Refined, R.J. Reynolds Tobacco Co. Left: "Most Harmless," c. 1902. Right: "Best Quality Piedmont Section Tobacco," c. 1910. Cloth bags. 3″ x 2″. *Courtesy of Thomas Gray.*

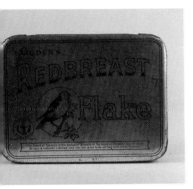

Redbreast Flake, Ogden, Imperial Tobacco Co. (Great Britain & Ireland), Liverpool. 1.25″ x 6″ x 4.5″. *Courtesy of C.J. Simpson.*

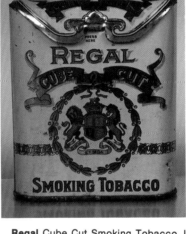

Regal Cube Cut Smoking Tobacco, Imperial Tobacco Co. Elegant embossed flip top pocket. Rare in this condition because of the thin finish. 4″ x 3.5″ x 1.25″. *Courtesy of Dennis O'Brien and George Goehring.*
Regimental Mixture, John Middleton, Philadelphia. Lithographed tin. 2.25″ x 2″ x 2″. *Courtesy of C.J. Simpson.*

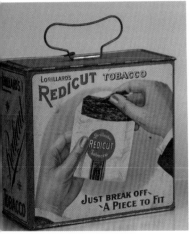

Redicut Tobacco, P. Lorillard. Lithographed tin lunch box. 7.25″ x 8″ x 3.75″. *Courtesy of Betty Lou and Frank Gay.*

Reel Cut Plug, Scotten, Dillon Co.,, Detroit. Paper. *Courtesy of Betty Lou and Frank Gay.*

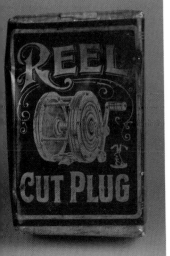

Reinhard's Virginia Cut Plug, Reinhard Bros., New York (Factory No. 1, 6th Virginia). Tin with paper label. Top: 2.5″ x 5.25″ x 4″; bottom: 3″ x 7″ x 5″. *Courtesy of C.J. Simpson.*

117

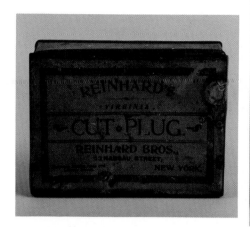

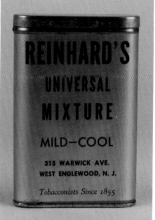

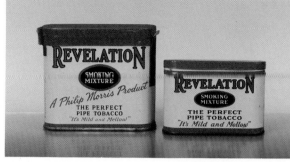

Revelation Smoking Mixture pocket and sample. Philip Morris Co. 3" x 3.5" x 1", 2" x 3" x .75". *Courtesy of Dennis O'Brien and George Goehring.*

Reinhard's Virginia Cut Plug, Reinhard Bros., New York (Factory No. 2, Maryland). Tin with paper label. 2" x 4.5" x 3". *Courtesy of C.J. Simpson.*
Reinhard's Universal Mixture, Reinhard's, Englewood, New Jersey (Factory No. 93, 1st Missouri). Tin with paper label. 4.5" x 3". *Courtesy of C.J. Simpson.*

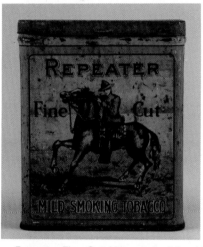

Rex, Spaulding & Merrick, Chicago, Liggett & Myers Tobacco Co., Successor (Factory No. 3, 1st Illinois). Lithographed tin, 4.5" x 4.5" x 3". *Courtesy of C.J. Simpson.*
Rex Tobacco pocket. Spaulding and Merrick, Chicago, Illinois, branch of Liggett & Myers Tobacco Co. (Factory No. 3, 1st Illinois) 4.5" x 3" x 1". *Courtesy of Dennis O'Brien and George Goehring.*

Repeater Fine Cut. Lithographed tin. 4.25" x 3.75". *Courtesy of C.J. Simpson.*
Reposed Chipped Plug, John Middleton, Philadelphia. 3.5" x 4" x 4". *Courtesy of C.J. Simpson.*

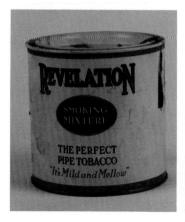

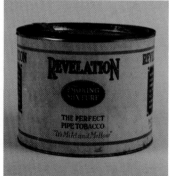

Rex Mixture, Imperial Tobacco Company, Montreal. Lithographed tin. Left 2.25" x 6.5" x 4"; right 4.5" x 4" x 2.25". *Courtesy of C.J. Simpson.*

Rex Virginia Straight Cut Cigarettes, Imperial Tobacco Company, Montreal. Lithographed tin. 1.5" x 5.5" x 3.25". *Courtesy of C.J. Simpson.*

Revelation Smoking Mixture, Philip Morris, New York (Factory No. 15, Virginia). Lithographed tin. 4.5" x 4". *Courtesy of C.J. Simpson.*
Revelation Smoking Mixture, Philip Morris (Factory No. 15, Virginia). Tin with paper label. 4.5" x 5". *Courtesy of C.J. Simpson.*

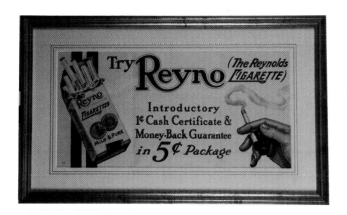

Reyno Cigarettes, R.J. Reynolds, advertisement, c. 1914. Paper. 9" x 18". *Courtesy of Thomas Gray.*

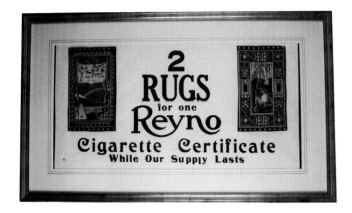

Reyno Cigarettes sign. As a premium Reyno offered felts of rugs. This sign features the actual felts applied to the paper sign. Sign: 12" x 25"; felts: 8" x 5". *Courtesy of Thomas Gray.*

R.J. Reynolds paper tag featuring the Reynolds factory, 1895. 7.75" x 7.75". *Courtesy of Thomas Gray.*

Reynolds Natural Leaf Chewing Tobacco, R.J. Reynolds Tobacco Co., Winston-Salem (Factory No. 8, North Carolina). Lithographed tin. .75" x 3.5" x 3.5". *Courtesy of Thomas Gray.*

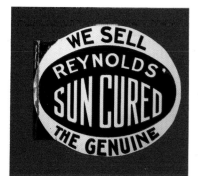

Reynolds' Sun Cured. Two sided tin sign, H.D. Beach Co., Coshocton, Ohio. 13.5" x 12". *Courtesy of Thomas Gray.*

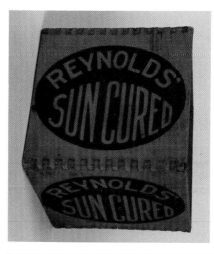

Reynolds' Sun Cured, R.J. Reynolds, Winston-Salem. Wood caddy. 7" x 7". *Courtesy of Thomas Gray.*

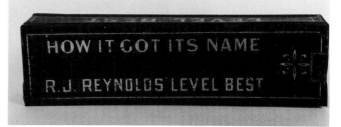

R.J. Reynold's Level Best tobacco. Lithographed tin. The top tells how it got its name-after carefully selecting and brushing the choicest leaves produced on original soil or home for nature's best production of chewing tobacco and pressing it into plug it was pronounced, R.J. Reynolds Level Best. *Courtesy of Thomas Gray.*

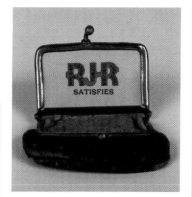

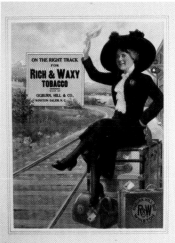

R.J. Reynolds coin purse. A coupon premium or advertising piece, this is a leather purse with engraved metal works. 2.5". *Courtesy of Thomas Gray.*

Rich & Waxy, Ogburn, Hill & Co., Winston-Salem, North Carolina, hanger, c. 1890. Ogburn, Hill & Company was acquired by R.J. Reynolds in 1912. 15" x 19". *Courtesy of Thomas Gray.*

Richman's Straight Cut Segars (Factory No. 128, 11th Ohio). Lithographed humidor tin. 4" x 5" x 5". *Courtesy of C.J. Simpson.*

Richmond Belle Old Style Cut Plug, Cameron & Cameron, Richmond (Factory No. 4, 2nd Virginia). Lithographed tin. 1.25″ x 4.5″ x 3″. *Courtesy of Betty Lou and Frank Gay.*

Richmond Gem Cigarettes (50), Allen & Ginter, Imperial Tobacco Co. (Great Britain & Ireland), Successors in the United Kingdom. Lithographed tin. 1.25″ x 5.5″ x 2.75″. *Courtesy of C.J. Simpson.*

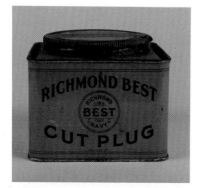

Richmond Best Cut Plug, Larus & Bro Co., Richmond (Factory 45, 2nd Virginia), 1926 stamp. Lithographed tin. 4″ x 5.25″ x 5″. *Courtesy of C.J. Simpson.*

Richmond Gem Cigarettes, Allen & Ginter, Imperial Tobacco Co. (Great Britain & Ireland), Successors in the United Kingdom. Lithographed tin. 1.25″ x 4.25″ x 2.75″. *Courtesy of C.J. Simpson.*

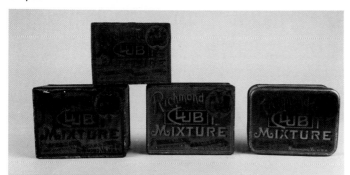

Richmond Club Mixture, Cameron & Cameron, Richmond (Factory No. 4, 2nd Virginia). Lithographed tin. Top: 2″ x 4″ x 2.75″; Bottom, all: 2.25″ x 4.5″ x 3.25″. *Courtesy of C.J. Simpson.*

Richmond Club Mixture, Cameron & Cameron, Richmond. Lithographed tin. 2.25″ x 4.5″ x 3.25″. *Courtesy of Betty Lou and Frank Gay.*

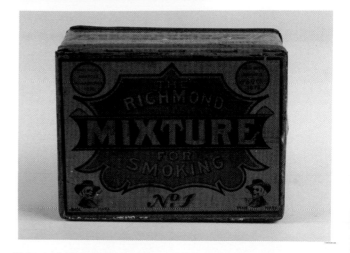

Richmond Mixture No. 1, Allen & Ginter, Richmond (Factory 14, 2nd Virginia). Lithographed tin, Ginna. 2″ x 4.5″ x 3″. *Courtesy of C.J. Simpson.*

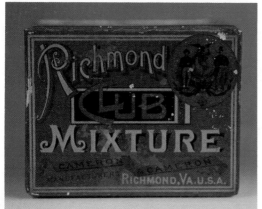

Richmond Star Mixture, Cameron & Cameron, Richmond (Factory No. 4, 2nd Virginia). 2.25″ x 4.5″ x 3.25″. *Courtesy of C.J. Simpson.*

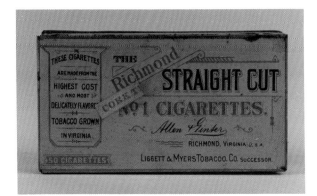

Richmond Straight Cut, No. 1 Cigarettes (50), Allen & Ginter, Liggett & Myers Tobacco Co., Successor, Richmond. Lithographed tin. *Courtesy of C.J. Simpson.*

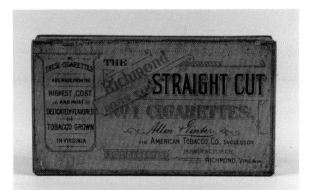

Richmond Straight Cut, No. 1 Cigarettes (50), Allen & Ginter, American Tobacco Company, Successor, Richmond. Lithographed tin. *Courtesy of C.J. Simpson.*

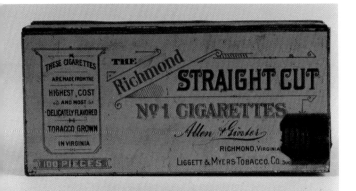

Richmond Straight Cut, No. 1 Cigarettes (100), Allen & Ginter, Liggett & Myers Tobacco Company, Successor, Richmond. Lithographed tin. *Courtesy of C.J. Simpson.*

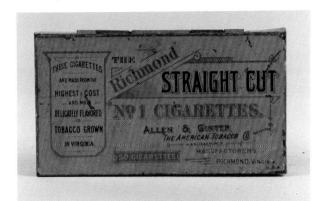

Richmond Straight Cut No. 1 Cigarettes (50), Allen & Ginter, American Tobacco Company, Successor, Richmond. Lithographed tin. *Courtesy of C.J. Simpson.*

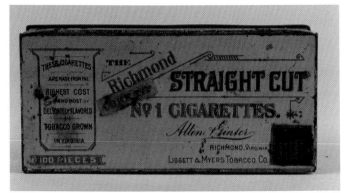

Richmond Straight Cut No. 1 Cigarettes (Cork Tipped, 100), Allen & Ginter, Liggett & Myers Tobacco Company, Richmond. Lithographed tin. 3.25" x 6.5" x 3". *Courtesy of C.J. Simpson.*

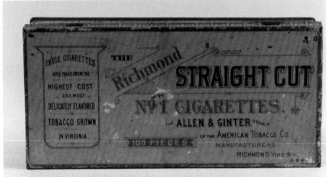

Richmond Straight Cut, No. 1 Cigarettes (100), Allen & Ginter Branch of the American Tobacco Co., Richmond. Lithographed tin. *Courtesy of C.J. Simpson.*

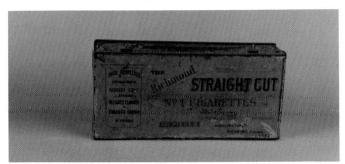

Richmond Straight Cut, No. 1 Cigarettes (100), Allen & Ginter, American Tobacco Company, Successor. Lithographed tin. 1.75" x 6.75" x 3". *Courtesy of C.J. Simpson.*

Rigby's Value, J.A. Rigby Cigar Co., Mansfield, Ohio (Factory No. 463, Ohio). 5.25" x 6" x 4". *Courtesy of C.J. Simpson.*

 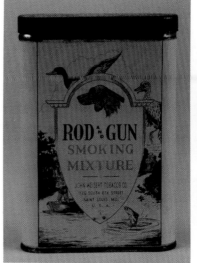 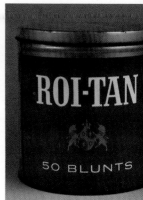

Rigby's Rough Havanas, Rigby Tobacco Co., Ohio. Tin with paper label. 5.25″ x 3.75″ x 3.5″. *Courtesy of Betty Lou and Frank Gay.*
Ripple Cigarette Case, P. Lorillard Co. Lithographed tin. 3″ x 3″. *Courtesy of C.J. Simpson.*

Rod and Gun Smoking Mixture, John Weisert Tobacco Co., St. Louis (Factory No. 93, 1st Missouri). Tin with paper label, 4.5″ x 3″. *Courtesy of C.J. Simpson.*
Roi-Tan Blunts (50), American Cigar, New York. *Courtesy of C.J. Simpson.*

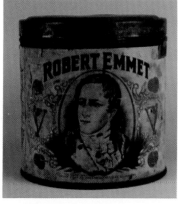 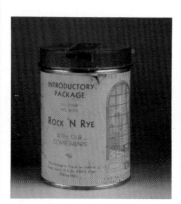 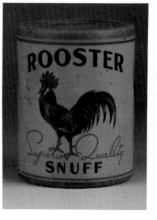 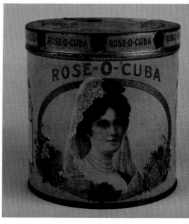

Robert Emmet Cigars, Spietz Cigar Co., Detroit, Mich., successors (Factory No. 3, Michigan). Tin with paper label. 5.25″ x 5.25″ x 5.25″. *Courtesy of C.J. Simpson.*
Rock 'N Rye sample, Christian Peper, Missouri (Factory No. 3, Missouri), Series 109 stamp. Tin with paper label, 4″ x 3″. *Courtesy of C.J. Simpson.*

Rooster Snuff, sample, United States Tobacco, Nashville (Factory No. 33, Tennessee) 2.5″ x 1.5″. *Courtesy of C.J. Simpson.*
Rose-O-Cuba, Fleck Cigar, Reading, Pennsylvania (Factory No. 77, 1st Pennsylvania). Lithographed Tin, Liberty Can Co. 5.5″ x 5.25″. *Courtesy of C.J. Simpson.*

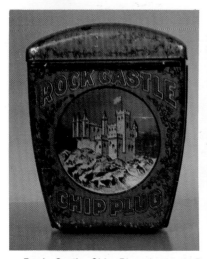 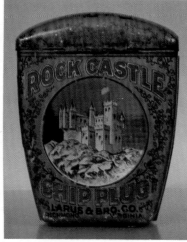 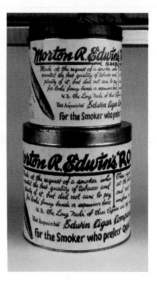

Rock Castle Chip Plug, Larus & Bros. Co., Richmond, Virginia. Lithographed tin pocket in a unique shape. The disc with the Castle is concave on both the front and back. 4″ x 3.25″ x 1″. *Courtesy of Dennis O'Brien and George Goehring.*

"Roughneck" and **"Roughneck" Shrimps Cigars,** Edwin Cigar Company, New York. The smaller tin is from Factory No. 1850, 3rd New York; the larger is from Factory No. 808, 1st Pennsylvania. 6″ x 6 and 5″ x 5″. *Courtesy of C.J. Simpson.*

122

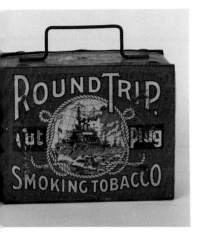

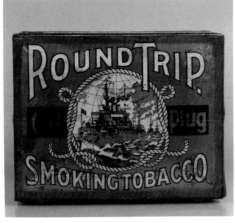

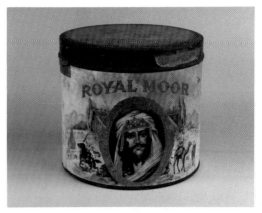

Royal Moor Cigars (Factory No. 249, 14th New York). Tin with paper label. 5″ x 5.5″. *Courtesy of C.J. Simpson.*

Round Trip Cut Plug Smoking Tobacco, Larus & Bros. Lithographed tin lunch box. 5″ x 6.5″ x 3.5″. *Courtesy of Dennis O'Brien and George Goehring.*
Round Trip Smoking Tobacco, Larus & Bros., Richmond, Virginia (Factory No. 45, 2nd Virginia). Lithographed tin with rounded top. 3.75″ x 6.50″ x 5″. *Courtesy of Betty Lou and Frank Gay.*

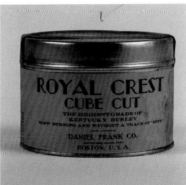

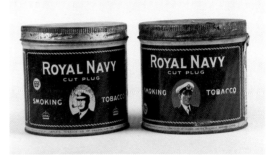

Royal Navy Cut Plug, Imperial Tobacco Co. of Canada, Montreal. Lithographed tin. 4.25″ x 4″. *Courtesy of C.J. Simpson.*

Royal Flake Cut Tobacco, Frishmuth Bro. & Co., Philadelphia (Factory No. 1, 1st Pennsylvania). Lithographed tin. 2.25″ x 5″ x 3″. *Courtesy of C.J. Simpson.*
Royal Crest Cube Cut, Daniel Frank Co., Boston (Factory No. 17, Massachusetts), 1910 stamp. Tin with paper label. 3″ x 4″. *Courtesy of C.J. Simpson.*

Royal Standard Bird's Eye, Surbrug, New York (Factory No. 16, 2nd New York). Lithographed tin. 2″ x 3.25″ x 4.5″. *Courtesy of C.J. Simpson.*

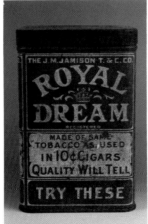

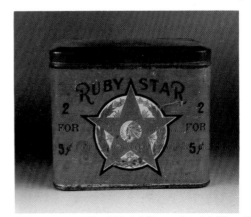

Royal Derby, Ed. Lauens, Egypt. Lithographed tin. 1″ x 5″ x 3″. *Courtesy of C.J. Simpson.*
Royal Dream Cigars, J.M. Jamison Tobacco & Cigar Co. (Factory No. 835, Maryland). 6″ x 4″ x 4″. *Courtesy of C.J. Simpson.*

Ruby Star Cigar (Factory No. 281, 1st Pennsylvania). Tin with paper label. 5″ x 6.25 3.5″. *Courtesy of C.J. Simpson.*

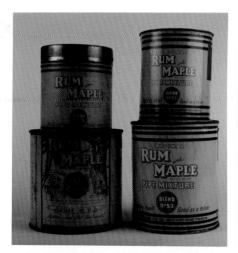

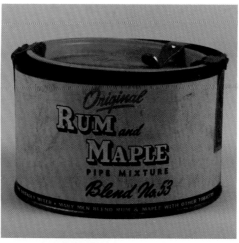

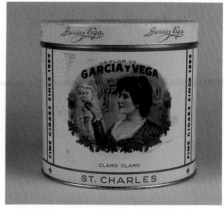

St. Charles, Garcia Y Vega. Lithographed tin. 5.5" x 5". *Courtesy of C.J. Simpson.*

Rum and Maple, The Rum and Maple Tobacco Co., New York (Factory No. 6, Kentucky). Bottom left: oldest in group, copyright 1939, lithographed tin, 5.75" x 5"; top left: "The Original," tin with paper label, 5" x 5"; top right: "Original," lithographed tin, 5" x 5"; bottom right: "Original," lithographed tin, 6" x 5.5". *Courtesy of C.J. Simpson.*

Rum and Maple Pipe Mixture, The Rum and Maple Tobacco Co., New York (Factory No. 6, Kentucky), copyright 1949. Lithographed tin. 3" x 4". *Courtesy of C.J. Simpson.*

St. James Mixture, Cameron & Cameron, Richmond (Factory No. 4, 2nd Virginia). Lithographed tin, 2.25" x 5.5" x 3". *Courtesy of C.J. Simpson.*

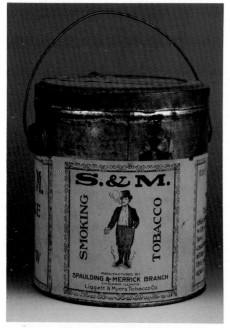

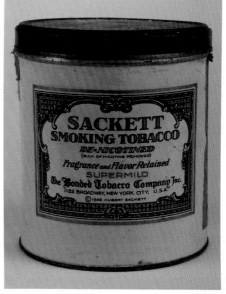

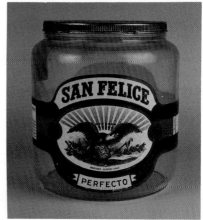

S & M Tobacco, Spaulding & Merrick Branch, Liggett & Myers Tobacco Co. Tin pail with paper half-label. 6" x 5.5". *Courtesy of Betty Lou and Frank Gay.*

Sackett Smoking Tobacco, De-Nicotined, Bonded Tobacco Company, Inc., New York (Factory No. 12, 5th New Jersey), copyright 1928, Hubert Sackett. Lithographed tin, Continental Can Co., Passaic, New Jersey. 5.75" x 5". *Courtesy of C.J. Simpson.*

San Felice Cigars, DWG Corp. (Factory No. 155, 10th Ohio). Glass jar with lithographed paper label and tin lid. 6.25" x 5.5". *Courtesy of C.J. Simpson.*

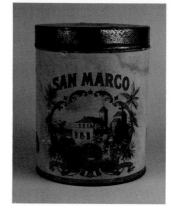

St. Bruno Flake, Ogden's, Imperial Tobacco Co. (Great Britain & Ireland), Liverpool. Lithographed tin. 1.25" x 6.25" x 4.5". *Courtesy of C.J. Simpson.*

San Marco Cigars (Factory No. 21, 9th Pennsylvania), 1916 stamp. Tin with paper label. 5.25" x 4.5". *Courtesy of C.J. Simpson.*

Sanches Grande Cigar (Factory No. 1040, 1st Illinois). Tin with embossed paper label. 4.75" x 3" x 3". *Courtesy of C.J. Simpson.*
Sante Fe Blunt Cigars, Ohio. Lithographed tin. 6" x 5" x 5". *Courtesy of C.J. Simpson.*

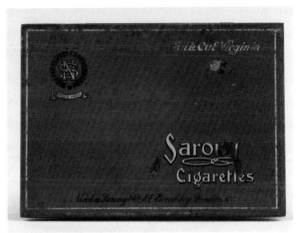

Sarony Cigarettes, Nicolas Sarony & Co., London. Lithographed tin. 0.5" x 5.75" x 4.5". *Courtesy of C.J. Simpson.*

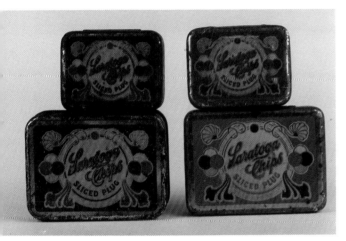

Saratoga Chips Sliced Plug, United States Tobacco Co., Richmond (Factory No. 15, 2nd Virginia). Lithographed tin. Large tins: 1.25" x 4.25" x 3"; small tins: 1.25" x 3" x 2.5". *Courtesy of C.J. Simpson.*

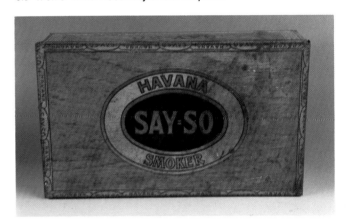

Say'So Havana Smokers (Factory 11, Maryland). Lithographed tin. 2.5" x 9" x 5". *Courtesy of C.J. Simpson.*

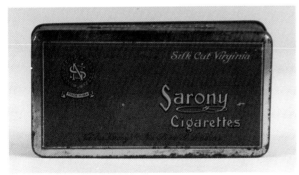

Sarony Cigarettes, Nicholas Sarony & Co., London. Lithographed tin. 1.5" x 5.5" x 3.25". *Courtesy of C.J. Simpson.*

Schnapps Chewing Tobacco, R.J. Reynolds, Winston-Salem. Wood caddy and paper label. 8" x 7". *Courtesy of Thomas Gray.*

Schnapps Chewing Tobacco, R.J. Reynolds, Winston-Salem. Kicking machine advertisement, paper. The name Schnapps came about as a typographical error. An earlier Reynolds product, Snaps, appeared first in 1885 was a big success. One day labels came from the printer with the name misspelled. This angered Reynolds until he was told that Schnapps was the name of a popular German beverage. The change became permanent. The kicking machine theme was used for more than four decades. 3.5" x 4". *Courtesy of Thomas Gray.*

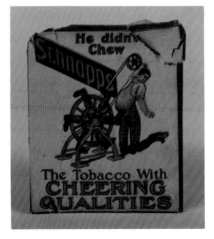

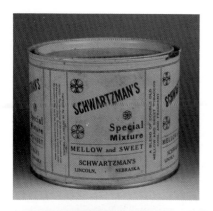

Schwartzman's Special Mixture, Schwartzman's, Lincoln, Nebraska (Factory No. 15, Virginia). Tin with paper label. 4.25" x 5". *Courtesy of C.J. Simpson.*

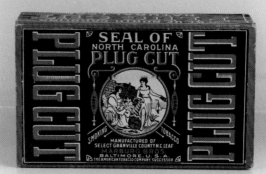

Seal of North Carolina, Marburg Bros., Baltimore, Maryland, American Tobacco Co., Successor. Wood box with paper labels. 2" x 7" x 4". *Courtesy of Betty Lou and Frank Gay.*

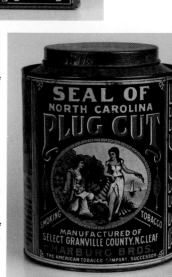

Seal of North Carolina small top canister, c. 1902. Marburg Bros., the American Tobacco Company, successor. 6.25" x 5". *Courtesy of Dennis O'Brien and George Goehring.*

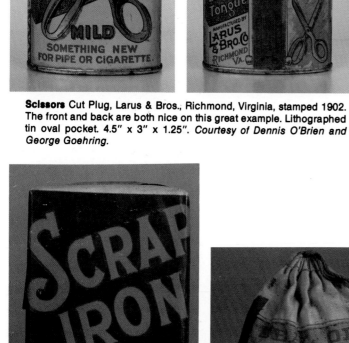

Scissors Cut Plug, Larus & Bros., Richmond, Virginia, stamped 1902. The front and back are both nice on this great example. Lithographed tin oval pocket. 4.5" x 3" x 1.25". *Courtesy of Dennis O'Brien and George Goehring.*

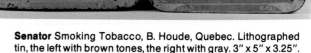

Senator Smoking Tobacco, B. Houde, Quebec. Lithographed tin, the left with brown tones, the right with gray. 3" x 5" x 3.25". *Courtesy of C.J. Simpson.*

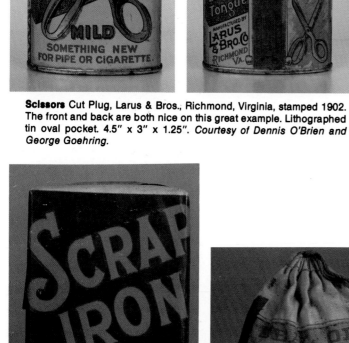

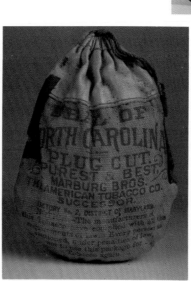

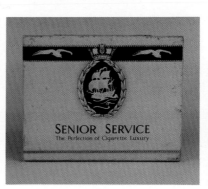

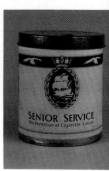

Scrap Iron Scrap, Luhrman & Wilbern Tobacco Company, P. Lorillard, Successor, 1910 stamp. Paper. *Courtesy of Betty Lou and Frank Gay.*
Seal of North Carolina, Marburg Bros., American Tobacco Company, Successor (Factory No. 2, Maryland). Cloth bag. *Courtesy of Betty Lou and Frank Gay.*

Senior Service Cigarettes, J. A. Pattreiouex (Overseas) Limited, England. Lithographed tin. 0.5" x 5.5" x 4.25". *Courtesy of C.J. Simpson.*

Senior Service, J.A. Pattreiouex (Overseas) Ltd., England. 3" x 2.75". *Courtesy of C.J. Simpson.*

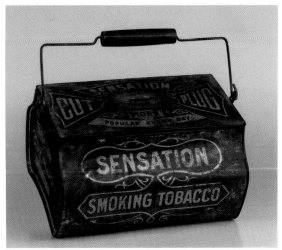

Sensation Cut Plug, P. Lorillard Company. Tin with paper label and embossed lid, Ilsley. 3″ x 6″ x 3.75″. *Courtesy of C.J. Simpson.*
Sensation Cut Plug, P. Lorillard Co., Jersey City (Factory No. 6, 1st Ohio). Lithographed tin. 6″ x 4.5″. *Courtesy of C.J. Simpson.*

Sensation Cut Plug. P. Lorillard, Jersey City (Factory No. 10, 5th New Jersey). Lithographed tin lunch box. 4.25″ x 7.5″ x 6″. *Courtesy of Betty Lou and Frank Gay.*

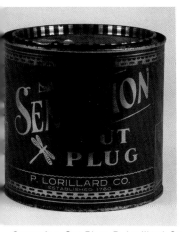
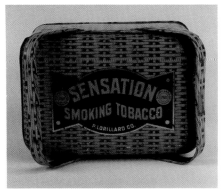

Sensation Cut Plug, P. Lorillard Co., Jersey City (Factory No. 6, 1st Ohio). Lithographed tin. 5″ x 5″. *Courtesy of C.J. Simpson.*
Sensation Smoking Tobacco, P. Lorillard Co., Jersey City (Factory No. 6, 1st Ohio). Lithographed tin, 4.5″ x 7″ x 4.5″. *Courtesy of C.J. Simpson.*

Sensation Christmas tin, side view.

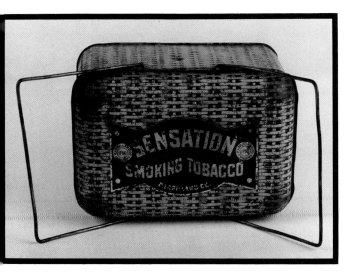

Sensation Smoking Tobacco, P. Lorillard Co. (Factory No. 10, 5th New Jersey). Lithographed tin. 5″ x 7″ x 4.5″. *Courtesy of C.J. Simpson.*

Sensation Smoking Tobacco, P. Lorillard Co. (Factory No. 10, 5th New Jersey). Lithographed Christmas tin with Asian motif. 5″ x 7″ x 4″. *Courtesy of C.J. Simpson.*

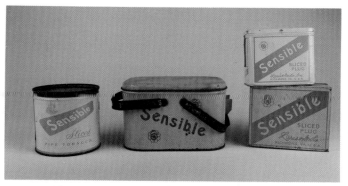

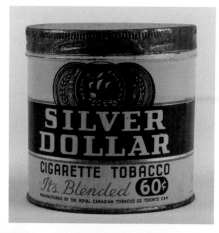

Sensible Sliced, Larus & Bro. Co., Richmond (Factory 45, 2nd Virginia). Lithographed tin. L-R: 4″ x 4″, 1926 stamp; lunchbox, 4.25″ x 7″ x 5″; (bottom) 3.75″ x 4.5″ x 3″; (top) 3.75″ x 3″ x 3″. *Courtesy of C.J. Simpson.*

Silver Dollar Cigarette Tobacco, Royal Canadian Tobacco Co., Toronto. Lithographed tin. 4.25″ x 4.25″. *Courtesy of C.J. Simpson.*

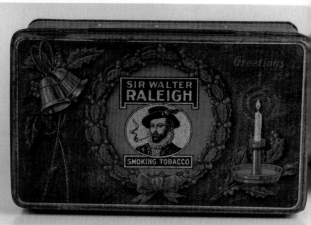

Setos Amber Egyptian Cigarettes, Nestor Gianaclis Ltd., Cairo. Lithographed tin with reverse shown. 1.5″ x 4.5″ x 3″. *Courtesy of C.J. Simpson.*

Sir Walter Raleigh Christmas tin, Brown & Williamson Tobacco, Louisville, KY. 3.5″ x 7.5″ x 4.25″. *Courtesy of Betty Lou and Frank Gay.*

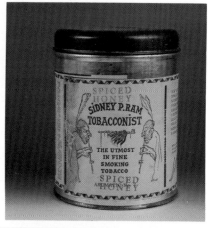

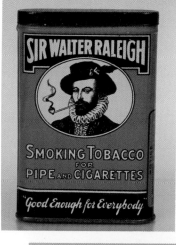

Shot Plug Cut Mix, Cameron & Cameron (Factory No. 2, Maryland). Lithographed tin. 3.75″ x 2.5″ x 1.25″. *Courtesy of C.J. Simpson.*
Sidney P. Ram Tobacconist, Chicago (Factory No. 8, 1st Illinois). Tin with paper label. 5.25″ x 4″. *Courtesy of C.J. Simpson.*

Silk Cut Cigarettes. Lithographed tin. .75″ x 6″ x 4.5″. *Courtesy of C.J. Simpson.*

Sir Walter Raleigh Smoking Tobacco pocket. Unusual with the name on one line. Brown & Williamson Tobacco Co., Winston-Salem, North Carolina. 4.5″ x 3″ x 1″. *Courtesy of Dennis O'Brien and George Goehring.*

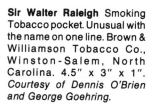

Skiff Mixture Samuel Gawith, Kendal, England. Lithographed tin. 1″ x 4.5″ x 3.25″. *Courtesy of C.J. Simpson.*

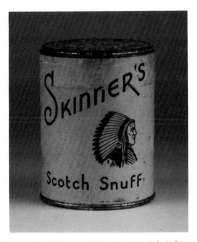

Skinner's Snuff. Embossed glass. 7.25" x 3". *Courtesy of C.J. Simpson.*
Skinner's Scotch Snuff, United States Tobacco (Factory No. 33, Tennessee). 2.25" x 1.5". *Courtesy of C.J. Simpson.*

Society Snuff (Factory No. 4, 5th New Jersey). Cardboard with paper label. 2" x 1.25". *Courtesy of C.J. Simpson.*
Spanish Export Cigars (Factory No. 475, 9th Pennsylvania). Lithographed tin, American Can Co. 5" x 4.5". *Courtesy of C.J. Simpson.*
Special Cigar, The D'W Company (Factory 88, 10th Ohio), 1910 stamp. Lithographed tin, Heekin Can Company, Cincinnati, Ohio. 5" x 3" x 3". *Courtesy of C.J. Simpson.*

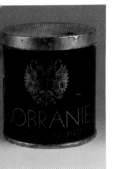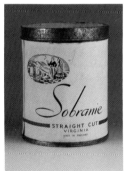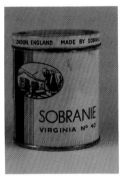

Sobranie Black and Gold Russian Cigarettes, Sobranie Ltd., London. 3" x 3". *Courtesy of C.J. Simpson.*
Sobranie Straight Cut Virginia Cigarettes, Sobranie Limited, London. 3.25" x 2.5". *Courtesy of C.J. Simpson.*
Sobranie Virginia No. 40 Cigarettes, Sobranie Limited, London. Lithographed tin. 3.25" x 2.75". *Courtesy of C.J. Simpson.*

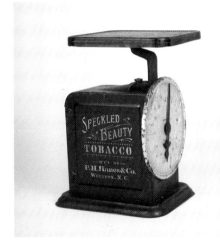

Speckled Beauty Tobacco scale, advertising P.H. Hanes & Co, Winston-Salem. Steel. 9" x 6". *Courtesy of Thomas Gray.*

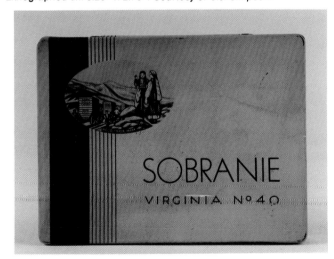

Sobranie Virginia No. 40, England. Lithographed tin. .75" x 6" x 4.5". *Courtesy of C.J. Simpson.*

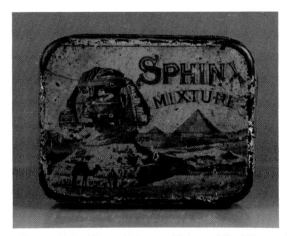

Sphinx Mixture, United States Tobacco, Richmond, Va. Lithographed tin. 3.25" x 4.25" x 1.25". *Courtesy of Betty Lou and Frank Gay.*

129

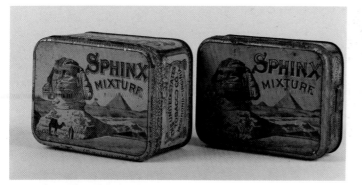

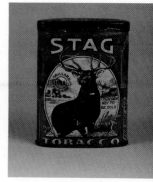

Sphinx Mixture, United States Tobacco Co., Richmond (Factory No. 15, 2nd Virginia). Lithographed tin. Left: 2.5" x 4.5" x 2.5"; right: 1" x 4.5" x 2.5". *Courtesy of C.J. Simpson.*

Squatter Brand, Cameron & Cameron, Richmond (Factory No. 4, 2nd Virginia). Lithographed tin, Hasker & Marcuse. 2.25" x 4.25" x 2.25". *Courtesy of C.J. Simpson.*
Stag Tobacco sample, P. Lorillard Co., Jersey City, New Jersey. Lithographed oval tin. 3.5" x 2.75" x .75". *Courtesy of C.J. Simpson.*

Spinet Cigarettes, R & J. Hill, Ltd, London. Lithographed tin. 0.5" x 3.5" x 3". *Courtesy of C.J. Simpson.*

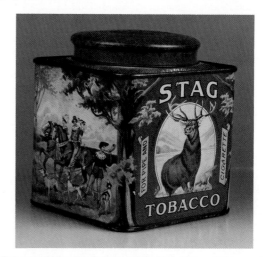

Stag Tobacco, P. Lorillard, Jersey City, New Jersey. Lithographed tin. A larger size exists. 4.5" x 4" x 4". *Courtesy of Betty Lou and Frank Gay.*

Sportsman Cigarettes. Lithographed tin. 0.5" x 5.75" x 4.5". *Courtesy of C.J. Simpson.*

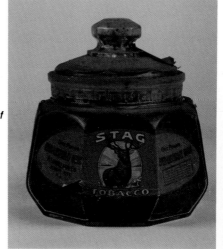

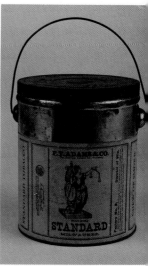

Square Snuff box and sample, George W. Helme Co. (Factory No. 4, Delaware). Tin with paper label. 2.25" x 1.5". *Courtesy of C.J. Simpson.*

Stag Tobacco, P. Lorillard, Jersey City (Factory No. 10, 5th New Jersey). Glass and paper. 6" x 6". *Courtesy of C.J. Simpson.*
Standard, F.F. Adams & Co., Milwaukee, American Tobacco Company, Successor (Factory No. 2, Wisconsin), 1910 stamp. Tin pail with paper half label. 6.5" x 5.5". *Courtesy of C.J. Simpson.*

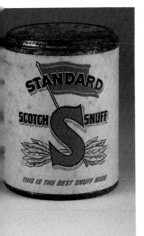 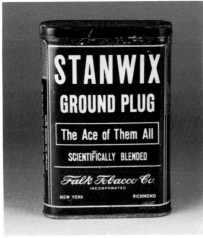

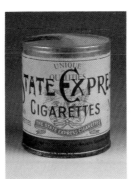

State Express Cigarettes, Ardath Tobacco Co., London. 3″ x 2.75″. *Courtesy of C.J. Simpson.*
State Express 333, Ardath Tobacco Co., London. Lithographed tin. 1.25″ x 5.75″ x 3″. *Courtesy of C.J. Simpson.*

Standard Scotch Snuff, sample, Standard Snuff Co., United States Tobacco Co., Successor, Nashville. 2.25″ x 1.75″. *Courtesy of C.J. Simpson.*
Stanwix Ground Plug, Falk Tobacco Co., New York, Richmond, back view. Lithographed tin, American Can Co. *Courtesy of Elsie and John Booker.*

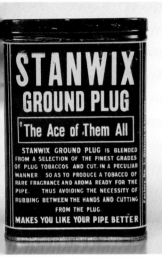 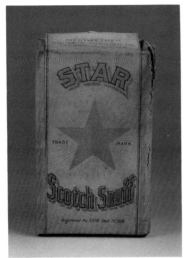

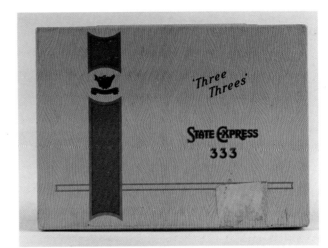

State Express 333 Cigarettes, Ardath Tobacco Co. Ltd., London. Lithographed tin. 0.5″ x 5.75″ x 4.5″. *Courtesy of C.J. Simpson.*

Stanwix Ground Plug Tobacco, Falk Tobacco Co., American Tobacco Co., Successor. Front View. Uncirculated lithographed tin pocket, originally from the Tindeco sample room, Baltimore, Maryland. 4.5″ x 3″ x 1″. *Courtesy of Dennis O'Brien and George Goehring.*
Star Scotch Snuff, Meriwether Snuff & Tobacco Co., Clarksville, Tennessee (Factory No. 140, 5th Tennessee). Cardboard box. 3″ x 2″ x 1″. *Courtesy of C.J. Simpson.*

State Express Cigarettes, Ardath Tobacco Co. Ltd., London. Lithographed tin. 0.5″ x 3.5″ x 3″. *Courtesy of C.J. Simpson.*

State Express Cigarettes, Ardath Tobacco Co. Ltd., London. 0.5″ x 3.25″ x 3″. *Courtesy of C.J. Simpson.*

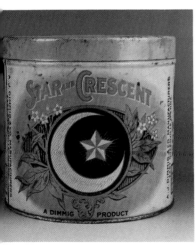

Star & Crescent Cigars, A.J. Dimmig & Co., East Greenville, Pennsylvania (Factory No. 353, 1st Pennsylvania). Lithographed tin, Liberty Can, Lancaster, Pennsylvania. 4.5″ x 5″. *Courtesy of C.J. Simpson.*

State Express 555 Cigarettes (25), London. Lithographed tin. .75″ x 3″ x 4.5″. *Courtesy of C.J. Simpson.*

State Express 555 Cigarettes, Ardath Tobacco Co. Ltd., London. Lithographed tin. 0.5″ x 5.75″ x 4.5″. *Courtesy of C.J. Simpson.*

State Express 777 Cigarettes (50), Ardath Tobacco Co. Ltd., London. Lithographed tin. .75″ x 6″ x 4.5″. *Courtesy of C.J. Simpson.*

State Express 555 Cigarettes, Ardath Tobacco Co. Ltd., London. Lithographed tin. 0.5″ x 5.75″ x 4.5″. *Courtesy of C.J. Simpson.*

Steber Spanish Hand Made Cigars, distributed by Tinkham Bros, Jamestown, New York (Factory No. 546, 23rd Pennsylvania). Lithographed tin, Heekin Can Co., Cincinnati, Ohio. 5″ x 3″ x 3″. *Courtesy of C.J. Simpson.*

Steel King Pittsburgh Stogies, The Duquesne Cigar Co., Pittsburgh (Factory No. 1, 23rd Pennsylvania). Lithographed tin, Lockwood Mfg Co., Cincinnati. 6.5″ x 4.25″. *Courtesy of C.J. Simpson.*

State Express Cigarettes, Ardath Tobacco Co., London. 3″ x 2.75″. *Courtesy of C.J. Simpson.*
State Express 777, Ardath Tobacco Company, London. Lithographed tin. .75″ x 6″ x 4.5″. *Courtesy of C.J. Simpson.*

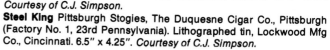

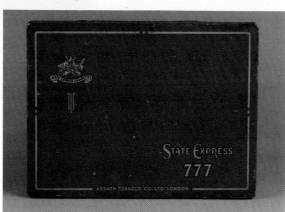

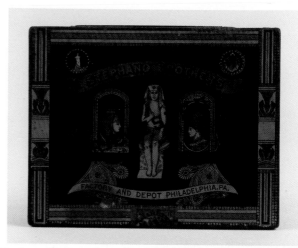

Stephano Brothers Cigarettes, Philadelphia. Lithographed 100s tin. 1.5″ x 5.5″ x 4.25″. *Courtesy of C.J. Simpson.*

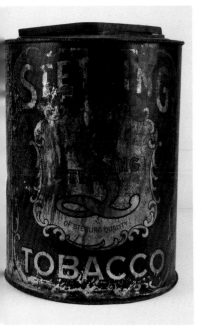

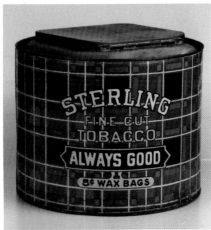

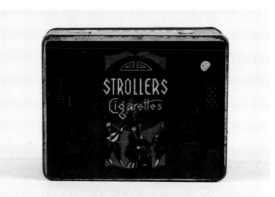

Strollers Cigarettes. Lithographed tin. 1.5" x 4". *Courtesy of C.J. Simpson.*

Sterling Fine Cut Tobacco. Lithographed tin store tin. 6.50" x 8.25". *Courtesy of Betty Lou and Frank Gay.*
Sterling Tobacco, Spaulding & Merrick. Lithographed store tin. 11" x 9". *Courtesy of C.J. Simpson.*

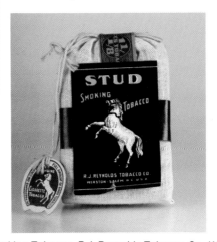

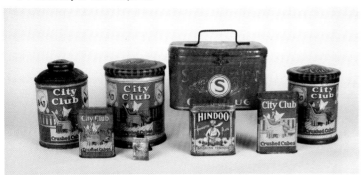

Stud Smoking Tobacco, R.J. Reynolds Tobacco Co., Winston-Salem, North Carolina. Cloth bag. 3.5" x 2.5". The trademark "Stud" was first used in 1884 by Allen Washington Turner, Macon, Georgia. It was purchased by Reynolds in 1909. *Courtesy of Thomas Gray.*

Strater Bros. Tobacco Co., Louisville, Kentucky (bought by R.J. Reynolds in 1919) made Hindoo, Satisfaction Cut Plug and City Club. Left to right: City Club canister, lithographed tin, 6.5" high; small City Club upright pocket, lithographed tin, 3.5" high; large canister, 6"; City Club watch fob, 4.75"; Hindoo pocket, 3.5"; Satisfaction Cut Plug, lunch box, 4.75" x 7.25"; City Club upright pocket, 4.5"; City Club canister, 5.75". *Courtesy of Thomas Gray.*

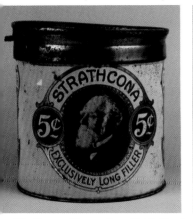

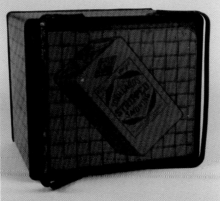

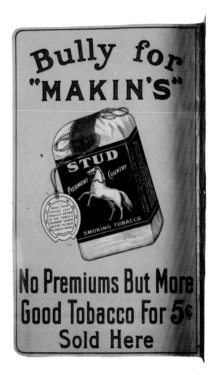

Strathcona Cigars, Forest Ltd., Montreal. Lithographed tin. 5.5" x 5.5". *Courtesy of C.J. Simpson.*
Stripped Smoking, P. Lorillard, Jersey City (Factory No. 10, 5th New Jersey). Lithographed tin lunch box. 6.25" x 9.25" x 8". *Courtesy of C.J. Simpson.*

Stud, R.J. Reynolds. Tin and enameled two-sided sign. 17.5" x 10.25". *Courtesy of Thomas Gray.*

133

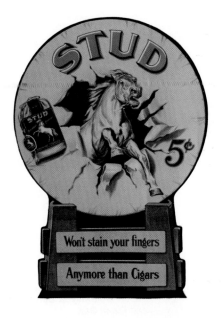

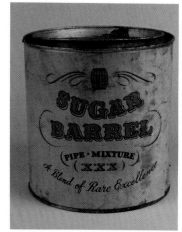

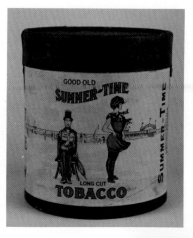

Good Old Summer-Time Long Cut Tobacco, Spaulding & Merrick, Liggett & Myers, Successors (Factory No. 74, 1st Missouri), Series 114, 1926 stamp. Cardboard with paper label. 5.75" x 5.25". *Courtesy of C.J. Simpson.*

Stud sign. Paper. *Courtesy of Thomas Gray.*

Sugar Barrel Pipe Mixture, Sugar Barrel Associates, Philadelphia, Pennsylvania, 1926 stamp. Tin with paper label. 5.25" x 5.25". *Courtesy of C.J. Simpson.*

Summit Cigarettes (100), International Tobacco Co., London. Lithographed tin. 1.5" x 6" x 4". *Courtesy of C.J. Simpson.*

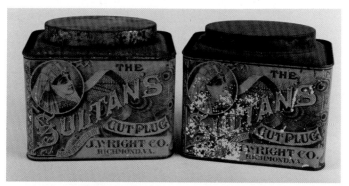

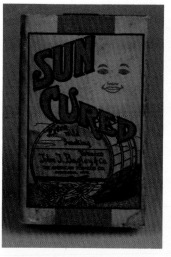

Sultan's Cut Plug, J. Wright Co., Richmond (Factory No. 51, 2nd Virginia). Lithographed tin. 5" x 6.25" x 3.75". *Courtesy of C.J. Simpson.*

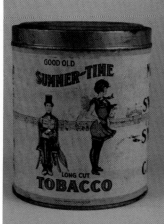

Sun Cured, John J. Bagley & Co., American Tobacco Co., Successor. Paper. *Courtesy of Betty Lou and Frank Gay.*

Sun Cured Tobacco, John J. Bagley & Co., Detroit, Michigan. Lithographed tin. 4.5" x 3" x 1". *Courtesy of Dennis O'Brien and George Goehring.*

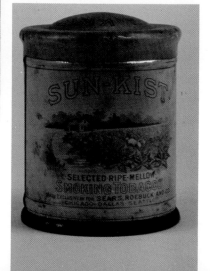

Sun-Kist Smoking Tobacco, made for Sears, Roebuck, & Co. Chicago (Factory No. 42, 2nd Virginia). Lithographed tin. 5" x 4". *Courtesy of C.J. Simpson.*

Sultan's Cut Plug, J. Wright Co., Richmond (Factory No. 51, 2nd Virginia). Lithographed tin. 1.75" x 4.5" x 2.5". *Courtesy of C.J. Simpson.*
Good Old Summer-Time Long Cut Tobacco, Spaulding & Merrick, Liggett & Myers (Factory 74, 1st Missouri). Tin with paper label. 6" x 5". *Courtesy of C.J. Simpson.*

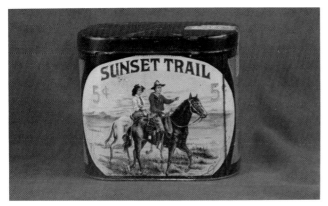

Sunset Trail Cigars, The Roby Cigar Co., Barnesville, Ohio. Lithographed tin. 5.5" x 6" x 4". *Courtesy of Joe and Sue Ferriola.*

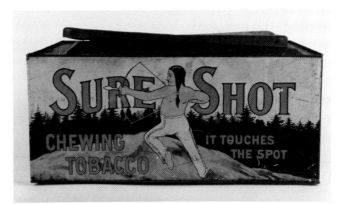

Sure Shot Chewing Tobacco. Lithographed tin. 7" x 15" x 7". *Courtesy of C.J. Simpson.*

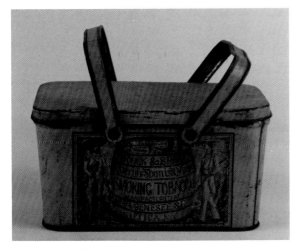

Superior Spanish Mixed Smoking Tobacco, Warnick & Brown, Utica, New York (Factory No. 1, 21st New York). Lithographed tin lunch box. 4" x 7.5" x 4.25". *Courtesy of C.J. Simpson.*

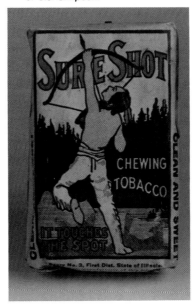

Sure Shot Chewing Tobacco, Spaulding & Merrick, Chicago (Factory No. 3, 1st Illinois). Paper. *Courtesy of Betty Lou and Frank Gay.*

Frank Gay.

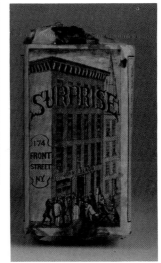

Surprise Cigarettes, John F. Flagg, New York. Paper. *Courtesy of Betty Lou and Frank Gay.*

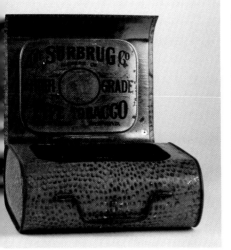

Surbrug High Grade Pipe Tobacco, The Surbrug Co., New York, Richmond. Lithographed tin pocket book. 2.25" x 7" x 5". *Courtesy of C.J. Simpson.*
Surbrug High Grade pocket book closed.

Sweet Afton Virginia Cigarettes, P. Carroll Co. Ltd, Dundalk, Ireland. Lithographed tin. 0.5" x 5.75" x 4.5". *Courtesy of C.J. Simpson.*

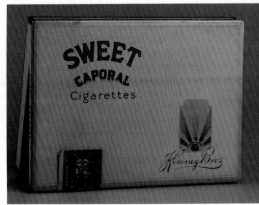

Sweet Burley Fine Cut Tobacco, Spaulding & Merrick, Chicago (Factory No. 3, 1st Illinois). Lithographed tin. 2" x 8". *Courtesy of C.J. Simpson.*

Sweet Burley Fine Cut Tobacco, Spaulding & Merrick, Chicago (Factory No. 3, 1st Illinois). Lithographed tin, 2.5" x 6" x 3.5". *Courtesy of C.J. Simpson.*

Sweet Caporal Cigarettes, Kinney Bros., Imperial Tobacco Co. of Canada. Lithographed tin. .75" x 5.75" x 4" *Courtesy of C.J. Simpson.*

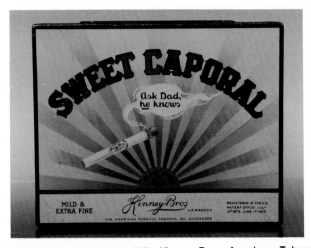

Sweet Caporal Cigarettes (50), Kinney Bros, American Tobacco Company, successor. 4.5" x 5.75" x .5". *Courtesy of Dennis O'Brien and George Goehring.*

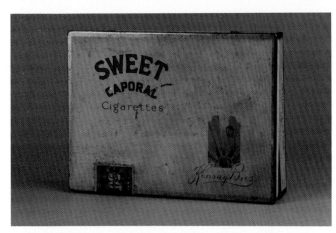

Sweet Caporal Cigarettes, Kinney Bros., Imperial Tobacco Co., of Canada. Lithographed tin with "50" written on the side and writing on the back. .75" x 5.75" x 4". *Courtesy of C.J. Simpson.*

Sweet Caporal Mild & Extra Fine Cigarettes (50), Kinney Bros., New York, Imperial Tobacco Co. of Canada, Ltd. Lithographed tin. 1.5" x 4.25" x 3". *Courtesy of C.J. Simpson.*

Sweet Caporal Kinney Bros. Aluminum. 3" x 1.5" x .75". *Courtesy of C.J. Simpson.*

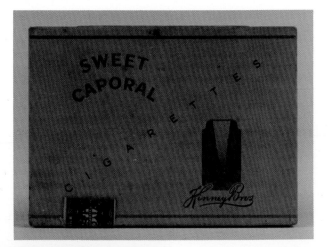

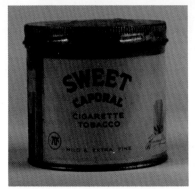

Sweet Caporal Cigarettes, Kinney Bros. Lithographed tin. 0.5" x 5.75" x 4.5". *Courtesy of C.J. Simpson.*

Sweet Caporal, Kinney Bros., 70 cents. Lithographed tin. 4.25" x 4.25". *Courtesy of C.J. Simpson.*

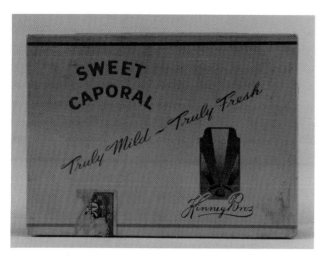

Sweet Caporal Cigarettes, Kinney Bros. Lithographed tin. 0.5″ x 5.75″ x 4.5″. *Courtesy of C.J. Simpson.*

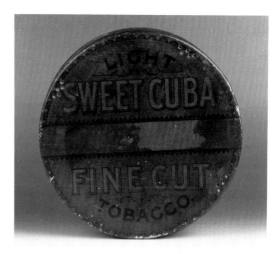

Sweet Cuba Light Fine Cut Tobacco, Spaulding & Merrick, Chicago. Lithographed tin. 2″ x 8.25″. *Courtesy of Betty Lou and Frank Gay.*

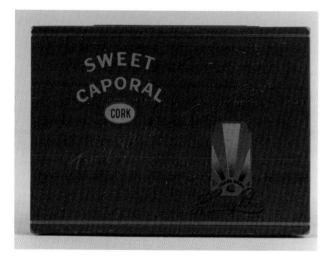

Sweet Caporal, Kinney Bros. Lithographed tin. .75″ x 6″ x 4.5″. *Courtesy of C.J. Simpson.*

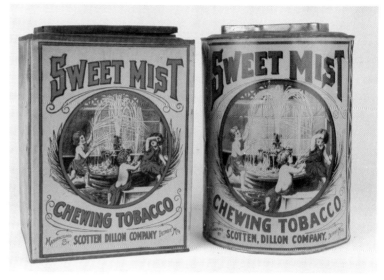

Sweet Mist Chewing Tobacco, Scotten Dillon Company, Detroit. Lithographed tin store bins. *Courtesy of Holt's Country Store, Grandview, Missouri.*

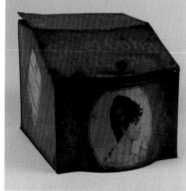

Sweet Cuba Fine Cut. Lithographed tin. 2″ x 8″. *Courtesy of C.J. Simpson.*

Sweet Cuba, Spaulding & Merrick, Chicago. Lithographed store bin. 8.5″ x 8.5″ x 9.5″. *Courtesy of C.J. Simpson.*

Sweet Mist Chewing Tobacco. Scotten, Dillon Company, Detroit (Factory No. 1, Michigan). Tin with paper label. 5.5″ x 3″. *Courtesy of C.J. Simpson.*

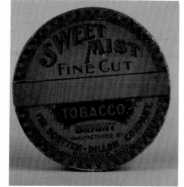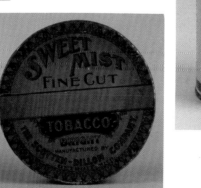

Sweet Mist Fine Cut Tobacco, Scotten-Dillon Company, Detroit (Factory No. 1, 1st Michigan). Lithographed tin. 2″ x 8″. *Courtesy of C.J. Simpson.*

T & B Cut Fine, Tuckett Tobacco Co. Limited, Hamilton, Ontario. Lithographed tin, 2.25" x 6.25" x 3.75". *Courtesy of C.J. Simpson.*

Sweet Tips Smoking Tobacco, Jno. J. Bagley, Detroit (Factory No. 6, 1st Michigan). Oval tin with paper label. 4" x 2.5". *Courtesy of C.J. Simpson.*
Sweet Tips flat top pocket. Jno. J. Bagley & Co., American Tobacco Co., Successor, found in the Tindeco sample room. Lithographed tin. 4.4" x 3" x 9". *Courtesy of Dennis O'Brien and George Goehring.*

T & B Myrtle Cut, Geo. E. Tuckett & Son Co., Hamilton, Ontario. Lithographed tin, MacDonald Manufacturing Co., Ltd., Toronto. 4" x 3.75" x 6.5". *Courtesy of C.J. Simpson.*

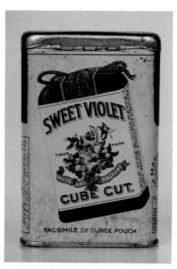

T & B Renowned, Tuckett Tobacco Co., Limited, Hamilton, Ontario. Lithographed tin. 3" x 5.25" x 3.5". *Courtesy of C.J. Simpson.*

Sweet Violet, Globe Tobacco Co., Detroit, Michigan, c. 1905. One of the prettiest of all pockets. Both sides are beautifully illustrated and details include a field of violets as the background. Lithographed tin. 4.5" x 3" x 1". *Courtesy of Dennis O'Brien and George Goehring.*

Tango Panatellos, "There's a Reason," Joseph Schwartz, Cleveland, Ohio (Factory No. 1945, 9th Pennsylvania). Lithographed tin, American Can Co. 6" x 4.5". *Courtesy of C.J. Simpson.*
Target Cigarette Case, Brown & Williamson, Louisville Kentucky. Lithographed tin. 3" x 3". *Courtesy of Elsie and John Booker.*

T & B Myrtle Cut, Tuckett Tobacco Co., Limited, Hamilton, Ontario. Lithographed tin. 4" x 6.5" x 3.75". *Courtesy of C.J. Simpson.*

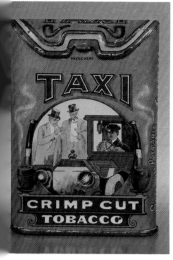
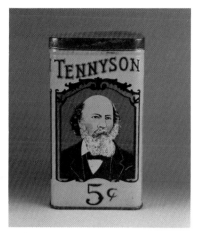

"Three Castles" Cigarettes, W.D. and H.O. Wills, Bristol and London, Imperial Tobacco Co. (of Great Britain and Ireland). Lithographed tin. 1.75" x 7" x 2.75". *Courtesy of C.J. Simpson.*

Taxi Crimp Cut Tobacco flip top pocket, Imperial Tobacco Company, Montreal. Lithographed tin with beautiful graphics, considered by many to be the best pocket ever. 4.5" x 3" x 1". *Courtesy of Dennis O'Brien and George Goehring.*

Tennyson Cigars, Mazer, Cressman Cigar Co., Inc., Detroit, Michigan (Factory No. 86, Ohio). Lithographed tin, Cadillac Can Co. 5.5" x 3" x 3". *Courtesy of C.J. Simpson.*

Three Feathers Plug Cut, American Tobacco Company. Lithographed tin with convex front and flat top. 4" x 3.25" x 1". *Courtesy of Elsie and John Booker.*

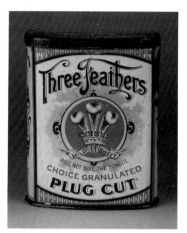

Theod. Vafladis & Co., Egyptian Cigarettes, Cairo, Egypt. Tin box with paper labels. 2.25" x 5.75" x 2.75". *Courtesy of C.J. Simpson.*

Thorough Bred Tobacco. Tin pressing sheet, used to impress the product into the tobacco plugs at the factory. 12" x 9". *Courtesy of Thomas Gray.*

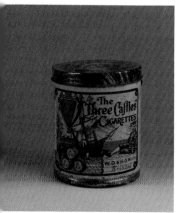

Three Feathers tobacco two-sided sign. One side depicts the tin and the other the pack. Heavy paper. 16" in diameter. *Courtesy of C.J. Simpson.*

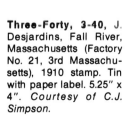

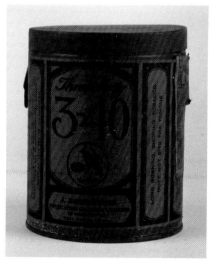

"Three Castles" Cigarettes, W.D. & H.O. Wills, Bristol. 3.25" x 3". *Courtesy of C.J. Simpson.*

"Three Castles" Tobacco, W.D. & H.O. Wills, London, American Tobacco Company, sole distributor in U.S. Tin with paper label, embossed top. 4.5" x 3". *Courtesy of C.J. Simpson.*

Three-Forty, 3-40, J. Desjardins, Fall River, Massachusetts (Factory No. 21, 3rd Massachusetts), 1910 stamp. Tin with paper label. 5.25" x 4". *Courtesy of C.J. Simpson.*

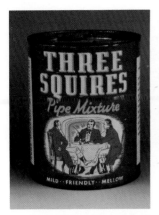
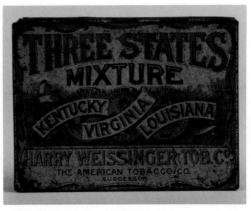
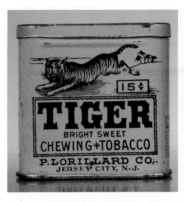

Three Squires Pipe Mixture, Westminster, New York (Factory No. 6, New York). Tin with paper label. 5" x 4" x 4". *Courtesy of C.J. Simpson.*
Three States Milith convex front and flat top. 4" x 3.25" x 1". *Courtesy of Elsie and John Booker.*

Tiger Bright Sweet Chewing Tobacco short pocket. P. Lorillard Co., Jersey City, New Jersey (Factory No. 10, 5th New Jersey). 3" x 3" x 1". *Courtesy of Dennis O'Brien and George Goehring.*
Tiger Bright Sweet Chewing Tobacco. Paper. *Courtesy of Betty Lou and Frank Gay.*

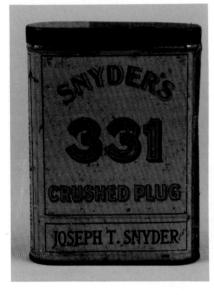

331 Crushed Plug, Joseph T. Snyder (Factory No. 15, Virginia), 1910 stamp. Lithographed tin. 4.25" x 3.25". *Courtesy of C.J. Simpson.*

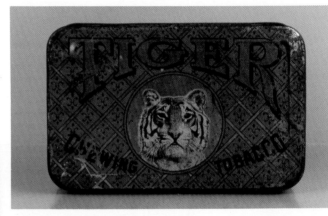

Tiger Chewing Tobacco, P. Lorillard (Factory No. 10, 5th New Jersey). Lithographed tin. 2" x 6" x 4". *Courtesy of Betty Lou and Frank Gay.*

Three Thistles Scotch Snuff, Bowers Snuff & Tobacco Co., Geo. W. Helme Co., Successor (Factory No. 4., Deleware). 2.25" x 1.75". *Courtesy of C.J. Simpson.*

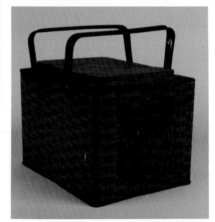

Tiger, P. Lorillard Co., Jersey City, New Jersey. Lithographed tin lunch box, inset lid. 6" x 8.25" x 6.25". *Courtesy of C.J. Simpson.*

Thunder Clouds, Wm. Clarke & Sons. Lithograped tin. 1.5" x 6.5" x 4.25". *Courtesy of C.J. Simpson.*

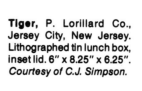
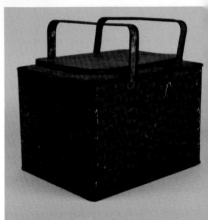

Tiger, P. Lorillard Co., Jersey City, New Jersey. Lithographed tin lunch box, inset lid. 6" x 8.25" x 6.25". *Courtesy of C.J. Simpson.*

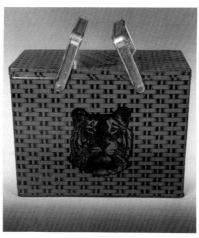

Tobaclets Chewing Tobacco, Tobaclets, Inc., Richmond, Virginia. Chewing tobacco packed as individual chews. Lithographed tin. 0.5″ x 3.5″ x 1.5″. Courtesy of C.J. Simpson.

Tiger, P. Lorillard Co., Jersey City, New Jersey. Lithographed tin lunch box, full lid. 8″ x 10″ x 5.5″. Courtesy of C.J. Simpson.

Tiger Tobacco lunch box in excellent condition. Lithographed tin, full lid. 8″ x 10″ x 5.5″. Courtesy of Dennis O'Brien and George Goehring.

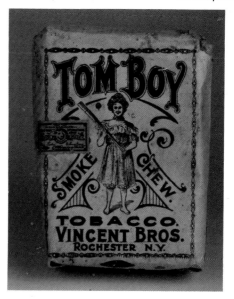

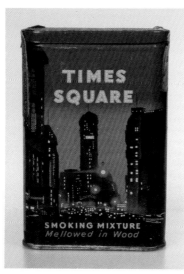

Tom Boy Tobacco, Vincent Bros., Rochester, New York. Paper. Courtesy of Betty Lou and Frank Gay.

Times Square Smoking Mixture (Factory No. 15, Virginia). Tin with paper label. 4.5″ x 4.5″. Courtesy of C.J. Simpson.

Times Square Tobacco (Factory No. 15, Virginia), with series 117 stamp, 1926. Lithographed tin. 4.5″ x 3″ x 1″. Courtesy of Dennis O'Brien and George Goehring.

Topaz Turkish Mixture, W.W. Russell, Richmond (Factory No. 13, 2nd Virginia). Lithographed tin, 2.5″ x 4.75″ x 3″. Courtesy of C.J. Simpson.

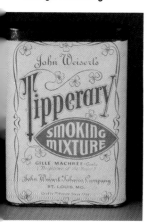

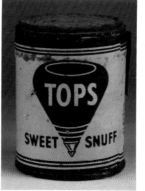
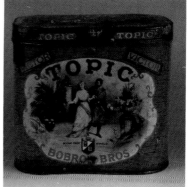

Tipperary Smoking Mixture, John Weisert Tobacco Co., St. Louis, Missouri (Factory No. 93, 1st Missouri). Tin with paper label. Courtesy of Elsie and John Booker.

Tobacco Oriental, Warner & Brown (Factory No. 1, 21st New York). Lithographed tin. 2″ x 4″ x 2.25″. Courtesy of C.J. Simpson.

Tops Sweet Snuff, George W. Helme Co., New Jersey (Factory No. T-4, New Jersey). 2.25″ x 1.75″. Courtesy of C.J. Simpson.

Topic Cigars, Bobrow Bros., (Factory No. 318, 1st Pennsylvania). Lithographed tin with a scene from Othello. The same scene is lithographed inside lid. Courtesy of C.J. Simpson.

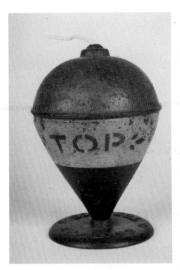

Tortoiseshell Smoking Mixture. Lithographed tin. 2.25″ x 6″ x 3.75″. *Courtesy of C.J. Simpson.*

Tops Tobacco string dispenser. Cast iron. 6.75″ high. *Courtesy of Thomas Gray.*

Torpedo Short Cut Smoking Tobacco, the "Destroyer." Rock City Tobacco Co., Quebec. While less rare than the "Submarine" there are fewer than twelve known. 4.25″ x 3″ x 1″. *Courtesy of Dennis O'Brien and George Goehring.*

Totem Tobacco. Lithographed tin oval pocket with sliding lid. 3.75″ x 2.5″ x 1.25″. *Courtesy of Dennis O'Brien and George Goehring.*

"Town Talk" Mild Tobacco. Lithographed tin. 1″ x 4″ x 3″. *Courtesy of C.J. Simpson.*

Torpedo Short Cut Smoking Tobacco, Rock City Tobacco Co., Quebec. One of three known "Submarine" Torpedo pockets. Concave with wonderful graphics. 4.25″ x 3″ x 1″. *Courtesy of Dennis O'Brien and George Goehring.*

Train Master Cigar (Factory No. 1171, 1st Pennsylvania). Lithographed tin. 5.5″ x 4.25″. *Courtesy of C.J. Simpson.*

Tortoiseshell Smoking Mixture flat pocket, 1″ x 4.25″ x 3.25″. *Courtesy of Dennis O'Brien and George Goehring.*

Train Master Invincible Cigars (Factory No. 1171, 1st Pennsylvania). 5.5″ x 3.25″ x 2.5″. *Courtesy of C.J. Simpson.*

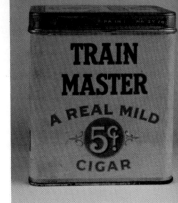

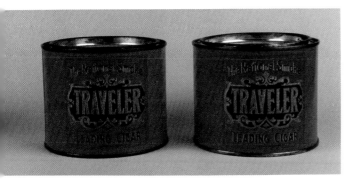

Traveler Cigars, "The National Smoke". Lithographed tin. 4" x 4" x 3.5". *Courtesy of C.J. Simpson.*

Trumps Long Cut playing cards. 4" x 2.5". *Courtesy of Betty Lou and Frank Gay.*

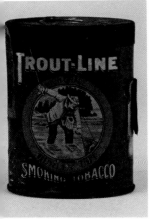

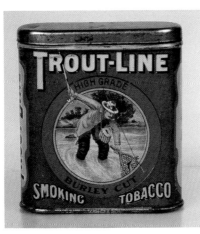

Turf Cigarettes. Lithographed tin. .75" x 6" x 4.5". *Courtesy of C.J. Simpson.*

Trout Line Smoking Tobacco. Oval tin with sliding top and paper label. 3.5" *Courtesy of C.J. Simpson.*
Trout-Line Smoking Tobacco pocket. 3.75" x 3.25" x 1.25". *Courtesy of Dennis O'Brien and George Goehring.*

Turkish Mixture, Allen & Ginter, Richmond (Factory No. 14, 2nd Virginia). Tin with paper label. 2.25" x 4.75" x 3". *Courtesy of C.J. Simpson.*

True Blue Long Cut Tobacco, Reid Tobacco Co., Milton, Pennsylvania, Liggett & Myers, Successor. Tin with paper label. 6" x 5.25". *Courtesy of Betty Lou and Frank Gay.*

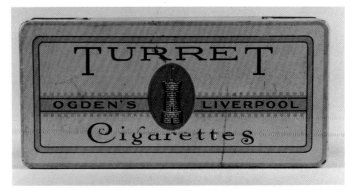

Turret Cigarettes, Ogden's, Liverpool. Lithographed tin. 1.75" x 6.5" x 3". *Courtesy of C.J. Simpson.*

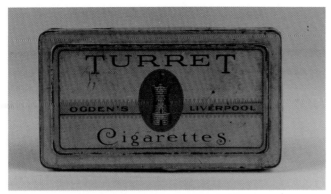

Turret Cigarettes, Ogden's, Liverpool. Lithographed tin. 1" x 5.5" x 3.25". *Courtesy of C.J. Simpson.*

Turret Cigarettes (50), Ogden's, Liverpool. Lithographed tin. 0.75" x 6" x 4.25". *Courtesy of C.J. Simpson.*

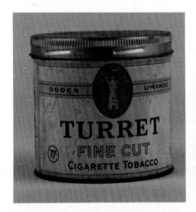

Turret Fine Cut Cigarette Tobacco, Ogden Liverpool, Imperial Tobacco Co., Canada. Lithographed tin. 4.25" x 4.25". *Courtesy of C.J. Simpson.*
Tuxedo Tobacco, R.A. Patterson, American Tobacco Company, Successor. Tin with paper label. 2.75" x 3.25". *Courtesy of C.J. Simpson.*

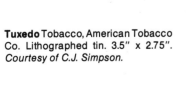 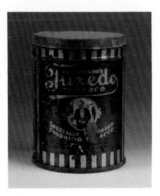

Tuxedo Tobacco, American Tobacco Co. Lithographed tin. 3.5" x 2.75". *Courtesy of C.J. Simpson.*

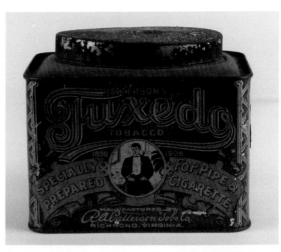

Tuxedo, R.A. Patterson Tobacco Co., Richmond (Factory No. 1, Virginia). 1906 anniversary tin. Lithographed tin with oval lid. 4.5" x 6" x 4". *Courtesy of C.J. Simpson.*

Tuxedo Tobacco, R.A. Patterson Tobacco Company. Lithographed tin canister with domed top. 5.5" x 4.5". *Courtesy of C.J. Simpson.*
Tuxedo (Factory No. 127, Kentucky). Lithographed tin. 6" x 5". *Courtesy of C.J. Simpson.*

Tuxedo, R.A. Patterson, American Tobacco Company, Successor (Factory No. 1, Virginia). Lithographed tin. Left: 5" x 5"; right: 4" x 2.5". *Courtesy of C.J. Simpson.*

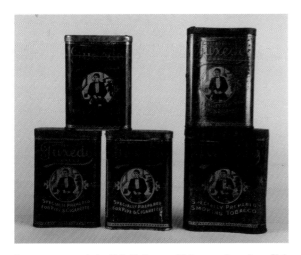

Tuxedo concave pockets, R.A. Patterson Tobacco, American Tobacco Co., Successor. Lithographed tin. *Courtesy of C.J. Simpson.*

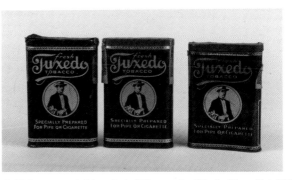

Tuxedo Tobacco upright pockets. Lithographed tin. Left two: flat, 4.5" x 3"; right concave, 4.25" x 3". *Courtesy of C.J. Simpson.*

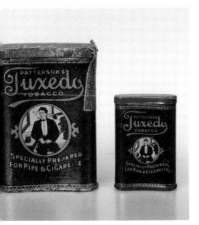 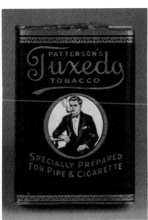

Tuxedo Tobacco concave pocket and sample. R.A. Patterson Tobacco, American Tobacco Co., Successor. 4.25" x 3", 2.75" x 2". *Courtesy of Dennis O'Brien and George Goehring.*

Tuxedo, Pattersons Tobacco Co., American Tobacco Company, Successor. Paper. *Courtesy of Betty Lou and Frank Gay.*

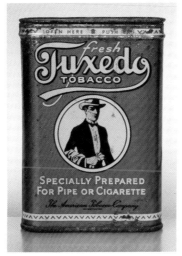

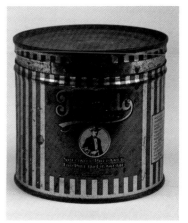

Tuxedo Tobacco pocket, American Tobacco Company. unique for its blue color. All others are green. 4.25" x 3" x 1". *Courtesy of Dennis O'Brien and George Goehring.*

Tuxedo, American Tobacco Company (Factory No. 1, Virginia). Lithographed tin, blue stripes. 4" x 4.25". *Courtesy of C.J. Simpson.*

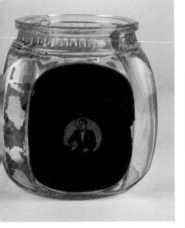

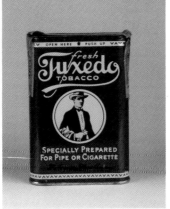

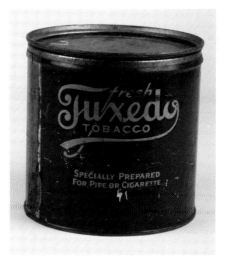

Tuxedo. Glass with paper label. 5.5" x 5". *Courtesy of C.J. Simpson.*

Tuxedo Tobacco, American Tobacco Company. Lithographed tin. 4" x 3" x .75". *Courtesy of C.J. Simpson.*

Tuxedo, American Tobacco Company (Factory No. 1, Virginia). Lithographed tin. 5" x 5". *Courtesy of C.J. Simpson.*

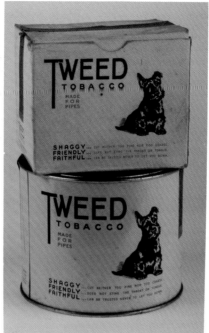

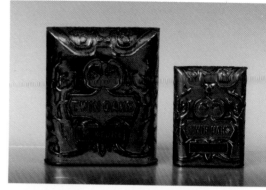

Twin Oaks embossed flip top pocket and sample. 4″ x 3.25″ x 1″, 3″ x 2″ x .75″. *Courtesy of Dennis O'Brien and George Goehring.*

Tuxedo Tobacco and Pipe display held three pipes and two round tins. Lithographed tin. 13″ x 12.75″. *Courtesy of C.J. Simpson.*

Tweed Tobacco, United States Tobacco Co. (Factory 25, Virginia). Top: Cardboard box, 1943, 4.25″ x 5.25″ x 4″; bottom: tin with paper label, 1951, 4.5″ x 5.5″. *Courtesy of C.J. Simpson.*

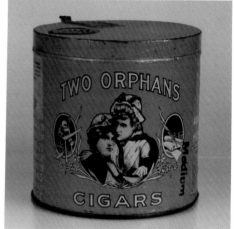

Two Orphans Cigars. Lithographed tin. 5″ x 5″. *Courtesy of Betty Lou and Frank Gay.*

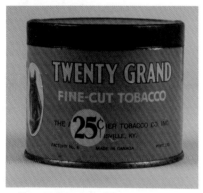

Twenty Grand Fine Cut Tobacco, Louisville, Kentucky, Canada (Factory No. 6, Port 13D). Lithographed tin. 3″ x 3.75″. *Courtesy of C.J. Simpson.*

Twin Oaks (Factory No. 2, Maryland). Embossed lithographed tin. 4″ x 3″. *Courtesy of C.J. Simpson.*

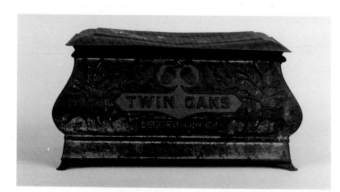

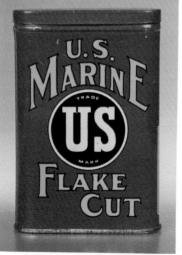

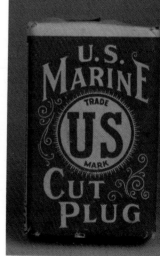

Twin Oaks (Factory No. 2, Maryland). Lithographed and embossed tin caddy. 4.25″ x 5.25″ x 4.75″. *Courtesy of C.J. Simpson.*

U.S. Marine Flake Cut Tobacco, American Tobacco Company (Factory No. 2, Maryland), c. 1910. Lithographed tin, mint condition, uncirculated, Tindeco, Baltimore, Maryland. 4.5″ x 3″ x 1″. *Courtesy of Dennis O'Brien and George Goehring.*

U.S. Marine, American Tobacco Company. Paper. *Courtesy of Betty Lou and Frank Gay.*

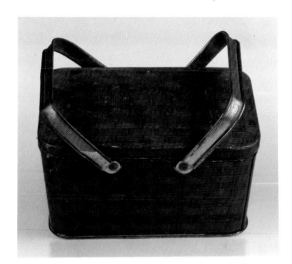

U.S. Marine Cut Plug Tobacco (Factory No. 1, Virginia). Lithographed tin lunch box. 4″ x 7″ x 5.25″. *Courtesy of Betty Lou and Frank Gay.*

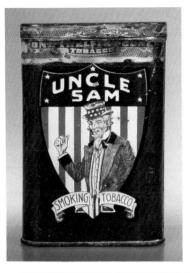

Uncle Sam Smoking Tobacco, a rare pocket tin from the Dominion Tobacco Co., Montreal, probably to appeal to American buyers. 4.5″ x 1″ x 3″. *Courtesy of Dennis O'Brien and George Goehring.*

U.S. Marine Cut Plug. Cloth bag. *Courtesy of Betty Lou and Frank Gay.*

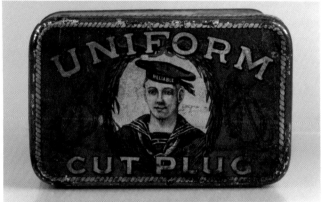

Uniform Cut Plug. Larus & Bros., Richmond. Lithographed tin. 3.25″ x 6″ x 3.25″. *Courtesy of Betty Lou and Frank Gay.*

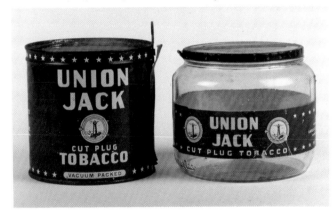

Union Jack, Larus & Bros., Richmond (Factory No. 45, Virginia). Left lithographed tin, 5″ x 5″; right glass with paper label and lithographed tin lid, 4.75″ x 5.5″. *Courtesy of C.J. Simpson.*

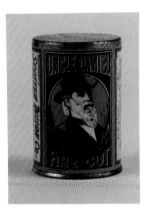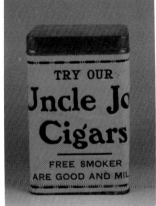

Uncle Daniel Fine Cut, Scotten, Dillon Co., Detroit. Tin with paper label. 3″ x 2″. *Courtesy of C.J. Simpson.*
Uncle Joe Cigars (Factory 1068, 1st Pennsylvania). Tin with paper label. *Courtesy of C.J. Simpson.*

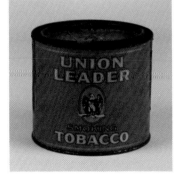

Union Leader Smoking Tobacco, P. Lorillard (Factory No. 6, 1st Ohio). Lithographed tin. 3.75″ x 4″. *Courtesy of C.J. Simpson.*

147

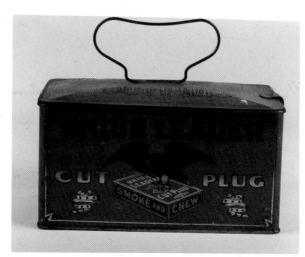

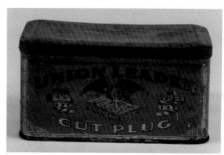

Union Leader Cut Plug, P. Lorillard Co., Jersey City (Factory No. 10, 5th New Jersey). Lithographed tin. 3″ x 6″ x 3.5″. *Courtesy of C.J. Simpson.*

Union Leader milk can tobacco tin in fine condition. Lorillard Tobacco Co. 9″ x 5″. *Courtesy of Dennis O'Brien and George Goehring.*

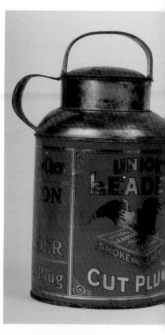

Union Leader, P. Lorillard Co. (Factory No. 10, 5th New Jersey). Lithographed tin lunch box. 4″ x 8″ x 4.75″. *Courtesy of C.J. Simpson.*

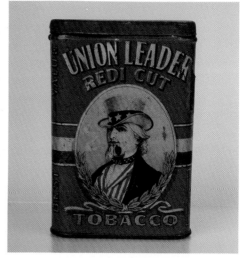

Union Leader, P. Lorillard Co. (Factory No. 10, 5th New Jersey). Lithographed tin lunch box. 5″ x 7″ x 4″. *Courtesy of C.J. Simpson.*

Union Leader Cut Plug, P. Lorillard, New Jersey. Lithographed tin. 6.25″ x 5″. *Courtesy of Betty Lou and Frank Gay.*

Union Leader Redi Cut Tobacco pocket, with 1910 stamp. Lorillard Tobacco Co., 4.5″ x 3″ x 1″. *Courtesy of Dennis O'Brien and George Goehring.*

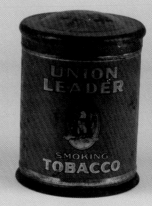

Union Leader, P. Lorillard Co. Jersey City (Factory No. 10, 5th New Jersey). Lithographed Christmas tin. 5″ x 7″ x 5″. *Courtesy of C.J. Simpson.*

Union Leader Cut Plug, 1902 stamp. Paper. *Courtesy of Betty Lou and Frank Gay.*

Union Leader, P. Lorillard (Factory No. 6, 1st Ohio). Lithographed tin. 5″ x 4″. *Courtesy of C.J. Simpson.*

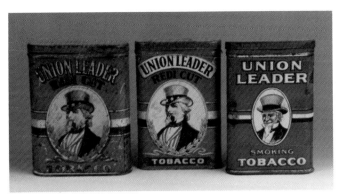

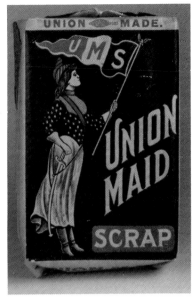

Union Leader, P. Lorillard, New Jersey. Lithographed tin. 4.5" x 3" x 1". *Courtesy of Betty Lou and Frank Gay.*

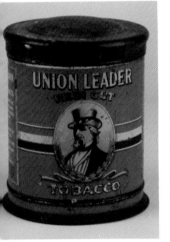

Union Leader Smoking Tobacco, P. Lorillard Co., Jersey City. Tin with paper label. 5" x 5". *Courtesy of C.J. Simpson.*

Union Maid Scrap, Ohio. Paper. *Courtesy of Betty Lou and Frank Gay.*

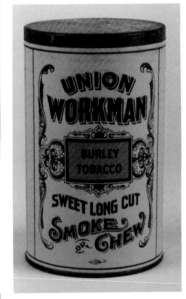

Union Leader "Redi Cut" Tobacco, P. Lorillard Co., Jersey City (Factory No. 10, 5th New Jersey). Lithographed tin. 6" x 5". *Courtesy of C.J. Simpson.*

Union Leader, P. Lorillard (Factory No. 6, 1st Ohio). Lithographed tin. 6" x 5". *Courtesy of C.J. Simpson.*

Union Workman Smoke or Chew, Scotten, Dillon Company, Detroit (Factory No. 1, Michigan). Tin with paper label. 5.5" x 3". *Courtesy of C.J. Simpson.*

Van Bibber Little Cigars, H. Ellis (?) & Co., American Tobacco Company, Baltimore. Cardboard. 3.5" x 2.25" x 0.5". *Courtesy of C.J. Simpson.*

Union Leader, P. Lorillard (Factory No. 6, 1st Ohio). Lithographed tin. 6" x 5". *Courtesy of C.J. Simpson.*

Union Leader Smoking Tobacco, P. Lorillard Co. (Factory No. 6, 1st Ohio). Lithographed tin. 5" x 5". *Courtesy of C.J. Simpson.*

Van Bibber Sliced Plug (Factory No. 2, Maryland). Lithographed tin. 1" x 4.5" x 2.5". *Courtesy of C.J. Simpson.*

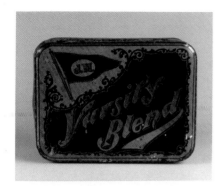

Varsity Blend, John Middleton, Philadelphia. Lithographed tin. 2" x 5" x 3.5". *Courtesy of C.J. Simpson.*

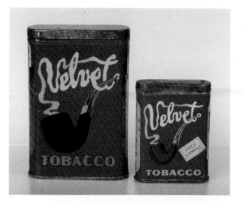

Velvet Tobacco pocket and sample. Liggett & Myers Tobacco Co. 4.5" x 3", 3" x 2". *Courtesy of Dennis O'Brien and George Goehring.*

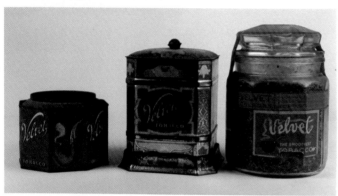

Velvet Tobacco. Left: lithographed tin, 4" x 4.5"; middle: Spaulding & Merrick, Liggett & Myers Tobacco Co., Successor, embossed lithographed tin, 6.5" x 4.75" x 4.75"; right: glass with paper label, 1913 stamp, 7" x 5". *Courtesy of C.J. Simpson.*

Venus High Class Egyptian Cigarettes, D. Condachi & Son, Malta. Tin with paper label. 2" x 6.25" x 2.75". *Courtesy of C.J. Simpson.*

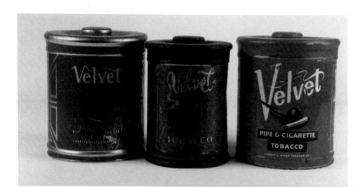

Velvet Tobacco, Liggett & Myers Tobacco Co. Lithographed tin. Left & right 6" x 4.5"; middle: 5.5" x 4". *Courtesy of C.J. Simpson.*

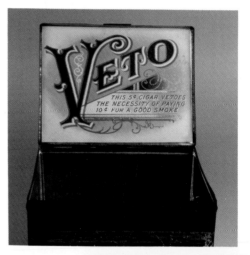

Velvet Tobacco. A scarce small-sized Velvet canister. Liggett & Myers Tobacco Co. 4" x 3.5". *Courtesy of Dennis O'Brien and George Goehring.*

Veto Cigars, "This 5 cent cigar vetoes the necessity of paying 10 cents for a good smoke," Deutsch Bros., New York (Factory No. 92, 3rd New York). Lithographed tin caddy. 2.75" x 6.75" x 5". *Courtesy of C.J. Simpson.*

Viceroy Filter Tip Cigarettes. Lithographed aluminum. 0.75″ x 5.5″ x 4.25″. *Courtesy of C.J. Simpson.*

Virginia Extra Dry Smoking Tobacco (Factory 16, W. Virginia), 1910 stamp. Lithographed tin with embossed lids. Left 6″ x 6″ x 4″; Right 3.25″ x 6″ x 3.5″. *Courtesy of C.J. Simpson.*

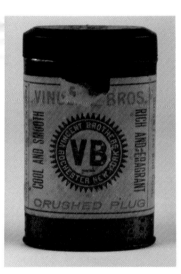

Vincent Bros. Crushed Plug, Vincent Brothers, Rochester, New York (Factory No. 1, 2nd Virginia). Tin with paper label. 4″ x 2.5″. *Courtesy of C.J. Simpson.*

Virginia Ovals, Philip Morris & Co., Ltd., London. Lithographed tin. 0.5″ x 5.75″ x 4.5″. *Courtesy of C.J. Simpson.*

Virginia Returns, Ringer Tobacco. Lithographed tin. 1″ x 4.25″ x 3″. *Courtesy of C.J. Simpson.*
Virginia Rounds, Benson & Hedges, New York (Factory No. 5, 2nd New York). Lithographed tin. .75″ X 5.75″ X 4″. *Courtesy of C.J. Simpson.*

Virginia Brights Cigarettes beautiful lady cards. Cardboard, they were enclosed in cigarette packs. 2.5″ x 1.5″. *Courtesy of Betty Lou and Frank Gay.*

Virginia Creeper Granulated Mixture, W. W. Russell, Richmond, Virginia (Factory No. 13, 2nd Virginia). Lithographed tin. 4.5″ x 3.5″ x 2″. *Courtesy of Betty Lou and Frank Gay.*

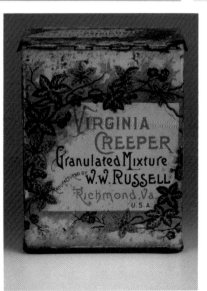

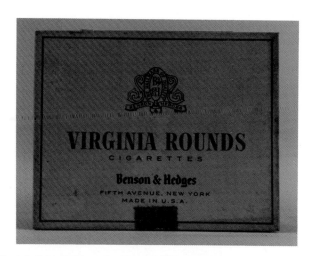

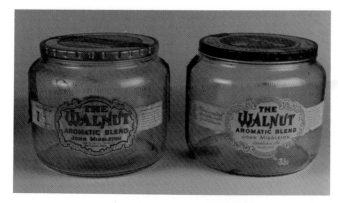

Walnut Aromatic Blend, John Middleton., Philadelphia. Glass jars. 5″ x 5.5″. *Courtesy of C.J. Simpson.*

Virginia Rounds Cigarettes, Benson & Hedges, New York. Lithographed tin. 0.75″ x 5.5″ x 4.25″. *Courtesy of C.J. Simpson.*

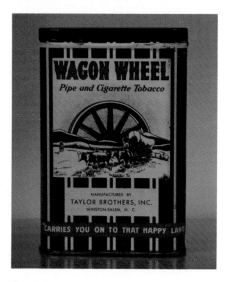

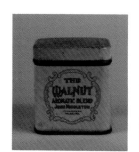

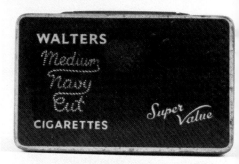

Walnut Aromatic Blend, John Middleton, Philadelphia. Lithographed tin. 2.25″ x 2″ x 2″. *Courtesy of C.J. Simpson.*
Walters' Medium Navy Cut Cigarettes. Lithographed tin. 0.5″ x 5″ x 3″. *Courtesy of C.J. Simpson.*

Wagon Wheel Pipe and Cigarette Tobacco, Taylor Brothers, Inc., Winston-Salem, North Carolina (Factory No. 183, North Carolina), probably from the early 1930s. The legend reads "Carries you on to that happy land of smokers satisfaction and contentment," a far cry from the Surgeon General's Report. Lithographed tin. 4.25″ x 3″ x 1″. *Courtesy of Dennis O'Brien and George Goehring.*

Walters' Medium Navy Cut Cigarettes. Lithographed tin. 0.5″ x 4.5″ x 3″. *Courtesy of C.J. Simpson.*

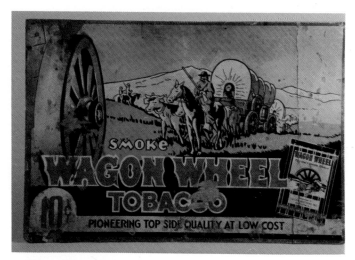

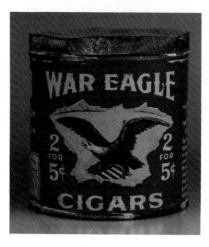

Wagon Wheel Tobacco sign. Cardboard 12″ x 18″. *Courtesy of Betty Lou and Frank Gay.*

War Eagle cigars, Virginia. Lithographed tin. 5.5″ x 5″. *Courtesy of Betty Lou and Frank Gay.*

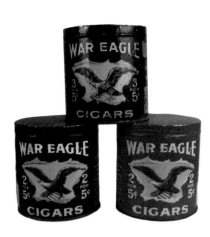

War Eagle Cigars (Factory No. 17, Virginia). Green and red tins are 2 for 5 cents, while the black tin is 3 for 5 cents. Lithographed tin. 5″ x 5″. *Courtesy of C.J. Simpson.*

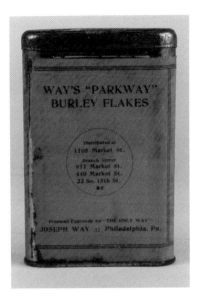

Way's Parkway Burley Flakes, Joseph Way, Philadelphia. Tin with paper label. 4.5″ x 3″. *Courtesy of C.J. Simpson.*

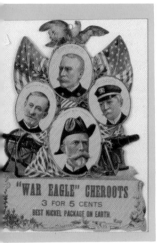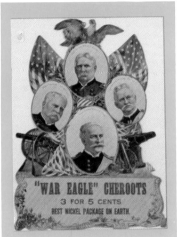

War Eagles die-cut signs, c. 1898. One features U.S. Navy heroes and the other honors the heroes of the army. 14.5″ x 10.5″. *Courtesy of John Kemler.*

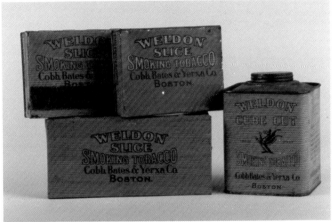

Weldon, Cobb, Bates & Yerxa Co., Boston (Factory No. 45, 2nd Virginia). Lithographed tin. Top left: 1910 stamp, 1″ x 4.5″ x 3.25″; top right 1″ x 4.5″ x 3.25″; bottom left 2.25″ x 6.75″ x 3″; bottom right 4.5″ x 3.5″ x 3.5″. *Courtesy of C.J. Simpson.*

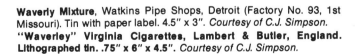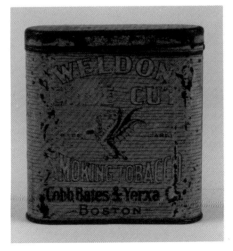

Waverly Mixture, Watkins Pipe Shops, Detroit (Factory No. 93, 1st Missouri). Tin with paper label. 4.5″ x 3″. *Courtesy of C.J. Simpson.*
"Waverley" Virginia Cigarettes, Lambert & Butler, England. Lithographed tin. .75″ x 6″ x 4.5″. *Courtesy of C.J. Simpson.*

Weldon Cube Cut, Cobb, Bates, & Yerxa Co., Boston (Factory No. 45, Virginia). Lithographed tin. 3.25″ x 3.25″. *Courtesy of C.J. Simpson.*

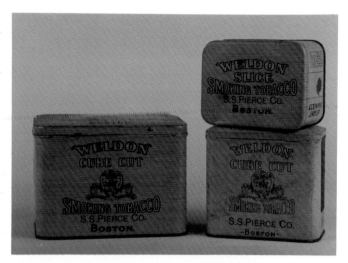

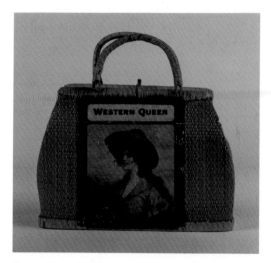

Weldon, S.S. Pierce Co., Boston (Factory No. 45, 2nd Virginia). Lithographed tin. Left: 4.25″ x 6″ x 4″; top right: 2″ x 4.5″ x 3.25″; bottom right: 4″ x 4.5″ x 2.5″. *Courtesy of C.J. Simpson.*

Western Queen Tobacco. Straw handbag. 5″ x 7″ x 3″. *Courtesy of C.J. Simpson.*

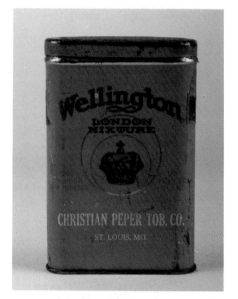

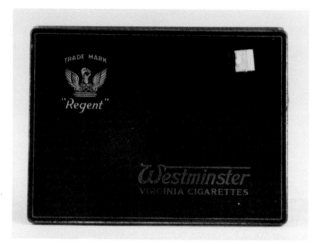

Westminster Virginia Cigarettes. Lithographed tin. .75″ x 6″ x 4.5″. *Courtesy of C.J. Simpson.*

Wellington London Mixture, Christian Peper Tobacco Co., St. Louis (Factory No. 3, 1st Missouri), series 1910 stamp. Lithographed tin. 4.5″ x 3″. *Courtesy of C.J. Simpson.*

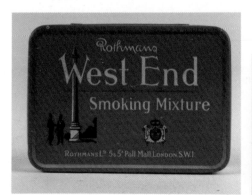

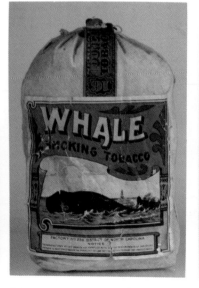

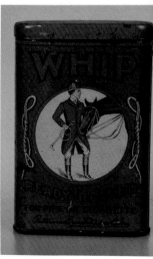

West End Smoking Mixture, Rothman's Ltd, London. Lithographed tin. 1″ x 4.5″ x 3.25″. *Courtesy of C.J. Simpson.*
West Indies Hand Made Londres Cigars, Puerto Rico. 5″ x 3.25″ x 3.25″. *Courtesy of C.J. Simpson.*

Whale, R.J. Reynolds, Winston-Salem (Factory No. 256, North Carolina). Large (7″) cloth bag. *Courtesy of Thomas Gray.*
Whip Ready Rolled Tobacco pocket. Patterson Bros. Tobacco Co., Richmond, Virginia. 4.5″ x 3″ x 1″. *Courtesy of Dennis O'Brien and George Goehring.*

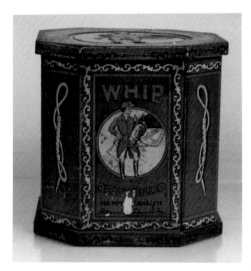

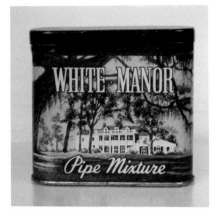

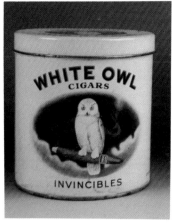

Whip Ready Rolled Tobacco, Patterson Bros. Tobacco, Richmond, Virginia (Factory No. 60, 2nd Virginia). Embossed lithographed tin. 5.5" x 5.5". *Courtesy of Betty Lou and Frank Gay.*

White Manor short pocket, c. 1940. Created by Willoughby Taylor, made by Penn Tobacco Co., Wilkes-Barre, Pennsylvania. 3" x 3.5" x 1". *Courtesy of Dennis O'Brien and George Goehring.*
White Owl Cigars, General Cigar Company Limited. 5.25" x 5". *Courtesy of C.J. Simpson.*

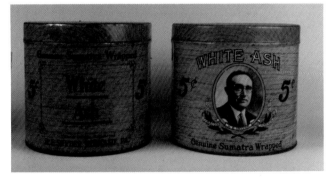

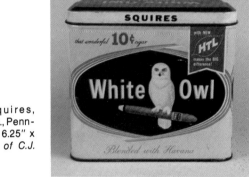

White Ash Genuine Sumatra Wrapped cigars, H.E. Snyder, Perkasie, Pennsylvania (Factory No. 875, Pennsylvania). Lithographed tin. 5.25" x 6". *Courtesy of C.J. Simpson.*

White Owl Squires, General Cigar Co., Pennsylvania. 5.25" x 6.25" x 3.75". *Courtesy of C.J. Simpson.*

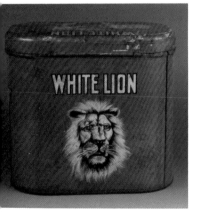

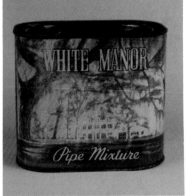

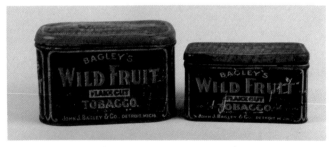

Wild Fruit Flake Cut Tobacco, John J. Bagley & Co., Detroit (Factory No. 6, 1st Michigan). Lithographed tin. Left: 4.25" x 7" x 4"; right: 3.25" x 6" x 3.75". *Courtesy of C.J. Simpson.*

White Lion Cigars (Factory No. 463, 1st Pennsylvania). Lithographed tin. 5.25" x 6" x 4". *Courtesy of C.J. Simpson.*
White Manor Pipe Mixture, Willoughby Taylor, Penn Tobacco Company, Wilkes-Barre, Pennsylvania. Lithographed tin. 4.25" x 5" x 3". *Courtesy of C.J. Simpson.*

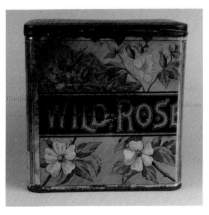

Wild Rose Plug Tobacco, John Finzer & Bros., Louisville, Kentucky, American Tobacco Company, Successor. Tin with paper label. 6" x 6" x 3.5". *Courtesy of C.J. Simpson.*
"Wild Woodbine" Cigarettes, W.D. & H.O. Wills, Bristol & London. 3.25" x 2.75". *Courtesy of C.J. Simpson.*

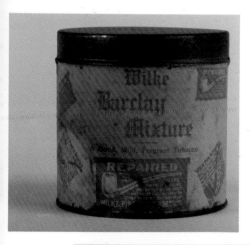

Wilke Barclay Mixture, Wilke Pipe Shop, New York (Factory No. 15, Virginia). Tin with paper label. 4.5″ x 4.5″. *Courtesy of C.J. Simpson.*

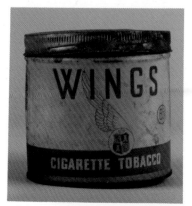

Whip Ready Rolled Tobacco, Patterson Bros. Tobacco, Richmond, Virginia (Factory No. 60, 2nd Virginia). Embossed lithographed tin. 5.5″ x 5.5″. *Courtesy of Betty Lou and Frank Gay.*

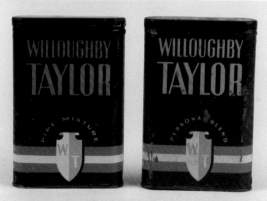

Willoughby Taylor. Lithographed tin. 4.5″ x 3″. Left Pipe Mixture, Penn Tobacco Co., Wilkes-Barr, Pennsylvania; right Personal Blend, Bloch Bros. Tobacco Co., Wheeling, W. Virginia. *Courtesy of C.J. Simpson.*

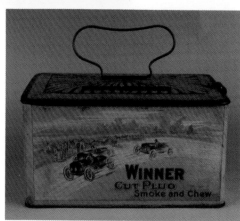

Winner Cut Plug Smoke and Chew, J. Wright & Co., American Tobacco Co., Successor. Lithographed tin lunch box. 4″ x 8″ x 5″. *Courtesy of C.J. Simpson.*

Wills' Fine Cut Cigarette Tobacco, W.D. & H.O. Wills, Bristol & London. Lithographed tin. 4.25″ x 4.25″. *Courtesy of C.J. Simpson.*

Winchester Cigarettes. Lithographed tin. 0.5″ x 5.75″ x 4.5″. *Courtesy of C.J. Simpson.*

Winner, J. Wright Co., Continental Tobacco Co., Successors, Richmond (Factory No. 42, 2nd Virginia). Lithographed tin and leather. 4.25″ x 7″ x 3.75″. *Courtesy of C.J. Simpson.*

Wisko cigars, J.H. Wisler Co., Inc., Souderton, Pennsylvania (Factory No. 972, 1st Pennsylvania). Tin with embossed paper label. 5.75″ x 5.5″. *Courtesy of C.J. Simpson.*

Wizard Quality Cigars (Factory No. 771, 1st Pennsylvania). Lithographed tin lunch box with embossing on lid. 3″ x 6.75″ x 5″. *Courtesy of C.J. Simpson.*

Worker Cut Plug Tobacco, Virginia. Lithographed tin lunch box. 5.25″ x 7.25.″ x 4.25″. *Courtesy of Betty Lou and Frank Gay.*

World's Navy Tobacco. Lithographed tin. 2.5″ x 7″ x 6″. *Courtesy of C.J. Simpson.*

World's Navy Plug Smoking Tobacco, Rock City Tobacco Co., Ltd., Quebec. Lithographed tin. 3.25″ x 6″. *Courtesy of C.J. Simpson.*

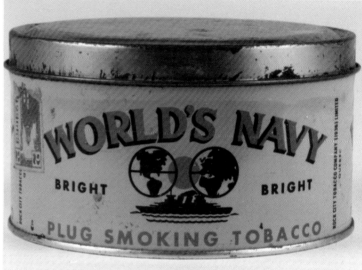

World's Navy Plug Smoking Tobacco, Rock City Tobacco Company (1936) Limited, Quebec. Lithographed tin. 3.25″ x 6″. *Courtesy of C.J. Simpson.*

Xanthia, Xanthis Frères Egypte. Lithographed tin. 1.5″ x 6″ x 4.5″. **Lithographed tin.** *Courtesy of C.J. Simpson.*

Y-B Cigars, Yocum Bros. Tobacco (Factory No. 103, 1st Pennsylvania). Lithographed tin. 5.25″ x 6.25″ x 4″. *Courtesy of C.J. Simpson.*

YAN Tobacco. Embossed lithographed tin. 3″ x 4″ x 2.75″. *Courtesy of C.J. Simpson.*

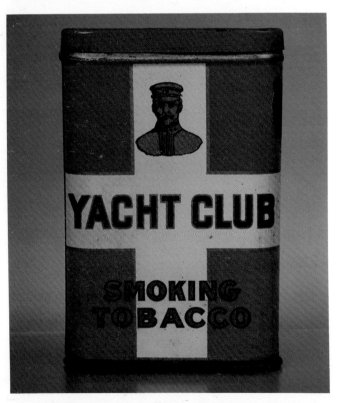

Yacht Club Smoking Tobacco, P. Lorillard Co. Lithographed tin. 4.5″ x 3″ x 1″. *Courtesy of Dennis O'Brien and George Goehring.*

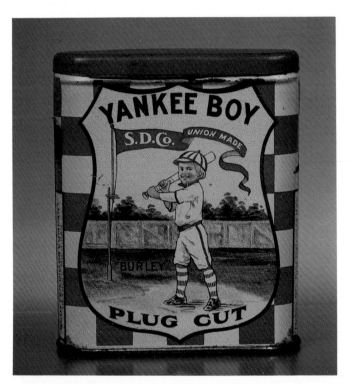

Yankee Boy Plug Cut, Scotten, Dillon Company, Detroit, Michigan. Lithographed tin. Also made with brunette boy. 4″ x 3.5″ x 1″. *Courtesy of Dennis O'Brien and George Goehring.*

Yale Smoking Tobacco, Marburg Bros., American Tobacco Co., Baltimore (Factory No. 2, Maryland). Lithographed tin. Top: 1.75″ x 4.25″ x 2.5″. Bottom, l-r: 1.25″ x 4″ x 2.5″; 2.25″ x 4.75″ x 3″; Ginna, 1.75″ x 4.25″ x 2.5″. *Courtesy of C.J. Simpson.*

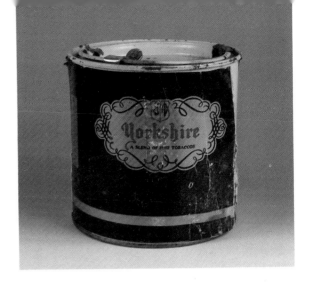

Yorkshire Tobacco. Tin with paper label. 4.25" x 4.25". *Courtesy of C.J. Simpson.*

Yellow Jacket Tobacco hanger, T.A. Crews Tobacco Co., Walkertown, NC. c. 1910. Paper. *Courtesy of Thomas Gray.*

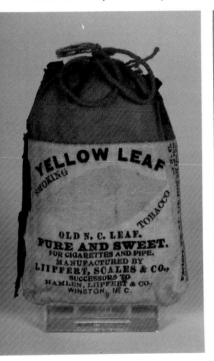

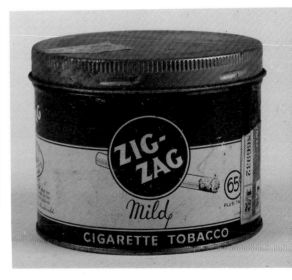

Yellow Leaf Smoking Tobacco, Liipfert, Scales & Co., Successors to Hamlen Liipfert Tobacco Co., Winston, North Carolina (Factory No. 97, 5th North Carolina), c. 1880. Cloth pouch, paper label. *Courtesy of Thomas Gray.*

Yellow Rose Smoking Tobacco, R.H. Fishburne & Co., Roanoke, Virginia (Factory No. 62, 8th Virginia). Cloth bag. *Courtesy of Betty Lou and Frank Gay.*

Zig Zag, MacDonald, Canada. Lithographed tin. 4" x 4.25". *Courtesy of C.J. Simpson.*

Bibliography

Bergevin, Al. *Tobacco Tins and their Prices.* Radnor, Pennsylvania: Wallace-Homestead, 1986

Burns, R.M. and Bradley, W.W. *Protective Coatings for Metals.* New York: Reinhold Publishing Corporation, 1967.

Congdon-Martin, Douglas. *America for Sale: A Collector's Guide to Antique Advertising.* West Chester, Pennsylvania: Schiffer Publishing, 1991.

————— *Country Store Collectibles.* West Chester, Pennsylvania: Schiffer Publishing, 1990.

————— *Country Store Antiques: From Cradles to Caskets.* West Chester, Pennsylvania: Schiffer Publishing, 1991.

Enger, C. Hall. *Tobacco Tin Encyclopedia.* Unpublished manuscript, 1989.

Golden Leaves: R.J. Reynolds Tobacco Company and the Art of Advertising. R.J. Reynolds Tobacco Company, 1986.

Goodrum, Charles, and Dalrymble, Helen. *Advertising in America: The First 200 Years. New York: Harry N. Abrams, Publishers, 1990.*

Hornsby, Peter R.G. *Decorated Biscuit Tins.* West Chester, Pennsylvania: Schiffer Publishing, 1984.

Hyman, Tony. *The World of Smoking and Tobacco: At Auction.* Claremont, California: Treasure Hunt Publications, 1989.

Porzio, Domenico, Editor. *Lithography: 200 Years of Art, History, and Technique.* New York: Harry N. Abrams, Inc., Publishers, 1983.

Sacharow, Stanley. *Symbols of Trade: Your Favorite Trademarks and the Companies They Represent.* New York: Art Direction Book Company, 1982.

Smith, Jane Webb. *Smoke Signals: Cigarette Advertising and the American Way o' Life.* Richmond: The Valentine Museum, 1990. Distributed by the University of North Carolina Press, Chapel Hill, North Carolina.

Collector's Associations

Zigret Tobacco, Turkish and Domestic Blend, Goldsmith, New York. 4" x 3.5". *Courtesy of C.J. Simpson.*

Tin Container Collector's Association (TCCA
Box 440101
Aurora, CO 80044
Publication: *Tin Type*
Membership: $25 per year

Clark Secrest, alias "NOZ" (Nosmo King) started TCCA in 1971 and has beem turning out the newsletter ever since. It is an invaluable source of information on tins, written with humor and a down home style. TCCA also sponsors annual "Conventions".

Antique Advertising Association of America
P.O. Box 1121
Morton Grove, IL 60053
Publication: *Past Times*
Membership: $35

With the first issue of *Past Times* in 1991 this new organization brings new enthusiasm to the field of collecting. While including tins, it has a breadth of interest that include all phases of antique advertising. They hold an annual convention at various locales around the country.